INSIDE

THE

ENDLESS HOUSE

Art, People and Architecture:

A Journal

by

FREDERICK KIESLER

SIMON AND SCHUSTER NEW YORK

87337

Published by Simon and Schuster
Rockefeller Center, 630 Fifth Avenue
New York, New York 10020

First Printing

Library of Congress Catalog Card Number: 65–18655
Manufactured in the United States of America

Contents

In memory of Steffi, my unforgettable companion of 45 years.

Introduction

October 26, 1965

The absolute silence was shattered by a punch into the entrance door which swung open.

There stood a young lady, the perfect tramp.

She had come to apply for a secretarial position which I had advertised. I was shocked at her appearance: "Please stay where you are. I have a good view of you from my desk. My personal secretary will come right in to take down all the necessary data."

Kay Johnson, that was her name, gave a fashion-collage appearance: irregular long pigtails, a blouse and skirt not changed for weeks, and shoes open at the toes.

But she spoke very intelligently:
"You advertised for a Girl Friday. I am it! I have written books, although unpublished. I work on portraits, although unsold. I have to make a living. Please give me a try."

I addressed my old secretary who stood next to her:
"Please, Olga, take thirty dollars, go down to Lane's on 14th Street and buy this young lady a blouse, a skirt, stockings and some decent shoes. From there, take her up to the hairdresser in the same building and let those pigtails give way to a contemporary hairdo, whatever the style."

Then I turned to the apparition that was Kay:
"Please come back tomorrow at the same time, and let me see the transformation. I am not promising to hire you. I still have three other applicants to interview. But, whatever happens, at least I want to help you look a little more like New York."

Her appearance and intelligence were a contrasting shock. One of those migrating, parentless, friendless isolated waifs. Still, she did have that sparkle in her eyes.

9

The next day she arrived and wordlessly handed me a violent letter of accusations such as: "a typical bourgeois boss." I asked her to sit down and in a three-minute discussion was again made aware of her superior intelligence.

She stayed with me for half a year and during that time once tried to throw a typewriter at me. However, that did not deter me from appreciating her—and her deep-born intelligence.

The typewriter-throwing incident occurred to dramatize her insistence that I must start to write: "because I have written many books myself, although unpublished, and I know, with every fiber of my intuition, that you can do it."
"But you know I cannot pay you."
"But I don't want to be paid. I will stay here as much time as necessary, after office hours, to take dictation from you."
"Well, then," I said, "let's take a chance. Put a piece of paper into the machine."

From that moment on, I found I could write, for the sake of writing, on any subject that came to my mind.

This is how my book was started. There was no rhyme nor reason for it—but, there had been Kay who had insisted.

At the end of six months, she could no longer stand the coldness of New York, the casualness of its people, having been born in New Orleans. She asked me to replace her. She wanted to return to New Orleans.
"Why to New Orleans," I asked her, "since you were so unhappy in that place and you have no relatives there?"
"But," she answered, "I have my own furniture, my reliable friends, stored there in a warehouse."

She left. Subsequently, every two or three months I would receive a letter or price-negligent telegram, culminating in a long note telling me that life in New Orleans had become even more boring for her than before and that the only saving spot for her would eventually be Paris. She would sell all she owned, including some rotten paintings, and would take a chance and move to Paris: "What do you think of my idea?"

I immediately stripped a page from a pad and answered:

"Dear Kay,

It's O.K. with me. Go! I shall immediately send you a ticket from New York to Cherbourg and three dollars a day for a year just to help along. Good luck to you."

I did not receive her answer until many weeks later, when her reply came from Paris.

That was eight years ago. From then on, every month or so, she would send me a telegram of Chinese poetry. She knew I couldn't read Chinese, but this black calligraphy was her bouquet of international flowers, not to be read, but to be understood, one by one.

I have to render bouquets to editor Elizabeth Sutherland, who for one and a half years came to survey the script with me at any hour of the day. I thank her deeply for her sympathy and exactitude.

And, of course, I am deeply obliged to my wife Lillian for never failing to stand by. Without her the manuscript would have never been finished.

the artist's flight
into nowhere, the nowhere
his home
uncontested

time and again
he is down to earth
to pay rent, and debts
to the hard sidewalk
and respects to his studio

through a hole in the
ceiling the sky-light
filters down
in its halo he is
waiting for the stigmata

the window is rectangular
iron bars are
welded into hard-edged squares
through which the artist looks up
from his chosen prison of solitude
into a screened infinity

he closes his palms to a
chalice holding up its emptiness
hoping for the manna of life

happy turtle whose cave
grows on its back and
protects it from the imaginary blessings
of the heavens

it crawls the earth
bound to it forever

food is on her path
no matter where she turns
the mate appears uncalled for,
and is welcome

there will be egg rolling
on the green lawns of
millions of white houses
not built by architects

lucky turtle

the touchdown is continuous
belly to belly
shell against shell, constant
friction and no harm

you have the total independence
without that pseudo security of
science, agriculture, industry, art

oh lucky turtle
you are the very dream image and reality
of independence
resting securely in the palm of your shells.
 just being a summary of split seconds lived
 continuously

crawling

 crawling

 crawling

1956—

New York, U. S. A.

Towards the Endless Sculpture

Saturday Afternoon
July 25, 1956

Steffi, my wife, said, "I don't understand what you mean by an endless sculpture. No object exists in nature which is endless. Nor in art, whether it's a painting or a sculpture.

"A tree grows from seed to crown and is finished. A man develops from the nucleus of his genes to his shape and content. A painting has a frame and that's its border; a fresco has its beginning and end. Everything has its limits, everything ends.

"You don't think you can change all these laws, do you?"

I began to answer her; and my arguments turned into a monologue —almost endless.

"I don't know what the laws of nature are as far as art is concerned; that is, does nature also control the impetus to art or is art a completely independent development by man for man? I do know something about nature's laws concerning mutations of its own forms in space and time. But how strong or how weak is her will to art—if it exists at all?"

"Others have thought about that, too, you are not the only one," Steffi broke in, and I replied, "I know, and I hope that they will support me in my effort to clarify the issue."

I began again: "Nature is so rich, so compact and so condensed that each innermost particle would open an endless world to us if we had strong enough lenses in our eyes and enough cells in our frontal lobes to see and grasp it. We don't. But artists present us that world outright.

"Most people see only the result of this world of mutations, the outer reality: that which we can chew with our teeth, record with our ears, smell through our nostrils, take in through the pupils of our eyes. The rest of perception seems to us illicit and of no practical value; mystical, a tea-leaf prognosis. It is the poet, the artist,

18

who senses the inner drive and workings of nature. The poet's feeling is inspired by a force conveniently known as the unknown, and he loves to surrender to it. The average man is afraid of this power which he cannot grasp and grip. That's where the creator and the burgher diverge. The poet's feelings go deeper, wider, faster and farther than any of the electromagnoscopes which man constructs to poke into the secrets of nature.

"Nature permits the philosopher and the scientist and the technologist to crawl into its innumerable secret chambers, through its various portholes and trap doors, disclosing one petty aspect after another, but never the whole interior. Nature thus makes man believe he has gotten to the heart of the matter when, in fact, he has entered only antechambers. Amusingly, with each of our 'discoveries,' a new system of the laws of nature has been proclaimed and dogmatized, only to be overthrown one or two hundred years later, indeed a short time considering the cosmic world. The charm of man is that, with all his arrogance of detail-knowledge, he has remained utterly naïve (and the artist makes the most of this naïveté). He is constantly being consoled by a new system of 'absolute truth.' Euclid's laws worked, the non-Euclidean laws worked and Einstein's laws work too. They all work, because nature delights in having her toes licked by these charmingly inquisitive dogs, and her laughter is seized upon by them as the utterance of ultimate truths. A delectable misunderstanding."

"You are sardonic, I wish you would be laconic," Steffi interjected.

"All right, let's get on with art. There is a connection between the approach of the average scientist to nature and the way most people think about art. In fact, the situation is worse in art with a capital *A*, as well as in architecture.

"In contemporary sculpture or painting, the paintings end with their frames and are finite; sculptures, from their pedestals to their tops, are finite too, no matter what their material.

"To extend these art forms in space, beyond their customary limits, is indeed changing their constitution and might rightly be called a revolution against the state of art today.

"The artist/creator has always been in search of the basic laws of the world he lives in. He tries to express the unknown *with* the

19

known, contrary to the scientist, who tries to find the unknown *in* the known.

"He has become aware of the forces which hold planets, suns and star dust in set relations to one another so that, even when orbiting, they do not lose their family relationships. (The continuity of this correlation is never interrupted.)

"Let me give some specific examples of how I have tried to break through the borders of the finite, the prison of the frame, and to express a sense of this correlation. As you remember, in World War I I was in the press corps stationed at the Schwartzenberg Platz in Vienna. Because of my work, I was able to see the Swiss newspapers and thus knew several days before the signing of the Armistice that the war was about to end. I therefore quit going to the office and started to build a large 'galaxy' of paintings out of gray cardboard—about twenty pieces, irregular in size and covered with white tracing paper. I nailed them to the wall at different intervals from each other and painted in *grisaille* a vast field of human bodies whose proportions grew larger and larger the higher they were placed. Do you remember that, Steffi?"

"I certainly do."

"Then, twelve years ago, I revived the galaxial idea to portray personalities fixed in space and time—E. E. Cummings, Marcel Duchamp, Henri Laugier. These were *families of paintings* instead of bachelors and spinsters in isolation. To do this, I had one main tool and technique: the proper dimensioning of distance between one unit and another. Thus the intervals between the units became of major importance to the correlation of the total work. One unit closer or farther, higher or lower, from another will have a great impact on the composition of the galaxy per se and also on the observer who is drawn into this world of a man-made expanding universe.

"In my galaxies the paintings are also set at different distances from the wall, protruding or receding. Naturally they have no isolating frames, since the exact interval-space between them makes frames superfluous. The total space of the wall or room-space provides a framing in depth—in fact, a three-dimensional frame without end. These galaxies, although they start from a minimum of three units and expand to as many as nineteen, were only an at-

tempt at endlessness within the enclosure of a room. But I t[l]
they could, with careful nurturing, be added to *until the power of
the inner magnetism* is exhausted.(And if they actually end (physi-
cally), their capacity to inspire continuity would still be great, in
that the observer could go on adding more and more units accord-
ing to his own imagination. He would then be extending the new
magnetic field derived from the existing nucleus of the original
concept.)

"Everything I have been saying up to now should help toward an
understanding of the 'endless' sculpture I have been working on
for a long time, 'The Vessel of Fire.' But, as you will see, theory
does not always come first. The actual moment when I felt the
need to extend my first bronze sculpture beyond its primary unit
came late one evening when I was doodling. But I will tell you
from the beginning the whole story of my endless 'Vessel of Fire.'

"As I remember, that first unit was the original model for the 'End-
less House,' a piece of architecture done in clay and constituting
a triple interplay of shells, one hollow laid within another, like
broken eggshells. Altogether they were about one and a half feet
long and one foot wide. Not a sculpture, mind you, but a piece of
architecture. The mutation into sculpture apparently started when
I looked at it after a lapse of time and its form became more
prominent than its function. I felt differently about a thing that
had suddenly become something different.

"Since I had had no recent experience with clay, and my assist-
ants had never had any, the clay shells cracked when put into a
wooden cradle for drying. Although we tried for several weeks to
fix the cracks, and we carefully mixed 'slips' of clay, the shells
barely held together and the model was ready to be thrown away
because, as two specialists told us with amiable finality, it would
not withstand the firing by ceramic heat.

"But having spent so much time on it and taken so much care with
the interrelation of these various shells, and having the Graham
Foundation's grant, that is, some funds to pursue 'artistic' work, I
decided not to let the labor of several weeks be totally lost but to
take a chance and cast it in bronze, just to preserve a record of a
part of the 'Endless House' model.

"We put the dry clay architecture-sculpture into a new wooden

cradle to fit its contracted form; we bedded it on soft pillows in the car to reduce shock and drove out to the foundry. When we arrived, all its old cracks, those wounds from an amateurish craftsmanship, had opened again. There was really nothing left to do but to cast it in bronze, no matter what the cost, and at once.

"When I was shown the cast of it two months later, it looked good to me: the cracks had been filled solidly with bronze. The shell-architecture rested on its back, rocking peacefully like a cradle.

"I asked that it be lifted on its edge; why, I don't know. That spontaneous demand was really the beginning of the endless sculpture. Standing, like a baby that had always lain on its back and finally has the strength to get on its feet, it assumed a non-functional expression, it was no longer the shell of my 'Endless House.' It acquired a new personality, the plasticity of a sculpture.

"If I wanted the curvature of these now-upright shells to remain standing permanently, they would have to be supported by a pedestal of stone or marble with pins driven in. The sculpture would then come to rest somewhere in the concentration camps of art. That would have been the normal way. That would have been the exhibition way, the Museum way. And that would have been the end of this creative process.

"But I got restless. The impact of this unexpected transformation haunted me, as if a roaming bat had taken refuge in me. I could do nothing but make friends with it and accept its companionship.

"In a few weeks, I added a high structure of wooden planks underneath the bronze shell. This enlarged the sculpture downward, and at the same time lifted it up seven feet into the air. We had quickly hammered some planks together, and before making a final decision on the validity of this conglomeration, we suspended it from the foundry's steel pulleys, which carried the weight with ease. Thus we had a chance to study it without fear of a sudden collapse.

"The vertical planks and crossed pieces looked factory-dressed, precision-cut, like flooring with lumber-yard smoothness. That wouldn't do. No, couldn't do. It must show the touch of a human hand, in sympathy with the textures of the bronze shells. I have never carved wood. Carving has always seemed to me to be a pas-

22

time occupation, a long-winded process of burrowing one furrow next to the other so that some form might finally emerge. It's like needlework with steel tools. No, that wouldn't be it. I could see it hewn rough, crude, not smooth. Surface split. In that shop-of-all-tools, I decided to ask for an axe, a heavy one, then I requested a second axe, with a small blade. They found them. I handed one to Ralph, and we both chopped the surface up and down, up and down, incising, splitting, hewing, tearing—and within two hours the planks looked like wood in the raw, ripped from a tree trunk, utterly muscular.

"When I saw the bronze cast and the plank-scaffold together, it seemed right—but not entirely. Something was needed to further the expanse. I felt I must again enlarge the bronze unit itself; it simply had to continue if it was not to remain merely a sculpture on a tall pedestal. I wasn't sure how to do it, but I knew that it needed wings to conquer space.

"After lunch, I walked casually over to another section of the foundry where wax was prepared for pouring. In a playful mood, I snatched a wax sheet, cut it in two, heated the pieces, bent the square panels into slightly twisted curvatures and asked them to be cast. This was the first addition to the bronze unit, and improvised it was.

"In another two weeks, these two new shells were ready in bronze. The moment had arrived for me to place and integrate them. I climbed a ladder, helped by my assistant Ralph. We held the shells in position, called Bob with his mask, flame-thrower and rod, and welded them to the existing bronze shell. The sculpture took a deep breath and expanded its chest. It seemed surprisingly right.

"I soon realized that the tall framework of the two planks had to have a widespread base, otherwise the massive bronze above would make the whole sculpture top-heavy and it could topple over, killing me and my assistants before it crashed down on my critics.

"An extended new sculpture consisting of several wooden pieces, planks or blocks and beams, had to be added to the base to give it better leverage. A new and natural enlargement. Quite easy to concoct a wide sculpture base, but was that the solution? No. It must not be on a pedestal. It needed an extension of the sculpture as

23

such—something quite different in character and form from what would be above.

"I stepped out into the courtyard of the foundry for a breath of fresh air and, looking around, I discovered pieces of wood lying about, dilapidated, with a natural patina of age. There was one plank in particular, burned and charred like a black diamond with many facets, a life lived to the limits of heat. I stole them outright and carried the logs inside. This seemed to be the answer to my problem.

"Rapidly, with the many hands of the workmen around me, I fastened them with nails and cords to the planks, giving the sculpture an approximation of the necessary leverage and finally releasing it from the grip of the pulleys. We could then see that it would stand up all right. And in that moment of sensing the sculpture's security, I found myself in a very tense state between satisfaction and dissatisfaction.

"The jet black of the charred leg protruding from the pile struck me with persistence. This encounter proved to be a turning point. My glance rested on the silky blackness of the charred beam at the base, and I saw the crust cracked into squares which girded the log all around. I wondered how deep the fire had eaten into the core of the wood. The fire! In a flash the array of wood, the burned bark, became a pyre. I could see a vessel of fire built into the sculpture, becoming the heart of it. This was the instant, as I remember, when the *content* of the sculpture affirmed itself—a content born from the plastic constellation of its materials of wood and bronze in space. Thus emerged the sculpture as it is now: not illustrating a preconceived content but following its own dictum.

"Clearly, the next step was to intensify this command by incorporating a source of fire into the sculpture. I grabbed a saw and as quickly as I could cut apart the tall flanks of the wooden planks to insert into this cut a bronze plate which could carry a vessel of fire. It was a violent break in the solidity of the total sculpture, but I knew that placing a bronze vessel filled with oil on this plate and setting it alight would produce a flame that would fill all parts of the sculpture with a vibrating light, a meaning which I could not exactly account for.

"I dimensioned the plate carefully and ordered one to be cast to

size. The plate was ready in a few days. The upright planks, already cut apart diagonally at the designated spots, were now chiseled and fitted so that the bronze plate could be sandwiched between them, and tightly. It felt right, and looked as if it had been planned that way from the very beginning. It cut the total structure by one-third, as determinedly as a saber swiftly beheading a man. The blood spurted out of the cut and etched itself on the plate in a strange calligraphy (later I thought of calling the sculpture 'Letter to a Woman'). I laughed at my bafflement in trying to find a rhyme and reason for doing all these things which had never been thought of before by me yet were done now with determination.

"But the most unexpected evolution was still to come.

"Seeing the bronze plate with its doodle-like engravings scooped out with electric rotary files, I found myself focusing upon one spot on its surface and seeing in my vision a flame (which was not there) shooting up through a hole in the plate: golden, red, smoky.

"Fire and water have always haunted me as sources of life, and I had placed both of them in the floor of my 'Endless House.' The question now was how to produce the fire, self-contained, independent of any outside source.

"I had often been fascinated by the smudge pots placed at night on the streets of New York to guard the open diggings of street repairmen. The flame of these smudge pots was just the type which presented itself in my vision, fluttering like a flag and giving off enough dark smoke to nighten the wooden sculpture above and around the flame. The idea was exciting and appeared irrevocable.

"I had to acquire a smudge pot to understand its inner mechanism for reproduction in the vessel. But where?

"One day, driving on Seventh Avenue, Alice, Ralph and I saw four of them burning in our path, but we did not have the courage to steal one. We awaited our opportunity.

"Two weeks ago, I flew to Montreal to visit a prospective client who, having seen a photograph of my model of the 'Endless House' in a magazine, had invited me to look over a possible site for a deluxe apartment house to be built in the manner of the 'Endless.'

I had never been to Montreal before. The son of my host met me at the airport in a Cadillac limousine and drove me to the hillside home of his father outside the city. I could not get a clear impression of the environment during this short upward drive. The evening had already made its inroads with long shadows over the empty avenue, lined on both sides with the villas of wealthy citizens.

"Here and there automobiles rested along the curb. A perfectly peaceful atmosphere, as if all motion in this suburb had been halted and the street was ready to go to sleep. But through the wide front window of our car, I saw a lone man emerge from a side street and cross the road. He stepped along the shadows, cradling in his arms several dark gray balls of considerable size. Coming closer and closer to him, I recognized the objects he was carrying: smudge pots, exactly the type I had looked for in New York.

"I immediately asked the son if we could stop for a minute. Clambering out, I faced the man with the smudge pots. I tried to seduce him into selling me one, but he was Italian and spoke no English, French or German. I do not speak Italian but apparently he was afraid to accept money, being a city employee. My chance vanished, and we drove on. The silence was dark. The encounter with that man of the flame vessels persisted in me as a verification of my concept. I became firm in my desire to incorporate a flame amid the heap of wood and bronze.

"After my return to New York, I heard to my amazement, that Ralph had in the meantime located a store that sold smudge pots, right in our neighborhood! Thank God, because by then—being obsessed by my vision of a flame—I was trying to concoct in my mind the mechanism of a smudge pot into the bronze vessel.

"I quickly and casually designed the shape of the vessel that was to hold the mechanism for the wick and aeration. I was so sure now that my decision to incorporate fire in the sculpture had been right that I didn't care much about the form of the vessel. Giving John, the bronze-caster at the foundry, only approximate dimensions, I left him to finish it.

"But arriving home late that night, at about two in the morning,

I became wide awake, as so often happens with me when facing my desk.

"I took my pad, a fountain pen, and started to scribble and doodle. Gradually the strokes developed the sculpture further and further, higher and wider. A whole array of sketches accumulated under my hand, forming a soft cushion of ideas for the bounding sculpture. By three in the morning I had decided to add one, two, three or even five new wings to the crown of bronze.

"Then, if the top bronze still should not achieve a sense of continuity with the wooden torso, the intersecting bronze plate and the vessel of fire, I would have failed to achieve continuity within self-imposed limitations. That I would be able to judge only when the new additions had been cast and actually welded on. These were moments of anguished waiting. You see, the sculptor's wings are really made of clay and his work is earthbound. It is the breathing of the intervals between details that makes his materials live and expand visually. Isn't the dimensioning of space-distances, the exactitude of intervals, the physical nothingness which links the solid parts together so powerfully—isn't this the major device for translating nature's time-space continuity into man-made objects?

"At this stage of the game my sculpture actually consists of five different units, each of which is complete in itself, yet none of them lives unless correlated to and feeding upon another. Here are the five sectors: *first*, the footing, the pyre consisting of six logs; *second*, the bronze plate; *third*, the vessel of fire; *fourth*, the upper structure of the scaffold called 'the guillotine'; and *fifth*, the bronze crown above.

"This is its present status; it might change any day or minute into flocks of new generations, new units.

"The necessity for expansion, that is, the necessity for expanding further the original family of sculptures might have many different physical and emotional reasons. It is not just a whim of adding more sculptures or color or textures, it really must have validity through an inner necessity.

"Take, for instance, what would happen if the 'Vessel of Fire'

sculptures were moved from their present environment, with its strict dimensions of space, into a new hall or room or corridor. There might or might not be the necessity of adding new pieces to it to close the circuit of correlation. It really depends entirely on the strength of expression of each piece, how far its influence will reach across intervals toward the other pieces and to the walls and enclosures it must meet in the new environment. So you see the field is indeed wide open; new units can be adopted, adapted or eliminated as the spatial necessity of the environment arises. The only difference from ordinary interior decoration is that in the concept of an endless sculpture or galaxial painting, all units depend entirely on one another and cannot be interspersed with draperies, other pictures, etc., all the fill-in, fill-up paraphernalia of wall coverings. The endless sculpture is indigenous to its environment and constitutes a global organism in itself growing constantly from fixation to discontinuity within the will of an unlimited continuum.

"Its new content is that continuum. I can only describe how I and friends felt when we confronted an early galaxial sculpture of mine in Paris. This content seems to have the ritual of a landscape, the embrace of space—a verification of being alive, the world of a beloved face, and peacefully so. There is nothing that I can add to that. You have to see it yourself. I hope you feel the same way as I do."

"This all sounds rather plausible, I must say," Steffi replied after a long pause in which she tried honestly to gain distance from me and what I had said. "You have almost convinced me—theoretically. Of course, I agree that any artist has the fundamental right to use his imagination as much as the materials will allow. You seem to believe in your idea firmly. I and others will still have to be convinced by the actual sculptures or paintings which you execute. Then I will be very happy to give you my honest reaction as to whether the 'endless sculpture' is only a theorem or a new plastic reality. Let's wait until it's assembled."

"Of course, I agree with you, Steffi, that the breath of continuity must be sensed by almost everybody. If not, I have failed.

"My 'Vessel of Fire' is an endless sculpture because it was born from the laws of continuity. For that reason, it has given birth to a content of its own, neither premeditated nor superimposed by

28

me. Within the existing environment of nature and man, it has created its own environment of being. I feel that I have broken the chains of traditional single paintings by linking a variable number of painted or sculpted units to an ever-expanding new totality.

"Believe me, I have not tried to make a theory out of accidents and incidents. I have only tried to follow an inner drive. The spreading of the wings without goal was happiness indeed.

" 'The Vessel of Fire' will probably continue to grow and grow in its fluidity as its physical and human environment changes.

"Strangely enough, what appears, in art and in life, to be a standstill of plastic forms is actually only a slowdown in the creative evolution of space-time. We cannot escape it. Space-time cannot be taken any more in a material aspect only. We realize now that the perception of our physical reality is triggered by the swinging pendulum of the psyche."

Postscript I (*March, 1960*)

By today, "The Vessel of Fire," which is the main floor sculpture as described in my discussion, has expanded to a wall sculpture called "Heloise" and a ceiling sculpture called "Embryo," and thus creates the measures of its own environment.

Postscript II (*September, 1960*)

In writing down the dialogue, my thoughts suddenly converged on a time eight years ago when I exhibited a large sculpture at the Museum of Modern Art called "Galaxy"; a *Life* magazine article called it "a sculpture to live with and within."

That was the first of the New York "environmental sculptures," as my colleagues called them.

They were right: to live with and within, that is, directly with art and architecture, is the new concept of art. Non-objectivity is past history.

Separatism, segregation, isolation in our social life must make way as never before to integration of purposes in all fields of en-

deavor. It will bring greater appreciation of our individuality, not conformity, simply because caring for each other is safeguarding the respect and esteem for every one of us.

Poetry and art, the forerunners of social revolutions, should now take the lead in promoting the new content of this age of falling boundaries. Correlate free will with fate or die.

Art can no longer live in mid-air nor architecture on the ground of business. That's over. Spread your roots and you'll be solidified.

Art-tricks, or elec-trics or mechano-clicks or the temptations of new materials in architecture cannot save the artist from his responsibility to the wellspring of ethics. This is it.

The performances of mechanical art-toys unfortunately are, by their very nature, as repetitious and limited as push-button releases of jukeboxes.

Sculptures as electronic marionettes, architecture as engineering antics, amusing as they may be in themselves, must not lure us from the real issue. They are seductive dances on the volcano of our earth ready to erupt at any minute, to burn us in melted gold and choke us with black smoke.

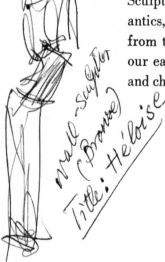

"Vessel of Fire"—expanded into 4-unit sculpture, later entitled "The Cup of Prometheus"

↑ ceiling pieces
The ectoplasme
(Brouse)

Title: The cup of Prometheus
(wood and brouse)

Twice Gertrude Stein

April 17, 1956

The date is yesterday. Virgil Thomson's opening night of *The Mother of Us All* at the Phoenix had been brewing in my thoughts for some days. The date arrived suddenly and at five o'clock in the afternoon the face of the evening stared at me blankly. I still have the feeling that "in relatedness I can enjoy more, be more and give more, than in isolation." But no one whom I telephoned was free to go with me. My wife, whom I called at the library, was surprised that I had decided to go, because two days before I had said I would not, having seen the world première of the opera about ten years ago.

I designed the opera for Virgil at that time, as a gift in friendship, and now I wanted to see how someone else had conceived the production, see it while leaning back in my theater seat and happy not to be backstage with all the worries of whether everything and everyone is in place and how the décor, dialogue, music all click with the spirit of the opera, starting with the sudden rise of the curtain. For twenty years, as scenic director of the Juilliard School, I had dozens of opera productions to manage, to design and to watch. What a relief to stare at the curtain this evening from the site of the auditorium.

Virgil and I—once close friends—had been out of touch for a few years, sidetracked by our changing occupations as so often happens in New York. We would be blown together again, I had always thought; Virgil is very fond of my wife—literature and music having created a tight bond between them. But Virgil had another way of explaining our drifting apart:

" 'Swallows must change climate.'

"After ten years of being music critic at the *Herald Tribune* in addition to conducting my own concert work, I have become withdrawn into myself and so much so that I need to see hardly anybody any more. I have become self-sufficient—even from my best friends."

I accepted his return to himself. I hope the swallow will come back someday!

Animal-Rex

May 27, 1956

Man is flesh-made, I read again, not exactly as I wrote it, in fact: man is spirit, it is printed, although no one of us has ever seen either the spirit or the soul; yet soul and spirit have a corporate implication, like a fluid solidity, yet devoid of quantity and spatial extension, like a whiff, a breeze, like ectoplasm that flows in and out of our corpus, a wind through a ghost house.

Are we so sure that animal is not soul, that animal does not at least have what we call extra-sensory perception, or instinct of an abstract nature? Are we truly sure that plants have not soul or at least soul-intelligence?

Are we ready to guarantee that rocks and crystals are not soul; and that water is not; and that light is not; and that darkness is nothing else but a raggy shroud of the day? How about architecture and paintings and sculpture—might they have a life of their own and a nervous system generating a spirit, a spirit generating a nervous system, a pulsation forth and back, an immortality, man-made, perhaps madman-made, but made existent and not perishable like intelligence?

Scientists claim now to have found experimental proof that plants have a nervous system in the manner of the human being, although not exactly the same. They, scientists and curio-seekers of natural laws of chance, have explained that termites have a language of their own, apparently; otherwise how could they communicate through solid walls without knocking at them? Two million termites, inhabitants of a giant concrete home building in which they live, act simultaneously, most of them not seeing one another, separated by walls, floors and barricades of solid concrete construction of their home edifice, yet think, feel together, know, communicate, wireless, touchless, without earphones and alphabets or Morse codes.

A dog, we are told, will salivate when accustomed to expect the serving of food at the sound of a bell. I have seen men already belching when they sat down to dinner, before the food was served. Is man superior to animal?

In all honesty, if as a man of this globe and society I can muster

it, the assumption that man is the pinnacle of creation seems, in this age of equality for all, split into animals, minerals and vegetables, inside and outside, micro-here and micro-beyond, throughout the ages of Confucius of China, Plato of Greece, Einstein of Palestine, Hooton of the U.S.A., with all due respect to their indulgence in blindfolded visions of the unseen, in their attempt to verify and fortify the traditional self-glorification of Homo-sapiens—this assumption is, in fact, a most average animal act.

But honestly, it seems to me, that all our investigations should indulge in deeper humility rather than in this persistent effort to affirm with ever-increasing scientific machinations the idea of a natural superiority of man over matter, no matter if flesh, mineral, vapor or crystal.

Are there not enough proofs to the contrary? And this without resorting to the witness of continually progressive war techniques among men. Has the master-man mastered himself or his relation to other masters in his terrestrial life? His outer conflicts, using axe or guided missile—is their origin animal instinct? Perhaps man's battle cry is a survival of the imagination? What are we here for, to battle, to split up, or to co-ordinate? Man remains a maniac of egocentricity.

Sure, I am not an exception, being duly infested with the tradition of feeling superior to the animal, vegetable or any other kingdom: me, the animal-rex.

The Business Phantom

May 28, 1956

Yes, I remember now, it was Wednesday, May 16, and the schedule:
9 A.M. to Noon Dress rehearsal of opera Pantaloon *at Juilliard School*
1 P.M. All-Nations meeting at Yale Club, and then at
2:30 back to Juilliard for second rehearsal, squeezing in
4:40 visit with Dr. Hewett before
6:00 Fitzhugh's public relations meeting, then
8:00 Night rehearsal Pantaloon

Everything went according to schedule. Nothing was effective. All hopes were exaggerated.

Each appointment a pressure chamber in which the pressure was supplied by me. Everybody else relaxed, casual, floating on the waves of the sea of routine, lying on their backs, but me deep-sea diving to the left, to the right in front of them, jumping out of the water, hoopla! over them and into the depths again, like a flying fish bouncing about while others were sunning themselves happily, playing the waves which carried them, unaware of the dangers I was creating for myself.

Yes, now let me recollect properly, because, after all, these chambers were provided for me by institutions and personalities and they are not inventions of mine.

Dress rehearsals at Juilliard had become such routine dilemmas that this one of *Pantaloon* was now whistling like a teakettle rather than a high-pressure chamber.

However, the real
Pressure Chamber No. 1 was an
All-Nations Art Gallery and its Man-Director.
An industrialist of the machine age adventures into handmade Art. A good-sport businessman, who, in the routine manner of wealthy industrialists, made millions of dollars in the postwar years, relaxes in his stone mansion in Purchase, New York, reading *Fortune* magazine. It's an article on Art and Investment. It says that buying valuable modern paintings has now proven a more secure investment than stocks of the highest industrial order such as Union Carbide, General Motors, Pan American Airways. No need to buy old masters, either, such as Rubens, Titian, David; now it suffices to acquire Braque, Pollock, Giacometti. And they are available, right here, everywhere. There is enough adventure in contemporaries. No digging into old centuries. Since the second World War, the sheep market of art has turned into a bull market. Grab it by the horns. The red-magenta cape is lined with gold. Yes, it's no surprise to me that in 1962 there finally appeared an *AMG Art Buyer's Guide*, which, gambling with the hopes of innocent gamblers, prints whispers in black and white, convertible into greenbacks now, soon or later.

Here are some of the investment "tips" it has to offer:

"After decades of private exploitation by 'insiders,' the Art Market is only now commencing to 'go public' in a substantial way. Here is a market where gains totaling *19,000,000 per cent* have been made by a 'blue chip' Old Master (not Rembrandt but Vermeer!) . . . where *50,000–60,000 per cent gains* in one's own lifetime are not uncommon . . . where rapid, even sudden *doubling and tripling of prices* is literally *normal* for painters for whom demand continues to outstrip supply.

"And, in the Art Market, you can invest with any capital from $5 to $500,000! . . . Now, *without leaving your home*, you can invest *by mail*—with the aid of completely impartial advice.

". . . while it took seventy years for Van Gogh to go from $3 to $369,000, it took only twelve years for Pollock to go from $750 to $37,000; and but thirteen years for Buffet to rise from $10 to $12,000!

"When you buy well-selected art you acquire: (1) . . . profit potential. (2) . . . inflation protection . . . (3) tax-saving opportunities . . . (4) . . . ready exchange of your art for cash as needed, and (5) a portability (especially for paintings) that can mean *survival itself* in time of war."

Our businessman was not the kind to hope for a nineteen million per cent profit, but he saw the potential advantages of organizing a clearinghouse for art which could meet the demands of many new collectors. The idea of such a clearinghouse was in the air and he had the courage to take a chance to do it.

Our Man sits in his cozy stone mansion and decides after reading the magazine to take over the contemporary art market—from Iceland to Greece. Contemporary works only.

Within three weeks, he has rented one-third of a block front on Madison Avenue and the whole second story of the block for his New Adventure. He calls a relative who in turn calls another one in search of an architect to design plans to convert this office space into an art gallery in which each culture-conscious country of the Old and New World shall have its permanent exhibition space. In spirit, a United Nations art center.

Our patron returned two weeks ago from Europe where he had

rushed three months ago. Soon after he arrived in Europe, carloads of paintings were shipped to Purchase, New York, where a staff of four male office workers and two ladies began assembling them in the basement of the palace,
indexing them,
cataloguing,
converting currency prices
and setting the dollar pace.
I visited there four weeks ago.

Six hundred paintings were paraded in a quality contest. Perhaps five of them were above the standard gallery level. The rest were unfit for an international market place. Good will is not enough in the shark-infested sea of the art market.

He was promptly discouraged from continuing his European adventure and came home.

Ten days ago he arrived at our architectural office to see the designs for his gallery. No decisions. The door of the first pressure chamber closed behind me.

This Wednesday at one we met to discuss the survival of the project in spite of the lack of adequate paintings and sculptures for which we had planned, designed and estimated the gallery.

All arguments, pro and con, were included in an eight-page report I had prepared. My associate and I were present at this luncheon, so were two of his associates, and it was the moment to hand him the report and get his positive or negative reaction to it. We would then know where we stood or fell out.

It was one o'clock in the lobby of the Yale Club, and I was on time. My secretary came on time, too; she had clean-typed the report at home, and handed it to me. One member of the meeting after another appeared, except the businessman. He came three-quarters of an hour late. It was one forty-five then, and I knew I had to be back at 122nd Street for the opera rehearsal at two thirty. Our man was all smile and charm and casual. He handed us the front pages of the local Greenwich paper. There was a picture of an automobile crash in which his wife had been severely injured.

"I've just come from the hospital. She feels fine. I haven't seen her

so cheerful in a long time, although they put sixteen stitches in th
skin of her skull. Apparently she enjoys having everyone so con-
cerned about her."

We all remained silent, and his smile froze. He continued, after a
few seconds: "I'm afraid my European lady expert is late for our
meeting and we'll have to wait. Let's go upstairs to the double-sex
dining room and I'll leave word to have her sent up."

We piled into the elevator, five men strong. It was a lovely pent-
house dining room with a lounge, glass-enclosed, disclosing the
crowns of New York's stone forest. An open-air prison: the indus-
trial city.

"The gentlemen will have to wait until the lady arrives," said the
dining captain, with a German accent and French overlay in ges-
ticulation, "because we cannot seat you without a lady present. If
you wish to dine at once, you will have to go down to the third floor,
to the men's dining room; but then the lady could not be with you.
What do you prefer, gentlemen?"

All of us, with smiles hiding in our pockets, unanimously declared,
"We shall wait for the young lady."

We stepped into the lounge, pulled chairs around a low side table.
My watch showed two fifteen. I couldn't wait any longer. I could
hear the distant knocking in my second chamber, so I handed my
report to the gentleman and his companions to read. Time passed
slowly to the busy clatter of the luncheon-eaters in the adjoining
dining room.

"Excellent report. Very accomplished," said my man, and he
looked toward the elevator. He was right. From there had emerged
Miss Expert. We all stood up, and walked over to the dining room
which had suddenly become a void. The lunch-hour rush had
passed the bottleneck and all tables were at our disposal.

My watch showed two forty-five.

I could see the rehearsal of the opera at the Juilliard school already
fifteen minutes in progress.

I ordered a sandwich.

I didn't wait for the coffee.

I quit, waving goodbye to everybody, after saying to my companion: "I'm sorry, but I'm sure you'll present our ideas at this meeting better than I could. I'll call you in the evening."

Pressure Chamber No. 2

> *Teaching Art is business.*
> *Teaching Business is art.*
> *The Business Phantom of*
> *the Opera was calling.*

Entering Juilliard through the back door, I found the stage overflowing with sound, in semi-darkness with dim lights peering from underneath the rim of the cyclorama, indicating the opera was in progress and that I was horribly late. I knew the score of *Pantaloon*, (adapted from Andreyev's *He Who Gets Slapped*). A good three-quarters of an hour had elapsed since the overture. I stole my way around the stage into the auditorium and slipped down into a seat far enough back so the reflection from the brilliantly lit stage would not disclose my face.

I started to relax. I wondered if the discussion at the Yale Club, which must have started by now, would produce any hope for continuing work on the gallery. Its design meant much to me, having been the architect who got slapped so often by business that Philip Johnson called me "the world's best-known non-building architect." I prayed for a break in that chain of negatives.

One Hour Later: ### Pressure Chamber No. 3

"Dr. Hewett, you, a master of psychologistics and an old friend of mine, you should be able to explain to me why, in these last few years, I sometimes feel desperately anguished when I am left too long by myself after I have brushed against all kinds of people and activities during the day. Brooding over it doesn't help and I wonder if you can clarify for me that state of not-being-myself. I visit you haphazardly, now is a chance to dig into this cave. I wonder if today we can't discuss this automatic reluctance of mine to remain alone with my ideas, secluded and shut off from any possibility of making them concrete, that is, three-dimensional, to walk in and

41

out of. At such moments, my unrealized ideas crowd me in, almost choke me. I feel helpless. It has by now become so intense that I am fearful if there is even a stretch of an hour between two appointments in which I'm left alone. I've become a nuisance to myself. Can't we excavate the roots of this conflict? Can't we from now on deal with that and nothing else? Please don't spare me. I know the analytical process is a disillusionment. I don't fear it. Perhaps it's masochistic of me not to fear it, but I don't. I am ready to be split open for the sake of being one again—put together as a whole, unified, not by a strait jacket, but by an inner cohesion.

"I know you have only forty-five minutes for me, and just today when I feel so much the pressure to understand myself, I have to leave earlier than usual. I have an important engagement which may spell some business for me. It was arranged weeks ago by promoter Fitzhugh Connelly, I can't be late, it's near the rush hour, I'll have trouble finding a taxi; it's too far to walk. I'm caught between my desire to talk with you and my obligations. Please forgive the pressure, but can't we at least break some ground today?"

He answered with a flat no. "Even if I were a bulldozer, the time is too short to reach any depth. Next time."

Released from the pressure of the subconscious, I found a taxi driver with a chance cordiality. What a relief.

After the initial remark of the beautiful weather this afternoon, we talked—I don't remember the subject—but I know it put me at ease. And when I got out of the taxi two houses farther than he was supposed to stop, I didn't mind it, I handed him a warm tip and rather joyfully strolled back the two houses, enjoying the open vista of New York's side streets from east to west, where the sun had started to set and the canyons of the north and south valleys of the houses rose like anonymous sculptures of our industrial age. I felt sheltered.

But it's six o'clock and the business phantom gets into action and makes sure that I don't escape ***Pressure Chamber No. 4:***

Business and Its Sticky Wrappings

I was ushered in by Fitzhugh Connelly with a grin and a breath of liquor. He had arranged for me to meet Flo McClure of Barry-

more's office at the home of the Marchesa Donati. The typical promotional ritual began. My public relations counsel, the first (and only) one in my life, likes to drink any time of the day, and I can't get accustomed to it. My fault. I glanced at him, passed by, and saw the Marchesa Donati sitting in the hallway waiting for me, a charming young actress at her side whom I assumed could not very well be manageress Flo McClure. Evidently Miss McClure hadn't arrived yet, but no one mentioned it. I finally was told that she had phoned, she would be late. I was offered drinks or an orange, not an orangeade, the traditional stand-by. I asked for the orange. The Marchesa, elegant, skinny, black-silk-slip-covered, turned quickly, went to the kitchen, brought one orange, put it on a small plate, peeled a rosette out of its shell and handed it to me. The taxi driver's melody still humming in my ears, smooth in its total unimportance, had put me so much at ease that I, in my good old peasant fashion, dug with my fingers right into the rosebud orange while the Marchesa watched in controlled anguish. She rose hastily, disappeared behind the swinging door of the kitchen, and, before the swinging had calmed down, she swung it forcefully again from behind and dashed forward toward me, handing me, like the Greek runners, a paper napkin. "It unfolds four times, Mr. Kiesler. Let me help you hold the plate with your orange while you spread the napkin over your lap." She took the plate away. The young actress took the paper napkin and folded it over my lap while Fitzhugh Connelly watched in helpful attention as I, with my hands lifted up like a prisoner awaiting deportation, smiled and felt very comfortable. I wished Dr. Hewett could have seen me then, how relaxed I was. "Oh," came suddenly from the Marchesa as she handed me back my plate and the ravaged orange rose, looking at my uplifted hands, "your palms and fingers are all yellow from the orange peel. Wait, don't put them down—I shall fetch a towel with hot water. Fruit juices are very difficult to clean." She disappeared more rapidly than before behind the swinging door and, in an astoundingly short interval, appeared with a long towel, one end of which was gathered together and wetted, and with this end she stroked my palms, and it felt warm.

Manageress Flo McClure hadn't yet arrived. My casualness started to get undermined. Time began to advance rapidly, I'm sure much more swiftly in my consciousness than in actuality. Our crisscross conversation was irrelevant. It hopped forth and back like self-propelled ping-pong balls. One could hear the sound of the emptiness within their shells.

"Why not go upstairs and look at the Marchesa's paintings? She has four of the Odilon Redons, and others," Fitzhugh Connelly addressed me with a most inviting smile. "Oh," I said, and forgetting for a split minute my time schedules, "of course, that will be most interesting." We took the open staircase, and arriving at the next floor, I saw to the left and right the expanse of two sitting rooms completely encrusted with an array of the Marchesa's paintings, chaise longue, draperies, vitrines, and pedestaled abstract sculptures.

"Hello," resounded a deep voice behind me, quickly lifting itself louder and louder up the staircase. I turned. It was Manageress Flo McClure. "Certainly I know Mr. Kiesler. Hi!" she exclaimed. I couldn't see the smile of her eyes. She wore dark glasses. "Of course," I answered, "we know each other. You managed Martha Graham's ballet tour through Europe, and I had designed the collapsible décor for Martha's *Canticles*. We all worked under great pressures and stretched everything beyond its limits—time and money as well. And you, Miss McClure, managed the whole affair as a sideline, out of love and devotion for Martha, I know it. So did I, although at this period I was very busy at the opera school. Although the *Canticles* was not the triumphant success we all hoped for, we did our best and I remember that we all enjoyed working together." I smiled and felt a few inches taller because I finally had managed to make two speeches, which are supposed to be proper for such Upper East Side occasions. But with this supreme effort, after all the failures of the day, I felt I had reached the wall of this pressure chamber and that I would have to look for an exit at once.

I glanced quickly at the beautiful large painting by Monet, the Odilon Redons, a Hans Hofmann, a Bultman, then withdrew into the sidelines of myself, and, waving goodbye, grasping the Marchesa's hand, sneaking out, I disappeared into the hole of the stairway, followed at my heel by Fitzhugh Connelly, who, abruptly stepping between me and the street door—the handle of which I was about to reach for—faced me and asked if I had the check along, his salary, which was actually due two days before. "Oh, I'm sorry, but I'm sure it must be in the mail and if you don't receive it in the morning, do call me. But isn't it a pity that during this visit we didn't have a chance to talk about the theater production which you said Flo McClure wanted me to design. Wasn't that the purpose of the meeting with her today?" "Yes, but you're

leaving," he replied swiftly. "Yes," I retorted, facing Fitzhugh, "unfortunately she was three-quarters of an hour late. So let's look for another chance—if ever." "I'll follow it up," he said, and, bowing down to the door handle, he opened the door for me.

The steam of this pressure chamber had spent its heat. The steel was a cold shell.

The street was empty of cars and people. I stepped briskly toward Madison Avenue. I felt it must be late—late in the day and late for my dinner engagement. A bareness of the sidewalks and thoroughfares was indicative of the hour when people gather around dinner tables in their homes, and latecomers are not too welcome when maids have to leave at eight thirty.

I tried to shake off memories of the entanglements of the day. I needed to be clean of management, business, of . . . I had to get off.

The vista toward the Hudson River made me envision, rising out of its waters, the fifth pressure chamber, containing the night rehearsal at Juilliard, the last one. After that the steam of the day will have evaporated. Emptiness I welcome you.

stay home
sweet arch-artist
runner into stainless
 steel walls
the kitten's cute skin
 is torn off

stay home	*slum-bum*
sweet runner	*stay off*
into acid city foam	*stay home*
stay home studio-monk	*New York*
your cheeks are bleeding	*Paris*
sweat	*Rome*
	or
	better still plug
	Speonk

The Inevitable Suddenly

I

It was an average Tuesday morning, Tuesday, July 7th of 1956, the hour ten o'clock, about time for me to get up, hearing steps in the next room, however timid, behind closed doors, indicating that my office staff was already at work, and awakening partly to this new day, still dwelling in yesterday, unable to remember exactly what kept me at bay in the confines of yesterday, I tried to focus on the bookshelves opposite my bed and gradually pick out a volume, and, in an attempt to alert myself by trying to identify it, I was shocked out of my twilightdaze by the spitting of the telephone bell. I quickly choked the phone. The click of the uplifted receiver, the vibrating sound, had hardly struck my ear when a woman's voice, apparently caught in a squeeze of vanishing time and onrushing emotion, difficult for me to identify, spilled rapidly a message. Words, breathing, and sentences were garbled. I couldn't untangle them quickly enough to get the content, but I did get the timbre of the voice. "Ruth?" Her message had only overtones and undertones—the core was squashed. "Ruth!" She continued without responding and hurled at me:

"Kiesler, it's too terrible to tell, but I must. John is dead. Your John!"

"John, John? Which John?" My lips almost touched the receiver, ready to suck the answer in. "Touche! La Touche? Oh, Ruth, I don't believe it! When? Where? How? It's one of his pranks. Don't be fooled by his play-acting. I know him too well. It's his vein. I remember . . ."

"He is dead. Dead.

"Ten thirty yesterday morning I got a call. He had just returned from Salt Lake City, drunk with the success of his opera *Baby Doe*. He drove up to his shack in Vermont, arrived late, played rummy the rest of the night with a friend, felt sweaty, faint, refused to be driven from his hilltop to the nearest city, said he just wanted to rest on the couch, and slumped over onto his left side. His friend tiptoed into the next room so as not to disturb him. He fell asleep. Three hours later he woke up, went into the living room and found Touche in the same position as he had left him. He bent

over him. The face was turned toward the wall and he saw a dead man with a dried trickle of blood from one corner of his mouth. The shock was so great it electrified him into frantic action. Leaving Touche alone, he drove down the valley. He returned with a doctor. It was too late, much too late.

"I'm exhausted. I've just returned from his mother. Please visit her. I'll come later."

I could feel my brain expanding. It filled my skull to capacity. It seemed to knock its pulse relentlessly against my temples. I fought the truth. I tried to escape it. My cranium seemed to reach its limits. I pressed the receiver against my head as if to counteract a breakthrough. As Ruth stopped talking, the silence brought my speech back.

"I'll be there. There. Yes."

I walked backwards, my eyes glued to the earphone that so casually had spilled waves of deadly sentences, I slumped on my back to feel the support of that still-warm bed, although partly uncovered from my getting up, listening with closed eyes to myself: "It was only three weeks ago, seems like three days, that I was, yes was, with Touche, he sprawling on the floor, getting up, halfway up, that is crawling on his knees toward the piano, tapping on it, testing a tune just composed by his composer-conductor-friend Rosenzweig, sliding again to the floor, looking like a black tulip in his turtle-neck sweater, scribbling, deleting, filling in, correcting his lyrics while Pomer and I read, compared and switched sentences on and off, trying to set them right into the grooves of the script of *Adam and Eve,* a new musical planned for Broadway, our work watched by two youngish producers, eagerly present, whom I had met twice before at the 'composing sessions' of our four-man team in that same room of a tiny hotel apartment on West 58th Street, second floor, a slender dark corridor leading up to our door, ducking under the shadow of the big "Plaza," a two-room double neck, one holding an upright piano, the springboard of the new songs, eight of which were done and O.K., oh, very O.K., we agreed, and felt that sessions with Broadway angels were now not far off any more and the dough that goes with them, and the setting of the date for the tryout at New Haven, which would, luckily, include the new ending for our *Adam and Eve* suddenly clinched, and it was I who chanced to burst forth

47

with an idea after despairing evening after evening in search of a conclusive ending, all of us rejecting the standard finale, that is, Adam's kick-out from Paradise—but what to replace it with? Yes, that paralytic biblical ending, frustrations and punishments, the curtain to come down like a heavy stone wall, plunk; no, there must be a way out, and a way out was found, thanks to playing within the play, the way out came from a Paradise lost, the best inspiration the Lord had since the creation of the matzoh ball earth floating in the soup of the cosmic tureen. The pre-manufactured Eden-Paradise was now put back into the dead storage of the universe, basta! that smooth guest-life in the crystal palace-paradiso was parasitical indeed, we managed to slip out of it and off, and the curtain rose on absolute nothingness, zero incarnate appeared, a primordial void, definite indeed as to vagueness, the endless desert, the horizon retreating limitless the more one advanced, man, oh man! start digging where there is no earth, drink where there is no water, the woman holds on to her man like a crab. Give him time. He started with the sky, filled it with images, Fata Morganas of his own imagination, they will revert one day to hard-boiled reality, nothing ready-made, consumer. That first man planted the seeds of his visions into floating clouds, and they resisted with lightning, the growl of thunder, God's anger of guilt, was and still is heard, but rain fell, swamps ate swamps, birds drowned and worms crept up, beasts sank and disappeared below the ever-forming mud's skin, the cold night froze live and dead creatures alike, hurrah! man-made chaos emerges and a new Paradise is rising, the first child born, the hut, the horse tamed, the dog, man's first friend, appears without letup; it's going to be tough. But he'll make it. He made it, the bastard. The village grows and forests too, wheat and apples, cities and scrapers of the sky appear, no letup. On and on. The curtain falls, the curtain rises. The nights and days of man's work repeat themselves like nature's seasons, dying, born, hell-swell! the ending of *Adam and Eve,* a carmagnole with God's head in the basket."

When I woke up, it was way past ten o'clock morning. What I felt was so fact that I phoned Gore Vidal, close friend of John, to meet me at the Algonquin Hotel. And the same day noon we discussed his possibly taking over the finishing of *Adam and Eve.* Gore, in the midst of his literary rise, went back to his writer castle in Tarrytown in the circular room crowned with a dome, apparently stored the script there at the shore of the Hudson River.

Thus Touche's last writing vanished without Adam and Eve being reborn through the womb of the stage.

II

I confess that

I have never seen a dead man; or even a dead man's face. There were vague chances. I always skipped them. But, today I felt, this was it. And I wanted to take it straight. I came alone.

I approached Lexington Avenue from 68th Street. John had lived just around the corner on 69th Street. Not any more. On the corner of 66th Street and Lex, only one more street down, was a tiny, two-story building, country-like in design, painted gray with gleaming white window frames. It looked almost cute and was, no doubt, planned to make visitors feel at home. It was the funeral parlor, "The Abbey." I had passed it for years on my way to visit John. I never dreamt that one evening, and this was it, I would enter the Abbey to view the dead body of John, my dearest among the young friends.

I left a dinner party alone and deliberately so. I refused all gentle suggestions of friends to go with me. I wanted to confront myself without witnesses. This urge was irresistible.

When I finally turned into Lexington Avenue on my last stretch, I found myself face to face with the dark brick wall of an armory filling the whole block between 68th and 67th Streets, as impersonal and forbidding a sight as a giant dump heap. A white poster, smack-hit by the light of a lamppost, was tacked to its surface. It read: "Come to the 105th birthday of the 107th Regiment." "Join the Army."

I remember how astounded I was at being so calm and observant, as if training my eyes for the sight to come, feeling my figure singularly alone walking in the shadow of that brick-block, setting equal footsteps one after another in as straight a line toward the Abbey as I was able to project. And I could hear the distance between my steps. The silent interval between two taps. There was no holding back. I had hesitated the whole day to make that walk. Now, confronted with the situation, I became strangely secure. The space between the Abbey and me became smaller and smaller, but my calm remained undiminished. I felt the desire to produce

some sense of guilt, but I was unsuccessful.

I had to stop and wait for the traffic light. I stood at the curb, facing the Abbey. I wondered what the proportion of black and white was, the mixture that produced the seductive silvery gray with which the Abbey was painted. All along toward downtown I could see Lexington Avenue as average in her make-up as every other night. Darkish, dreary, with some spotty colored advertising lights far away, and the long view of the vista fading into a nondescript background of gray, brown and purple. But the little Abbey on the corner had glowing yellow lights in the windows, coming from white porcelain table lamps placed there and diffused by translucent curtains. A private home awaiting guests. It was deliberately festive. A business-as-usual cordiality. I felt hurt.

A young man stood at the entrance, leaning, rather bored, against the open doorframe. The air was sweaty warm. I crossed the street and confronted the young man. "John La Touche . . . ?" "Yes. Step in. Straight ahead." I walked through a brightly illuminated hallway where another young man was lounging in a chair. "Hi!" said his facial expression. The door to the living room I was to enter was wide open. I recognized two young men, friends of John's, Harry and Ken. They got up immediately from a couch next to the entrance to greet me cordially. "Don't go over to look at John. They made him up." They sat me at once between them. There were no other guests.

Opposite the couch, at the end of the average-sized living room, stood the casket, elevated.

I could see the head of John, in profile. His body was exposed almost down to the waist, clad in a dark suit. His arms were not folded over his breast, as I had expected, but were placed straight alongside. They looked so much shorter than I remembered them. I was surprised. I was sure the disproportion would haunt me for a long time to come. A single bouquet of mixed colored flowers covered the rest of the bronze casket which looked a very massive box. Left and right from it were wreaths on easels, evidently a routine exhibition of floral mementos. On the walls were some pictures in frames, landscapes. A carpet of beige and rose-leaf designs on the floor. Living-room furniture here and there arranged in the traditional manner of suburban homes. Lamps on side tables shed soft light.

50

Harry and Ken spoke consistently to me from the left and from the right. They tried to drug me away from looking. I listened, but I focused my attention on John, transfixed. I was at a loss to comprehend what I saw. It wasn't John. He was pale, very pale, but this was not the upsetting thing. Yes, these were his features, but it was not a human being. What I saw was an object. And it probably never had lived before.

I turned to Ken and Harry.

I suddenly heard the sentences they had spoken to me before. They reverberated.

My ears woke up.

Now I could answer them, but the young man appeared at the threshold and said, "Closing time."

We three walked out together in one line, I in the middle. We squeezed our bodies through the doorframe. We spread out on the sidewalk. We walked silently along the armory wall. That wall seemed to rise higher and wider than before. It assumed an endless perspective and magnetic power to rest against it, to lean and never to get off. But we tramped along, knowing our duty to meet the mother at home. Finally Harry spoke into the darkness: "John's mother and we, his friends, want you to consent to carve the tombstone." I had never carved. "Naturally I will," I answered.

At John's home we found his mother had gone to bed. Surprised that she did not wait for us, we looked at one another, mute. Her daughter-in-law attended her. The room was empty, except for Donald, waiting.

I was handed a typewritten page. It was signed: Carson McCullers. A eulogy for John. Ken, Harry and Donald sat down with me. We read it together, head to head. John was the poet, the Broadway lyricist, the buffoon of daily life—too much for anyone to account all his individualities without creating a jungle of his character. The "Ballad for Americans," written during the WPA time, sung by Paul Robeson, a hit, striking the adventurous spirit throughout the land to such a degree that both political parties, Democrats and Republicans, selected the Ballad as their

campaign song for the presidential elections. (Paul! Where are you now? This is the time to sing the Ballad for John.) We searched for the lasting values in the script and dared to cut out those commercial successes and failures which could cast an oblique shadow on his honest ambitions as a poet. We tried it deep into the night, and agreed on all points to make the eulogy conservative without disturbing the original script, which was written with tender scrutiny. This was the last moment to give him satisfaction through honesty and love. "He died at the height of his career" we changed to "He died approaching the height of his career."

Oh, Johnnie

Life is
a playboy
without money

honey
you're bound
to lose

your fate
is even
number 38

I had difficulty restraining my sympathies. I met Touche in 1936. He was thirty-eight when he was struck down. It was at the opening night of *Helen Retires* by John Erskine with music by George Antheil, another very young American of small physical stature but great talent. The Juilliard stage had emptied of visitors and I was still there for a last glance at the order and disorder backstage before leaving for a reception at John Erskine's home. Every prop seemed to have been well stored away, the scenery lifted, the lights extinguished in the auditorium and on the stage except for the stand at the footlights, the eternal light of the teacher, when a young man, diminutive of build (and reminding me of my own figure way back when I was well dressed by our housekeeper in old Vienna in dark blue shorts, socks and pumps and a sailor's jacket with a black bow tie under my collar) walked across the empty stage and presented himself to me, releasing a discourse on the modern theater, the poets of France, Cocteau, Breton, Giraudoux—I was stunned by his curiosity and knowledge, and delighted.

52

"It would be lovely to continue talking to you, but unfortunately I must leave. Will you come and visit us, so we can chat more? Perhaps in the evening when your classes at Columbia are over, I know the first year is rather harassing, but do come. Here is my telephone number and address." He came twenty years long.

Editor Leo Lerman was to read the eulogy tomorrow. He had been helpful these last two days, steady at our side. We liked to forget that he had been critical the past few years of John's life and work.

Late, after midnight, having come home, I knocked at Steffi's door and a few minutes later read to her the eulogy. She knew Touche well, yet, in spite of my close friendship to him, remained an impartial observer. Her reaction would be valuable to us. While I was reading, the telephone rang, a call from Ken, to say they had decided to ask me to read the eulogy at the funeral.

Next day I arrived an hour earlier than scheduled at the Little Church Around the Corner. I sat down into the emptiness of the church. The coffin was placed at the end of the aisle, blocking it. No one was present, the vast space holding me, the casket and the altar during an immobile half hour. It seemed part of eternity. Finally, people started to enter. Most of them had gathered outside earlier. I heard them. They must have assembled under the wooden church arcade, like on a front porch, so conducive for a last whisper before entering the nave. Time, for me, suddenly became unbearably long. And I was relieved when finally a clergyman approached me with such muffled steps that I wondered if he wore bedroom slippers or was specially trained in a silent heel-to-toe walk. He bent down and asked me to move from the last row to the second, front center. The entire half of the church where I sat, facing the coffin, was kept rigidly empty. The other half filled gradually with people. As at his performances, they came here late too. Without warning, the organ started to play and raised the curtain for the rites. Suddenly I was joined in my lonely section by Lucia Wilcox, who came from far Amagansett. She clutched my hand and wept without control. Steffi sat in the middle of the other section with Hans Richter. My turn to speak came after one of Touche's Broadway songs was beautifully delivered by Miss Ray. I had lost myself in the abstract world of memories. The last word of mine, I knew, will separate me from here and him forever like a final curtain of one of John's plays on a clos-

ing night. I could hear it ringing down, slowly, but with finality. The organ swelled and stopped. The minister nodded to me. It was my cue to deliver the eulogy. I released Lucia's hand with a last comforting pressure, got up, stepped to the side of the casket, turned to the audience. I held on to myself as firmly as I could and delivered the sentences in slow motion. The minister descended the altar steps, the ceremony ended, and I turned into the center aisle toward the exit.

We all met outside. Lucia broke a yellow rose from the flower car. I stepped forward and tore two small stems of white daisies. I gave one to Harry and one to Ken.

There was no interment in New York. The body will be shipped to Richmond, Virginia, the town where he was born. We dispersed quickly toward Fifth and Park Avenues through 37th Street. The Little Church Around the Corner was nothing any more but architecture.

Monday, August 5, 1956

To my secretary:
"Would you like to have a piece of ham? It's three o'clock you know, late as usual, my brunch. Don't worry, we'll work soon." "No, thanks, I just had two raw eggs." "Raw eggs?" "Yes, you see, a lady who lives on the top floor of my house always wanted to teach me how to drink eggs. So today I did it. An egg, you know, is equal to half a pound of meat. I don't like meat. So I drank the egg. I drank two eggs and a glass of milk. And I feel as light and clean as if I hadn't eaten." That was K. speaking in her best of moods. She wore a turtle-neck sweater, new, and of peach color, black skirt, her old tramp shoes, a horsetail at the back of her head and one in front falling over her forehead. I think our dictation will gallop along fine.

I would like to recall yesterday and a drive back from Connecticut with friends and strangers. A young associate of the Guggenheim Museum stunned me during the drive by telling of a large Picasso lying on the floor of the museum, spread out twenty-two feet by thirty, but not wanted. It's too large. Would not fit into the new museum Frank Lloyd Wright is designing—the highest room being only nineteen feet. The painting was actually a backdrop for the Diaghilev ballet in Paris, 1925, which I had once seen. Strange to receive this message today, because we have been

looking for a large painting by Picasso for our opening show at the World House gallery and could find none. I was quite desperate.

It would have been lovely to roll the canvas vertically from the floor up along the rising parabolic wall and continue it along the ceiling, laying it against the various flowing curvatures and planes and finally at the end descending again from the fifty-foot expanse of the dome into the hyperbola of the back wall and down to earth. Indeed, it could be done. That way we would have just enough space for it. But it shan't be. The two seated figures, gigantic females basking on a seashore against the horizontal stretch of the sea and sky, would, on the parabola, not exactly be upside down, but perpendicular, and that would agitate the critics and the cohorts of experts. They'd claim I had used a Picasso painting as decoration, crying, "What will Kiesler do next? As usual, his presumptuousness exceeds his creativity." But I know Picasso would have liked it: "Let them turn their necks and let their heads drop on their shoulders to view it. That's the least effort we can expect from idle spectators. Or let them lie on the floor, sidewise, you know, relaxing on the marble like the two nudes on the sand."

The picture rolling along the ceiling would have been a fine integration with architecture: painting, wall and space, reality and illusion, actually grown together. The whole floor of an art gallery becomes the living body of our imagination, breathing deeply. A torso of marble filled with fresh air, expanding and contracting visibly!

But it shan't be.

Tuesday, August 21, 1956 To K., who came in for dictation, I remarked, "How typical it is for all young American architects to omit main dimensions in their plans.

"They'll put in all the detail measurements, but omit total length, total depth and total height.

"In other words: they will be able, at a meeting, to give the width of a door, or its height, the width and height of a window, the space in between the windows, the height of a ceiling—but they

55

will not be able to give at once the measurement of, let's say, the actual height of the entire building. That is left to a far-distant occasion. This technique is a handicap at a meeting when cubic content and costs are discussed and quick answers desired. But there is a much deeper evil in such fragmentation. In the life that we all lead here, a day composes itself like the piling up of one stone on top of the other, and the wall one day will be five feet tall, another day seven feet, and on another date reach perhaps the height of twenty feet in a great rush and pressure of piling up of doings after doings. There is a feeling of immediacy, a desire to finish off, a habit of forgetting the last minute and on to the next and not to know what the next is after the next. 'Nexting' we could call it. And we think we have gained a lot over former centuries with their visionaries, their ambitious thinkers ahead of the times. But we have only created a split between reality and dream, between fact and vision.

"I am accustomed to composing big and small units in a *multiplying* way rather than by *adding* details to details. This is all-over planning, encompassing both reality and vision. Minute-to-minute planning splits them. The young architect, by negating main dimensions, merely expresses our minute-by-minute approach to life —a life without content and continuity."

World House Minutia

August 30, 1956

I remember annotations which I had made a long time ago on a small card, and which, fingering in my pocket, I found today. They concerned a slit along the walls near the ceiling for the picture rods to be hooked into instead of onto a molding. Then there was the question of the bottom of the wall close to the floor. My aim was (without increasing expense) to have the wall continue straight down but to stop six inches or a foot above the floor, then remove the plaster and reveal the old brick surface, thus producing at the bottom a setback. That would make the whole wall protrude like a panel, a foray of about three to four inches. The pictures hanging on this wall would strive forward, for better

56

integration with the public. The painful question was, could the slit on top of the wall (about a foot or two below the ceiling) be eliminated altogether and the upper part recessed like below. That would leave a ledge of three or four inches deep on top, too. The picture hooks could be attached right onto that.

Pondering about this and trying to visualize the effect, I came to the conclusion that the continuous flow of the curvatures of the ceiling must not hit left and right into a recess of the wall (as a panel effect would make them do) but rather they must hit head on, on the side walls, while the recess would be only at the bottom near the floor. Thus the ceiling, although not directly bending into the wide wall downward, would still continue at a right angle and flow back into the recess at the bottom. A continuity would be achieved of the ceilings and side-wall enclosure, although actually separate.

The telephone call from Greenwich came through; a welcome break in my harassing dilemma. No time to make decisions tonight. But I do not feel that I have reached the saturation point. Work will only start in a few days. Still, I must be careful not to burst into the middle of construction with even minute changes. No contractor or builder or workman will accept small (even if important) changes with good grace. And they always cause annoyance, grievances which tend to hurt the reputation of the architect—more than if the whole plan is found cockeyed and has to be revised.

August 31, 1956

Ten thirty in the morning to builder Paul Tishman to present my new set of plans for the Washington Square housing project. Flo had the water whistling for one cup of coffee. I had no time for more and dashed off.

At Tishman's, I explained my ideas: "What is it we really want to achieve? Why does everybody find the blocks and blocks of a housing development so inhuman? Isn't it because the vast brick walls and standardized window squares remind everybody of prison cells? That's number one reason. Number two: Doesn't the brick material in square blocks, by its very mass, have an angularity so foreign to living freely? Isn't it a pity that we have to put flower boxes in our windows to simulate nature and satisfy our longing for outdoor living?

57

"This housing project covers three blocks. Each of the three huge buildings, six hundred feet long and approximately seventeen stories high, looms like a potential brick monster with hundreds of window eyes staring at the home-coming inhabitants. To overcome this, I propose three remedies. First, taper each building slightly at the ends so as to give it a flow of continuity. Second, insert all along the building three green belts of garden terraces— the first at the second floor, the next at the middle of the building and the third at the roof. Finally, instead of single-color bricks, we would use strongly colored bricks in horizontal formations and so divided sectionally into different hues that homebound people of the building would recognize their own apartments from the outside by the color which is theirs, and not feel overwhelmed by the conformity of window holes."

The midway green belt of the skyscraper was hailed by Tishman, opposed by the associate architect, and received with neutrality by John Prine, the vice-president.

Luncheon was served, prepared by Tishman's secretary: avocado pears with tuna fish and hot coffee in thermos bottles. I was in doubt whether I should cut with my spoon right through the avocado shell while scooping out the tuna filling, or stop at it. I finally went right through the shell, which was soft and tasted delicious. Tishman came in several times for a minute or two from his other conference room. I spread my frontage print over a big desk and started sketching ideas for eliminating, subduing, short-cutting the green belts.

Postscript

I worked on the plans continuously, even over weekends when I was invited to fly with Tishman in his private plane to East Hampton. There we discussed my ideas in the quiet of his home. I didn't know then that all this joint effort would prove in vain, and that my ideas were doomed to obliterating compromises. The wonder with which Tishman had first regarded my plans through his own eyes eventually gave way to seeing them with the committee members' eyes. My enthusiasm remained unmitigated.

In One of Those States

In one of those states today which make me feel blank yet full of agony without knowing exactly why. All my thoughts directed toward work are being shot through by bullets fired from an automatic gun, the location of which escapes my awareness. Whatever I do, whatever I think, is torn by this onrush. Got up three times today. Twice back to bed, groggy from having taken a sleeping pill at six in the morning, a time when I'm usually awake—unwillingly. Always that ambivalence in the morning: welcoming the day with all its possible activities, and wanting to go back to sleep and forget it all. The ringing of the telephone, planned appointments coming through, others to be made, all those daily contacts which hold delinquent life together and keep the day wound up. Strangely enough, there is also the urge to do more, and the undertow to do so much less. A feeling of useless repetition toward all undertakings which have links to the past and which lack the sense of new adventure. Usually I can banish it. But today I was too weary to muster enough energy for that. And, worst of all, I was longing for somebody to help me, but there was no one around except my private office staff. No one close to me with whom I could talk without polite words or gestures. A mother, a sister, a lover, a doctor, a neighbor, a good friend. No one. The room I sleep in is all to myself. It harbors books and papers and chairs, carpets and lamps and a few illustrations tacked on the wall. I am alone, amidst them. An object, breathing.

I suppose that in France, if one were in such a state of not-being, it would be much worse. Because here, thanks to our business gymnastics, at least the telephone will ring sooner or later and artificially bolster a sense of being. And whether I like it or not, I'll have to pick it up, speak, and hear a voice. My melancholia gets a short-circuit shock that way. Once up and out, involved with Louis, the designer, and Florence, my secretary, dormant energies are stimulated, purely physically, purely in time and space, purely outwardly, but somehow they finally bring me forward to the immediate necessities of the hour. As a piece of paper, crumpled in your hand and thrown away, drifts with the tide, not by its own power, so do I move on and on.

I Felt so Jolly

September 13, 1956

I felt so jolly today that I used shaving cream to brush my teeth. Both tubes squeeze out white, and, ignoring the packaging, I only discovered the difference when I failed to foam the creamy mass on my cheek. I laughed hilariously into my face in the mirror, then lustily added a glob of shaving cream and lathered the whole mixture together. My happy unconcern gushed forth when a wild ringing of the house telephone forced me to get out of bed earlier than usual, and, once up, although groggy, I seized the Chinese Pelikan ink bottle still on my table from sketching last night, pulled out its eye-dropper and poured black ink which gradually flowed on the paper into the shape of a blessed dove.

Monroe Wheeler, the cordial and encouraging head of the publishing department of the Museum of Modern Art, had asked me to design Christmas cards for them and last night I played with ideas. However, I could not achieve any valid expression in my drawing, not having painted for more than two years. My technique was all fouled up. Neither form nor line nor composition made any pictorial sense. And no willful effort could set it right.

Then, this morning, I left like "what the hell," grabbed the eye-dropper, plunged it into the bottle and squeezed ink directly on the paper, hoping for inspiration. When I discovered that some drops which fell belatedly made a stunning pattern, I grabbed the image, repeated it, linked the drops with a few connecting lines. Encouraged by the results, I took the bottle stopper and started to use it as a design tool. This stopper—a glass tube two inches long and narrowed at one end—seemed more and more to possess me. Sucking up the ink from the bottle by squeezing the rubber hood at the other end of the tube, I poured streaks of swollen lines back and forth on the paper until I felt handy with the technique. Now I used it freely. Instrument and image became one, and pictures splattered forth.

From each ink blot there seemed to rise luminous arcs which fell on the paper and rose again and fell, commending me where to set down the next blot and where to connect the drops. As if blindfolded, I followed the course of the arcs across the empty cards strewn on my desk. I rapidly finished one after another, six in all

as I remember, and christened them Star-Dove, Galaxy of Wishes, Birth of a Star, Moon-Baby, Snow-Rose and White Laughter.

I felt so unconcerned with their success or failure before the tribunal of the Museum that the mere experience of producing them was sufficient reward for me. Never mind the selling.

I took a shower, hot and cold, cold and hot, and felt reborn. All imagery had vanished. I was ready to tackle my daily curriculum. Christmas was forgotten, although still ahead.

Ritual in Art

Saturday Morning
September 15, 1956

Ritual plays in art the same role that blood plays in the human body. Diminish its content, and the body bleeds white. Diminish the ritual in art, and it dies of anemia.

That's where we are now.

The ritual in art has vanished. Art itself has become the ritual.

The artist, instead of being part of a belief, believes only in himself.

The cult of independence has replaced interdependence.

Hints and Blueprints

Monday
September 17, 1956

The door stood open, the door to the corner store of the Carlyle Hotel—I mean, to the new gallery to be opened soon in that building. Cold, wet smell came out sweet-sour. Rubbish, heaps of rubble, dangling cables, toppled beams, people, crosswalking, like moonshots. Confusion everywhere. And I am in the way of everyone.

Construction—meaning demolition—had started four days ago. New walls are beginning to rise. All hands on board. Unknown faces, unknown spaces appear. So different a situation now than in our finished plans, and so different from the original areas we are now demolishing. Between two worlds. Although we had measured inch by inch, when the old partitions were gone and new wings were spreading, I could neither recognize the old nor envision the future space. I felt hatred for the old and hidden anguish for the new.

That cold smell! It's like a narcotic. No matter where you step, your foot is up or down or twisted, sliding, depending on what you step on, planks, tubes or bric-a-brac of tumbled walls. You walk in a trance of anticipation; your balance is constantly at stake. Professional routine keeps you perpendicular.

It is now 5 P.M. I have had so many quick decisions to make—on the building job, on the drawing board, by telephone listening to a most temperamental reportage by my student-protégée, Anna, concerning her decision to return to college, which would mean quitting her job prematurely; redesigning once more, just a half hour ago, the façade of the Washington Square housing unit, and trying desperately for the eleventh time to push through a concept I've always kept on the back of my retina; waiting anxiously for secretary K. to arrive so I could dictate a description of it; getting the maid, who came two hours late, out of my apartment and making her angry by not letting her finish the job properly as befits a conscientious German maid; and now, Thank God, I am finally settling down to my journal.

I remember my first encounter with the construction circus twenty-seven years ago when I designed the Eighth Street Cinema in 1928.

Building pangs haven't changed in all these years. But now as then there are moments of delightful clownery and comradery.

Let me now go ahead with the story of the World House gallery. I've rooted myself in this battlefield from ankle to neck, and I intend to stay that way and see it through.

There I stood, transfixed in the midst of the upheaval of demolition. Like young Parsifal in a new land, getting his first sight of the holy chamber where Amfortas, the king, was lying deadly wounded, the cause unknown, and his salvation from Death to be achieved only by the Holy Grail. There was the air of miracles around me. And that smell! The smelt-gray smell. Intoxicating. That smell of cold sweat from dying debris. It stimulated visions to the point of hallucination. They crept out from underneath the litter, floating upward, turning around loose wires, wafted through dangling chandeliers swinging in the foul draft—there was no escape from the spectacle of death and birth, each striving for the upper hand. It is a passion play, called remodeling.

Praise for the general contractor, a young man, with very quick motions of his athletic body which carried his head like a Roman bust.

"Don't you think, Mr. Kiesler, that this wall which is now halfway built up is still not inclined enough, just not enough . . . don't you think it should be inclined a bit more, even though it is in the exact inclination defined by the blueprint?"

He was right. And I was delighted. Hallelujah, finally a good contractor, I said to myself; he sensed the need for *translating flat paper-design into actual conditions of life-space.* I stepped quickly into his phrase. "Right you are! Please incline it more. I was wrong in my translation. You are correct."

A pack of workmen had in the meantime assembled around us. They stood in silence. Suddenly somebody picked up a wooden bar. I gripped it and held it at one end; someone lifted the other end. With it we traced the inclination-to-be in mid-air. "There, there! Yes, exactly there." All agreed. It needed barely six inches more to be right and we all felt happy. Now a grumbling voice: "It might cost you more money. We'll have to build it up in blocks, in wire lath, and that takes time." Voice II: "Take it

63

down. It's easier. Make it all new." Voice III: "Why didn't you make it right before? Why now, when it's half done? Wait until it's completed. It might be O.K."

The kobolds of vision and the leprechauns of dreams were gone. They had been replaced by workmen, associates, managers, doers. I was in the midst of the building trade in action. No time for dreaming any more. Facts were closing in on me.

The future parabola of the wall to be raised from the floor to the high ceiling of the open mezzanine was tested on an iron bar which lay on the floor. It looked like a black snake in a peaceful bend. I stood above it and looked down onto the floor which was underneath the bar covered with wet dust and mud and broken bricks and mortar morsels. The snake looked happy in that artificial swamp. "There"—bending down to her—"it needs some slight retraction of the curve, perhaps one inch or less. This way" —and I indicated the corrected bend in the damp dust with my index finger. "Yes, that's right, I can see," said a subcontractor. "I hadn't noticed before." His small figure and face had disappeared in his overall trousers and cap when he bent down to me and followed with his thumb my mark of the new curvature. I could see in his quick co-ordination that he was with me on it. A happy moment, to see him so sensitive. He knew his trade, and he bore a smile.

Next we climbed through a hole in the ceiling of the mezzanine to the second floor. Here, on the ceiling, the parabola will continue, jumping now over wooden horses, wires, ropes, curving from the main-floor wall, gradually rising higher and higher and finally bending into the mezzanine and landing on its ceiling. The link of two floors was well established. Small or very large paintings will look their best floating as fixed stars against the sky of the parabola. My first day on the field was invigorating.

The second day was a more difficult one and more unexpected. The rubble greeted me as before. I came late and darkness had slipped in. The sun had gone behind the Parke-Bernet building, the auction house across the street from the Carlyle. I had arrived with supervisor Freddie. Every workman was gone, there was dead silence on the battlefield of wreckage. The foreman, already in Sunday attire, was about to pass us on his way out when we cordially stopped him and asked him to stay with us for a little while.

This "little while" extended to two hours. Union rules were cracked.

I found myself in a no man's land, once more in that bewildering moment of non-recognition of past and future. The tall space of the main hall was bluntly making a grimace at me. I couldn't recognize the face I thought I knew so well from our drawings. We all three felt the same way. We didn't talk about it. My two companions turned silently toward me. And they froze in that position. Without looking at them, I said, "Yes. We must change again. To hell with paper architecture."

I fell into work as into a trap, grabbing strips of wood, struts of metal, Freddie freeing planks under a mountain of bricks. We got ready to measure, to lay out plans, upward and down, left and right, pushing the water trough backward, backward toward the entrance, away from the parabola, away from it until we found the limit of the spatial extent. The foreman took off his coat. He handed me his hat. There was no hook, so I held it. That hat was passed from hand to hand during the following hour and a half, depending on who was holding what.

Freddie, with the voice of a grumbling frog, kept burbling about this and that, costs and delays, and why on earth didn't we think of it before,
before,
before . . .

We sweated it out, our improvised brotherhood of design. Finally the foreman straightened up. He was through. I handed him his coat. Armand, my congenial partner, wore a smile. But the rest of us were disconcerted. Freddie's face was grim. No one listened to his croaking and it always bounced back to him without any accompaniment. And I was deeply concerned about the discrepancy between drafted plans and the demands of space-reality. I sank into contemplation. Peace suddenly settled upon me.

We all turned to the exit door. A few seconds later, I wanted to go back and almost had to be dragged away. I caught a last glimpse in the turn of my head backward as the panel door snapped into its frame and closed for the night. But just at this moment Freddie stopped us and said, "Let's go back for a minute. I swear only a minute. I have a suggestion to make." The rest

65

of us looked at one another, astounded. We turned the key, opened the door, re-entered and waited, letting Freddie pass us, following him with our eyes. He stopped about fifteen feet away underneath the big square hole in the ceiling of the mezzanine, where an old emergency staircase was still in place, and said, "I have an idea. Why not leave this well open after removing the stairs, instead of closing it up as provided in the plans? It is so nice to look from below through the hole into the upper floors. It would be inspiring to see the exhibits that way for a change. How about it?" We were quite stunned, and walked forward to look up through the well. It was truly a beautiful expanse.

Freddie stammered. He felt he was on the spot. I stepped toward him, smiled and said, "It's a brilliant idea and I'll buy it. Good-bye, Mr. Contractor, we'll close up the joint ourselves. Go home to your faithful wife and have your supper. We'll stay on."

And so it was.

We walked around the crater of the stair well cautiously like panthers. We smelled space, and we made our rounds like Indians around the fire, warming our imaginations on the possibilities of that uplift of vision. I was enchanted. I could see a glass tube rising from the main floor through the hole toward the other ceiling. One could look at exhibits from below up, and from above down. What a chance for stimulation! I could see a sculpture coming from the ceiling halfway through the square opening and meeting another one coming up from below. We laughed happily over our last-minute discovery and then became, unavoidably, serious. I suddenly recollected that three years ago I had finished a sculpture of that kind, that is, one part coming down and the other part going up. She is now leaning in a corner of my old studio on Ninth Street, wrapped up in newspapers.

"Now, Freddie, you have been working on squeezing a new staircase into that open well for four months; you were the man we were consulting all the time. We turned the run of the stair this way and that way, entering it west and exiting north, entering east, exiting south, switching to west and exiting east, and we finally had to abandon the whole thing. We couldn't manage a comfortable and legal staircase through that well. Damn, too bad. And so the idea of a staircase was abandoned for good, and the hole was doomed to be closed. That's clear in the plans. And now,

Freddie, now, exactly one day before that open sarcophagus of the floor was to be closed with a concrete lid, you, of all people, try to exhume an idea which was buried in our prehistoric discussions. That contradiction you will have to explain to me. Why didn't you think of it before? before? *before?*"

The silence which followed was a corker. I broke it. Honest as he was, he could not answer.

"I can tell you why," I said. "Like every one of us, you were flat-footed on the drawing board. But now, when we've worked two hours long in the open, you are no longer seeing space in its dimensions of the blueprint, but you are inhaling space and being filled with it. The creative moment arrived for you when that open well with its vistas rose in your memory as we shut the door to leave here. You were drawn back into the original vision. You *could not* have had that feeling before. You needed to meet the situation physically, not on the board, and we gave it to you. And you rose to the occasion. I'm very happy that you let me live with you through this experience.

"On second thought, I don't know if we will be able to keep the well open. That is a matter which we will have to decide tomorrow. There are too many implications as to costs and time, and legal permits involved, as you would say. Time really might be the determining factor. However, let's be happy about your flight into the imagination, even if the idea lands with a crash—it was beautiful up there."

On the sidewalk of Madison Avenue everything looked brutally dark. The Parke-Bernet building already wore its night mask, with only two windows lit with bulbs like Lucifer's eyes.

We dispersed in three different directions.

1 P.M., Tuesday,
September 18, 1956

Today the well was closed at noon.

5 P.M., Tuesday,
September 18, 1956

Beams were put across the opening early in the morning. Sand and water and gravel and cement were already mixed when I arrived at 10 A.M. By eleven thirty the wooden planks stretching from rim to rim of the well received the pour of the concrete

mixture. Seen from above, the hole had disappeared under the wet cover of the lava. By tomorrow night no trace will be found of the well. That is, if the closing of the fill was well done. I hope it was. The lava will have hardened to a dead lid of stone.

In months to come, and years, visitors will walk over that stigma, unaware, with a nonchalant swaying stroll, looking for the gayish Mirós and the cockeyed Picassos, all visual puzzles never to be resolved.

Monday
September 24, 1956

Anna's Departure

The next day was a hard-working day at my home office and on the battlefield of the new art gallery. Arrangements for a birthday dinner for me were completed and the vision of it at Henri IV's elegant restaurant loomed on and off during the whole day.

In the afternoon I went to Anna to assist in her packing for the departure next day. Her apartment was another battlefield strewn with bodies: clothes, summer and winter; shoes, high-heeled, low-heeled; bottles and books; all the paraphernalia that should be left behind plus those gathered to be taken along. I didn't touch anything. I sat down and held myself in readiness in case I would be needed in that atmosphere of hard work. The necessity of making decisions was strengthening for both of us. She knew that I must spend the evening at home and then go out for dinner with friends. But she hoped, as I did, that I would be able to join her after midnight again. I managed with as much tact as I could to leave my dinner guests.

When I arrived at Anna's house, I saw one large and two small suitcases ready to be closed lying in the middle of the floor of her living room, and in her bedroom two other suitcases almost filled. The bodies were off the floor and stored away.

It was late in the evening. Somewhere in the early-morning hours, without talking about it, we agreed that she should have as much

sleep as possible this last night in New York. I went into the living room and sat down on a leather stool which I have always liked. It reminded me of the simple square designs of Miës van der Rohe. I feel at home with them. I looked about, as if for the last time, to take in the walls with their hangings, the canopy of the blue ceiling, the brown wooden shutters of the old-fashioned windows, and one by one I studied everything around me, object after object so familiar, for quite a long time. When I entered her bedroom, she was already resting under the blanket. I sat beside her and took her hand in mine. Time seemed to stand still. I couldn't say if it was long or if it was short until I left. She had gradually fallen into sleep, and I could finally withdraw my hand without danger of awakening her. I switched off the customary two lights in the living room, one in the hall, and with a long glance into the dark bedroom I turned away, slowly opened the door and let it snap back as cautiously as I could.

The next day was Sunday. The day of her departure. I promised I would be up early in the afternoon for my visit. The train was to leave at five o'clock and perhaps we could have luncheon together, she had intimated.

It was a sunny day. Contrary to the night before, everything in her apartment was well ordered, clean-cut. The suitcases were closed and stood at attention, ready to be taken downstairs. We went to Longchamps. We ate well, then went back home for the last hour of our being together. On and off we felt a slight choking at the throat. The best thing for her would perhaps be to relax and sleep awhile. She stretched herself out in her gray travel skirt and sweater on her neatly covered bed, and closed her eyes. I sat next to her, waiting for sleep to come. And it did, gradually, not too deeply. On the side table next to her bed was a pad with large red lettering on it: "DON'T FORGET." I reached for the pad and one of the three pencils—two yellow ones and one black—lying among the other objects in perfect order. I started to sketch the table. The pencil wandered from object to object, settling their contours one by one in my drawing. In the left corner, close to the bed and the wall, against the blond color of the wood, was the box of the telephone, jet-black and with many highlights gleaming on it. Next to it, a handful of space away, her night lamp, a round base on it, a glass ball, an upright glass tube holding the socket and the bulb, and above that a lemon-colored silk shade with a slight swing outward at the bottom rim like a Chinese roof.

69

Lying beside the lamp was the little fox of beige fur, a gift of mine of five years ago. Farther toward the other end of the table was the voluminous telephone directory in gray with the familiar yellow band on its back saying *Manhattan*. On it rested a box of Kleenex, blue and gray, a white flap protruding. Back to the front corner of the table next to her bed was a tiny ceramic bowl of an ash tray. In it I spotted two butts, one long and one very short. No ashes. I did not see, but I do remember, a Chinese horse painted in black strokes on the inside of the ash tray. Her eyeglasses followed next to it with precisely folded arms, and then the one black and the one yellow pencil, lying like operating tools in a rectangular order at the edge of the table. These were the last items.

I folded the sheet of the pad quietly over onto its back and turned my head toward her. Warm color had in the meantime come into her pale cheeks. The crown of her rich black hair surrounded her face almost completely. Finding the sharpest edge on my pencil, I followed the contour of her head, bend by bend. Then turning to the niches of her face, I drew first the dark eyebrows, the slight swing of her closed eyelids, added the two dark spots of her nostrils and then the warm curve of her lips, slightly open. Now I went over the ebony of her hair strand by strand, each group of her locks placed as well as I could the way they followed each other. One particular strand fell across her temple down to her ear and I remember it so very much because she never wore it that way, and she would have smoothed it back if she had known, but as it appeared now, so casual in its darkness against her ivory and rosy cheek, it gave away at once her ancestry. One more glance at her, a pause in which I tried to transfix her image into my retina, in case the drawing should ever get lost. I wrote into the left corner *Sept. 23, 1956* and put my initials beneath.

She awoke just in time to get up for the train. She took a final glance at her bags and decided that we both should carry them downstairs, one by one. Before leaving, I handed her the drawing. She looked at it, smiled, pleased, but folded it right through the middle briskly and put it into her bag.

I walked underground with her at Grand Central Station along the standing train. Soon the porter came, pushing his cart stacked with luggage. He placed the bags, two next to her and two up on the racks, was paid, and went off. I waited outside. A minute or

so later Anna came out. She was nervous and dreaded to say a definite goodbye, and so did I. She bent quickly toward me. We kissed. We both turned apart, and I walked slowly off.

Back to the street through the dark tunnel, I emerged at 42nd Street. The day seemed twice as bright as at noon. I sat down outside the Liggett drugstore and had my shoes shined. Having my shoes shined has always been a great relaxation for me.

At home, I knew K. was waiting, having been told not to forget to come at five o'clock. I did not want to remain alone until I went to sleep that night. She was there, and Steffi in the other room. I dictated continuously for two hours. Tried to eat dinner at Marianne and Marguerite's but was rejected. Under pressure Steffi fried two eggs for me and ate a single one herself. At ten there was an art quiz on television between Edward G. Robinson and Vincent Price. I went to Marianne and Marguerite's to see it on their large new TV set, having been invited for the showing as a substitute for dinner. When I got there, I suddenly felt so tired and helpless that I had to leave almost as soon as I arrived. Home alone, I wrote, and corrected my diary late into the night. At midnight Anna phoned. She had arrived safely.

Monday
October 1, 1956

About nine thirty in the morning the telephone rang. It was Anna. "Sleepless the whole night. Decided to quit. After a break of four years, I can't take all that curriculum business and that protocol again. I'm coming back." The call was from Wellesley.

Two days later, I rushed a full hour before the arrival of her train at Grand Central Station at 2 P.M. I knew too well that no visitors were permitted to the perron where the trains arrive. Guests have to wait on the floor above, facing the ascending staircase. So I secretly sneaked underneath, to be on the same level as her arriving train. She would be coming with suitcases of dresses, a handbag and coats over the arm, and probably another suitcase filled with books. Too heavy to carry for her or for me alone. No porters would be available. The escalator probably at the other end of the track, and it would be a dismal return after a tiring week at the college and the disappointment of giving up. I knew exactly what state of nerves she must be in and what recriminations she must endure. Below, in Grand Central Station, underground, hidden behind the ramp of the staircase she will walk

71

up after her arrival, I waited, a solitary vagrant, leaning against the flank of the stairs, flattening my body against the wall as much as possible so as not to be discovered. Impossible to discern in that pseudo darkness, or pseudo light, if it was day or night, dusk or dawn. The years and seasons seemed here to stand still. There will never be sunshine or the sheen of the moon, only electric bulbs making grimaces of artificial light. The empty tracks, left and right from an endless platform, look like petrified lonesomeness. They lead everywhere and nowhere.

Coal dust, oily sweat of engines of time past, makes the wooden tiles, already tar-struck, even blacker, sweaty. The tracks running over a moisture land filled with puddles of seeping underground water. Barren steel columns form a veritable forest along the platforms, supporting a low concrete ceiling whose gray paint has curled its skin in lacerations of old age.

She looked fatigued, beaten, was wordless all the way home. I did my best to be factual, bought food and three yellow roses for the vase (the old ones had wilted away). A wreck, she still prepared dinner silently and tried desperately to hold her own. Afterwards she went immediately to bed. I sat next to her as always. Soon she opened her eyes, and insisted on telephoning news of her dismaying adventure to her family. I tried to make her rest first, and call tomorrow. No, she would not postpone it. I left the room, closed the door. I read a newspaper, skipping headlines and skipping text. After fifteen minutes I heard her call me. She was shaken, shocked. She asked me, after a sudden embrace, to leave. She did not want to go on being spoiled by my waiting for her to fall asleep before I went away. She had always demanded my presence until her slumber came. This time it was the reverse. The events were too much for anyone to bear. I understood.

Out on the street, I realized to my surprise that it was only nine o'clock. In the taxi riding downtown, I remembered that this was the night of the performance of Ionesco's and Ghelderode's plays, to which I was invited by Marianne and Marguerite.

When I arrived at the Tempo Playhouse on Fourth Street, I found no money to pay the driver. I directed the cab toward my neighborhood drugstore at Twelfth Street and Seventh Avenue, cashed a check, drove back, and arrived in time to see the second act of the Ghelderode play. Critic Brooks Atkinson nodded to me,

72

but left before the final curtain without saying whether or not he had accepted an article of mine for the *Times* that he had requested. Years ago that would have reduced me to despair. Not now, thank God.

Afterwards I wandered sickly fatigued for several blocks. Luckily I was in the company of Marianne and Marguerite, my old friends. We looked for some sympathetic place to get a cup of coffee, but none seemed suitable. At Howard Johnson's mass stable we talked about *The Lesson*, Ionesco's play. The sadistic attitude of the teacher toward his girl student, whom he kills, stabbing her to death with an empty hand, had left the audience aghast. And the rebound of this reaction hit the three of us. After the girl's death, the teacher carries her body out for secret burial with the help of his faithful housekeeper, who warned him several times during the lesson not to excite himself too much. But after they exit, the doorbell rings again and the same schoolgirl enters to take her lesson. Evidently the stabbing is purely symbolical. He screams for a knife, but does not get it from the housekeeper. (It is true that we often wish we could have one.) Receiving no material help, his impulse to inflict suffering, based on his unique concept of righteousness, destroys the girl nevertheless. His imitating in a trance of hate the actual gripping of a handle and stabbing with a blade is the only new contribution of the playwright to this old theme of the theater. Very rightly then the girl appears again. She never was really dead—she was only killed. And she was not and will not be the only one destroyed.

On my way home, I ran into David Smith, the sculptor. We leaned against the new Brevoort, an architectural stinker bearing a famous name. In spite of this, we continued leaning against the monstrosity, two incongruous bodies—mine, low and small like a cellar door, and his, tall and wide like a barn gate. I asked him if he knew of any American artist who had produced molten-iron sculptures prior to 1934. He said, "No. Are you one of those damn foreigners who look only for first-nighters?" "On the contrary, I would like to help break the myth that most trends of art, old and new, started in Europe. To be the first doesn't mean absolute quality, but to be second means rarely to offer obsolete quality."

I had been meaning to invite him to join the forthcoming first exhibit of World House galleries as the American representative of

all the "Torch Bearers," but somehow I had failed to notify him —and here he was, still in time for the show. I offered the invitation.

He sent us a beautiful, tall flowering iron man. I exhibited it with its feet ankle-deep in a water pool. It was a successful marriage of gallery and sculpture.

Astor's Tower

October 12, 1956

These are days ago that I am going back to now.

What springs to mind first is my flying trip to Miami exactly one week ago. Sudden and fast. I left Saturday noon and returned the next day, Sunday evening. Those were a short twenty-eight hours. I had never expected to see Miami. John Jacob Astor was the man to visit. One of my associates notified me the night before that we might receive an interesting job from John Jacob Astor. If we could leave quickly, we might still catch him in the mood.

At nine thirty in the morning I was at the airport and so was my associate. But he came toward me strangely, waving his arms, marching down the long hall of the airline ticketry, and the closer he came the more serious, I remarked, his facial expression became. "I can't go. I'm sorry. I can't go. Will you fly alone? Can you?" I answered, "What happened?" "My wife didn't feel well last night. She fell asleep only at seven in the morning, when you phoned and woke her up . . ."

I felt guilty for having phoned so early—I who always get up so late. I actually had made a special effort, and killed in that way the companionship of my friend. I'll have to go alone and be with John Jacob Astor on my own, and take all the responsibilities for success or failure of the project.

"Oh, I'm sorry," I was saying aloud. "I only notified you that I
74

was leaving for the airport. We made such a hasty decision last night—I thought you wanted to be assured that I would be there."

He: "Don't misunderstand me. I wasn't talking about your phoning. That was incidental . . . can you go alone?"

Yes, I was ready to go alone. I suggested calling on the second associate to come with me. It might be helpful to have him along. He is what is designated a "practical" man, although in my definition a practical man is a pseudo specialist who only believes in that which *has proved* to be practical in the past—not now. He has no ideas about the present, not to speak of the future. He stands for the inert past and fights for it, blindfolded. His self-confidence is congealed insecurity.

He does not realize that when "The Iceman Cometh" to the house and unloads the cold crystal rock from his shoulder into the old-fashioned tin-lined icebox, he has done a practical job, true, but that the electrified refrigerator does it better. Practicability grows too, as function does. That was always my credo. But no one thinks *that* is practical.

We flew down together. He was as practical as I had expected. He took care of the incidental expenses.

As I rang, Mr. Astor appeared in the doorway. He regretted having missed us at the airport. I was ushered into the bridal suite with a Carrara black glass bathroom in whose nooks, cubicles and compartments I got lost. Black toilet seat, black porcelain bowl, arrays of assorted bath towels along the wall colored black to lead-gray. At night, on retiring, I asked my companion to change rooms with me—the adjoining one was so much smaller and with a square bathtub that would fit me snugly. He cordially agreed. Air-conditioning units stuck their noses from each window into the interior. The atmosphere was freezing. In the corridors it was sweltering.

The dining room was astoundingly small, so was the living room. Apparently two old houses had been thrown together to make for the breadth and width—but the only exuberance was in the décor. Walls, floors and ceilings made four-decker sandwiches, with layers of wallpaper, mirrors, brackets and woolen rugs.

75

The man Astor was much too big for his own house, and I was much too little. He was a mountain of flesh, sweating through a seersucker suit that stuck to his back.

"See, my pet idea is a tower, ten stories high. I'll only occupy the top three floors. It's too hot down here. My view of the sea is blocked by several rows of houses and by those beach hotels with their flashing neons. See, I'll be above all that . . . I'll get a view . . . I'll get a breeze. I've done some research into towers: look at the reproductions—towers from Siena, Venice, Bangkok, and ones by Frank Lloyd Wright. I had three architectural firms designing some of their own tower ideas, but I don't like them. I have my own thoughts about towers. I like them in brick, or even better in marble. No glass! Old towers in form, but in white marble. The top to stick out—the three highest floors, I mean, to be square, thirty-five by thirty-five. The shaft doesn't need to be more than twenty-five by twenty-five.

"See, like the Italians, you know . . ." And I answered, "Like the Armory in New York, which is a ruthless copy of Italian models, brick by brick, stepping forward to make the base for the balcony above." "Exactly," he answered with finality, "that's it."

While I was flying back to New York, I pulled a pad out of my pocket and designed an all-glass tower. I felt the flash of an idea.

"You know, Kiesler, sometimes you frighten me!" said my companion when I handed the pad over to him.

It was a glass tube of ten stories suspended on three totem poles. Not a brick in the house!

"And utterly impractical." I laughed and hoped the airplane would start rolling from side to side and make the practical man sick. But no such thing happened. I was the only one excited.

I pushed the button under the armrest, and the seat flung back so that I could stretch out. I knew I had it.

In New York my companion's family—wife and two girls, aged fourteen and seven—awaited him. We had ice cream together. He took care of the expenses. I shook hands and was glad to have met them.

I wonder what they, the family, thought of me. I was wearing my old Tyrolean plush hat.

November 24, 1956
These were days and nights of many weeks when the days had become nights with flashes of light interrupting the all-enveiling darkness, and the nights had become days, not continuously so, but illuminated unwillingly by bursts of suns of memories, a brisk interchange of white and black, too often a reversal of their natural assignment to make one feel at ease and peace.

Again and again during these weeks my design for the Washington Square project was almost brought to a happy conclusion, but again and again new variations were instigated. There was so much hope that certain ideas could go through, but in the days following they were smothered under a blanket woven by our business advisers. Very few clients have sustained power of their convictions when facing committees. Most owners want something new and better in design, color, materials and living conditions, but when they are confronted with a new solution, they back out at exactly the moment when they are about to put their signature to it. Here again looms the great question for me: to build or not to build. I feel like an imaginary totem pole built of ice blocks held together by red-hot iron bars, all enwrapped in screaming steam. Have I to quit the job because the compromise is too great, or am I to keep on fighting to save something that most probably would no longer pertain to my basic ideas, but only be a satisfaction to the committee and perhaps of some financial gain for me?

I feel so often like a beggar who is truly rich and extends his hand for alms only to give pleasure to the giver.

"You can't have everything as long as you have something. As long as you have nothing, everything hoped for is possible," I have often been told. Having waited so long, truly half a lifetime, for a chance to build, and now coming unexpectedly into those realities, I encounter the turnstile where I must pay in order to go through.

It seems to me that according to the tradition of human behavior in our society, I have to resign myself to sole satisfaction by my design-planning.

77

Has not I Ching told me:

"When the water has flowed out below, the lake must dry up and become exhausted. That is fate. This symbolizes an adverse fate in human life. In such times there is nothing a man can do but acquiesce in his fate and remain true to himself.

"Therefore, in times of adversity, it is important to be strong within and be sparing of words.

"The ablution has been made, but not yet the offering. Full of trust they look up to him."

But I revolt at the thought of giving up. I revolt at giving up what I never had but always hoped for. I revolt at giving up the hope of love for love's sake. I deny a duality between love and work or life and dream. Work is the crown not the root. The root is love. And before work becomes a crown, it is sprout and branch and nothing else. It takes its sap from the root, and root is every day's experience, dirt and chastity, anguish and truth. The horizons of the imagination are as real as a burning scar in your own flesh. There is no division at the root. Only the crown splinters.

Splitting the event of life is only due to the shortcomings of our senses and chiefly to our brain-machine. When I feel, I know. I feel, I am. I think, I am split.

A Theater for the Poet

December, 1956

The poet's theater is nothing new in histrionic history; but each period has tried to solve the problem of the stage in its own way. Our time, with its social issues in full turbulence, is now willing to listen to the poet's voice again. How will the contemporary stage support him, and by that I mean, how will it help him visually, physically and acoustically to convey his message to the audience?

When I was asked to design the décor for *No Exit* by Jean Paul Sartre,* I thought it an excellent opportunity to tackle the design problem of a poet's theater. That we have none—architecturally speaking, and scenically—is evident. Show business on Broadway and elsewhere, in big cities at least, is primarily a feast for the eyes; and whenever drawing-room comedies are heard and seen, they tend, alas, to confine themselves to more or less pleasant décor.

But the poet's theater, by which term I understand a stage set for the spoken word, imposes much more difficult problems than the mere consideration of an appropriate scenic background. First of all, the dialogue must be clearly heard in the whole house; and secondly, the action must be brought into a most expressive visual plasticity instead of mere haphazard melees of motion. Third, the physical relationship between audience and actors must be established so as to permit direct contact or definitely cut such contact off; under no circumstances, I feel, must it be left undecided, as on our present stage where the proscenium arch is nothing but a shelter for the curtain.

Thornton Wilder's *Our Town* is an excellent illustration of how far the poet's theater was helped or not helped by the present-day stage. It was played "without décor"; but the fact is that it was played with *reduced décor*, with décor *in abstracto*; with décor reduced to props. In that sense it was a revival of the expressionistic German theater of the 1920's, which also had an earlier revival in Orson Welles's staging of *Julius Caesar*. In both cases the poet's stage was approached only in terms of an oversimplification of décor bordering on emptiness. The bare wall of the stage was shown, the emptiness of the stage prevailed, the design of the locale where the action took place was omitted (no painted backdrops or side wings) and lighting was used only for the creation of smaller or larger play areas. It was a successful method, there is no doubt about that, and I certainly do not want to diminish its merits. But to think that play after play could be presented in that manner would mean to reduce the possible means of dramatic expression to a very meager formula.

* This first American production, on Broadway, was produced by Oliver Smith and Herman Levin, directed by John Huston. The three actors were Claude Dauphin, Annabella, and Ruth Ford. The translation of Sartre's play was done by Paul Bowles.

In other words, the poet's stage must be an architectural conception bursting forth with improvisations and not a decorative one. The architectural concept of a poet's stage would (if the problem were properly solved) then permit any décor without loss of the most important optical, phonetic and dramatic issues at stake.

Now let me illustrate this with the story of the architectural stage I designed for *No Exit*.

In *No Exit* there are only three people on the stage for an hour and a half. It was evident that the "acoustics" would have to be fool-proof, almost to the point of being independent of the limitations of any type of auditorium. With regard to the actor, he must have the feeling (and must be convinced of it) that no matter how he turns and speaks, his voice will be heard clearly and distinctly everywhere; that he must not be afraid of turning his back to the audience if the action demands it. In other words, stage director and actors had to be freed from acoustical slavery to achieve the fullest development of action within the dramatic blueprint. Let's admit that we are so accustomed to taking the proscenium stage or the arena for granted that we limit our designs a priori. We love to excuse this with such ready-made phrases as "under the circumstances this is the best we can do." But from a craftsman's point of view, the invention of a new and better tool simply permits him to function more effectively and more convincingly. Any stage that would act as a better tool with which the actor and the playwright can express the play should be welcomed.

Therefore I first of all raised the stage floor two feet and put the whole action on an elevated platform. With a slight but distinct inclination toward the front, this elevation will act as a projector of sound and in addition will put into relief the actor's figure moving on it. We must not forget that on a normal stage floor two things diminish the plasticity of the actor: the hood of the footlights and the flatness of the stage floor. They prevent the spectator from perceiving fully the distances which the actors cover, the design of the space relationships he creates in moving to and fro, which contributes greatly (as in dance) to the dramatic expression of the stage, and is particularly important when only a few actors project the interplay.

Of course, if the action were confined merely to facial expression, hand-moving and head-turning, then the proscenium opening could

be reduced to a pictorial oval where actors might be grouped as for daguerreotypes; and the stage would present itself as a moving picture with spoken dialogue. But because we have a contemporary way of acting which includes expression by the whole body in interpreting a part, we must carry through the same total concept in our stage designs. An elevated platform with a proper inclination helps enormously to clarify sound and vision.

When the set for *No Exit* arrived and the actors had rehearsed a very short time, they stopped and asked in amazement if we in the audience, who were watching them, also heard them as clearly and distinctly as they discovered hearing themselves. It was true: we heard them incomparably better than on a conventional stage.

Yet they had violently objected to being elevated when they first heard the plan, insisting they would be too exposed to the audience and too loud. We had brought a chair onto the old, flat stage; one of the actresses had got up on it and, being somewhat isolated, let out a scream as if a mouse were about to reach her. Others followed on other chairs with similar yells and the idea seemed doomed.

I was ordered to design the same set *without* elevation; but a third and then a fourth version brought it back with a compromise height of one foot. And so it remained. (The truth is that originally I planned a much higher elevation, an elevation of the stage floor almost to the height of a motion picture screen.)

The play took place inside a rectangle enclosing the new stage opening, which is much smaller than the usual stage area. It is an opening almost in the middle of the proscenium wall. The proscenium arch is negated by being covered with black cloth. This new space stage focuses the attention of the audience much better than the normal proscenium. It is conducive to a more intimate relationship between actor and audience. The normal proscenium is too wide; it is much too high to be taken in by the eye. Sound and vision are diffused, concentration is difficult. The new opening is set into the proscenium, with enough area around it to isolate its rectangle completely from the stage floor, the sides and the ceiling of the auditorium! This is isolation of the stage from the auditorium, of the actor from the spectator; this is the break which Sartre himself demanded in a lecture in New York. The purpose: to separate the reality of the play from the reality of

81

the theater. Yet, as he said, in Paris they were unable to find the stage-means to achieve this division. "What we have not brought about, and what we of the new French theater would like very much to achieve, is a pathos, a new pathos of language, based on everyday discourse but without artificial aggrandizement or surrealistic paraphrasing." Distance! The poet's distance—the aloofness of the orator—with the aim of hitting his target (the audience) with the least interference and with absolute accuracy.

The décor inside this new stage, such as walls, ceiling (if any), furnishings or props, can be of any design and style. That depends on the play. It might be more naturalistic or more abstract—but here it is less necessary than on the normal stage. Even without any décor, acting within this complete frame-enclosure, the actors moving on an elevated (strongly lit) platform (like a prize ring) against a dark horizon (curtain) is all that is needed to bring the attention of the public into focus and into proper mood. This space-stage works like a magic eye. Once its lid has opened, it hypnotizes the spectators into fascinated attention.

The opening of the eye is a mechanism of great interest to the stage designer. It is the curtain of the stage of vision. So is the stage curtain. The curtain of the Shakespearean stage was in back of the forward platform, where the main action took place. And in Vienna, in 1924, I omitted the stage curtain altogether, replacing it completely with a white sheet spanning the existing proscenium to be used for projection, because the action took place on a two-level round platform in front of it. The stage was not used at all. It was shut off by the enormous drum-tight sheet. It was dead. Beginnings and ends of acts were indicated by bringing the lights on or dimming them out. Entrances and exits of actors were fully visible to the audience, and no attempt was made to masquerade them.

Now, in our poet's stage the problem of the curtain poses itself differently. Here the curtain does not play hide-and-seek any more. There is not a "show" to be disclosed. The trickery and illusionistic foolery are absent. The stage picture which the opening of the curtain will disclose is a mere adjunct to the spoken word, running behind, parallel, or ahead of it. Therefore, the curtain assumes more the role of "clapping hands" to call the gathering to order. It also has more life of its own than if it were a mere mechanism. It assumes almost the role of an intermediary between ac-

tors and audience. It has more personality. The way it will split and open is indeed very important. I proposed for *No Exit* the following ideas.

Like the human eyelid, the curtain—a solid wall—splits itself horizontally in two parts: a larger upper part and a smaller lower one. The upper lid disappears upward, while the lower falls forward over the orchestra pit, where it forms an extended proscenium. The advantage of this is twofold: first, the stage becomes very quickly opened up, almost instantaneously, and second, contact with the audience is achieved through the extension of the lower lid. The protagonist-actor may now step forward to the depth of the aisle toward the audience and deliver his lines almost in the midst of the audience. However, this contact is not the intermingling with the audience which the Russian constructivist theater of the 1920's tried to achieve. This is distinctly different. Here, the stage brings the actor merely forward, if he wishes, and helps him to bring the action to the brim of physical relationship with his audience. In the Russian arena of the 1920's the division between actor and public was completely abolished at certain moments of the play.

In Sartre's play there were excellent occasions to use these possibilities of extension, particularly where the three people tell of their lives on earth or when they suddenly see and hear the earth and describe it vividly, as a telescopic image.

Let's hope that another poet-playwright will be courageous enough to give his spoken word the advantage of all technical possibilities to make himself better understood, giving equal importance to color, form, space, light—all changing with the rhythm of the spoken word and commanding attention like a child in a classroom, who by raising the hand becomes momentarily the focal point of the group, then fades away. The dictum of contradiction is the lifeline of the poet's theater.

1957

Spivy's Renaissance

It is three in the morning and I have unexpectedly been in the presence of John La Touche as vividly as I ever knew him.

I hadn't seen Spivy for ten years; she had gone off into oblivion after having been, twenty years ago, the song-in-our-hearts at nightly gatherings. Almost every evening after ten o'clock we had gathered at Tony's on West 52nd Street—La Touche, Marc Blitzstein, Jane and Paul Bowles, often Virgil Thomson, Aaron Copland, sometimes also E. E. Cummings . . . songs and lyrics were produced on the spot and tried out by Spivy at the piano. The songs became well known and Spivy, already a rounded cocoon, quickly emerged as one of the great night butterflies of New York.

In this exuberant atmosphere, Tony and La Touche would sometimes stand on their heads and transpose the songs into duets.

Tonight I went to Spivy's night club—she was making a courageous attempt to have her own place. With me were my wife, Steffi, Jane Bowles, Ruth York and other friends of La Touche. We old troopers had decided to bolster Spivy's renaissance, and marched up the four flights to her mansard-cabaret. She struck a gong at midnight, a long white cigarette holder clamped between her teeth at a wide angle. Then Spivy lighted it from her lips and swung out the holder with its smoking end, like a macumba initiating a voodoo ceremony. She conjured up old-time La Touche songs and soon turned us into cave dwellers of the past.

The lyrics which La Touche had written so long ago for her, to which she had brought so much life, made us feel the presence of La Touche as if he had really been with us.

We all sank into a coma of memory and dwelled together in the presence of our lost friend. When Spivy's song died out, we woke up and automatically looked at one another as if to make sure that we were all really there, and we tried to embrace one another with our eyes. A noisy group of guests arrived, wearing masks of real life. We realized this was a night club, not a séance . . . two Scotches, bourbon and water, gin and tonic . . . the spell was broken.

High Fidelity

March 16, 1957

At Spiro's air-conditioned diner on Twelfth Street, *Fidelio* by Beethoven in high fidelity. I wonder what Beethoven would think of it, mass-played during the hustle and bustle of restaurants, diners, luncheonettes, in the north, south, west, on the road, on city corners, everywhere amidst the clutter, clusters of people coming in, trotting out. The ringing cash registers, shouted meal orders—this symphony, too, could be recorded in high fidelity and played back between Beethoven and Brahms: a musical club sandwich. It could inaugurate a new type of music. "La musique infidèle."

In olden, that is, in Beethoven's time, music was heard without added background sound. Just in simple fidelity to the composition. But nowadays it would be highly antisocial to stop the noise and listen only to the original composition. How old-fashioned can you be! Imagine everybody putting his fork aside and doing nothing but listening. Absurd! This is the age of enlightenment, art education by mechanical injection. The wheels of industry turning out high-speed culture.

Music is meant to stimulate, but canned, it only tranquilizes. It fills a gap, relieves anguish, in our daily emptiness or loneliness. Human relationships are cumbersome; drop a dime in the box for make-believe happiness, Mozart, Bach or Gershwin becomes your soul-sitter while you eat. They'll rock your cradle. Just push a button. Don't be a sap and wait for live music.

Final Proportions

April 4, 1957

One annotation about a somewhat crucial incident of a type which is bound to occur in a perfectly cordial association between a client and architect. Overcoming such a challenge, one discovers that human and artistic relationships, if honest, can hold fast in spite of anguish on one or both sides. Thank heaven for the ambivalence of truth.

Two evenings ago Mrs. Wright, her managing director, my senior designer—Mr. Iversen—and I walked through evening darkness and mud on the grounds of Mrs. Wright's gardened estate. There is a summer theater there with a Venetian colonnade and I had been asked some months ago to advise on its conversion into a theater. Recently Mrs. Wright had insisted on our checking the proportions of the new theater wings because in my plans they seemed to her arbitrarily wide.

We reached the forest in the near-evening misty dusk in Mrs. Wright's limousine. Still chatting, everyone in the car stepped over somebody's feet out onto the wet ground. The forest was silent, wrapped in dense fog. One by one we gradually stopped our chatting. It reminded me of the limousine arrivals at a duel in the bois, seen so often in French films. We walked off, dark figures painted in washes of black ink, disappearing behind trunks and bushes, leaving the car lonesome and lifeless.

Missing our hostess, we stopped and looked back. To my surprise I saw our lady sitting down on the floor of the car, its door open. She lifted one foot lightly up and stretched it out. The chauffeur produced a pair of high-buttoned rubber shoes which he now, bending low, slipped over her shoes one after the other. The rest of us waited in mute attention. She got up from her low crouch with a sigh of relief, appeared much taller, and was ready to lead us on, erect and jolly. We followed as closely as the darkness of the evening would allow.

The beam of a flashlight broke suddenly into sight, moving erratically over the ground. It was the gardener, who apparently had heard us and had come to illuminate the ground leading to our goal, the marble colonnade. "Hello Joe," came from Mrs. Wright

encouragingly. "It's nasty weather," she stated, firmly taking command of our excursion.

I deliberately fell behind. I didn't want to splash my shoes and (new) trousers with mud. I found the moving caravan an intriguing tour de farce. At the risk of being called a typically belated Austrian, I stood still for a few moments, as if waiting for a faithful dog to appear out of the darkness; I would then caress it with my naked hand in spite of its rain-soaked fur because the animal had searched me out and did not care if I was professionally right or wrong. But there was no dog. Only shadows of men moving away from me.

When I joined the group, Iversen had already laid out a white six-foot ruler on the ground. He worked with a twig broken from a fallen branch to mark the measures and continued to do so until he had worked fifty feet to one side of the colonnade and then to the other.

"I knew it, I knew it," said my lady client. "It sticks out too far. There will not be enough space left between the extended wing of the new building and the forest. The actors will not have enough free area to rest in the open when they are off stage."

The situation was easily resolved. "The actors will have plenty of free space farther forward and backward from the wing. Last year's empty space around the colonnade will naturally change with the new building." That was I who was speaking. I, as the architect, had taken responsibility for the extension—with conviction.

A silence, equal to the sudden stopping of a rain shower, followed. We soon turned one after another and marched toward the car. What really made me stop and wait for a guardian dog I forgot to tell. Let me say it now.

When I was just about to step out of the forest fringe into the wide clearing at one end of which rose the ghostly apparition of the colonnade, I saw to my amazement that the beautiful lawn of a deep green, which had been one of my most delightful inspirations, had completely disappeared. I discovered that it was cut up into squares of one foot each. These scalps of grass were carried off and piled up at the edge of the clearing in heaps, evidently

preserved for later use. In the meantime, the naked ground would, I realized, be sloped (under the eyes of the gardener and his mistress) toward the colonnade. Thus the audience could sit gradually elevated—in standard auditorium manner.

The ground, once a carpet of malachite-green, appeared now pitch-black. Bereft of her protective skin, the earth was, so to say, bleeding mud, and we all stalked right into her wounds. Of course, I knew that was only temporary, that the scalps of topsoil would be replaced once the ground was sloped. Still, the image was shocking because it was so unexpected, and presented brutal evidence of conformist planning.

I could not help thinking, what enervating arguments had been set forth some time ago concerning the need to drive foundation columns into the ground in back of the colonnade (to support the new high roof) and the possible damage that might be inflicted on the roots of the old trees fifteen feet away! Yet, here on the lawn the owner had gone ahead with the sweeping operation of sloping the ground—without consulting or informing me, her confessor-planner.

The fact is I had made another very definite plan to provide for elevation of the audience. The plan was fully developed in blueprint and well known to the owner. The idea was new, a transformation scheme, and inexpensive. Three separate plazas would be built in the lawn area at different heights, each of them a foot or two higher than the next one. They would be flat, covered with tile, and could be used as open-air stages for ballets and dramatic performances—or what normally would be called three theaters-in-the-round or in the oval—or for audience seating. The varying height of the plazas would allow for audience elevation. In addition, I had proposed a covered arcade running around three sides of the rectangle of the total lawn area. This arcade would contain three stadium rows for audience seats so that in case of rain, spectators could retire there to sit—again with elevation. These rows could also serve to seat the audience in case the three plazas were used for performances.

Seeing now the slope-in-the-making, I felt that my original plan for a transformation auditorium was definitely rained out. The result would be a commonplace auditorium looking into a com-

monplace proscenium theater. Perhaps that was really all that Mrs. Wright wanted, and I should damn my own imagination for finding myself in a quandary. Yet I was filled with an irrepressible feeling of futility.

My lady client had not demonstrated ill will. Having created on her vast property seven highly individual gardens, she probably felt she had a right to do with the lawn according to her considerable experience in landscaping. I, of course, did not feel or think in terms of landscaping but in terms of a versatile summer festival theater, including symphonies, opera, and dance, but I was overshooting the goal.

Twenty minutes later, we were having dinner at a colonially styled inn. Rustically beamed, stone-floored, blue and white checker tablecloth. We were all generous with charm covering up any memory of irritation. A costumed-à-la-Williamsburg waitress served coffee in Wedgwood cups and then we all rode in the beige-and-black dream Cadillac back to New York.

The managing director continued the meeting with Mrs. Wright at her city villa until three in the morning (I heard later). He phoned me early the next day—yesterday—to ask for an immediate appointment so he could convey "suggestions for the architectural proportions of the theater" from the owner.

Here is a description of his visit:

He arrived twenty minutes after his phone call, in a whiff of urgency. I invited him to sit down at my drawing board. I took the place next to him.

"Mrs. Wright and I very much want to cut the width of the side wings, namely the dressing rooms, to make them *one foot* narrower! I know we spoke about it yesterday and you convinced us it should not be done. Today, however, I feel we just have to do it, one way or another. I spent the rest of the evening with our patroness in New York and I could see that this idea meant a lot to her and she begged me to convey this message to you. It's the wider space between the new wings and the surrounding forest she cares greatly about. I know that one foot is not much in an architectural plan, but that foot apparently means a lot more to

her than just twelve inches."

I watched him closely as he reported. His erect, handsome young figure in gray flannels was still tall sitting down. He spoke directly at the drafting board (with its blueprint of the theater on it) as if hypnotized by it and without once turning toward me. He spoke rather rapidly, and acquired more and more of an English accent than I had ever heard before. He pressed his point in a very decided rhythm, holding clear intervals between words and sentences without permitting any possibility of interruption. To my surprise, he seemed to become very heated and some beads of sweat appeared on his forehead. I became concerned with his concern. Could one foot more or less have such an emotional effect on anybody? I felt compassion, and knew: evidently it was not the foot. It was the anguish of not granting a wish important to the lady of the theater. He, as its future director, was naturally interested in maintaining not only the pace of the building but the peace, as well.

I answered calmly, "We can certainly cut it here and there," I replied pointing with a scale to the blueprint, "and reduce it even *more* than one foot, as long as we're going to do it. Perhaps one foot plus six inches on each side, three feet altogether, which means that the total width of the theater will drop from ninety-two to eighty-nine feet. That should take care of the problem."

He jumped up, warmly shook my hand and held it for a full second, and then disappeared like an arrow through the maze of my studio.

> Let me take this occasion to make a remark about changing dimensions in final plans. Architects are usually opposed to it for reasons of economics, aesthetics and personal pride. But I would say, Dimensions can be altered, even in final stages, if done with neutral concern for the problem involved and steadfast imagination concerning scales. There are no final proportions in architecture, unless they are *built*. Then it is too late and the judgment stands on its own merits.

> I do hope I will soon have a chance to write in detail about similar encounters between client and architect. The old-time client (pope, Fugger, Medici) believed in the man of his selection. He handed over the scepter-brush or the scepter-

pencil and it did not occur to him to wrench it from the artist in the process of creation, obliquely to try to change the original composition.

Today, particularly in the United States, magazine and newspaper information have bolstered a client's knowledge of art and architecture to brazen self-assurance. He becomes a self-styled teacher of design, and the architect an apprentice. This fact and the client's claim of insufficient funds or shortage of time, can be powerful weapons with which he justifies interference.

There would be nothing wrong with this phenomenon if the situation were clearly stated from the beginning. But the client usually sugar-coats the pill, speaking only of his concern for Art, and God help you if you bite into the pill instead of swallowing it. Thus financial investment and not a true desire for architecture is usually the origin of a project. Philanthropical and public projects have their own inherent variations on this theme of expanding and contracting compromise. We architects and designers should take a course in diplomacy at an early stage of our professional game.

Art in Society

April 28, 1957

It is 2 P.M. Sunday, April 28. I have just returned from Boston's Fogg Museum, a conference on museum architecture. Philip Johnson and I tried to fly back to New York right after the conference ended, but our plane was forced to land again because of fog. I remember vividly the radiant diffusion of all the lights on the airport road: enormous balloons, floating green moons against the night sky. We started again today, in the morning, and it went off all right. The fogged lights still lingered in my memory, but they were gone once we were up in the air—like the architect-stars who had appeared at the conference.

Participants were museum directors and prominent architects—

Philip Johnson, Gropius, José Luis Sert, Hayes of Cleveland and a few more, among them Kahn of Yale.

The conference was confused as to its aims. There were not more than thirty or forty participants in too large a lecture hall, which made it rather somber and full of echoes of things that were not said but that I felt should have been said; these unsaid things everybody heard, and the things we heard nobody cared much about.

We started at 2 P.M. It ended close to midnight. There were two sessions in the afternoon and one in the evening.

To summarize what the museum directors wanted: more and more space, and certainly more space behind the display walls in order to manage the exhibition better. As a matter of fact, they said, the ratio of storage and managing space to display area should be three to one. The other point was the height of museum rooms. One should be able to change the heights and the widths of the rooms at will. If possible, automatically. Skylight, daylight from the side, should not be excluded. All in all, an ideal museum would be changeable to any size and dimension, and the lighting, too. No one spoke about the paintings or the artist. Art was treated as abstract merchandise, either bought or bestowed. We were quite impressed by the story of the Cleveland Museum, as told by its architect. They are spending $7 million for an addition to their museum which will contain the most mechanized technical equipment for lighting, moving walls, and shifting exhibits. An attempt at pseudo automation to facilitate the exhibition maneuvers of museum directors.

The architect talking so casually about all this looked like a rancher. With the greatest of ease he drove herds of paintings and sculptures from one gallery to another like cattle. Artificial sunlight would filter in any direction through sky roofs, manhandled by a crew of museum mechanics above the glass ceiling. The service floor above the museum exhibitions was almost as high as the galleries themselves. There seemed to be enough equipment to transform this art museum, if necessary, into a plant for atom bombs.

When I came to speak, I found I could not. But I finally burst out: "We cannot consider art museums today an integral part of

life—I mean our daily life. None of us, and certainly not the population at large, has any compulsion about art, any inner necessity for it. The meaning of art has been lost. Art is not a ritual any more, it is an aesthetic subterfuge. The art museum everywhere today is often a tour de farce. In the best sense, museums have become oxygen tents of art. But we cannot live all the time in oxygen tents. It would be better, more honest, if we closed the museums and eventually gave all the art back to where it came from. But that would take a long time and require new international laws. In the meantime, we could disperse the works to community buildings and homes—large paintings to large homes, smaller paintings to smaller houses. And they should also be brought to the homes of the poor. We outsiders could then go and visit the paintings and sculptures of the memorable past and of our time in private homes, gardens, courtyards, rooftops and basements. What endless displays, and no cost of maintenance! We shall have tea with those who cherish them, talk about them, enjoy them, linger in the past, speak about the future and perhaps enjoy the present.

"As it is today, we force art upon the people under the disguise of education. Paintings, with captions, producing a conformity of judgment—without discrimination. Of course, I realize artists have to go on producing, architects have to go on building, art directors and museum directors have to go on managing and educating; and so we will continue and try to do the best we can under the circumstances. But we must not forget that the circumstances are not conducive either to the creation of art or to its natural distribution. Art and public live in an artificial relationship. The place of art in society should be as necessary as the sun is to chlorophyll. Art is not a matter of grafting."

I woke up from my talk to rousing applause. I was surprised, not having expected approval. When I slipped back into the dark aisle, a man stepped up to me and almost embraced me, saying, "You spoke from my heart. Thank you. I am the architect Belluschi." For a moment I was stunned. It was Belluschi I had wanted most to meet on this trip to Boston. Yet it was an anticlimax, because I had to run off to a lecture by Oppenheimer which I was most anxious to hear.

I found myself among thousands of worshipers in an enormous wooden auditorium waiting for the appearance of the martyr. He

came in, lean, relaxed, paying no attention to the clapping which rolled up the moment his figure was visible, trying at once to co-ordinate his lecture table, chair, blackboard. He spoke sparsely and his voice sounded as if it were coming from between book covers: "Kepler thought he had finally verified his theory; Einstein assumed the same. But science is infinite. Let's stick to small sections of it, for we are only a small particle of the world of truth."

Time

June 7, 1957

I don't know why, but I have always, always had the feeling that I have time. Time to go. Time to do. Time to be. That any time is just a beginning and that the real time to live, to give and to achieve is far ahead of me, and that I do not need to worry about it now. Why I have always had that feeling—even today at an age of over sixty—I can't explain. But the feeling is definite.

I only know now that I must stop postponing actions or decisions to execute ideas. I must act, and I must act at once, immediately. I feel that postponement is deadly by now. I have skipped and still skip so many chances, and I have learned that they don't come back.

I have been letting them go in life—every day, and in my work week by week—for thirty years. Why? Why have I that security of waiting and at the same time that lack of security to take the chance at once? Afraid to change any status quo?

This is the last sentence I wrote at 1 A.M. yesterday at Hans Richter's cottage, where I am staying over the weekend of June 7th.

Yes, I have come to see that I am extremely conservative about changing any of my life habits. To change a bed, a coat, even a dilapidated coat, relations to business people, whether old failures or new successes, friends and frenemies—it does not matter;

96

I don't want to change any sort of relationship, good or bad.

I think I am afraid to face new situations. To me, any old aspect of my environment (a toothbrush, an unfit drawing board, a mediocre earning position) is still preferable to a change. I am not so much opposed to a new chance as to giving up an old habit. Yes, that is the crux. I live within the armor of my old habits and cast it off only for creative moments when the naked truth must break forth. And then, back into the armor.

Somewhere I lack the courage to face the fact, the fact that an old relationship might be played out. I don't feel sorry for myself then, I feel confident that I can afford to hold on to the past because time is with me—as if standing still.

If I could give up, if I could face the death of a situation, I could have those new lives, or better lives and occupations, that I have naturally dreamed of and am dreaming of now, every day, every hour (in various directions). But I am not willing to give up the security of the past. I hold on to deadly situations. It is a lack of self-confidence, so it appears. Yet no one will say that I am not self-confident. On the contrary, people say that I am over-confident, aggressive.

I have built up an underground network of honest and dishonest habits, my true habitat, for the most part a world of falsely secure tradition. I feel that this security, based on right or wrong traditions, is in many ways a European attitude (opposed to change), and that it is healthy, at least it has vastly contributed to my "creative survival" (not only in America) and kept my ideas (and also my private life) clean (of compromises). Particularly in the long intervals of waiting, waiting. Eventually there always came the thrust forward, my foray out of the cave into the open, unafraid. And if I was successful most of the time in the arts, I never ventured forth with determination to thrust in everyday life situations: to conquer a position, a woman, a possession. I felt it was unimportant and corrupting. Whether right or wrong before, now it seems wrong, because I feel I have continuously lost contact with life and one half of my globe is an empty shell.

I have lonely mornings, lonely evenings and nights. I could break these spells, I feel, by taking some of the many chances that come by in my life. But I avoid them, still afraid of changing a present

status. The chances are open to me. I choke myself voluntarily, rather than free myself of false traditions. Strange. But it has given me the peace to work, and therefore to survive.

Conquering Nature

June 20, 1957

Yesterday, I saw a bullfight film called *Torero*. It contains footage showing the last bullfight of Manolete, the most famous matador. He was killed in this fight. We also saw the original newsreel of his funeral. All the balconies of Madrid were draped with black crepe. From them and from the rooftops, men and women threw garlands onto the passing cortege.

I wondered how it is possible that the killing of an animal should bring so much acclaim for the killer. I had a thought: There is hardly any difference between the appraisal of the skill of a bullfighter and of the skill of a painter or an architect or a writer. Man apparently needs to achieve self-assurance by realizing his power over nature. A painter conquers nature as much as a bullfighter conquers the bull. That is his heroism. The true reason for public acclaim of a torero is not the bloodthirstiness of the people in the arena. Those in the audience want to see nature dominated, for verification of their own being—and they get it in the majority of cases, through the artist as well as through the matador.

The Seed of Growth

June 24, 1957

The question of fenestration in a new building is not a matter of how it looks from the outside but chiefly how the light looks from the inside. Now, a great deal has been blubbered about inside and outside fenestration, and by now every high school kid knows that

architects try to make the garden come into the house and the house into the garden, which is most embarrassing for cats, because they can't find a fence to sit on.

Yesterday at Hans Richter's, we heard him tell about the very beginning of abstract film making in Berlin. The most interesting part of the discussion concerned who came first, Eggeling with his *Symphonie Diag'nale* or Richter with his *Rhythmus 21*, and in what way had film historians falsified the true story. It reminded me of the controversy as to who made the first cubist painting, Braque or Picasso.

Hans started from painting. His approach, he said, was the line as part of a surface, large or small. Eggeling remained within the line proper; the line as a flow, and the relationship of lines to each other as an expression of time flow. Hans Richter feels that his is an expression of space mutation, while Eggeling's is only a two-dimensional time expression (left to right, up and down, diagonal). Richter's goes into depth; moves in all directions.

The question of architecture and art and their interrelationship is not a question of putting them together, side by side, overlapping or underlying, but a question of inner growth. The seed for that growth cannot be bought at nurseries—it must be nursed inside oneself. To be able to do that, there must be a wealth of relationships experienced, absorbed, converted and, over a long period of time, condensed into seeds of belief. This belief—and nothing else—will make the vision grow. This belief spells the content of architecture; not the cubic content of a building.

The Flame of the Unknown Soldier

October 10, 1957

The unknown soldier of art lives underground and walks the skies.

I have only admiration for the artist who has not yet been handed his thirty pieces of silver, because he is a man who works his life long without counting on remuneration. Continuously, day by

day, year by year, without pay, he works, and hard work it is, because he not only works as a mechanic of high skill, but he is also emotionally involved to a degree which could easily make the average citizen tremble. And he buys raw materials, paints, brushes, canvas, is obliged to pay rent—all without having an income—and making relatively no complaint. He supplies the dealer with the finished picture, with frame and hook complete, and most of the time he donates one-third of the price to the dealer—if it is sold. There you have high merchandise which arrives at the market place without being paid for, most of it on consignment; if not sold, the work is returned to the artist, who stores it among others in dark corners of his studio until another chance calls for it and another chance lost returns it again. One can say he has the satisfaction of feeling like a martyr, but most of them do not feel that way at all. The artist has always rooted his work in a consciousness of duty to his own self, whether genius or talent. No blame, no fame for that. He is beyond good and evil. He is impractical and dedicated to the unknown. He is bound to it and eventually is its liberator. His only true possession next to his art, but without which his art would be impossible, is the security of independence—independence from social mechanics. Woe to the disturber of it, male or female. Neither the artist nor his work is truly wanted, collectively—not yet, after centuries and centuries of tries—no, not yet. He is the deadly enemy of fashion —although in the end he often creates it. His manners are unreliable, his friendships often obscure. Politically, he might be a risk, and financially he is a liability in most cases.

Yet he is the blindfolded seer who opens the eyes of the world, sooner or later. When thanks are due, he is usually gone.

October 28, 1957

The curtain went up today for two hours on a theater not yet built.

Virginia Whitehead, wife of the producer Robert, telephoned and asked me to come over as soon as I could. She told me that Burgess Meredith is leaving for Hollywood tomorrow and therefore this was the only day we could all meet to discuss a project.

Burgess' wife, also Virginia, and I met at Whitehead's office and, followed by four people from the office staff, we dashed to look

over Billy Rose's Golden Horseshoe. Only on the way was I told of the project, namely, the remodeling of the night club into an experimental theater. Virginia Meredith is good-looking, like a postgraduate student with dreamy eyes which do not suggest her astute nature. While everybody was measuring and tapping the walls of the night club, I invited her to fly with me to Rome, which she with good humor accepted, and we had a charming dialogue about it. Burgess finally tore me away and explained that he would like to transform the night club into an American version of a Japanese Kabuki theater. He tried, tried, tried to explain the Japanese stage to me but could not manage amidst the commotion—until I threw him the term for the main element of it, the peripheral stage. After an hour of play-acting theater architecture inside the night club, we went over to Sardi's for a bite. Robert Whitehead joined us there; in fifteen minutes, he and his wife had to leave for the opening of *Compulsion*. Within seconds, our table was swarming with actors and producers greeting Burgess Meredith, his Virginia and Robert and Virginia Whitehead. Finally Fritz Loewe, composer of *My Fair Lady*, stated that he too was leaving tomorrow for Hollywood. He and Burgess decided to change their tickets so they could fly together, while Burgess' wife would pilot her own plane later. Loewe offered Burgess a penthouse in Hollywood where he could stay after Loewe left; Burgess accepted with amazement at the easy solution of what had been a problem for him. The food came too late for Virginia Whitehead to eat; she and her husband dashed off, grabbing a bite of my broiled chicken liver and a sip of Burgess' chowder.

Burgess and I began discussing possible plays and authors for the coming theater, without which the best architecture would be useless. But, as so often in America, everything was being propelled impetuously, the result of a haphazard coincidence, so that the producers are ready to go ahead with a remodeling plan to be executed within six months, while there are no plays at hand to provide the very meaning and direction of the whole enterprise. I left for a dinner engagement uptown, with a feeling of joyful bewilderment.

Peggy Jackson and Lucia Wilcox came over to bring me names of rheumatologists. Both insisted that I must see their recommended doctor. I was very touched by their interest and loving care. Today a blood test was taken by my physician. In the evening I shall know the results. Tomorrow I will see specialist Cecil, who cured
101

Mrs. Murphy, whom I remember as a friend of Fernand Léger when he was in New York.

At my studio we have finished the preliminary plans for the Shrine of the Book to house the Dead Sea Scrolls in Jerusalem. The drawings are now being enlarged at the office uptown, while I am continuing to develop perspectives, vistas and various aspects of the proposed buildings. The date of my departure for Israel is awfully close, a week from this Thursday, and yet I don't have the feeling of being about to leave. Something is holding back my enthusiasm, and I don't know exactly what it is. It might be my rheumatic health or my unsettled private life. In the meantime, I already have answers to my letters to Italy—from Milton Gendel and Dorazio in Rome, Dorfles and Peresutti in Milan— who all expect me to stop over. Rooms in Paris have been reserved by my partner.

My designer is bringing me the perspective outline of the Palm Beach house, the project our office finished this past summer which was unexpectedly halted by the client. He is in Turkey, having donated a road between Iraq and Turkey costing many millions of dollars, and stopped the house planning to await a more exact budget from us. We expect his return any day now and decided to surprise him with a lively view of the interior of the house, as well as with an aerial view from ocean to swimming pool. Sometimes such colored perspectives (which I have always refused to do) can really sell a project to somebody who is not equipped to read blueprints and imagine the final result. In America this is a very standard office procedure. As a matter of fact, these perspectives even precede the plans, because the client is so eager to see how the house will look rather than to know how it will function.

Phoned Al Hirschfeld to thank him for the two tickets he sent me for Saroyan's new play, *The Cave Dwellers*. Saroyan is a rather embarrassing, bewitching talent. He is strong in his relations to people and the world, very much himself, but when he starts to transform his feelings into speeches, dialogues, and scenes, his inner strength vanishes and it becomes a play with philosophy and ethics dancing like fairy children around the Maypole of love. There is hardly any structure to carry all the networks of discussion. They float about like loose leaves fallen already from the

trees—or in the process of falling. The atmosphere has a smell of sweet decay.

Christmas Is Gone

Christmas is gone. Six days ago. I am at home working on the project for Jerusalem. For two months so much involved in it that I realize only now I have not mentioned it in my diary. My diary. My poor diary has left me or I have left it. So long we have been together. This moment of today seems like a reconciliation. Shall I recount what has happened in all these months or shall I go on and start with this very instant? I think it is that which I will do.

The past is not gone, never gone, it's seeping into your memory whether you like it or not; and if you like it or not, it will rise some day, either slowly, treacherously, or like a jet. So, the past will take care of itself. I take refuge in the present.

My partner is in Palm Beach over the holidays. Steffi is working at the public library as usual, Castelli and his wife are wrapped up in their new gallery. Herbert Mayer, Patricia Moore, Stella Yang are working at the gallery during work days, off on holidays and Sundays—but I seem never to quit work. I defy the calendar.

A new habit makes me extend the day over from midnight till four in the morning.

Coming home from my dinner engagement about 1 A.M., I settle at the desk in my bedroom. I turn two lamps on, one on my desk and one on the side table next to my bed. There seems to be an inner compulsion to turn the desk lamp on first, as I enter the room, and as the night progresses, I will eliminate the darkness around my bed by turning on the side lamp.

103

The whole space is filled with a warm glow. I am very much at home. I am very much at home with myself. I read stray books. I look over my work program and start making notes for the next day.

Gradually I arrive at doodling design thoughts. Details or total concepts I have not solved. It seems that my wandering about in this room, my casually turning the radio on and off, are only gears shifting to arrive at the moment where a design solution would seem to come to the fore (to my consciousness) and guide me, take my hand like a wise man a naïve child, but only to the moment where the pencil touches the empty paper of the pad; then I am left to myself. It is done gently. There is not the slightest command in it. Confidence is all that is given. I start to scribble, truly scribble. There is no intention or inner desire to produce draftsmanship. Yet I cannot say that it is automatic writing or designing. It is play—a deliberate playing with pencil and paper—and there is continuous reading of the gradually evolving designs. At the slightest hint of a solution, the stroke becomes faster and more determined, directive, and I leave the sketch at that. I deliberately detach myself from it, as soon as an answer is indicated. Not yet given. But indicated.

Strange; it seems I shun an ultimate solution. As a cat postpones the kill of the mouse. There is lust in his postponement.

2 P.M.
January 22, 1958

Heavy fog has settled around the skyscraper I am living in like a circular curtain, dropped out of the sky, reaching the earth, and isolating me.

When the day progressed toward noon the fog curtain became slightly transparent at mid-height and I could see two masts and two smokestacks of an outgoing ocean liner visible through a hole ripped in the fog bank, gliding slowly along the slit of the mist. What a dreamlike image! But it brought me back at once to my own isolation, and I wished that the vista of the open slit would close so that my solitude might be complete, and give me back the sense of being sheltered, though only by fog.

7 P.M., Saturday
January 25, 1958

Instead of going to dinner . . . There was a call, and a call it was; a call to work, and back to the theater. It was ten years ago,

exactly 1947, when the bugle sounded for Sartre's *No Exit*. Now it sounds for Pirandello's *Henry IV*. The Fourth, meaning (I have in the meantime read the play) neither the Fourth of England nor the Fourth of France, but both eventually, or none of them, or one of them—it was Henry the Fourth of Pirandello.

I phoned Lucy Kroll, onetime agent of John La Touche. I had glimpsed her at his opening parties but never talked with her alone, only in cocktail compounds. Nevertheless we seemed to have known each other. So I called her now to handle my prospective Broadway contract (Burgess Meredith was to play Henry IV). She took me on, but said bluntly that I must not expect her to get other scenic jobs for me; since I already had one, she would be glad to act as my agent in drawing up the contract. I asked for an appointment to discuss details, which she refused. "Honey," she said on the one-minute phone call, "we're both grown-up people, we don't need to visit. We can settle everything on the T." I was shocked. Here I was, bringing her a ready-made commission, and she would not see me! I was also disappointed, because I had hoped to find a Theater-Mama at last, now that I had a Broadway show to show off with, and I had been refused the warmth of a personal encounter although I was not a beggar but a giver.

The next day I called Cilla Caridba, whom I had often met socially and who has always assured me exuberantly of her esteem, however abstract. She was well equipped to handle me at the T (Theater) and F (Film) Agency. But she had no time to see me either, was too busy with the authors and producers of last night's opening. Having her home telephone number, I managed to visit her there. While listening to me enthusiastically, she fed her two dogs, took two telephone calls from California, refused to talk longer than three minutes to her mother, plugged in two electric heaters to warm us (in her greenhouse apartment) then finally plunked down a bottle of champagne for us from an open wine rack, a generous gesture which successfully cut off business talk once and for all. Then she had to dash off to a dinner engagement.

In the taxi we shared, she casually revealed her destination which, to my amazement, was the address of my latest rival. She dropped me off with a tra-la-la of goodbyes. As I closed the taxi door behind me, I saw a bottle of champagne (which must have been destined for her hostess) roll over into the void of my seat.

105

The following Monday I vainly waited for her call. I had left the incomplete union contracts with her. I was to visit her at the agency to be introduced to the new department head and finally be linked to Business. Two anxious days without a call from her! My secretary, who had worked in the theater years ago, told me of a good male agent, phoned him, handed me the receiver, and there I was in touch with a third promoter. Our talk was completely ephemeral.

In the meantime, to my astonishment, Lucy Kroll left message after message for me at home and in the office: the producer was eager to "sign." On the third day of waiting for Cilla to call, I decided to cancel my prospective affiliation with the T and F Agency. Lucy Kroll convinced me that our business could best be handled by telephone. I had to give up Mama if I wanted work. "Be practical, Kiesler," I thought I heard my friends shouting from all directions. And so I was.

Lucy fought staunchly for my rights, my fee: "You—design for minimum wages—never if I can help it! You have to get double —and a percentage from the profits, too." And so the contract specified.

The fifth day, and the sixth, Cilla called and left her telephone number, but I had already married somebody else.

For a scenic designer, business life is always intermissions. But once in a while, it's worth waiting for a chance to throw the dice.

I was fascinated by the theme of Henry IV, the mad king who believed himself to be living in another century. He had three lackeys who were garderobiers of specific costumes; visitors who desired to see him had to change into a dress of the century the king at the moment believed himself to be living in. And the interior of his castle had to be transformed accordingly.

For this purpose, I constructed a half-circle consisting of triangular columns which pivoted. Each column had one side painted to create an eleventh-century stone interior, another side white, the third side covered with black velvet. In this manner, the décor could be transformed from that of the original stone mansion to other styles by slide projection on the white surface, while, with the depthless absorption of the black velvet, *die Umnachtung*—

the night of madness—could be created. The columns could whirl and the mood change at eye-blinking speed.

I also had the stage floor elevated twenty degrees toward the back. Upstage right, a rectangle about two by three feet was cut out of the floor. Over it, I placed an old-fashioned trunk with its bottom removed. Underneath, on the real stage, were piles of costumes, stored according to centuries. When it was necessary to dress people up, the servants lifted the trunk top and a concealed stagehand passed up to them costume after costume, headgear after headgear, ten, twenty, fifty—a magic performance in the manner of prestidigitators.

The king's throne was an upright cave in which he hid. To the right of the throne, according to the play, there was a portrait of the contessa who was the king's love of twenty years before. I changed it to a sculpture of supernatural size. She was hollow and open in the back. Toward the end of the play, a psychoanalyst is called in by the contessa (who has returned) in a last effort to save the king's sick mind. For this purpose, he induces a shock by presenting the contessa's daughter, who is now the same age as her mother was when the king fell in love with her. While Pirandello prescribed a transparency trick with the portrait for this, I had the shell of the sculpture burst into hundreds of pieces, as if struck by lightning, revealing the young girl in repeated flashes of ice-white against the black velvet. The king turns and stabs the doctor to death. A cortege bears the body off stage; the contessa follows. The king, now aware of having committed a murder, ascends his cave-throne while the stage returns to an eleventh-century stone castle.

A spotlight strikes the king's face in the semi-darkness of time. Addressing his dead-silent servants, he declares: "I have not been insane for the last ten years. I have only pretended, so as to learn the truth about the members of my court."

Henry IV was played by Burgess Meredith. A well-known Italian actress, Alida Valli, was the contessa. And the daughter was played by Delphine Seyrig.

We opened in Philadelphia, and had the usual party afterward; we were not gay. We played there for one week. The production never reached New York. Thus, neither Lucy nor Cilla saw it.

Santa Maria della Salute, Venice

Italy

Piazza di San Marco, Venice

THEIR POWER IS NIGHTGREEN

Fiesole, Italy
May, 1961

the phalanx of cypresses flank to flank
closes the ranks torso-tight
an impenetrable wall
wings of leaves solidly pressed,
dense, intense
stolidly erect
and then again they live in separation
live a life of their own
so much their one and own
the world about is
only the steamy mist of
nature's battle
for existence

each cypress a corporate garden in one

a garden compressed from the vast
landscape of Italy

cypress after cypress pressing skyward
halberds piercing the bushy earth's skull
spearing
toward heaven
self-reliant
shelled-in strength

soldiers harnessed
in leaf monoliths
arrows rooted deep
shooting at the sky's target

pulse-beating chlorophyll
nourishing
the mandate of solitude
with unmitigated pride
magnets of cosmic will

111

Rome at Dawn

Rome,
October 13, 1959

Arrived in Rome six hours late, despite super-jet flight; semi-darkness at five in the morning. Taxi to Hotel Inghilterra through a ghost town emptied of every soul in the Pope's capital. We rode with such proverbial Roman rapidity that I kept my eyes closed, looking at my God inside, except for brief moments when I had to open them for a gasp of sight. And I saw that the plasticity of the city was gone. It seemed reduced to a world of stage sets without illumination—flat, as if painted in grisaille onto the void.

Only two hours before, we had been in the midst of a violent storm, our giant ship rocking like a baby canoe on the surface of a rebellious ocean. Catching glimpses through the window, I saw the even sea level of clouds, far below the peaceful, star-punc-

tured sky, suddenly transformed into monstrous mountain ranges and craters pierced by lightning every other second. I suddenly found myself floating above Himalayas of white foam, lit from beneath by a brilliant stage electrician shooting up his carbon spots at close range through the holes torn in the clouds. They soared to giant heights and seemed to be grabbing at the plane with jagged fangs. But we escaped.

In two turns, we passed the Piazza di Spagna and sneaked into the via Bocca di Leone, the homestretch for the Inghilterra. A naked bulb, the only light in this hollow street—the Mouth of the Lion—illuminated a lonely fountain. A tablet and, below it, a stone lion's head with water spouting from its mouth into a wall basin. No question that it dates from the time of horse riders and carriages. Now automobiles are parked around the fountain. What still survives of Roman glory is the sound of water, the wet cobblestone pavement and the rivulets creeping underneath the automobiles like elongated lizards looking for the canal.

My hotel room is a square cell, but with inlaid wood furniture: armoire, tiny table, chair and a chest of drawers in the Biedermeier style, which I would expect to find in Vienna, but not in Rome. A happy transference. The French doors leading to a narrow terrace have elaborate lace curtains over them. The glass of the doors is covered with solid wooden panels painted white. No light enters the room, and no air. The outside shutters are closed, too. I opened the curtains, door and outside shutters for a whiff before closing them for the night. The wooden blinds I hooked together a bit later on the expanded latch, and the opaque panels I left ajar so that some light and air might enter to announce the Roman dawn.

Cats are chasing each other now on antique tile roofs, and the noise of automobiles is constant, like the breakers of the sea. One wall of the room has a small nook whose walls are covered with glistening white tiles, but they are imitation ceramic plastic. I am astounded at this Americanization of a craft born and nourished here in the Mediterranean. From the middle of the recess protrudes a small white basin with star-shaped nickel faucets. A portable bidet of white enamel rests on a frail metal folding chair. I wonder how a hefty woman could thus be supported? Its shameful hollow is covered with a white towel, fringed.

The Roof Village of Rome

I stepped out at noon onto the balcony-terrace of my hotel room. I heard old-fashioned music, coming from a machine—in this singing land. Mixed with it, cascades of natural sound, voices rising, a flow of lustily moving sentences, echoing, disappearing, the sonorous Italian overtaken by mechanized wave lengths.

The family opposite assembles all day long on the roof: one very old lady who either knits or reads large newspapers, a middle-aged woman, an old man, and a healthy young woman who brings out chairs or takes them in. I have never seen them eating. It is a continuous siesta, interrupted by casual labor.

Why has nobody sung the song of the roofs of Rome?

Why only those of Paris?

Here is warmth, the heads of houses huddled together, chestnut and gray and rain-bleached: the grandeur of Rome made intimate.

Rome is not one but two towns. Or one city and one village. One on top of the other. Not in the Schliemann way, when you dig out one city underneath another, but two at once, one on the ground and one aloft.

Just as Rome's legend credits its birth to two brothers, Romulus and Remus, so I attribute its rebirth to two Romes. It is not Constantinople, the city of Constantine; it is not Petersburg, the burg of Peter the Great. It is born of twins.

It is two. One on the ground and one aloft.

The roof village of Rome has its soft hills and sharp ridges of burnt sienna or red-brown, beige-gray, pure ochre, mauve and cheek-rose tiles, roofs slanting up, sideways, downward; it has its valleys, steep and mellow; worlds of ledges, balconies, and wide and narrow riverbeds of terraces; banks and bulkheads of mansards, not coyly inclined with skylights or gasping dormers, as in

Paris, but honest gray cement walls improvised as sheltering homes for the low-income generation living on top of the massive stone world of old Rome.

Terraces with potted flowers and plants, meager but persistent; greenery not aimed to impress, like the Via Appia of Rome, with full-grown trees on parade, or the parks, vast pieces of nature preserved and dressed up; no, the roof-village greenery is born of its own free will, planted and growing with a sense of independence, giving poverty the charm of nonchalance compared with the formal luxury of the stories, avenues, and plazas below.

The village Rome looks today like an endless sea of roofs, rising and falling waves of terra cotta stretching as far as the eye can reach.

Suddenly, breaking through the hills of the roof village, I see a dome. The narrow canyons of streets and their wall embankments must have run into one another and formed a plaza, making a big gap in the roof crust. The dome of a rich neighbor, a relative of the Vatican, accepted with tolerance. Even the giant miter of Saint Peter's, which dominates all the roof villages of Rome, is accepted because it was built by the craftsmen of the mansards themselves, together with the street-level artisans.

The canyon walls are covered with rows and rows of mulatto-brown window shutters, closed or half-closed, some wide-open, through which you look into poverty-stricken chambers of darkness where a woman—either haggard or plump—bends down and mops the floor unceasingly, her arms vigorously moving the long handle of the mop like a piston, back and forth, back and forth.

The gray, monotonous street resounds from time to time with the rattle of automobiles moving rapidly, a procession of metal bugs. For these descendants of horse carriages, the streets are open-air stables, a result of that industrialization which runs against the grain of all craftsmen, especially here in the Mediterranean whose grandeur has been created by craftsmen.

But the street-ravine with its wrinkled walls of mildewed ochre, like an elderly lady properly *maquillée* to give us the pleasure

at least of faded beauty, knows the little automobiles at her feet are just passing intruders (like the crusaders) which the ages, not she, will deal with.

Blessed is her face!

Above, through the slit in the canyon, I see an airplane high aloft, like an initial of Time pressed against a milky sky. A *mene tekel*.

I have changed rooms. I am one floor higher up, on the top floor of this old hotel.

Truly Rome's sky village is another world from the penthouses and terraces of New York. Opposite and a little below the level of my room, I see a curtain hanging above the roof balustrade, a drapery formed by washing hung on a line, held up by old-fashioned wooden clothespins, blocking my neighborly view. The wash is transparently lit by a midday sun just behind it. From left to right hang: a pair of man's cocoa-colored woolen underwear, upside down, the ankles neatly turned over the cord and clamped; then a blue checkered tablecloth; next, a towel, horizontally striped in pink, red and thin stripes of purple; then an unidentifiable piece of white linen, very white; then a vertically striped table-cloth with wide streaks of orange and pale blue; then a man's undershirt with shoulder straps downward; another piece of white material, embroidered on its edges; and finally, a piece of the same cloth, torn, full of holes, but aggressively clean. Together these form a lovely proscenium curtain, *commedia dell' arte*, behind which a woman, who did not answer my *buon giorno*, is repeatedly touching the laundry pieces, stepping back and forth in tender observation.

In a dark corner of the terrace, under an improvised tin roof, a middle-aged man in an undershirt is shaving without a mirror, and at the same time watching me, a foreigner, a sudden neighbor accepted with good grace.

My corridor-terrace extends to the left and right of the shutter door, which I have now flung open; this tile street in the sky seems endless. All along it, cemented gray stone posts interrupt a long and simple iron fence. On each of these posts stand vases, burnt leather-brown, out of which grow stubby trees, meager but hardy. Yet they look festive, they display their simplicity with pride. It

is evident: these fifty or sixty glazed vases at regular intervals form an honor guard for something majestic that is long gone, a grandeur that is alive only in the hearts of this warm people. You willingly accept the reverence paid, and fall in line with humility.

The long row of terra-cotta guardians is visually commanded at one end by a square stone tower, in reality far away on a hilltop, with sumptuously arched umbrella trees hiding still another tower, whose aged tile roof forms a miniature pyramid. Both watch the honor guards frozen at attention.

Legions of sounds go by the guards: orations, the trotting of horses, hoarse automobile horns, coughing motorcycles, bellowing vendors and the screams of mating cats.

Yes, the cats!
Below the houses and above,
all the way through
indoors and outdoors
the silent room- and street- and roof-walkers
of Rome, Paris
and Jerusalem,
cats the only survivors
of our future moon-life.
Poor New York!
It has only pet cats.
Queens of the lap.

And I, fool, after three days in Rome, feel anguished and eager to fly back to Manhattan because I lack a woman companion with whom to inhale Rome's climate of time eternal.

The plane reservations back to New York had been made for to-morrow. But only two hours ago my nephew called from Vaduz, woebegone at my imminent departure. I canceled my reservation, postponing the return to New York in order to take a detour via Liechtenstein.

117

Lunch with G. Franchetti

Anguillara (near Rome)
Sunday, October 16, 1959

Lunch with Giorgio Franchetti (host), his sister Tatia, her American husband Cy Twombley, Bill de Kooning and Ruth, Mr. and Mrs. Windisch-Graetz, and Italian painter Afro.

Walking uphill through Sunday afternoon crowds promenading aimlessly on the edges of this hill town overlooking a lake, once a crater, now a floating mirror of the sky, we finally reached a terrace restaurant cooled by an awning of dense vine leaves, the labyrinth of many years' growth.

During lunch, when I lifted my head from the plates filled with standard *zuppa*, scaloppine and provolone, my eye fell again and again onto a narrow mountain street, closed by sunburnt roof pyramids of terra cotta perched on stone cubes of primitive shelters, a cluster apparently immobile since ages past.

The roof tiles were an extraordinary color. Covering their original hue of an aged red was the incessant growth of a fungus, blessing the tiles with a golden-green shimmer which was shockingly beautiful.

The potato-peel color of the house walls provided a counterpoint to this exhilarating flare-up. The town looked like an icon painted rose and brown on a golden-green background.

But what do I see under the overhang of one of those old stone roofs?

Perched on a corner is an open cage of angle irons painted black, footings for electrical wires, stuck ruthlessly into the cleavages of the stone setting! What a superimposition of machine progress upon these primitive dwellings.

In olden times, these ledges harbored nests of swallows, cups of earth and sand, the same material as the tiles above. But now the nest is an iron cage, and on the iron bars sit swallows of porcelain holding metal wires in their mouths, stretching them from house to house, serving electric bulbs in rooms which once were lit by candle.

Progress—invaders! Their advance can no longer be halted, it seems.

Vincible only by riders of further progress . . . and they by new hordes of newer progress. The Apocalypse of Progress rides the world, and the topmost mountain villages are not safe from iron nests. The Machu Picchu electrified.

God save the moon from man.

Rome
October 14, 1959

The Spanish Steps and stairs of the Piazza di Spagna would never have their sweep and grandeur without the contrasting obelisk suddenly raised in their midst with the two cupolas of the church high in the background. The obelisk like a hooknose planted between the two arches of the eyebrows. The grinning rows of teeth below provide the ascent to this face.

119

First Clash with the "Last Judgment" of Michelangelo

Sistine Chapel, The Vatican
October 17, 1959

I made it. Getting up at 11 A.M., after working as usual until 3 A.M., and arriving at the Vatican in the tiny car of friend Dorazio just before one o'clock, the last hour to be let in.

A year ago I came a few minutes after one, and it was too late. "Michelangelo has waited so long for me to see his work, let him wait another year," I said jokingly to my sorrowing companion. I went back today.

Surprise at the resemblance of the form of its huge fresco wall to the shape of the biblical tablets of the Ten Commandments held up by Moses on Mount Sinai.

Exactly the same double page, an open book, here at the Sistine Chapel.

The wrath of Christ admonishing the praying mantises in front. Gestures of deep scorn like those of Moses repeated in the person of Christ. No more is He the forgiver, but the punisher.

Michelangelo—all content and all form. Content: anecdotes of folklore given universal meaning. Concretized. Every stroke a blow on the cheek of heaven, on the jaws of the earth, and under the belt of hell.

The wrestling and boxing matches which go on in the arena of the giant altar wall of "The Last Judgment" are all I expected from the fight promoter Michelangelo. No bribery in these bouts. The massacre is real.

Against all rules of the religious game, to conquer the flock by timidity and nonresistance, Christ appears as an athlete, a physical giant with the striking power of lightning. There will be no recourse. A verdict without trial. No hit and miss, only blow after blow.

The two horizontal strips of frescoes, into which each of the other three walls is divided, have nothing to do with the composition of this wall facing you. They are standbys. The Greek chorus translated into frescoes.

The upper strip is segmented into panels of paintings by Ghirlandaio and Perugino (I am told). Blows by shadowboxers compared with Michelangelo's approach to art, religion and architecture; he hits hard and, if necessary, creates his own opponent himself.

The lower strips, running along the side walls, are a *trompe-l'œil* curtain imitating the folds of draped brocade, a masterful surrealist fresco framing the center wall of "The Last Judgment." Guards of unassuming devotion. Transfixed bleachers.

The ceiling lunettes by Michelangelo are disappointing. The scale of the figures and of biblical groups is not convincingly coordinated with the architecture. Particularly Jonathan (I think that's his name) is much too large in shape, and loses all relationship with the rest of the ceiling panels. No sir. This wideswinging punch missed the target.

But the centerpiece, Michelangelo's "Last Judgment," is still the last word in composition and in abstraction of color. Search old art or modern, figurative or non-objective, there is no equal. It's a direct hit. A knockout in the first round.

121

The turbulence of "The Last Judgment," in its abstract dynamics, reminds me of Jackson Pollock, whose despair in dealing with this world found the same eternal expression. But no one has yet appeared to challenge Michelangelo's unification of realism and abstraction.

The challenge stands.

Raphael's *stanze* in the Vatican prove that he was a designer who colored.

Michelangelo is a space-man, even on a flat wall.

The colors of Raphael are manifold; Michelangelo is a *modeleur* in gray and brown, indifferent to *maquillage* in color, bent on drama, space and architecture.

Raphael—decorator; Michelangelo—space-computer.

I walked out, the last of the visiting crowd, almost forcibly expelled.

Marching through the corridors of the Vatican toward the exit, I was followed by a multitude of black-coated guards gently pushing me ahead. They were all glad their hour of siesta had come. My day had only started. The hatless cortege followed me diligently, en masse, like a funeral procession. After ten minutes, they made a turn and disappeared through a miniature door.

Companion Dorazio and I tiptoed respectfully over early Christian mosaics, all the way through the high-arched corridors, until daylight set us on our solid heels.

An hour later I left for Zurich.

Assisi Reborn

Assisi
July 3, 1960

Assisi, atop the ridge of a young mountain isolated among grown-ups, lifts itself up to a veritable cone and sticks out of the plain below like a dunce cap.

At first sight, Assisi is an apparition, a far-off hope, a phantom composed of reveries about St. Francis, architecture, and, of course, Giotto.

At a distance, the hill town looks like a sepia print, brown-on-brown, monotone: the earthen hills, the rocky houses, the walnut-brown tiles.

Assisi, seen from the road across the flat land, appears like a vision of Assisi. You have heard so much about it from travelers, read so much in books; now it is a reality so real that you are doubtful if it is a vision or truth.

Assisi was born for us, for no one else, for us three in the little Fiat car, model 1100. Whoever has seen it before was only a fly-by-night, a passer-by, a tourist with the finger of a doubting Thomas on the page of his guidebook. We, we three, Alice, Lillian and I, are the ones Assisi has been waiting for.

We are silent inside the hut of the Fiat. The expectation is too great; we prepare ourselves with muteness. All we know about it falls away like scales. We must be pure, unassuming, worthy of the moment of meeting.

Assisi assassinated by art historians, headline hunters, weekend marauders! We are sure it will be resurrected by us.

Assisi awaits us. Six hundred years is a long time. The town is following our car, looking for us as we wind our way along the valley road. Our silent expectation is near the breaking point.

Assisi vanishes for minutes; when the road bends it is lost, but reappears, thank God, with ever-mounting reality.

The hill town pulls our car up with the magnets of its stone-cube houses, growing denser and denser in power and cascading higher and higher until we reach the apex of the cone which finally carries the square tower of the Church of Saint Francis on its ridge.

We enter a court, and are surrounded by two cloistered colonnades and by the vast façades of the church proper, a conglomeration of masses of stone and marble. As we step through the portal, the vision is now transformed into the actual space of the interior of the church, which we enter with reverence.

We know there have been many painters who executed frescoes in the three sanctuaries from the beginning of the thirteenth century, to the end of the fourteenth century, such masters as: Cimabue, Torriti, Rusuti, Martini, Pietro and Ambrogio Lorenzetti, and the anonymous "Master of Saint Francis." But their work appears in their devotion to the legends they portray rather sentimental and embellished to decoration. Giotto is the only one who has unmitigated strength in his humble dedication and never weakens in his forceful craftsmanship. This is the benediction of a chosen one.

The center of the church floor is empty of pews. She opens for us the space with outspread arms. Only among the two nave walls run high-back benches—deep-brown wood, glossy-varnished. From one end of this overlong expanse, daylight floods in through an open portal but does not reach far inside. The sun stands high, and to the west.

Looking out of the door into the hill town, the eye meets a blazing image of craftsmanship, man fighting nature, conquering with perseverance through hundreds of years, building relentlessly, hand to hand, stone upon stone, wall along wall, creating a man-built perspective pointing its rising diagonals directly to heaven. The buildings meander below tile roofs, forming terrace upon terrace, their horizontal rim underlining the ascent, against the

sky. Some bend around rock formations steeper than buttresses, supporting towers of stone blocks occasionally comforted by olive trees and cypresses.

Inside the half-darkened nave, the much too high ceiling displays the Giotto azure-blue, in many places fallen off, revealing lakes and puddles of cerulean turquoise, apparently an underpaint of former restorations, exposing a destruction which fortunately has not reached—and will not for a long time to come—the frescoes by Giotto. On the two walls of its main nave, the church carries the three horizontal rows of frescoes, one flat strip of paintings above the other, these strips divided into square panels of imagery, separated by bands of painted architectural pilasters, friezes illustrating the life and death of Jesus and St. Francis, and three allegories interpreting and glorifying the vows of poverty, chastity and obedience.

It is, of course, impossible to describe painting in words (it is easier to summarize words in painting), and anybody who tries to make prose out of brush strokes is banalizing both crafts. If, as in the case of Giotto, architecture and sculpture enter the vision also, so much the more complicated is the task of interpretation. Indeed, it is as hopeless as a final language of death or love; they are here, and here to stay even after we are gone. Language is altogether the most superficial method to describe the multi-life organism of art, a most deceptive blabber with regard to the ultimacy and intimacy of human emotions, which are a well of infinite depth nourished by a plenitude of sources impossible to detect, dissect, and put together again. We can come nearer the truth only by *not* defining it while defying imitation in all its aspects.

I quote an old Chinese poem
of Su Tung-p'o:

He who judges pictures by the likeness of shapes,
Must be thought of as a child;
He who hammers out verse by rule,
Shows that he is not yet a poet.
Poetry and painting are rooted
in the same law,
The work of heaven and of the first cause.

Even the most direct experience of a painting can result only from an indirect communication; that is, a wireless contact where sender and receiver connect by the same wave length, and not by pre-set hard lines. The way we are taught to understand art is to tie art and observer together with ropes of heavy or light reading lines, yet as soon as the memory book is closed, the ties are gone, we face the object of our interest with empty minds and empty hearts unless we have freed ourselves of prejudice. Nevertheless this is our age of 1960, and we are limited to the schizophrenia of the purely visual and oral methods of communication. Any book reminds me of a herbarium, which is a bound assemblage of flat pages onto which three-dimensional, living, scenting flowers, leaves and capillary stems are pressed flat, dried out and preserved like mummies, their multi-dimensional emanations destroyed. That is how I feel about the printed word, which derives from a three- or four-dimensional experience of the full expression of the human being when he tries to communicate and to contact his fellow man. That's gone, just as pre-history and the Socratic relations and the relationships of man to man are gone. It is important to know less, fully and deeply, in spite of mass production by technological communication methods which will promote the further split-up of the encyclopedic knowledge day by day scanning the surface of events, outer and inner. Aquinas documented that neither Socrates nor the Lord transmitted their teachings in writing, simply because the kind of interplay between humans is not possible by means of writing. As J. C. Carothers says, "Whereas the Western child is early introduced to building blocks, keys in locks, water taps, and a multiplicity of items and events which constrain him to think in terms of spatiotemporal relations and mechanical causation, the African child receives instead an education which depends much more exclusively on the spoken word and which is relatively highly charged with drama and emotion . . . I suggest that it was only when the written, and still more the printed, word appeared on the scene that the stage was set for words to lose their magic powers and vulnerabilities. . . ."

But being caught within the spikes of our flattened world I have no other way but to still use the printed word—because mute communication, which would go far beyond the prehistorical ritualistic language, is not here yet. And we are still forced to walk Gutenberg's carpets of types and letters, which we feel everywhere under our feet and must tread in order to proceed in our daily

activities. I am guilty of accepting this method of communication, although at heart I am deeply opposed to it. Speed and depth are mutually exclusive. What a loss not to look into the face of our speaking companions, absorbing their expressions, the rise and fall of the words, the intervals without words but full of meaning—we just have to wait and wait.

I will therefore not attempt to explain Giotto's particular approach to art or to religious painting, because if I did, I would have to say that he is anti-art and anti-religion. He is, as far as art and religion are concerned, a simple storyteller and a forthright believer. He does not sell anything, neither art nor religion. Yet, his work certainly carries the blessing of art and the blessing of religion. To explain this contradiction would mean explaining the causes of magnetism, or the imagination. It is there, but you can't find it with a Geiger counter.

Giotto treats people like architecture and architecture like people. He is a tripartite artist. He is painter, architect and sculptor all in one. A subject, be it a person, a tree, a garment, a house, is executed according to the tools available; it is painting, architecture, sculpture, all in one, a tri-unity.

With Michelangelo, who is also a tripartite artist, it is different; his paintings are in fact transposed sculptures. Michelangelo's painting is ersatz stone and marble. He couldn't get enough orders for sculpture; his thirst for creating human configurations could not be satisfied in three dimensions, so he painted them. "The Last Judgment" in the Sistine Chapel is really nothing but a blueprint for 367 sculptures.

While Michelangelo's triple talent is focused in sculpture, Giotto's is focused in painting, with the qualification, and an important one, that he does not substitute any part of the tri-unity for the other, but integrates them insolubly. That Giotto's mountains are veritable sculptured architecture is understandable because they lend themselves to that form by their very nature as hard-molded, dense-edged materials with their horizontal stratification, vertically or diagonally ascending blocks of rocks. And each garment worn in his paintings is seized by him as an opportunity for sculpturing in such a free-flowing architectural formation that an article of clothing appears like a building consisting of columns, pediments, steps, arches, walls, niches, friezes and pilasters.

127

He abstracts from nature so masterfully, even in such details as the folds of a priest's vestments, of the women's robes, that form is condensed into an even greater reality than nature itself. Figures and garb appear almost as solid columns. The borderline of human scale is shifted and fixed; vision and insight create a realism beyond nature's depth and space. The genius of the artist triumphs over nature as well as over traditions.

It is astounding, to say the least, yet, these forms are not expatriates from sculpture on a flat surface. They do not fake illusion of shape, or imitate three-dimensionality. They have a plastic reality of their own. Be it the rhythm of the cloak-folds or any other object, the front, side or back views become part of the total architecture of the image expressed in plastic terms. Individually, or in relation to one another, they are in the total picture what sentences are in a drama.

For Giotto's pictures are a stage—each of them. The frame is the proscenium. Yet, we don't look through the arch at a *commedia dell' arte* but the *Divina Commedia.*

The Latin temperament of this Tuscan imbues his protagonists, his chorus, earthly or heavenly creatures, with movements and gestures which, in his paintings, become pantomimic expressions (of the human body), with an animation far from routine or mechanical. Their vitality evidently comes from within, despite the fact that Giotto's cast is drawn from dogmatic church rituals. His knowledge of measure is so strict that none of the acting ever overflows the cup of human dignity. Even the perfectionist Raphael, compared to Giotto, appears to be a stage director of amateur actors whose movements are the poses struck by stars and starlets.

Giotto never preaches, he reaches. He reaches you with naked facts, and these facts are offered with bare hands. No one else in the history of painting, up to our own time, has been able to achieve such an impact on the observer, not even during the Renaissance with all its grand-opera acting and full orchestration of pictorial, architectural or sculptural effects.

It is evident that Giotto possessed the secret of speaking silence. (Cezanne attempted it, Mondrian, too.) He also perfected methods of enacting it. One of his main discoveries was the plastic and psychological meaning of distance. Distance as space-

tension all around a solid body. He isolated all his figures, groups, mountains, animals, trees. He compacted them into distinct units, no matter how small or large, and related these particles to the total organization of the picture, just as heavenly bodies relate themselves (by their inner power) to specific galaxies, in spite of distances far off or too near. They breathe correlation, and we become part of these galaxies, drawn in by the magnetism of Giotto's great instinct. The intervals in his compositions are just as important as the forms struck. To hold an interval, long or short, is the question. Giotto knew the answer. No one else could time space as he did. His is not the physical strength of Michelangelo. He is an untouchable. This untouchable touches us deeply because his humility is never lost in the plasticity of his painting hard reality.

Giotto dwells inside the church. He is both guest and master of the interior. Saint Francis surrendered the key to him in the form of a ceremonial brush.

What seems to me so very characteristic of Giotto is the plasticity of everything he paints. Not an attempt, as is so often assumed, at three-dimensional perspective, but rather a relief of forms against the flat background of a blue sky. Giotto is unique as an artist of the period because of his persistent relief-modeling of figures, of rocks and of buildings in an "emotional" perspective which is "isometric." The lines of his composition do not converge, they diverge. The perspective is more of a dispersion than a construction of side lines. There is no pictorial focal point; the picture is decentralized. What makes it a total image is that the happenings of the story, which occur at different times, are here presented simultaneously. Now, that is an old-time procedure of medieval illuminators, and Giotto follows tradition strictly here. This tradition is part of a brotherhood stretching across to Asia, where the Chinese painters, illuminators and scroll rollers did the same.

Giotto transposes the methods of the incunabula, that is, of the Middle Ages' illustrated holy script, from manuscript onto the walls, from pen to brush, and from parchment to cement. He was not the inventor of cartoon tales, but he raised illustration to the immaculate conception of art.

A characteristic of this tradition is the disproportioning of the natural dimensions of people in relation to mountains, of trees to

131

architecture, of angels to animals, which is an important basis for his imagery.

What makes him even more individual as an indulger in and, at the same time, progressor in medieval tradition is his version of the human face, going further here than retinal three-dimensional perception.

Granted his plastic planning of a picture, the relief of the human head or any part which emerges naked, is painted with specific tenderness, particularly in the chiaroscuro where the shadows merge into light and light into its shadow. The total composition is modeled into a unique "compressed flatness," each part of which appears to us of the twentieth century almost like a photomontage. Even the color of the flesh is transposed, more neutral, not like nature—not pink-peach—but almost monotone, pale and hazy as if only caressed by the currents of the brush.

There is holiness in Giotto's respect for the nakedness of truth; a humane dedication, producing a slow movement over each painting, no matter what violence is portrayed: flying visions of monsters, tumbling architecture, rebelling angels and all the dynamic gestures of Latin lands, those mimed discourses between heaven and earth, between man and man, and man and woman —as in the "Touch Me Not"—between man and beasts, and priests and birds; there is always Giotto's conversion of agitation to peace. Only the eyes remain immobile, in fixed position, guarding the independence of their vision.

The church is built twice underground and once above. Like the roots of a monumental tree, the basilica below spreads wide each of its crossed arches, bending its vaulted curves, low and solid like the shoulders of a kneeling giant.

The basilica is superimposed upon the crypt, whose square central tower encases the sarcophagus containing the remains of St. Francis.

And above these two sanctuaries, upon the earth, on the level of the people's dwellings, rises the cathedral proper, a magnificent fortification of arches, towers, and columns. An inverse building-up of the three shrines, one upon the other, not with a wide base first, but on the contrary, the narrow crypt first, then the wider shoulders of the basilica, and finally the big cross in space of the ultimate Church of St. Francis.

Epilogue I

The total bulk of St. Francis' Sanctuaries
rises like a pyramid, upside down, from a toe point
spreading its arms wide
wider
and
wider
ever-ready to embrace
the promised heaven.
Or hell.

A life devoted to chastity, poverty and obedience
is impervious
to earthly concepts of suffering.

What validity, if any, have his postulates today? What are the assessments of Francis of Assisi's assets now? Are they old hat, just hates of prosperities of past centuries, relics of mysteries of old religions? I want to know the motives of my actions, of my forays and retreats, my indifferences. I want to find an alphabet for deciphering the unknown. What is the bread of life, if I am the knife?

What force is the yeast that makes it grow and give food to the hungry? Everyone has the spark of creativity. Man has to stop being an object, he must become an objective by insisting on his freedom of choice.

133

It is that urge that life has to satisfy, otherwise futility is brutal in its persistence.

The phenomenon of art is the inventor of a reality which we don't find in nature. It is the only road to truth with the sensuousness of life. There is no yes or no. It is. Accept the term "art" or not; old-fashioned, debased, nevertheless it grows out of that extra-sensory perception now in disgrace with magicians of our daily mechanics. It is the constant link between the Known and the Unknown. It grows out of an inborn instinct, unites with the intellect, and creates the directives for a man-made world. A marriage of mutations. The gulps of milk presuppose the hot rod of the steer, the milk nourishes my blood and the blood feeds the energies of my brain. The evolving dream is as practical as the excrement of the bread eaten and digested. The dynamisms of diverse entities lose their identity when they integrate or disintegrate. They are equal in power to the flow of life and death. How shallow are terms, words, compared to the instantaneous fourth-dimensionality of instinct, gradually being reduced by our limited sensory perceptions of a three-dimensionality to two dimensions, and finally to a flat calligraphy of writing or the stroke of a brush, to the one-dimensionality which naturally fails the grip of physical reality. It is not the measure of depth that we are seeking, but the stenogram of the surface.

I shall never accept the effigies
of a life on the surface, instead
of a life born of infinity and
sustained by our creative imprint.

——————— ———————

Scientists do not need to assure us of immortality, sooner or later it will be a fact.

Man's imagination is faster, more precise, more pinpointed, than the experience of calculus. "Excursions into pure mathematical fancy, although they seem hopelessly impractical, have an odd way of running ahead of physical science, of supplying equations that fit the facts before science stumbles on facts that fit the equations." "They are formulators of possibilities rather than discoverers of truth. The license imparted by this 'art-for-art's-

sake' outlook has resulted in a prodigal inventiveness. Like the hordes of horses of some fabulous khan, today's mathematicians have ridden off in all directions at once, conquering faster than they can send messages home." Man's home is forever the inside.

The only question we still have to face is: What is the purpose of life? What is its content? Because "that bit" of information is not given to us, we have to invent it.

Man's greatest invention has been constant since the beginning of time: the idea of immortality. However, no man can evolve an idea which isn't concocted by the forces of the universe itself and is put into us as computers of human visions. Because we are made of the same stuff the cosmos is made of. We are only one of those infinitesimal particles of a totality unknown to us, but sensed with certainty. Unless we resist wisely, we are only instruments of a cosmic will, disguised with the sweet icing of progress. The issue which is provided for us as individuals goes only as far as the carpet on which the toys are laid out for us to play with. But beyond the carpet remains the abyss of torment; the eternal "law of uncertainty."

"When sick people facing imminent death will be frozen and sent into space, computers will keep track of their orbits and bring them back once a cure is found for their illnesses." "Farms will breed special monkeys whose hearts, lungs, limbs, livers, kidneys and eyes will be used for quick transplantation to human beings." "Man's life span will be increased so much that immortality will be seriously discussed."

The scientist, however, does not tell us how often we will be able to die after being revived—once, twice? How often can we survive ourselves?

Will we be able to decree the End, or will that too be regulated by computers? Will our disobedience cause the nervous breakdown of all the cyclop-cyclotrons, betatrons, synchrotrons, and the collapse of the IBM brain-busters? Can we look forward to a time when we will be free again for ceremonial burial in the image of the Aztecs' Tezcatlipoca or of Christ's Francis of Assisi?

135

Embraced by the torso of the crypt,
scanning the ribs of the arches,
I felt suddenly frozen to a standstill
as though I had turned into a signpost,
immobile.
A fascinating inward urge started with
ultimate determination
it hypnotized and forced me to look into myself
I was compelled to
seek
my own star
sucked into a world which I can only call
the universe of myself
I was knotted with fire and hail.
But the tensions ultimately loosened and
fearlessness made its triumphant entry.
It filled me with what seemed immortal strength
to do the deeds I never dared to do.
My release from the fears of my past
was freedom itself.

The turbulence of pitch-black infinities,
circular spaces filled with dense charcoal grays
still gyrated incessantly in all directions
until, so very unexpectedly,
faint white formations
of cirrus clouds appeared
and moved silently across the spaces.
They grew longer and longer, softer and softer
until my own universe, so dark before,
was filled with a luminous
white glow.
I realized that these clouds must have been
the hands of a Goddess extended in tender sympathy.
All imagery vanished
like a child's prenatal memory.
I became myself, all burdens were lifted.
My heart and shoulders felt weightless.
I started first to see
the world around me
as I used to see it,

that is through the filters of my two retinae,
but now I had retained a different vision of the world
around and in me.
I perceived differently.
Every detail seemed to be bound to a wider world,
a world of infinite links.
Bound to links.
Links after links, Links and links and links . . .
What are they? How do they hold me
and the world together? Magnetic rings?
Or arrows shot through space, piercing everything
without pain?
Are they locks whose keys are invisible to man?
Or waves
thrown at you by natural forces,
whenever they feel like it,
to embalm you and then go on
to other plays in infinite space?
Now, it seems to me
we live a life of links,
a life of infinite links.
All and everything bound together.
There is no escape from this prison of cosmic love.

Are we trying to revolt against it?
Is the idea of independence to
tear these links apart
and live a life all by oneself
using only those links which one likes
at the moment—the rest is frippery.
The dream is:
Superman, Superwoman, extraterritorial.
But the fact that everyone of us
must die remains a revelation, after
youth has blossomed and the leaves have started
to wilt at the rim of roses.
Immobile trees, flying animals, walking mortals
all must die,
must,
mountains, too, waters and smoke. Everything, everywhere.

All fauna, flora, all humans will labor
to feed themselves day by day to stay alive
and procreate, packaged in love,
to please nature;
sleep night after night
to recharge the mind for the
blindfolded struggle of survival.
What is the goal?

Can anyone deny these facts and still
believe that man can be
immune, independent
of cosmic laws and their social derivatives,
remain a citizen of robust physical
quality and mental power, fight nature,
his fellow citizen,
realize creative ideas, the conquest of the unknown,
and remain a one-man world?
Chastity
Poverty
Obedience
Indeed a splendid answer of St. Francis
to the dilemma of an existence between fiction and fact.

What strikes us most in these postulates is:
poverty.

Is poverty the aim of our life? Could that be what is meant?
No. Not poverty by neglect, for the whole
globe would then consist
of nothing but beggars,
hungry and pestilential.
It is poverty by choice, and means a way of living
in unison with whatever changes occur
by environmental forces
and without the intent to profiteer beyond
the balance of one's own needs.

Poverty is the wisdom of self-restriction.
Yes, to limit our idea of profit is
the basis of chastity and obedience.

Poverty, peace and the enjoyment
of every crumb of life, wherever we find it,
not the obsession with possessions,
are the heart of being oneself:
continuously to conquer one's own wilderness.

We respect the achievement of science, the soaring
of the human mind
to incredible configurations
which research captures, models and pulls down to earth
for the comfort
of us poor earthworms
in our physical disasters.
We know about
building knowledge layer upon layer—
a universe of science:
but
there is something
in the energy structure of this world
beyond test tubes
or testicle testimonials
of psychologists—:
there are new worlds of correlation to be discovered
living far more than we imagine,
since ages past, *beyond* and *near* us,
which no radar screen can detect
and no electronic microscope
can see
but which are the very causes
that trigger anguish and despair
or concordance and harmony.
Though most of these will-particles exist
for no more than a fraction of a second
and some combinations known as
"resonances" live for no longer than
a hundred-thousandth of a
fraction
of a second,
their force is powerful enough
to hold us together
and control
the expansion or death
of our lives.

The awareness of it can teach us to take life and death
equally into our daily strife:
the yin and yang
of fate.

——————— ———————

Let us be serious for a moment:
shall we not divert the massive investments of private and
government laboratories including the cute projects
for outer-space vacationing
and concentrate
for one, two, or so-many years to beat
the massacre by ailments, whose tradition has ingrown
so deeply to sorrows of isolation . . . to the
beat of regimentation . . . to the hopelessness
of secret ills
ruthlessly undermining our body's life?
The doctors dance the can-can-cancer of death
with frou-frou cobalt rays,
knowing that the iron curtain
must fall.
Then after their standard routine is performed
they can go home
to the fizzes of television to forget.

In the morning they'll dictate their bills
to the dying patients
and pin the figures on the cross of
the blue shield.

How much liquor
did you consume St. Francis
to forget these cataclysms, and how much
cash did you leave in your savings account
for the safety
from death of your fellow man.

Poor medicos! who blame
their failure to save on the researchers,
and the researchers blame the
resistance by the Unknown.

Fate and failure in illicit marriage.

Indeed we cannot delay
any more, it is the last chance
to justify hopes of time past and present.
The many layers camouflaging lies and truth
must be torn
from our faces one by one.

Surely we are not so naïve as to believe that the
solution for any of these ills can be determined
at will, but what is more important than the
annihilation of these plagues
is the moral incentive that would be gained
by abandoning
a concept of life which is the
madness
of doing, doing, doing . . .
but nothing in depth.

What a hallelujah that will be!
All nations, the blacks,
whites, pinks and yellows,
will finally agree to
pool their resources, gold and silver,
and all the ores of their energies
to dedicate themselves
to the final solution of these miseries
and vow to stay with it until
it is achieved.
This is the spirit of St. Francis.

One day soon we shall put health before war and
sanity before destruction!
Scientists have all the power
to face such an issue
with knowledge and deep ethics!

(The governments can pilot their researches on a
lower scale harmlessly.
Let's not worry about it.)
Our moon has been lingering and waiting
a long time
for weekend visitors.

She won't mind waiting a few more years.
She can beautify herself
in the meantime
and become as coquettish as a white-powdered circus clown.

——————— ———————

Let's strike past the breaking point:
do we really think
that all the accumulations of nuclear science
throughout the hemispheres of the Eastern
and Western worlds
are meant only for the
benefit of a peaceful humanity
or are they actually schemed for the annihilation
of enemies, known and unknown,
but finally boomeranging
to destroy us, lock, stock, flesh and bones?

Does our intelligence not tell us
that the very goal of these weapons
is not simply
restricted to this earth?
We can easily agree that wherever our conquering paths will be
crossing wide and wilder cosmos,
the avant-garde of science and technology
will already be waiting for us
with the grin of their deadly capsules in fixed position
ready for the kill.

——————— ———————

Reckless progress reveals one of the incarnations of the devil. It is the devil who should have been crucified—not Christ—without resurrection; and we can still do it before it is too late; that is, before he takes over not only this earth but all of outer space. What are we waiting for?

——————— ———————

Confess, you and I, we all are caught in the
middle of this squeeze
between the Lilliputs of science and the golems of technology.

We are breathing heavily in
the oxygen tent of our civilization.
What are you, citizens of the world, doing about it?
What am I?
Damn it.

Epilogue II

Think, my fellow artists, think of how many have dipped brushes in pots and pans and palettes to outdo one another since the fifteenth century. Count them, take a good guess, and name me a round figure of brushes that have been used. One million? A billion, perhaps.

And think what a variety of brushes have been invented, some sharp as needle points, some cut off flat like a spatula—and don't forget the tubular ones, circular and ovoid, inflated and bony, all tamed horsehair, wild sable, camel's hair or bristles of porcupine, an arsenal of weapons for you to outdo one another with! But none outdid, outpointed, out-techniqued, out-timed Michelangelo.

He was only an amateur painter. You and I, professionals, have been mixing color-dusts with oils, yolks of eggs, albumens, cracking shell after shell, squeezing fruits and herbs, grinding them away in circular movements, going round and round, forward and in reverse, to bind together reluctant morsels of powder with fluids into plastic pastes of paint, to withstand the nagging of time and gnawing of weather and the wear and tear of manhandling, all without producing something more durable—and enduring—than "The Last Judgment." Da Vinci's "Last Supper" did not hold water; it leaked. Its technique—its durability—lacked the enduring quality of Michelangelo's fresco.

And a last word on "The Last Judgment," confronting myself:

Yes, he was only an amateur painter, an amateur compared even with himself (a master sculptor) and with all of those pros before and after who tickled and still tickle canvases through the centuries, including our own Century of the Sciences, which has given us pre-manufactured color, no longer hand-rubbed but honest-to-profit machine-made, produced with ultra-pliability, glistening softness, fast or slow drying, full, matte or semi-glossy, ever-ready at a slight squeeze, meandering excrement from a pregnant tube—yet with all those paints at our disposal, and all the refinements of the brush, we have not produced a single painting comparable in mastery of technique and expression to "The Last Judgment."

Friends of the Cedar Bar, surrender.

Epilogue III

The Correalism of Nature

We must abandon the purely
historical and archeological method of
discovered and dug-out truth, a documentation
of facts rather than of an evolution of
intrinsic values. Thus our reasoning
is based on unrelated events of a scattered past
to explain the present.
We are making the catastrophic error of
basing our wisdom on a past, its facts
questionable indeed, while in truth
the present is a marriage of the nuclei
of the bearers of the past and the
standards of the future, simply because
no future can evolve that has not its real roots
in the values of the past (no matter how far apast).
We work with myths of facts instead of
with facts of a myth.

144

Events and memory of events are
continually transformed by the present
to procreate the future. This is the
correalism of nature, and it is
a pluralistic genesis. And it is not
a monotheistic configuration but a unity
of a constantly changing diversity.

The purpose is to live a
realism which is not only corporeal,
matter and energy in exchange,
but a realism of the continuous flow
of inborn life-forces
into which we must throw ourselves,
swimming along with the tide, against the tide,
drawing power and lust
carried by the buoyancy of
merciless waves
which we have to conquer.

We humans, as part of the cosmos,
are the link
between the past and the future
(belonging to us and to the world), and neither
are we the product of the past alone
nor of the present alone, nor
of the dream-future alone. We must therefore
reject biblical findings as ultimate facts,
just as we must reject the
scientists' assertions of the present as finite,
as honest as they are,
and evidently we must also reject the so-called
documentaries of the biochemist,
the physicist, the sociologist, as well as
the projections of the parapsychologists,
because their vivisections of life are
two-dimensional by their very discipline of pinpointing
data. Scientists are segregationists by the
absolute character of their methods and tools,
such as the microscope,
as much as by their intellect, sharpened
into a micro-focus of the totality of events. Their findings
are not *visions of facts in*

continuity (Einstein's term), a continuity which breeds
the manifold dimensions of aggregates
in time and space,
impossible to pigeonhole, yet real
as any of the scientific deductions.

It is one of the seductions of life that we cannot isolate
all elementary forces in test tubes, and
that ultimate destiny
can be gauged only by instinct,
a most precise instrument of creativity,
if we learn to use it
with dedication to no compromise.

It has been a religious and scientific saying
that the spirit needs the body to house in
and that the body needs the spirit
to make its cells function. But that is a
comfortable generalization which uses imagery,
blinding in its aesthetic apparition,
to set aside further questioning. To develop
a thought, to recall a memory, to create a
vision, a deep sense of being, nature
has to provide soil
for its seeds,
call it a house, a cell, a root. But the
impervious fact:
the house of the human body is not a shell-shelter
whose void
is to be filled with the atmosphere of the mind
or of the emotion,
whatever term we use to name the unnamable;
but every cell, every molecule, every atom,
every artery, every ganglion is house and content
at once in a continuous-One, an
environment as well as an object, multifarious
and interchangeable.
Several million years of decay of animal
and vegetable matter with mud deposits sealed
under ancient seas created oil in rock
deposits which we extract by drilling,
squeezing, distilling and mining the earth.
Now we can reverse the process and grow

protein-yielding microbes from petroleum,
dry them, explode them and gain a nutritious
powder as food. A second reversal can follow
in time, by developing petroleum from proteins obtained
from grains and vegetables cultivated in our
earth. These are facts of nature,
grown in laboratories made by man to save
hunger and heat.
This continuity of rebirth by conversion
seems to be based on a law
of mutation
transforming its constituent parts at an
infinite variety of speeds
set forth by the inherent flow of radiant
vapor-heat and gravity-cold
of the cosmic forces
in constant fight for a *preponderance*
of power
in every one of its parts
against the other, naturally or artificially stimulated.

The very life of a human being seems to depend entirely
on the fight of these
preponderances of one world force against the other,
factual or visionary.
Finally, the positive
resources are overcome by the
apocalyptic thrust
of the negatives—from our point of view—
not so from nature's,
whose sole interest and obsession
seems to be the search
for a permanent balance, which she, agonized
by persistent failure,
cannot achieve.

Thus, the terrestrial creatures,
animate and inanimate alike,
are the sacrificial victims of her
creative impotence.
Nature has no responsibility
to any God, except
her ego.

Epilogue IV

The Correalism of the Plastic Arts

Our Western world has been overrun by masses
of art objects. What we really need
is not more and more objects,
but an objective.

Our objective can only
be defined by defining the circumference
of its core. It cannot be
defined in terms of inventions, such as the
steam engine which continued
the revolution of
mechanical production.
"In 1685 Sir Samuel Morland,
Master Mechanic to King Charles II,
submitted for royal perusal
a report on an intriguing and possibly
valuable reaction of water to heat.
'Water being evaporated by fire,' he wrote,
'the vapours require a greater space,
about 2,000 times that occupied by Water.
And rather than submit to imprisonment
it will burst a piece of ordnance.
But being controlled . . .
it bears its burden peaceably, like
good horses, and thus may be
of great use to mankind . . .' "

――――――― ―――――――

Art is not based on inventions,
because Art is an invention;
an invention by nature to
camouflage the inevitable
mortality of flora, fauna,
man and matter.

Art follows the impact of an inner dictate
attempting again and again to make the link
between the known and the unknown,
the search for an expression of what our life
is about and finally configurating
the results of this search
into visual orders.
Once we reach the level of Art
it remains constant. It is embedded in
the soil of cultures, past and present,
and is free of progress.
Free of progress
in contrast to the unavoidable evolution
of "Civilization," which goes on automatically
producing mechanisms in education and industry
for the physical and mental health
of a populace.
It is restless in its striving
to incessant progress, as if hypnotized
by an illusion of comfort.
If in contrast the plane of culture is once
reached, it harbors all ideas of creative men,
of all ages, past, present and future,
through their achievements in poetry,
basic science, philosophy,
architecture, painting, sculpture,
the crafts, from flints to the formula of
splitting the atom, without discrimination
to continents, races or creeds.
Art is the only *constant* in human society,
rich or poor, alive or dead. It is not
destined to any change in its aim. It is not
consecrated to altering the basic structure
of living methods once the level
of wisdom has been reached.

——————— ———————

L'art pour l'art of seventy-five years ago
and the period *L'art pour l'artiste*
of the last twenty-five years are over.
But before we can go into new creations,
a new objective must first be crystallized
out of consciousness which is the concern of us all, not of any

149

particular stratum of society.
The world of events since the last war
has grown in turbulence and has
thrown us together. Aestheticism as a sole
criterion for the validity of a work
of art is evaporating.
The artist will not work any more for his glory
in museums or galleries, but for solidifying
the meaning of his creations on a
large scale without falling into
the pitfalls of social realism,
anecdotal accounts of events,
or pseudo-scientific extravagances.
He will and must take active part through his work
in forming a new world image.
The era of experimentations in materials and forms
over half a century has run its gamut;
it has and is exerting stimulating awakenings;
they are like tributaries
but are not the flow of the main stream.

 A new era has begun,
 that is an era of correlating the plastic arts
 within their own realms, but with a life
 freed from self-imposed limitations
 by stale traditions, conceit,
 fashions of style or dictates by markets
 or money-changers.
 The poet, the artist, the architect
 and the scientist are the four cornerstones
 of this new-rising edifice of our existence.

_____ _____

Just as we have been restricting our lives
to this earth since Homo sapiens became man,
so have the plastic artists
acted within the confines of the spirit of this
planet. What we artists
were doing was simply trading traditions
with little forays into the unknown
to flatter our fickle ego.
To look up at the sky, the galaxies,

the moon, the sun,
was a romantic or fearful dream.
Now the awareness of the outer space
(as the super-galaxies are called)
has brought us closer to the universe
and closer to each other.
Our knowledge is changing from abstractions
into the realism of our personality,
not as a secluded, isolated entity,
but as a part of the continuum
of a total environment.
The plastic arts must now expand their
horizons, too, and widen the arena of their
activities to unforeseen,
but inborn, capacities.
It is evident that a world constantly renewing
itself forces us more and more
to give attention to the continuity
of the minutest detail of our sensitivities,
as well as to the expressions
of the so-called inanimate objects
which surround us.

The traditional art object,
be it a painting, a sculpture,
a piece of architecture,
can no longer be seen as an isolated unit,
but must be considered within the context of
changes in time and space,
moving physically and percepted visually
in all directions of environment,
be it man-built or part of nature.
Thus we are stimulated constantly by split seconds,
physically or emotionally with a world
already existent or in the making.
Object and environment remain
constantly one in unison with past and future.
Consequently the environment becomes
equally as important as the object,
if not more so,
because the object breathes with the surroundings
as we do.

No object of nature or of art can ever exist
or has ever existed without environment.
As a matter of fact,
the object itself can expand to a degree
where it becomes its own environment
(see the galaxy sculpture which I exhibited
at the Museum of Modern Art in 1951).

Thus we have to shift our focus
from any object
to the momentous environment consciously,
and the only way we can bind
the manifold parts together is through
a general objective,
a clarification of life's purpose, a content,
otherwise the whole composite image
will fall apart,
action by action,
unit by unit.

——————— ———————

A cup rests on the table top.
In between is a saucer.
The table top rests on four legs,
the legs rest on the floor.
The floor is supported by beams,
the beams by columns,
the columns by foundations,
and the foundations are stuck into the ground.
The dugout is secured by the crusts and shells
of the earth, kept alive by the vibrant tension
of the heat and fire at the core.
Up in the room the cup is waiting for
its fulfillment, a liquid to be poured in
by a human hand through a vessel
(a secondary object) which contains the coffee,
milk, tea, water
or whatever fluid will fill it.
The fulfillment of the object continues
when it is lifted up to the lips;
the mouth will suck it in
and the belly will swallow it up.
You and I sitting in a chair at the table

are simultaneously aware of the space
and dimension of the room,
its height and width,
its misty corners, lit and shadowed sections,
aware of a link by a window
between indoors and outdoors,
through which we see the streets,
buildings, people or sky.
The sun strikes into the room at her willful angles
and her consecutive order makes us feel the hours
of the day, the passing of time and space.
Years and eternity are in this cycle.
You are in the midst of it.
Evidently our physical change within a room
or outdoors is constantly linked to
an ever-shifting co-ordinate of the melting forms,
kinetic, static, colors,
blunt, hazy,
all objects commanded by their agitating forces.
All environment is an extension of us.
We can never escape the embrace of surroundings,
natural or artificial.
This is the sensory and physical monastery
we are living in and we must make the best of it
to be able to enjoy the present.
We become aware that our independence
is only a state of mind,
and that this state of mind,
if it is not to die or to be driven into a
psychotic realm, must draw its life-forces
from the energies of the universe in toto
and in parts, however fleeting
that relationship might be,
but always relying on its continuity,
the only constant in an ever-changing world,
a result of the correalism of our existence.
> Awareness of continuity
> is the new content of the plastic arts.

The arts shall therefore not only reflect this
inter-relationship of man with his environment,
but must mutate it by means of man's
own inborn craftsmanship

to be the ever-new creator of a technological
world, call it science or art,
basic or applied.

 However competitive it might be with nature,
 the link between the two must never be broken
 if our work is to survive us.

_____ _____

Cubism metamorphosed into constructivism;
constructivism into abstraction;
abstract art into non-objectivism.
After the baroque in painting and architecture,
furnishings, vestments, perukes and canes,
watches, calèches, fox-hunting and snuffboxes,
all once-united in their enjoyment of
a lusty life—there followed in Europe a
gaping void,
gasping for salvation,
and the arts split up over a hundred years
into their components.
It looked as if civilization would be drowned
in memories and choked by it,
no rebirth in sight,
until neo-plasticism of the early twenties
tried to reassemble the scattered parts
of the plastic arts into a correlation with
architecture, however unsuccessfully.

 Ship ahoy for the sinking! I can spot it with
 my inner eye. I can't wait
 for the embrace,
 breath- and life-giving, hull, bulk and me.

Unsuccessful we are because the promotion of
functionalism in architecture, structures of
austerity, were only a reaction to the
overstuffings of the Victorian age.
We put architecture on a diet.
It is by now a skeleton.
We can start eating normally again.
But nobody has ever defined the meaning of the
roots of function; it has not been recognized that
any function is subject to evolution just as man is.

Function is now frozen in hygiene,
light and air-conditioning.
Glass bric-a-brac
concrete block-heads
steel or aluminum mullions
anodized gold
anodized poison chrome
swamp green
deadly black
natural buff
all framed by steel, bronze, stereo-plastics,
plate glass, tinted
brown, pallid purple, bilious blue,
venetian-blinded horizontally, vertically,
indirect or spot-lighted
distempered by contemporary abstractions,
Grani's oil prints all spotted on walls
of upper-middle incomes
private or big business high-rise
skyscraper executive edifices,
or by scattered sawed-off-shotgun sculptures,
outcasts of classical monuments,
rubber plants mesmerized into corners,
this magic fake of pseudo functionalism
is vomiting its indigestion.
Its concept based on new materials,
welded, bolted, molded—what next?
I wrote in 1925 in the *Stijl Revue*

 ". . . the materials are not the important matter,
 the important matter is . . .
 how does one live,
 what new and inspirited life do they promote
 among the straight or curved lines?"

To build houses by the trap of claptrap
of industrial productions might be good
for helter-shelter,
but not for architecture.
We have not followed the call of architecture,
in its life-giving correlation with
the plastic arts.
That call got astray
in the convulsion of the machine age.
We must assist in the conception of

an architecture based
on knowledge of life from within
not by box-hoaxes from without.
But we are damned unfit by our college training
to understand the make-up of man,
his family life, to serve the inner and outer
horizon of his daily life.
Defunct functionalism has brought architecture
and the arts
to the turmoil of the surface,
leaving the core hollow and burnt out.
Dump! building bureaucracy of compelling
complexities in structure and interiorations—
any shell will do:
mud, straw, wood; canvas, brick, polychrome,
polyester—as long as the nest is warm
in its embrace
and permits changes and transformations at will
and responds to change.

> But the push toward a new metaorphosis had started.
> Domestication of the arts.
> That transformation is now working its way up and up.
> We are at the beginning of a new era
> of correlating the arts
> once more into a unified field,
> but in our own way,
> filled with the energies of a new content.

The wall, the floor, the ceiling,
are not any more segregated planes,
they flow into one another,
colors and lighting, breathing heavily and lightly;
so-called painting not created any more
in standard forms and planes,
sculptures not any more on pedestals,
or harbored in niches,
like frozen custard,
or conglomerations of parts,
animal and machinal, motorized or mortalized,
or pictures hung along walls like laundry
on washlines. No.

156

There is a breaking down of barriers
of separations between the constituents
or architecture, which by itself is contained
within the flow of nature's forces.
Thus the creative genius of man can express itself
once more with the power of his own time.

On the Ponte Vecchio at 5 P.M.

Florence
July 2, 1960

The sun is low
The sun is high
Arita near
all fear
gone

Narrow sidewalks of hollow streets with
old stone slabs and
fresh splashes of
pigeon shit.

Silk-smooth dresses laid
open in show windows spread
on their backs
against burly Brazilian
walnut
flower patterns raised by the marriage
of Italy's sun and earth.

The beautiful neck rising
from the lake of her white
shoulders.
I am
necklaced to it.

Her neck
a steep sea wave
of such pride that
it refuses to fall back into
the foam of her shoulders.

157

The Moon Cracked and a Sun Was Born

subway tracks of my
 down deep underworld
 rush halt go
air is choking
 arty fans try cooling sweat
 a switch jams

a N D s U D D E N L Y
love is a dove
 white feathered
 raven black
freedom encaged
 in the vast infinity
 of the body-prison

blood and sky-stained windows
 look in and out
sheep and lions
 change skins
the ram is blowing his horns
 meme youyou

mouth to mouth seal a cave
tongues play-swim
mating fish

four eyes go blind.
 A night-dome of crystals
 stops time.
The universe is a hug of silence

Massacre of the Sweat Shirts

Florence
July 1, 1960

When we arrived, the game was already in progress. The big
square of the venerable Piazza della Signoria had been cluttered
on two sides by pipe scaffolds with planks sandwiched in (pre-
fabricated grandstands—straight out of Manhattan) on which
thousands of people sat, crowded thigh to thigh, their heads dis-
played en masse like olives in a basket. The other two sides
were formed by the Palazzo Vecchio and the Loggia dei Lanzi, whose
arches displayed Cellini's "Perseus" holding the Medusa's head
and Giambologna's "The Rape of the Sabines," glorifications of
sports of a more private nature and much to the taste of the gory
Medicis. It was 10 P.M., a luxurious hour for a ball game. I had
been told that football originated in Florence and its invention is
celebrated every June 26 with all the ritual and pomp of a Span-
ish *corrida*.

160

The grandstands were so crowded with spectators that no matter how thin I made myself, it was impossible to make my way up the aisles. I crawled back and remained standing for two hours, virtually held erect by incessant pressure from the bodies of the dense crowd.

The square of the Piazza della Signoria, which is stone-paved, has a marker showing the spot where Savonarola was hanged and burned in 1498. For the soccer game, this plaque, as well as the entire square, had been evenly covered with a heavy layer of earth. The piazza looked barren, silent, brown.

Darting across the field were the two teams, their shirts stark white and their knickers purple or green. The players did not look like much of anything. They had no leather helmets with chin and nose brassieres, as our American heroes wear, nor any protective padding to give their shoulders a look of forbidding strength. No, these players wore short-sleeved, everyday sweat shirts—but with Renaissance knickers which hung around their thighs like pantaloons. As gladiators, their style was neither old nor new. A glance at their feet reveled no armored foot-fist, either of tear-proof canvas or rubber, laced or hooked compactly, flexible yet hard as knuckles of steel. Instead, they wore knee socks and imitation Renaissance sandals. A funny sight indeed, but their playing was serious, rapt and sometimes ferocious. The umpire wore a Marcus Aurelius beard, a red-and-black shirt and white-striped culottes. He blew the whistle as we do: sharp and short. The play, however, did not stop immediately, only gradually, with sporadic guerrilla fighting continuing while the white ball shot up, kicked by one of those Renaissance sandals in a high-pitched parabola.

As the game progressed, holes were ripped in the players' trim-fitting white sweat shirts, splitting them wider and wider until they hung over the knickers like ragged battle flags. But the most striking change was in their color. The players often fell to the ground, wrestling with each other, rolling in the dirt, bespattering each other with mud in these jumbled embraces, until, toward the end of the game, the sweat-wet remnants of the shirts were purple-green-black, as were the men's arms, their torsos and faces. Here and there, patches of suntanned skin shone through like glazed terra cotta, but the total image was a mess, a smear. The Italian-black hair of the players was tousled from battle and glistening damp.

161

In the drive for a goal, there was no mercy. Two serious accidents, the second more shocking than the first, occurred along with minor ones. Particularly distressing to look at was one player whose head dangled helplessly over the edge of a bath towel on which he was bedded and hurriedly dragged off. In the midst of these clashes and collisions, a player would dart off to one side of the field, grab a pail of water and empty the whole bucket over his head.

There were three persons in the audience who paid no attention to the game. Two of them were super-sized, chalk-white men, grand figures of Istrian stone, their cold and forbidding look aimed far away from the playing field. One was Michelangelo's David, the other Hercules, with his miserable victim, Cacus; the third personage, a descendant of the Medici, had mounted a horse encircled by the grandstands which covered the pedestal of the monument entirely, so that only the body of the horse and its master stuck out of the sea of the spectators' heads. This statue had assumed the traditional attitude of command, solidly frozen in bronze. Three cannon shots from medieval bazookas crashed into our ears, and marked the end of the game.

Next came a roll, a pause, and rattle of the drums, followed by the blast of trumpets, then drums and trumpets in unison, and the procession around the arena and into the streets of Florence began. All participants in the ritual march, both on foot and on horseback, bowed to the ladies in Renaissance costumes who were sitting on the balcony of the Palazzo Vecchio.

There appeared in the procession a white bull with gilded hoofs, his white horns bedizened, blood-red tresses falling over his eyes and his body draped with a flag of green, white and faded rose. He looked grim—his steps fell exactly into the martial rhythm of the somber drums and silver trumpets. When he turned my corner and his hindquarters came into sight, I expected to see the two majestic bells of his masculinity, but nothing was there. His thighs moved back and forth, and between them was emptiness. When he paraded a meter or two farther, and I could view between his legs, I saw the meager pellicle of a castrate. The bull is transformed into an ox according to Tuscan tradition: when six months old, he is playfully laid on his back, feet up. A heavy stone is placed against his testicles, and by the stroke of a heavy mallet, they are crushed. The steer then grows bigger, fatter, and

162

less savage—just right for parades. After the procession has passed through the main streets of Florence, a large banquet is always held for the game's victors and vanquished, at which the emasculated bull used to be sacrificed and devoured; but on this night, the dinner was prepared by the city, and mercy granted to the beast.

The great triumph of this grand opera of sport was threefold: the brightly illuminated mountains of spectators, shaded indigo by the depth of the shadow and an arena whose encircling balustrade was draped with a brilliant scarlet cloth; the exuberant action of the soccer teams, running madly against each other like motorcycles let loose, clashing with each other head on, body on, bouncing off, forming clusters, entangling themselves with delight in speed and clash; and finally, the procession with its luminous spectrum of colored costumes, velvet, silk, leather, steel. All this was heightened by a brigade of drummers whose drums, painted black and white and vermillion, hung diagonally from waist to knee. A cavalcade of banners of the sixteenth century trades, lustily ornamented with symbols of the crafts, followed by Legionnaires, their empty muskets shouldered with grim seriousness. A single Giotto-blue banner created a welcome interval in the kaleidoscope of color, a break in the Tuscan palette of the Gozzolis, the Fra Filippo Lippis and the Piero della Francescas.

Yet, the people, the play, the colors, the sounds were outdone in heroic attitude by a single piece of architecture, the Palazzo Vecchio, in front of which the man-ants were cavorting. Its tower rose one hundred and sixty meters into the sky-dome, like the horn of a unicorn, carrying in its ridges hundreds and hundreds of blazing oil flames kindled alive by the fanning of the night breeze. Like glittering eyes of suns, they overshadowed the vanity of the masquerade below.

One hour later, the square was deserted. Forlorn children were playing mock football. The scaffolds without people looked like skeletons, the meat fallen away.

But the Palazzo Vecchio, witness of these games since the fourteenth century, remained stolid, unchanged, proudly carrying its unicorn tower iridescent with breathing flames, a symbol of the glory of architecture, mother of all play.

By-Passers

Perugia
July 5, 1960

Entering the National Gallery of Umbria in Perugia, that mountain town with its eleventh-, twelfth-, thirteenth-, fourteenth-, fifteenth-century buildings, Etruscan gates, façades, around a single fountain sparkling like the favorite of an architectural harem, vaults, catacombs, and finally leading into the super-heights of an art museum. There is a silence emanating from the vastness of ivory-colored walls, an airy width into which the panels of Umbrian painters are inserted, thus beautifully integrating their medallion faces with each surface of the twenty-three consecutive rooms. Interspersed are paintings within carved and gilded Romanesque, Gothic and Renaissance frames borne on ledges singly and in triptych, projecting farther out than others, while a few recede, transforming the structure into a Sanctuary of Art rather than a modernized museum. So indigenously has it been accomplished that it truly does not matter any more if almost all the paintings and sculptures are second- or third-rate. Dedication, expressed through the utter simplicity of the architecture contrasted with the inlets of colorful painting at tactful intervals, makes the wanderer in foreign lands feel lost no longer. Paintings, like mellow hands, guide him through a home rather than a museum. He feels sheltered by the concrete realities of the artist's vision. His search for unreality has ended.

How different are our museums in New York! Where do the array of paintings on walls and the pedestal sculptures lead the soul of the visitor? What mood is evoked to connect us with the truth of the eternal? There we remain paying guests, forever visitors to art, never belonging to the family circle. Only by-passers.

Perugina Chocolate Factory

Perugia
Noon, July 5, 1960

Riding leisurely up the hill to Perugia along a long-walled fortress, I discovered on my left the legendary Perugina Chocolate Factory, guarded by a cordon of tall umbrella trees. Nothing in-

dicates that the superb Umbrian chocolate is being manufactured behind those ordinary-looking factory windows, walls and doors. We three car travelers are hushed to silence by the sight of the sign "Perugina," a name so often viewed in New York's candy stores, with almost awe-inspiring dreams of sweets from the sweet days of youth (the incidental whitening of the chocolate in no way diminished one's delight in it).

"Yes, we do send our famous Perugina chocolates to the U.S.A. Just give us the address. The charge is three dollars for the box you select and ninety cents for the telegram."

"For the telegram? What kind of telegram? . . ."

"Signori, we have representatives in almost all cities of the world. The delivery in New York will be made by Macy's. They will be notified by a telegram from us."

"No thank you, Signorina," I answered.

No, to remember Steffi, who delighted in Perugina sweets, with chocolates delivered in Manhattan with a New York postmark on the package. No, no! that would never do for her. Alice nodded toward me. She was in agreement with my decision.

The Umbrian girl with her olive-black hair, light milk-chocolate complexion and egg-white teeth, smiled, and in her broken English, in words molded by Latin gestures, indicated her regret at not being able to change the regulations of the company.

We walked out, appalled. The penitentiary of international commerce prohibits all personal insignia. The world is under the whip of a conformity as inescapable as the haphazard lash of the mistral.

2 o'clock

We are packing and leaving Perugia for Spoleto.

Tried to reach Contessa Gnoli in Spoleto. The answer was: *"La Contessa è a Roma."* I phoned her an hour ago at Rome: *"La Contessa sta a Spoleto."* I put in another call to Spoleto now. Hope it comes up before my departure—here it is: "The Contessa not in."

165

Now down the marble stair to pay my bill, telephone Spoleto to make reservations for Paul Taylor's dance recital. On our way. Alice already anxiously waiting for the kickoff.

Putting my hand into a side pocket of my jacket I discover to my horror that my beloved red-leather Hermes notebook isn't there. All my notes of the Italian voyage gone! and my sketches of Venice, Padua, Ravenna with it.

We decided to make a detour through Assisi, where I had made my last drawings. Perhaps it is there. On the way, my hands once again tap my jacket, my pants, hoping for the bulk of my notebook.

My hands drop hopelessly. I try to reconstruct this morning and the day before, in search of that lovely satin-touch notebook of mine: the last hope seems to be the Church of St. Francis of Assisi. There I had sat yesterday at noon in the basilica sketching the low bends of the ceiling arches; it was the third and last sketch I made at the church. The first was a view through an open portal with the unusually bulky rock formations of the rising terrain; the second, and I think I drew it over a double page, was of the only fresco painting of Giotto I copied among sixty or so, namely "The Stigmata." Christ in the upper right corner of the rectangle, floating with raised arms clad in bird feathers (as the torso of the flying Christ projects like a rocket; it's amazing to see Giotto jotting down jet-forms at that time).

Arriving at the churchyard, we stepped quickly into the chamber of postcards and souvenir miniatures of Assisi's architecture. The priest behind the counter called a colleague of his from an inner sanctum and we both walked around, back and forth, through all the areas I remember having visited: basilica, cathedral and crypt. Nothing there or here, nowhere. My anguish tried desperately to conjure up the notebook; it had vanished and with it my first design-impressions of Italy. I knew that neither the first impressions nor the notebook could be retrieved. Gone.

We returned once more to Perugia, once more making a last try to find the notebook at the hotel, then to the restaurant where we had dined last night and to the police-carabinieri's station (at the main entrance of the museum!) leaving with them my Rome address in case, in case.

We climbed to Spoleto late this evening. The crowds were just seeping into the streets from the Festival Theater. And there was Contessa Gnoli and Ken Elmslie, my young poet friend from New York, at whose mountain house we dined next day, the house which Pirandello occupied when he wrote *Henry IV*; only six months ago I had designed sets for the Burgess Meredith production of it in Philadelphia. What happy coincidences.

From New York, two weeks later, I decided to make a last attempt and wrote to the padre of the St. Francis Church of Assisi asking him to watch out for the possible upturn of my saffian-red notebook, and promising that a reward of twenty-five dollars would be sent to the church gladly if it were found.

To my astonishment, a flying answer came within a few days. Nothing had been turned in at the offices that even faintly resembled the notebook, as I had described it, but I was assured that new efforts would be made. My premonition seemed verified. I'll never see it again.

Tucked into the folds of the letter was a card, on one side giving the days and hours best suited for a visit to the Church of St. Francis and on the other side a color reproduction of one of Giotto's sixty-four frescoes. I stared at it in disbelief. It was "The Stigmata," the only fresco I had sketched in my notebook.

Basilica of San Vitale

Ravenna
July, 1960

We are, my two faithful companions and I, sitting on the entrance steps in the shadow of a "minor" church, dumfounded. We have just visited the Basilica of San Vitale, a most splendid architectural theater-in-the-round, and the square Mausoleum of Galla Placidia, a simple brick block with three niches, each containing a single marble sarcophagus. Although it is built in the plan of a

Latin cross, it is considered, because of its internal structure, a circular building. Illusion and fact coincide to make a perfect unity. Someone said, some wrote, some repeated and many a visitor blabbed: The mausoleum is the oldest religious structure of the fifth-century Romanesque, with the dust of dead human remains inside, but I say its interior is sparkling with architectural life! It is bursting with vitality, thanks to its concept, not to restoration.

There in the Mausoleum of Galla Placidia, the blazing fire of Byzantium, the temper of a ravishing beauty with raven-haired Ravenna's empress, Theodora, is expressed with constantly bursting explosives of colors. The simple brick walls, garbed inside with riches of mosaics, hand-laid glass stones, are knitted tightly one by one, like needlework; blue green, gold, white, gray and black. In spite of the exuberance of the mosaic technique, nothing is overdone. A deliberate taming of architectural powers.

How much we (painters, architects) can learn from that mastery of pictorial balance.

The skies above, the skies below, the saints robed in innocent whites, the shepherds, the doves, the bull-head, and the stag drinking from the fountain of life, nowhere is death portrayed except for a cluster of grapes at the very summit of the building, a traditional funereal motif—a generous concession to mortality.

There is also the discipline of the cube in dealing with the cupola, arched niches and the ground plan of a cross, all bound to the structural walls by the mosaics like a sequined garment tightly stretched over a voluptuous female body. There is no need for architectural extravaganzas, for make-up; the glow is indigenous. Three small windows sealed with alabaster afford the golden light of an eternal sunset.

Even the sky in the mosaic is limited in its expanse, the stars clasp hands with one another, at short range, making the infinite finite —and real.

This is "imaginative realism," a realism extracted from hard-fired earth (bricks and mosaics). In spite of the tomb, the image of life thus becomes ever-present.

The Galla Placidia mausoleum is not decoration
or abstraction, it is the perfect
example of poetry transformed into architecture
words of stones linked into sentences

clusters emerge and
form images
in rhymes and rhythms
with their own speed of dimensions,
all linked by a
single content
that is
love
for an irresistible memory.

Feelings on Rome

Rome
July 6, 1960

Once more in Rome, looking out from the same terrace as a year ago. Same land, same city, yet so very different feelings!

Peering out left and right over the roofs of Rome as it appears today, contrary to last year, they suddenly look like all other old town roofs—walls, chimneys, terraces; it's hardly worthy of further discussion and description. We all know it too well.

Last year, when I first saw it, I literally raised the roofs to poetry, my pen spouting like a fountain, writing the glories of the roof villages high in the sky. But how earthbound, downcast it looks to me today! Apparently a reflection of my inner self.

My nephew telephoned in the morning and I arranged to visit him in Positano via the famous Rapido-Express. So after this day in Rome, I'll go off to stay in one of his two Saracen houses overlooking the Mediterranean.

A wonderful chance to rest, but then I have to rush back to Rome and get ready for my return to New York—start and finish of my Italian escapade.

I have been dashing across Italy from Venice to Naples these two weeks, as though wiping my face with two back-and-forth strokes, anxious to return to my work. New York has become a powerful magnet of hopes for good work—the pull is irresistible.

I am clean again, and have the satisfaction of having lived for once according to schedule. The time for lingering and spontaneity is almost over. Then back into the harness of U.S.A. dreams.

Greco Café

Rome
3:30 P.M., *July 5, 1960*

The street is narrow. The sidewalk and houses practically cheek to cheek. The café a flight of deep chambers seen through open arches, dozing, one after the other. Deep red damask walls, decorated with old dark oil paintings of Roman ruins and illuminated by bright yellow electric bells. The interior looks like a memorial to the legendary riches of the Renaissance; the long perspective recalls the grandeur of Italy's past.

A midsummer day's petrifying heat, the perfect climate for the classical siesta hour. The only noises are those of tourist buses rushing by at intervals as full of emptiness as balloons.

Only three patrons are scattered about at this famous café, all Italian ladies. Two are black-haired, in flowery cotton dresses, just about to pay an old waiter-factotum, a bent figure in full evening dress; the third is an elderly lady shrunken to no-age, fighting her sleepiness valiantly. Her hands are folded over her eyeglasses, her head bent down toward the bill of fare which is resting on an outspread newspaper resting on the marble table top. She wears a broad-brimmed hat of creamy white straw, an ivory-white
170

sweater, a black skirt, and from one lobe of her ear dangles a massive piece of gold jewelry, its blackened craters, evidently once the settings for jewels that are now gone. She is awakened by the factotum who places on her table a tall silver container filled with raspberry ice. Bent over the silver goblet, she stretches her legs cautiously under the table, and I can see now that they are bandaged in bleached muslin, columnar, heavy, and apparently difficult to manipulate.

I wonder if that might be the reason for her keeping the lower part of her body immobile, trying not to put a strain on her legs; her upper body rising from or sinking toward the marble table according to whether she uses her elbows or her hands to support herself. The lady is apparently devoid of teeth; her lips sink inward and when she opens the portal, her tongue lashes out like a chameleon's toward the spoon to catch the fly in mid-air. The *gelato* devoured, she slips on her eyeglasses, puts the folded menu away, rests her body on one elbow, and with the other hand supports the rim of her eyeglasses, which look as if they can easily fall off her shrunken nose. The head remains bent heavy.

That distorted figure reminded me of Greco's emaciated, elongated personages, a strange but appropriate apparition in this Roman atmosphere steeped in all the decadent elegance of Spain.

Rome
May 23, 1961

Now I know:
it is the fig-testicle
that made the fig leaf
what it is
in the pubic eyes

Post-and-Lintel Game

En route
from Naples to Rome
July 7, 1960

An old American, evidently a member of a Cook's tour, his farm tools imbedded in his retired bones, came into our compartment, took off his Bali-batiked coat, and hung it up. His brown straw hat with diagonally striped silk band thrown into the rack, he himself fell back into a seat, his legs at once outstretched onto the opposite upholstery. The rest of his group, about fifteen of them, trekked through the corridor toward the diner, Midwest middle-aged female scarecrows in manufactured dresses, their heads studded with beauty-parlored curls and butterfly eyeglasses. One by one they appeared, completely skinned of their once in-born individuality, mummified, a gruesome Bataan-like march on a flying Rapido train carrying us to a goal to which, proverbially, all roads lead, Rome.

The new Naples station goes further structurally than the old-new station of Rome. Its design is schizophrenic: a Mondrianesque purity and clarity of functional organization which spreads into a cubist dream-forest of concrete, driven to mad dynamism by futurist idolatry. It has triple columns which rise like reversed tripods, tree-stemmed daisies growing from a common root into a ceiling foliage of crisscross beams upon which rest additional layers of beam branches to form the ultimate, flat layer of a roof-floor. *Tant de bruit pour une omelette d'architecture.*

This is à la Nervi, very nervous, playing the post-and-lintel game, old as Western civilization—a game he also plays in every one of his stadia (including the one for the Olympics in Rome). His domes derive from a circular array of bush stems bent to a knot on top of the skull. A forest of columns supporting a windblown, sinuous umbrella-sheet, a concession to shell styles. You too, Brutus, on the bandwagon? He has abandoned the diamond skeleton of dome beams, crisscross concrete crowns. But even Nervi continues to use the all-mighty column support of roofs, of which, they tell me, I am the assassin. Correct. The traditional post-and-lintel shelter has collapsed. The column as a support of roofs is dead indeed. Long live the shell of continuity. That play-game of colonnades supporting roofs, and roofs supporting snow and tons of water—Great-Grandpa's architecture.

172

Those old-time builders and architects chopped down tree after tree, making columns out of them. And then the sons of the Mediterranean lands blasted rocks to make columns out of them and roofs and sculptures and artifacts, chiselers all of a stony security. The Greeks took over Great-Grandpa's post and lintel and Athens boasted the Parthenon, where the columns no longer support anything but themselves, a perfect abstraction of what was once practical. And thus building was raised to architecture, making the superfluous aesthetically necessary.

And now the boys are crushing ores, melting steel and pouring new columns, but the old post-and-lintel game is still on. They rivet and solder and braze one column on top of another, manufacturing steel forests, tree posts imitated in steel, three thousand-fold stronger than wood, fine, but oh so weak when licked by lazy tongues of fire! They collapse in slow motion with weak knees and curl up, never to rise again. Sleep steel baby! Riveting was your lullaby. (The bitter end of the Crystal Palace in London.)

Today the wise guys struggle and now the tree rises in a different material, this time concrete. The post-and-lintel game starts all over again. The house-forests are now of poured concrete, the fourth transformation of the tree trunk.

Nature's forests go on as they were, their foliage still spreads a ceiling and a roof in wind and weather. The birds nestle and the apes swing from beam to beam. Glory is in the air.

A big wave rolled over the land from the sea and flooded all concrete columns and colonnades and they collapsed like sand, disintegrating like bubbles. And the people were without roofs. Without roofs over their heads, they almost lost their minds. But unexpectedly the big wave set a magic eggshell ashore. And it rolled. The fire couldn't catch it, and on the flood it swam. No beam, no column made its structure, yet a roof and a wall and a floor were all there. In a day.

From under
a summer umbrella—
"Gigli, Pasticceria, Gigli
pastice dalla vostra Piazza"
waiting
for Elizabeth Mann Borghese of Fiesole.
I read
high up on the parapet of
Cinzano's massive building
carrying like a crown
of letters—
insidiously luminous
> **SAPORI**
> **PANFORTE-PANETTONE**
> **ELIMINA L'ACIDO URICO**
and I am sipping
melted gelati

Spanish Steps Piazza

Rome
3 P.M., May 25, 1961

Spanish Steps piazza. A horse carriage slumbering. The head of the horse is half buried in a food sack. The old driver sitting in the guest's seat and eating, foodforlorn.

"What are you eating, sir—apples?" He was cutting apples into precise segments spread on a piece of crumpled paper, flattened out. The paper rested on the bench ledge facing him, a seat like the one where I used to sit in my childhood days when taken for a "fiaker" ride.

"Yes, apples," he retorted without turning, chewing the English word with his crunching rhythm.

174

"And the horse, what is he eating?"

"Groats," he said proudly, with a grin of his mustache.

"You mean oats, right?"

The horse snorted.

The car flies were hissing fast, crosscutting our path. The standing carriage receded into the past. The harness, sandy-raw leather cowhide cured purple-umber, bottle-green gilded with wine; malaise-mauve the reins.

Colors of Rome: tomato-red turned musty; rose-sienna burned to umber; orange-peel pink; all off-beat brown-mulattoes; soft ochre to hard dirt; washed-off greens gone mustard; foul apricots cocoa-stained; burning cheeks and ivory foreheads; cool-sounding violets; no trumpet colors screaming.

Rome's Pantheon

Rome
May 25, 1961

No man, terrestrial animal, or bird knows how to discover holes in walls, ceilings or floors better than cats can and do. The sky hole in the dome of Rome's Pantheon seems to have been made for cats. What a sympathetic Pope! A culmination for these four-legged creatures—yet never to be reached. Therefore they stick stubbornly to the basement.

Now, pressed into a mass of lunch eaters at the restaurant Otello, I see they have this small courtyard covered with corrugated plastic sheets, diffusing and mellowing the hot sun with its cool green tint.

It is late noon already. I overslept in spite of the slit in the closed window shutter of my hotel, through which the sun knifed my eyes with stiff rays, indifferent to the fact that this was the traditional

175

hour of my deep-sweet rest. Later, that is now, I look up through the opaque ceiling roof and see the shadows of distant tree branches and sunspots (like a Chinese makimono painting pattern). Among these, a splash of immobile darkness suddenly moves and shifts its contours. I am baffled, but continue to twirl my spaghetti.

To the right of me, the plastic roof reaches a wall and ends. A grapevine winds its way up, turns sharply, bends and swings with its main stem and one branch breaks right through a crack in the plastic ceiling. Some minutes later a small dark shape appears through the crack and winds its way down the vine, cobra-like.

Seconds later, the black abstraction becomes reality: a cat. Coming headfirst cautiously, the cat finally reaches the upright part of the vine, then turns around and descends tail first.

I was always told, as a youth, "When coming down rocks or ladders, descend backwards holding on with your hands." I never did.

The Portal of Florence

Florence
May, 1961

Opposite, and detached
from the Duomo
stands the Baptistery
a baby dome
holding hands with
the Duomo across the street
a link
imperceptible
to the materialist
but unmistakable to the believer

The Baptistery is nothing more, nothing less than
the measure of a pilgrim's inner prayer
expanded to its
shelter-limits, safeguarding
its independence from
the public's intrusion

its architecture
crosscut precisions
sections
ZENITH-NADIR
EAST to WEST—
NORTH to SOUTH—
integrating all the spikes
of our
cosmic compass rose—
a stone shell between the turbulence
of street walkers
and the solitude
of the one and only world
of you and me
in meditation.
thanks.

a bus had
spat a hundred Dutch
tulipists and
English
mine spaders
from its iron womb
they were
forming a dense circle
face to face with
the
The
THE
closed Portal of the
Baptistery cast in bronze
spelling out in high-
relief the story of Christ's
apparition on this earth

no, No, NO
I shall walk on
pass by
the wolf pack
of art seekers on the weathered face of
the prayer house

I studied in my Vienna youth
bent devoutly
over the engravings of these
reliefs sheltered by a stone wall
of Archduke Frederick's Albertina
protected by her
seven-foot stone mass into which
were carved arched niches deep
 and shadowy
(in the Romanesque manner)
with sacristy-type windows
high enough up
that the light fell

like the beams of stigmata
 blessing my table,
covered with felt, parrot-green
 and soft
as the shores near my summer house
in Amagansett.

there,
in those niches
year after year
of timelessness
I absorbed the images
of Ghiberti's **alto-rilievos**
in self-communing
and do
remember every one and each
of the panels in their micro-details
I could not endure a moment's interference
with my love for them from
anyone tumbleweeding art
or
nose-picking architecture

 I turned quickly. Walked off.
 Stopped unseeing at a
 show window.
 Aimlessly entering the
 store, I fingered neckties,
 bought one.
 The soft tissue paper in which
 it was swathed overlapping the
 silk neatly edged into
 a slender wrap
 gave me a sense of
 reassurance
 the instant sheltered my childhood
 memory of Ghiberti's reliefs

179

I felt
secured from the
public gaze of
head-hunters of art
artifactors
news-brooms
sweeping dark corners

smoking eagerly
the charred butts
of past centuries
these buddies
chums of art
give me nausea
for hours unending

but
downdeep
the mirth of
bygone youth
triumphs
unyielding
yes and yes
a neverno
to surrender

Florence
May 20, 1960

("You must see—go. The Uffizi." "I will, I promise." And I went. Entering bumped at once into a large painting singly on a darkened wall. Yet it reflected (like a mirror) my own self, a hallucination of my own world of plasticity. I left quickly seeking the outdoors to breathe freely the neutral air of nature.)

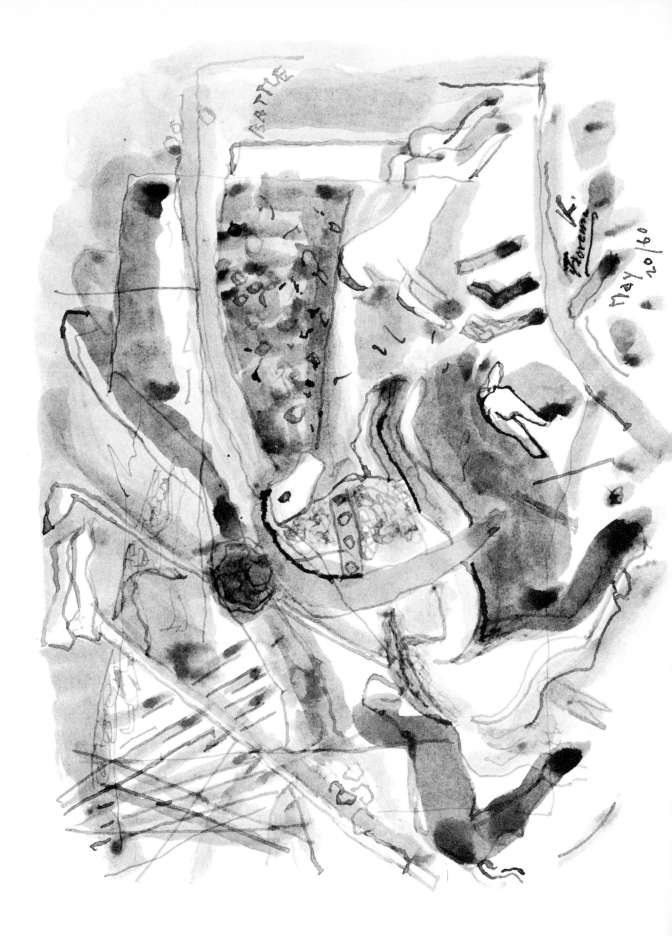

Paolo Uccello
of the Battle of San Romano

He plays ball with space. He twists
volleys, shoots straight,
shoots curved orbits
which boomerang home and bounce off
to new flights.

He throws men, armor, lances and arrows,
horses, beasts, trees and mountains
with the blindfolded security of a moon-walker
into nowhere and
catches them in mid-air

Thus he creates a man-made universe of space
within the spaces of nature
in constant motion and emotion

A fluid painting evolves and although
it is transfixed, it gyrates forever—

never mind the canvas, the panel,
the paint, it
could be shit or spit, it
jells to an objective reality
like a
hard candy
that rolls in your mouth
tossed by your tongue,
licked and sucked of its content until
it is absorbed making
way
for a new coming

(Now I know: the hallucination derived from my "Horse Galaxy" of 1951, exhibited in New York in four panels, one along an eighteen-foot-wide wall facing the visitor, one to the left, another hung from the ceiling and one more resting on the floor. They bounced forth and back, down and up creating their own environment. The ball game of the arts was on.)

Euridice *in Florence*

Florence
July 31, 1960

Staying unexpectedly, for lack of rooms elsewhere, at a deluxe hotel facing the Ponte Vecchio, walking in the evening over my childhood memory of this old bridge, in no way unreal, like a mirage of the past, finding the bridge actually transformed into a market street with its shop clusters hanging on to it left and right like Saracen-style birds' nests, making me unaware that underneath it all flows old river Arno with its yellow-green waters greasy as olive oil, sprinkled with dust of the setting sun; and then, continuing on the terra firma of Firenze, up and up but not too far up, toward the Palazzo Pitti, a name imbedded in me since kindergarten picture books, that Palazzo rising before me like a mountain range of edifices on a gravel-covered hill, closing off all vistas, the palace a stone giant bandaged in stone slings from rock to rock, with an endless array of blind windows like medals on his breast.

The main floor is pierced by arches as high and wide as the portals of St. Peter's, yet all blind, except for the very center opening at which we finally arrived for the evening performance of *Euridice*, by Peri of 1600, one of Italy's first grand operas. Two tickets provided by a member of the Italian antiquities conservation staff, who forsook them for our benefit, were waiting for us.

We enter the inner court. The view into the Boboli Gardens is blocked by a double-winged open staircase leading up to a fountain which we see from below as a black silhouette against the evening sky. The water overflows the basin's rim at such regular intervals and with such plasticity that it appears like icicles,

184

forming ever-spinning sculptures. The fountain is the perfect translation into life of the dream of an architect who long ago sold his idea to Signore Pitti, a wool merchant fabulously enriched by a brutal competition with the Medicis, a merchant to whom the world now owes this Palazzo with its galleries of art treasure, and behind it, the luscious Renaissance gardens where tonight's performance of *Euridice* will take place.

A silent cavalcade of dark figures, pilgrims to the Mecca of Opera, was steadily climbing the open staircase to the next plateau where the fountain stood. This procession then gradually spread out, released from the confinement of the staircase balustrades, but then again channeled toward vast wooden ramps temporarily erected in the oval of a dormant arena which was once a vast stadium for chariot racing and javelin throwing. The guests' steps are slowed by continuous uphill marching, treadmilling the ramps, which are of great length and at varying angles, the crowd always facing in the distance the pipe forest of the underpinnings of a huge grandstand that would hold two thousand people. When I and my lady companion finally reached mid-height of the scaffold, we emerged almost at the very spot where two canvas chairs had been assigned to us. From there we could see two rising hills; one, the garden-stage for the opera, the other, our own tribune, and in the valley between the two, the orchestra nestled.

Swiveling my head to the left and behind me, I saw the stands already filled to overflow with an audience of distinguished Italian citizens under a cool night sky, patient in their clamor for popcorn or *gelati*, subduing their chatter, denying the Italian temperament, waiting for the beginning of the performance. In this atmosphere of respect for the anticipated presentation of one of the first Italian operas, the matter-of-fact voice of a loudspeaker announcing the impending overture three separate times was the only incongruous sound jarring amidst the murmur of the somnolent Boboli Gardens, the quietness of the audience, the hazy shadows of the half-moonlit open-air stage. That stage rises in three levels, the center level dominated by an Arc de Triomphe through which apparently, the actors will make their appearance. Indeed a focal point for expectations.

The opera started. Two fountains on the middle level awakened the stage from its slumber by raising slender water jets into the air higher and higher and gradually falling and retreating into

185

silence. Then the flutes took up the sound of the fountains, mellowed by the lingering cirrus clouds. The harpsichords quivered their wings like pigeons released from a cage, enjoying their freedom, then effortlessly rising and gliding on sound-waves. The cold night lights of the garden were transformed into rose and faint ochres. The steps and terraces of the open stage-hill were waiting to receive the players. The opera held its breath. And, then, as if a curtain had parted, one could see now, behind the tripartite Arc de Triomphe and beyond the three stage levels, an endlessly rising hill like a stair without steps, creating the theatrical illusion of a continuous ascent on which figures slithered downward now until they reached the Arc. Seeping through the three archways in slow motion the figures gradually froze into groups, choreographed with marked precision.

Orpheus, expected but not in this manner, appeared momentarily from behind a pedestaled statue of Artemis in the middle vault of the arch, descending in a pale, star-blue costume of high Renaissance style, embracing a miniature golden lyre in his left arm, holding it close to his body like the baby-savior in which he believed with unflagging certainty. Descending continuously and reaching the lowest of the three levels, he raised his right hand as if separating past from future, and, after a brief pause in which the birds of the harpsichords settled down peacefully and the flutes began to open the way for his lament, he invoked the first aria of the opera.

Chorus members started to move behind Orpheus, and soon all three levels were filled with joyful people carrying garbs of corn, baskets overflowing with flowers and fruits. I was astounded at this intrusion of gaiety, so incongruous in the great tragedy of Orpheus and Eurydice, almost sacrilegious. What liberties were being taken here? The augmentation of the choral voices and Orpheus' keyed-up tenor aroused my suspicion as to the sincerity of the production which could so easily have slipped into music-hall parody. I felt it had gone too far. At any minute this mood might be heightened to a pagan orgy with sacrifices of sheep. A hunter's horn might pierce through the surrounding forest, and stags suddenly show their stunned heads between the columns of the Boboli Gardens only to be blinded by the flash of a paparazzo's bulb. But, splitting this mood, a funeral procession made its appearance downstage-left. All movement in the chorus halted.

Garlanded with laurel leaves, gowned in sapphire silk and golden shoes, Eurydice was carried in upon a bed of roses and laid down with the slowest of motions, a moment of rest on her voyage to the abyss of no-return.

Dark gnomes, crumpled ballet dancers in black, eerie purples, and greens, with masks of faded nights and days smoked to ruins, gesticulated impending disaster among the gay crowd of the chorus, which soon fled to the left and to the right in mounting anguish, and finally forced Orpheus to abandon the grove. A pigeon flew into the beam of a spotlight high above the trees and appeared for a split second, radiant white.

The scene darkened. A cerulean veil was cast on dead Eurydice by her bearers. They lifted the gauze by its four corners into the air and downward slowly, and up and down again over Eurydice's body, as if through this motion the lightweight veil would be made even lighter for Eurydice to bear. Now she was carried from the first level up the steps to the second and to the arch above.

There, the bed was slightly tilted, the blue veil cast off, and when the last of the bearers disappeared in that darkness which had fallen with leaden weight, Eurydice was seen standing alone, garbed in luminescence. Her figure trembled, awakened from death. Reborn, she started to move and soon melted into the night of the grove.

Second act. Hades. The gods of the underworld in black velvet, dark silks, plumed headgear and armored steel. The wailing voices come from chorus-bodies wrapped in gray and grayer costumes, larvae of sinister fate, moving continuously about, crawling on all three levels in a quest for lost souls, ever-searching, never finding. Ten strokes from a nearby bell tower are now heard. Its hammered rhythm becomes part of the scored fate.

Eurydice is seen on high, arisen; Orpheus downstage, transfixed.

The Hadean gods discuss their guilt. Never have I heard basso and baritone voices more surging, encompassing the stage like heavy chains of sound. The tribunal of demons pitch their rites to a sadistic climax; they torment Orpheus and Eurydice by making them touch hands, the living and the risen dead. First enchained,

then dissolved, Eurydice is led away.

The grove grows darker, blackened by her withdrawal; the larvae of human figures pursue one another out of the gardens, their fatal deed done. A night of hellish corruption has set in.

The third act was the surprise of the evening. The tragedy should have deepened to a fathomless abyss. But none of that. It was in reverse.

It is noon; it seems that many suns are shining. The garden is suddenly a market place of joy, a cornucopia of color and movement, the exuberance of gaily costumed people, flaring banners, dancing as if on wings of victory. Why?

Orpheus appears, singing the great aria, using his lyre for the first time. It is the song that has made the hidden sun rise.

When the crowd disperses, Eurydice is seen standing on the middle level, immobile, as is Orpheus below, only his hands and lips moving. He is unaware of her presence.

On the highest level a triumphant procession carrying Venus in a seashell drawn by white oxen moves by. Hounds on leashes spreading from the hands of Renaissance-clad guards flank her caravan. Venus is dressed in the tropical red velvet of Perugino's palette. She steers her carriage toward Eurydice, stops and descends. She takes Eurydice and leads her to Orpheus.

In a triumphant gesture, she clasps their two hands in eternal marriage and in a burst of joy, the stage is overrun by an abundance of *putti*, angels in human shape, children of saintly nakedness. A stage effect so apt to destroy the whole production anywhere, but not here, where overflow of eloquence is the natural taste of the land.

Only a month before, I had seen the Brazilian film *Black Orpheus*, a beautiful portrayal of violent emotions, desperation, and the burning of orchids in Hades. In these images, the yellow fires of hatred and revenge—the Grecian and the Northern myth of love destroyed—embody the traditional sadism of the story of Orpheus and Eurydice. But none of this in the capital of Tuscany. Italy's vision of their love ends well.

188

Did not someone ask Hermes in *Black Orpheus* the question: "Is it the truth that love must die with life and cannot survive death?"

"No," answered Hermes, "it is not the truth. Love is Eternity."

Florence
May 19, 1961

Firenze

the luscious thighs of the earth
carnivals of male and female bodies
hills of torsos spreading wide
outstretched ridges, knees bent,
hills of breasts and bellies
niches of pits and hollows of navels

—————————— ——————————

and in one of the folds
of the earth's flesh
nestles
Florence

—————————— ——————————

the landscape bursts again and again
into a terra-cotta rash
the pink scales of tile roofs
which meander toward the horizon
rising and falling mount
fading slowly into the haze
of a cobalt sky
sheeted in vapor

—————————— ——————————

but there where the lowland,
almost flatfold of the valley
 lingers lazily
the fertile earth of Etruria
brings forth with vigor and
ultimacy

———————

a giant cupola
the all-mother breast
of the **DUOMO**

———————

ripe to lactate
the secret sap of eternity for
every sacrificial lamb
squirting its milk, equally generous
to sacrilegious heretics
to fanatics of blind faith
to every doomed
or saved child of christendom and

———————

the **DUOMO'S** *black and white marble sheeting*
not black and white any more
(so many sunsets absorbed)
now faded rose and aged green
indoors benighted
outside radiating
the bliss of Italy's sun

———————

the octangle walls are
cut into frames of blind windows
one to one, each next to one
above and below the other
endlessly repeating the patterns of squares
a black cape with white lining
forming a Carrara cloak
around the DUOMO
free standing and fearless

Giotto's moon-blue campanile
is the dagger at the side of the DUOMO
readied for defense
of the body religious
hidden inside
naked, vulnerable,
securing in the
dark embrace
of its vaginal cave
the sacred peace
of lost souls

1959

Rainford of Triple VVV

March 10, 1959

Phoned Rainford today, the Negro photographer who so sensi-
tively photographed the "Endless House" model seven years ago.
A new model is ready to be photographed.

Percy Rainford is about fifty, tallish, of a flexible body, a Negro
with a certain paleness, the down of a white man's skin. A com-
bination which pleases both races; as far as I am concerned, I
prefer crossbreeding to automatic racial incest ad infinitum.

I first contacted Rainford in 1947, twelve years ago, when we
needed an inexpensive photographer for the surrealist magazine
review, *Triple V*. His price even then, as now, was three dollars
for one photograph. But we could not even afford that. Neither
André Breton nor Marcel Duchamp nor I had more money than to
pay for carfare, a sandwich, or telephone calls. Rainford pa-
tiently waited two years to be paid for that job.

He still lives on West 57th Street, in one of the old brownstone
houses, with no namecard in the entrance hall, semi-anonymously,
perched at the very end of a sinister corridor, in one room and
two niches, one used for developing and one for printing, the
whole habitat half artist's studio, half machine shop, lit by one
meager window looking out into the prison yard formed by
crumbling apartment houses leaning on one another. Fifty-seventh
Street has changed considerably in these last years. His own
building had been remodeled too, but his studio has remained un-
touched, like the forgotten set of a Biograph film production of a
half-century ago.

He is so unusual a man and a photographer, such a delight to be
with and to play with—like grandfather's golden pocket watch
which you inherited with its soft chamois leather bag protecting
it from dirty touches and looks, and you pulled it out of the bag
not to see the time but to feel the smooth golden surface and to
hear the click of the *couvercle*. Thus I automatically called this
morning when I needed a photographer. He, too, opens up as a
human being.

194

Today, in the era of the slick-clicking Leica, he works with a big hatbox of a camera, the type you see only in posters advertising portrait photography on boardwalks or in Luna Parks: a magic box on top of a tripod mountain. The upper half of the photographer's body disappears under the black cloth hood which then becomes a cloak, and, with the apparatus, an armor of mystery.

When he emerges from this cave dwelling, his face is still pale from the lack of sun and the abundance of night inside. He seems surprised to discover that what he had seen as an image on the ground glass is actually there in the room. For him, reality is on the glass of the camera, and the dream is the object which stands outside, in front of him.

I wonder if he could ever be sure which was more real than the other—and that is exactly what emanates from his pictures. He is the only photographer I know who portrays with sharpness and exactitude what the camera, not his own eye, sees, and that is a very rare quality in times such as ours when every member of our society not only believes in himself as a great personality, but also forces any type of mechanical equipment to show personality too. The effect of his prints is a perfect balance between vision and fact.

Before Rainford arrived, the magic boxes of his various cameras were already waiting in the corner of my studio, brought there by his assistant. Alice, Ralph, Arthur and I rushed to build up a tall paper background behind the model to shut out the daylight from the loft windows. We borrowed easels from our neighbor, who uses collapsible ones for his evening classes of drawing from the nude model. Ralph chased after a dark gray paper all morning; needless to say, that color was not to be found, although usually available, and so he had to compromise and take black. It later proved to be the perfect color.

While Ralph was out shopping, we poised six easels in a semi-circle around the model, lined up thumbtacks here and there, and had Scotch tape ready for an emergency. Finally, the nine-foot-tall roll of paper was stuck through the door by Ralph, like a fanfare of good hopes. We opened it like a Torah roll, from the middle toward both ends, so that the ends would be stiff, like two columns holding themselves up, and they did—but the middle kept caving in despite our tape and thumbtacks. There was simply

195

nothing else to be done but to take advantage of the image of this crumbling paper wall which I hoped would appear in the photographs like a background of heavy, rocky mountains.

The most difficult thing, of course, was the lighting of the "Endless," which was only formed of wire mesh: the lights fell not only on the surface, but pierced through the mesh, making images like X-ray photographs, without body and form. They were beautiful to look at, but were even less than two-dimensional. The house looked like streaks of black smoke dispersed in curves and parabolas over an indefinite horizon.

Just as Rainford arrived, I finally succeeded in forgetting the model while working under the black hood looking at the ground glass, and directed the posing of the various lights so that they struck only the outer surface of the model without piercing into the interior. The light, therefore, had to be planned entirely from behind the ground glass, and not, as we did it once before, by viewing the model itself.

When the proofs came two days later, we were all happy to see that he had succeeded in forming the total image, bringing out its plasticity rather than its fragmentation, as in X rays. The eagerness with which we had awaited the results was shown when the proofs arrived at the studio: everybody abandoned his work automatically when Ralph made his appearance through the studio door waving the large envelope containing the proofs. We huddled together like football players gathering to hear instructions from the coach before dashing off, everyone to his assigned post.

We knew that it was the last time the model would look as it did when the pictures were taken, because we had already started to cover the naked wire mesh with the dough of concrete. The transparency and glitter of the copper wire will now vanish behind the solid shell of concrete as the sun disappears behind the massive Earth. But, thanks to Rainford, we had fixed the model's years of youth. The prints were magnificently alive with the work just past.

Frank Lloyd Wright

A student of mine came unexpectedly into our workroom at eleven o'clock this morning. She held a newspaper in her hand and said, "It's a sad day. Frank Lloyd Wright is dead."

Only two days ago, I heard once more from grownups (and valuable people) the comment I have heard so often this last year: "That Guggenheim Museum is a monster. A disgrace to Fifth Avenue. A disgrace to modern art and architecture. It looks like a giant Mix-Master. Take it down."

I have always answered, and this time, too, "Don't judge buildings without entering them. We shall know better when we have been inside. I refuse to give final judgment before that. But it already appears to be the most individual, the most structurally progressive building in New York. It outdoes easily the glass and aluminum strip-tease façades on Park Avenue."

Wright's museum could have opened by now. It is practically finished, I am told. But the trustees wanted to wait and have the opening coincide with his ninetieth birthday this coming June 4th—only a short span of time away. After twelve years of work on the Museum plans, he died just two months before completion. Damn fate. He had hoped all his life, a long life, to have at last one building in New York City, the spiritual capital of his own land. He was a head-hunter. But it took him a lifetime to get his trophy. They always chased him off.

Since the plans for the museum were first published, he had worked against incredible difficulties arising from antiquated building laws and from the obnoxious *idées fixes* of art directors. With the "spiteful arrogance of honesty," to use his own term, he wound his way above, around and through the almost insurmountable obstacles, finally to see his building erected and almost finished.

Sisyphus, for the thousandth time, had rolled the heavy rock of his dream up the mountaintop. Legend tells us that the rock always rolled down again into the abyss. Wright beat the mythos, and perched it on the summit. And there it stays, immovable. But the creator himself tumbled down. A small obstacle in his in-

197

testines he could not overcome. He was operated on last Friday, six days ago. "He held his own well until one hour before his death." A lifetime hour before Eternity.

June 10, 1959 A new American magazine published by painters and sculptors, *It Is*, invited me to write on the death of Frank Lloyd Wright. I had a slight suspicion that since Wright was so much against modern art, they expected me to make an all-out attack on his Guggenheim Museum. But how much and how often can one be misunderstood by one's closest professional friends?

Stand Up and Take It

The Left Cheek	*The Right Cheek*
Frank Lloyd Wright, most crafty of all American craftsmen, is dead. The greatest of American craftsmen in architecture is gone to a point of no return.	*Frank Lloyd Wright, antichrist of modern art, has spoken his last word in concrete.*
The craftsman of unpredictable surprises has failed to surprise the old standard, death. Any small talent's work can be predicted; not that of a great one. Death is average.	*Instead of a museum he erected a mausoleum to architecture, and it is here to stay.*
We know what the mullion-glass-and-steel boys will do—the regular banks, churches or synagogues, sure enough in latest modern.	*The building is like a warning fist risen from the earth. Finger after finger winding their grip, ramps closing in on all open spaces and making it concrete.*
The unexpected is the genius's privilege and burden. Who could predict Michelangelo as the architect of the Campidoglio. Everyone knew what Bramante would do; but not what Michelangelo could arouse with architecture.	*There are only entries, no exits. You are captured by your own memory of the structure.*
	I have compassion for those modern artists who must smuggle their art in like contraband. There, they are intruders.
	But I also have compassion for the man-of-no-compromise in his rejection of a credo to the extent of denying to a building the very function it is built for,

198

No one could know what Wright would do. Not even he.

But we know what "they," the colleagues, could do to him. And they did.

in this case for exhibiting contemporary art, so completely that it is the ultimate achievement in non-functional architecture. So be it, as dictated by Frank Lloyd Wright.

The man who hated abstract art produced the only abstract building of our time. It is not really fit for exhibiting either painting or sculpture. Yet it exists in full validity as architecture per se.

If architecture is the art of making the superfluous functional, Wright has achieved it.

In affirming the existence of cosmic space he made his architecture functional on earth.

Baby-bourgeois, make the best of it.

Persistence of Inner Vision

11:10 A.M.
June 18, 1959

The sculpture which I am finishing now at the foundry is a strange break through the traditions of sculpture, and an interesting persistence of an idea which I've designed again and again for several weeks, forgotten, designed, forgotten, designed.

Somehow one feels, while actually executing and indulging in the physicality of these procedures, that the original concept of an idea would at least get partly lost or deviated from or changed, but not in this case—not in my cases altogether. They persist. They

199

come back in spite of being unwanted.

It seems that somewhere in the chambers of my body, there is a woman who is stubborn, unconciliatory, persistent in her ideas, whom I simply have to follow blindly.

Because this sculpture is a combination of bronze and wood, a combination of wide spatial three-dimensional expressions to be married to an engraved painting on a flat bronze plate intersecting this monument to space at strange angles, technically very difficult to inter-build, I've done it patiently, like moon-walking, for many months, continuing on a monorail of inspiration, balancing my intentions with the unique security of a sleepwalker, pursuing all technical preparations with the help of my assistant, and with Alice, who drives me back and forth to Astoria, until I'm sure that today or tomorrow the whole complex, including an eternal flame continuously singeing the wooden part of the sculpture, will be finished. I feel the achievement of the uncalled-for seems inevitable sooner or later.

Yesterday, I drove out again with Ralph, Alice and Lillian—one my assistant, and the others two good spirits.

I had bought two tickets for the chief bronze workman to see *Redhead* with Gwen Verdon (which he told me he would so much like to see) so that he'll be sympathetically inclined, both toward the mad rush and pressure under which I am doing the sculpture, and also toward the somewhat strange techniques which he has to carry out to satisfy the details of my concept. He was very kind yesterday, and, relying on his monumental German physique, he worked incessantly for four hours, like a Munich beer horse in a steady, relentless gallop—until I called, "Brrr . . . Halt!"

It is now just after eleven o'clock morning and I'm making myself ready to be driven out again by Alice, to keep up the tense procedures there, but I unexpectedly heard from Jackie that Mrs. Leyden of Holland had phoned, having arrived from Jerusalem, apparently wanting to see me about her Humanities Building project.

Now, between eating my customary eggs and coffee and dictating these lines, I'm waiting for her second call; the first call I couldn't take because I was dead tired and still sleeping, and Jackie was

kind enough not to wake me. No doubt, I will have to cancel my trip to the bronze foundry, scheduled for twelve o'clock, to be with her. Sorry; I was all set for it.

Incomprehensible to me why she hadn't wired she was coming, but being a very decisive woman, she must have taken literally my letter suggesting that she hop on a plane and come to New York. And here she is at the Stanhope, a smart and conservative hotel fitting her personality well. I'll have to be alert and courteous and wise in receiving her, being her guide, taking her to Katonah to show her my theater, then to my studio to see the "Endless House," receiving her first at my official office rather than in my home or in the studio, trying to be a gallant escort as well as an architect and businessman. She hasn't phoned yet, but Jackie and I are waiting, on the alert.

12:15. She has just phoned again. Appointment is for tomorrow at eleven in the morning—at her hotel. Will it be broken?

I will now make my way to the foundry. I'll phone Alice to pick me up quickly. The foundry closes at four.

Telephone Calls

2:30 P.M., Wednesday
July 1, 1959

This is the third day after sending off the letter to Mrs. Leyden. I know I couldn't already have an answer today, although she could have phoned if it had been urgent for her. But nothing was in the mail, not a sound over the telephone. Evidently, it was not urgent.

I am waiting. I am waiting with simulated patience.

Noon, Thursday
July 2, 1959

Finally the call.

"I am in New York. I'd like to see you," she said. It sounded hopeful. We made a new appointment for six thirty in the evening at my studio.

201

At six she phoned: "I'll be late—an hour. Do you mind?" She didn't know if we could have dinner together as I had suggested.

She came half an hour late, a typically sturdy Dutch woman with a bright intellect. She was most anxious as to whether her former secretary from Jerusalem, now living in New York, would find her way to my studio, the address of which she had given her.

We started talking. But she got up and went to the window again and again to try to see her secretary in the street, approaching the house. We finally had to write a note and tape it on the house door downstairs, directing the secretary to come up.

In between these concerns we talked about the project. It was to be an international center for scientists, philosophers and social planners who would meet there at regular intervals to approach the problem of disarmament and peace on a moral rather than political or economic basis. She had devoted many years to the project and had acquired the lands in Jerusalem. The next big problem was to translate her humanistic idea into a plastic expression of architecture. The building must not be merely a conglomeration of meeting rooms, dining facilities, library, auditorium.

I showed her our plans for the Shrine of the Book in Jerusalem and those for the "Endless House," with which she apparently was taken. I tried to induce her to make a decision as to whether I would be the designer. She finally suggested that I should come to Jerusalem to present a sketch. I accepted. The secretary arrived. A forty-year-old woman, apparently divorced, my guess being based on a certain self-imposed self-assurance, an independence which is often the result of a disappointed romance combined with a successful career. She was dolled up in a mass-produced black and white organdy dress, neat and hygienic, an Americanized Palestinian.

Mrs. Leyden forced me to show her the plans for the "Endless," which she looked over with reserve, asking the famous five routine questions over and over again:

"Where are the bathrooms?"
"What kind of furniture?"
"Where are the closets?"
"What kind of stove?"

"Can you close the rooms off?"

It was nine thirty and I was desperately hungry. I invited them to come with me to Lüchow's around the corner. Both had eaten some hamburgers, I was told. Mrs. Leyden didn't want to go. I, however, felt like celebrating because she had finally conceded to my proposed agreement. I was sure she was going to sign the contract-letter. But suddenly she became distracted by other business activities which her secretary brought up. The Humanities Building got lost and our relationship became "off-beat."

Lüchow's was a North Sea of people in a holiday mood, tossing and churning on waves of cold brewed beer. It was Rotary's Lion Day in New York, and I had not known it. Even while eating, people were swaying to the rhythm of a salon band, and it was impossible to discuss anything.

Mrs. Leyden consented only to a tall glass of beer, the secretary to ginger ale, while I ate a naked piece of meat. Both were stunned by this vast German place in New York, a mixture of Old Heidelberg, Munich and Yorkville, framed by carvings in hardwood like swollen epaulets of U-boat commanders or the oak-leaf insignia of deer hunters of the Black Forest. The whole restaurant was a gigantic beer mug in whose belly vast mirrors gave the illusion of even a greater "Reich" than it actually was. Each eater saw himself multiplied and glorified in an endless perspective of false depth. It was indeed not the locale for the birth of a Humanities Building.

The secretary said, "You know, Mrs. Leyden, we have nothing as large as this in Israel."

I: "Lüchow's has existed for fifty years, long before theoretical Palestine became realistic Israel. I am sure that in fifty years you will have a restaurant at least as expansive as Lüchow's. This is the natural result of industrial growth and success."

Mrs. Leyden looked pale and tired. She wanted to go home, but also wanted to see my apartment with its view of New York. Living on the same street as Lüchow's, I got a cab and we three ventured over to my place. A stormy sky around my skyscraper was most impressive to her. So were the town and the rivers, and the multicolored stars: the thousands and thousands of checkerboard

203

windows of Manhattan with their mosaic of varied light intensity.

"The most fascinating sight I have ever seen," said Mrs. Leyden. "Let me stand quietly at the railing and take it all in."

Looking out over the luminous Hudson River, she said, "From here, high up on the twenty-second floor, there is a deep drop to the street below. It reminds me of suicide."

"You sense right. Two people committed eternity by dropping off the edge of this brick canyon."

We came back into the apartment, and an unexpected glow came over Mrs. Leyden's face when she saw my large sculpture, "Totem of Religions." She asked her secretary what she thought of it. The secretary remained silent. It was evident that she was reluctant to see her employer impressed.

Nevertheless I was quite sure that we had reached an agreement. (O Thou incorrigible optimist!) I also felt that it was not up to me to press for a signature, but to wait for the formality until tomorrow.

Friday, July 3, 1959 The next day, I was expecting her call, promised for six o'clock.

I spent the whole day working at the foundry, where a most exciting incident took place. I hope to record it later.

Back with Ralph and Arthur at the studio at six, I received a visit from a southern friend of Alice and Lillian's, a neurotic, self-centered inheritor of a wealthy family's fortune, a grim but polite man. I left it to Arthur to show him the model of the "Endless," as I had promised, Ralph making drinks, Alice and Lillian forming the reception committee, walking around the "Endless" with their guest, while I was stretched out on the couch with my hand on the telephone, waiting and ready to pick it up and hear Mrs. Leyden say, "I'll be right over to sign the agreement." I knew that in three days she must leave for Amsterdam to visit her sick son.

The telephone rang at half past six. "I've been thinking about our project, and have decided that if you come to Jerusalem with your new plans, it would be a bombshell, because you are not an

204

Woman, Woe-man
have joined
the military army

now they have
joined business

peaceful sex
has been replaced
by hard
business strides
but in every woman
there is
a reluctance
to final decisions

profit or no profit
pride or disgrace
self-assurance
is the key
to all no-deals

business
propositions
melt away
the hands
are washed off
with girlish
innocence

Israeli. It might blow up my whole project."

"It was you who wanted me to come to Jerusalem, but there is actually no need for that. I can meet you in Rome or Amsterdam. It doesn't matter to me where."

"You are right; that's an idea. Amsterdam. That's good. My son is there, too. We can huddle and scheme together undisturbed. But excuse me now, I have a dinner engagement. Won't you call me at eight o'clock sharp, and then I'll see that we meet. I want to so much. I am rather tired."

I rang her at exactly eight from a Hungarian restaurant uptown, chosen for its proximity to her hotel, but I was given another number, the exchange indicating that she was downtown near my studio. When I called that number, she answered in a jolly dinner mood. She said, "Yes, I am here with friends. Won't you call me at nine thirty at my hotel?"

"Certainly. I'll be glad to."

Luckily, the service was leisurely at the Hungarian restaurant. The place was overfilled with people, and so were the dishes with food and cream and cabbage, and the time didn't go too slowly, just right. At the appointed moment I conjured some dimes and dialed her number carefully; the hotel clerk told me that madam was not in, and gave me the other number again. I was hurt. I left my name and hung up. I felt humiliated, a fool. I decided to stop treating her ego gently. The affair was finished, as far as my initiative was concerned.

Home after midnight, I found no call, no message from her. But the next morning I heard the phone at nine thirty, although I had turned the bell down. I knew it was she, "The nine-o'clock business woman." I did not answer the ringing of the telephone. It was meaningless.

The next day I hurried to the country for the weekend. That Sunday was probably one of the most beautiful displays of nature's nonchalance in her abundance of giving, and giving, and giving. A cool breeze in mid-July, shot through with glowing rays of the sun, producing even cooler shadows under the big tree of the country house where I rested. A reed chair held me snug.

205

Next to our lawn, behind the white picket fence, a mass of cars was ejecting families with their picnic equipment and fishing rods. Boys and men quietly lined the edge of the Delaware Canal, enjoying the Fourth of July holiday.

Watching this carefree crowd, I felt isolated and stirred at the same time. My cradle had stopped rocking.

Montreal

2:20 P.M., *Monday*
July 13, 1959

Ten days ago a man called my office from Montreal. "Is this the office of Mr. Kiesler whose picture of the 'Endless House' appeared in *Time* magazine last week?"

"Yes," replied Ruth, the office secretary. "What can we do for you?"

"My name is Douglas Owen. I am a lawyer. My father and I own an interest in a wonderful real estate plot in Montreal, and I will come to New York to find out if Mr. Kiesler would be interested in being the architect for an apartment building which we intend to build there."

We met late the same afternoon at my studio. The meticulously groomed young man amazed me with his absolute straightforwardness.

"How old are you?" I soon asked him.

"Twenty-nine."

"So, you have one year more to conjure up ideal projects."

"I have as long as I live, I hope."

And I trusted him.

206

He revealed that they already had an architect's plan for this apartment house, but he thought it nothing more than the ordinary modern glass construction which, he said, made him sick because of its general application of the same aesthetics to office buildings, churches, homes and apartment houses. They were ready to abandon this first plan. He had been about to visit Le Corbusier in France to ask him to design the building, but had decided against it for the time being because he thought Le Corbusier might be too set in his own style and do nothing more than transplant it to Canada.

Young Douglas was, he said, ready to print a full-page ad in *The New York Times* under the heading, "Wanted: Architect with imagination, etc." when *Time* magazine fell into his hands with the "Endless House" illustration. He did not hesitate to take a plane the next day to visit me in New York. For once, *Time* came in time for me.

Two days later I flew to Montreal to meet the father, see the plot, and return within twenty-four hours.

At the end of the day's conferences, we agreed on the main terms of the contract between us for a co-operative apartment house to be built at an approximate cost of three million dollars. I am now waiting for the outline of the contract which I am sure will arrive any day. It certainly would be a triumph for me as far as bringing business to my office. That's usually not my job.

Twenty minutes before I was ready to leave for the Montreal airport to return to New York, Mr. Owen, Senior, asked me to wait another minute (I already had my hat in my hand) so that he could show me the perspectives of a large new office building of his now in construction.

The usual glass cage with glass doors, two Miës van der Rohe Barcelona chairs, and rubber plants around a side table; a marble floor, a marble wall, an acoustical white ceiling. "But listen: my architect wants to make a waterfall along the stone wall in the lobby. What do you think of that?" "It's hard to say. Seems entirely decorative and of no promotional value since the clients are already inside the buildings—but let me see the floor plan and perhaps there might be some way to apply this idea more effectively."

They rushed the plans in. I could see that the structure was set back from the building line. Quite unusual for a main street. "You see, the Building Department forced us to set our building back twelve feet from the actual building line and we had . . ."

I interrupted: "That, of course, changes the whole picture. Why don't we move the waterfall from the inside to the outside? You have an empty twelve-foot area for a basin that it can tumble down into over a large bronze sculpture, the water cascading in front of the big windowpane of your lobby. Illuminated from above and below at night. Heated during the winter to defrost icicles and keep it flowing continuously. It would distinguish your building from any other in Montreal. And I don't think it would cost much.

Mr. Owen was nearly bursting with joy. He called in his son and his son-in-law, explained my idea to them, and got an immediate reaction of such enthusiasm that the deal was almost closed on the spot.

I asked for a piece of paper and put down at once the view of the sculpture and the waterfall as I felt it at that moment. It really suited the needs of the building almost to perfection. There was no doubt in their minds that Montreal and Canada would be richer for this idea and so would their investors.

A few minutes later, I hopped into the car and was driven to the airport.

Wednesday, July 15, 1959 The office called to say that a message from Canada asked me to be present in an hour so that I could receive a telephone call.

It was young Douglas Owen. He wanted to tell me that the contract for my work on the apartment building was on its way to New York. However, he added, he and his father had found that too much money had already been spent on the interior of the lobby of the office building for them to afford the waterfall and the sculpture.

I did not say, "You are making a mistake; the ten-thousand-dollar cost which includes water, casting, basin and sidewalk tiles is an

exceedingly good investment. As a promotion scheme for a new skyscraper on Main Street it is most inexpensive." I did not say it. I am making progress socially. I was glad that I had been courteous enough to give thought to their second project—the office building—although the first one wasn't in the bag yet. I am learning to wait and hold back the reins of design.

Wednesday, August 5, 1959 The air felt thick in Montreal as I stepped out of the air-conditioned plane. My throat felt as if it were held in a too-narrow collar, and no way to unfasten the button. I recalled this fact only later as a bad omen.

The airport-to-town avenue appears to stretch just for the sake of stretching, as in any other large town, with casually placed factories and manufacturing shelters in mullion-glass construction, punctured repeatedly by open slum terrains. These, the modernistic glass boxes, seemed to have been transported directly from New York's Park Avenue to Montreal's suburbia. Nothing to do with the new Waterway. It's via *Life* magazine and architectural publications for twenty-five and fifty cents that the latest fashions in Architecture and Art get distributed.

At the beginning of the city proper, a heavy stone structure spreads out unexpectedly along the avenue and draws attention like a major-domo among domestics. It is le Musée d'Art. And behind it I can see the mountain: Mont Real.

If there ever existed a petit bourgeois mountain, this is it. And as a flashy chain across its belly, it wears Main Street.

Douglas, who picked us up at the airport some minutes belatedly in a café-au-lait-colored open car, told me at once that his father was not available since he had entered the hospital two days earlier for his yearly checkup. Indeed a blow to me, since I had come to sign contracts—or at least hoped for that, and had therefore invited my lawyer to come along. The news was a shock because I had spoken with father Owen a week ago and set the exact date and hour of my arrival. I started wondering, between polite chitchat, how—under these new circumstances—I could manage a contract without the presence of the old man. My arrival seemed suddenly so superfluous.

209

Hardly out of the car, I searched for a solution to make the best of the situation. I tried to formulate some agreement that would prevent a break-off after so much hope of acquiring an interesting project. Between my anguish and attempts to keep grinning, I must have looked pretty lost.

And the adventure did come to a near breakdown that day. "You see, my father is an old-fashioned man. I understand his situation better now. I know you can't work for us without being paid properly. I didn't know that you would need the assistance of one or two designers and engineering consultants to develop preliminary plans for this apartment house. I thought that with your genius you would just sit down and make some sketches by yourself, and for that my father would be willing to spend three or four thousand dollars, although he could get preliminary sketches from the architects here for nothing, they are so eager for work. But I want you, and so does Father."

My lawyer was in revolt and threw me angry looks.

The Royal Institute of Architects' normal percentage would bring the fee for preliminary plans on a three million dollar structure to $35,000. Father Owen would be willing, according to Douglas, to go up to $3,000; more would be unimaginable for him unless he could first see something, approve it and be sure that he wanted to go ahead with the project. But he admitted that big and small firms are scabs even before a strike is called; they work without charge, submitting sketches for bait.

I cut through young Douglas' dismay, devising a four-point staggered payment system starting with $4,000. After that, the owners would have the right to accept or reject without further pay, but with the obligation never to use any of the designs or ideas either directly or in variations. I dictated the agreement and both men took it down by hand (the secretaries having left long ago).

Aslan, my lawyer, wrote it with a ball-point pen on a yellow pad; young Douglas Owen, sitting at his father's desk, with a pencil on the back of a letter. What a contrast they offered in appearance and mentality: a fox and a puppy dog.

I invited both to dinner at a Viennese restaurant near the office. Young Mr. Owen suddenly disclosed that he was terribly inter-

ested in the theater, would like to produce a play, had seen Robert Whitehead in New York about it, was astounded and happy to hear that Aslan is a member of a famous firm of theater lawyers and of the Theater Guild of New York and that I designed, in 1922, the Space Theater in Vienna and was Scenic Director of the Juilliard School of Music for twenty-six years.

He spoke of his friend McCleary, whom I knew as a maker of abstract films for the Canadian Government. McCleary joined us later for dessert. An elegant, younger version of Douglas Fairbanks, Junior. Douglas Owen was eager to have a play written where abstract film with sound music could be used as background, and asked me and Aslan if we knew of someone. "I have the money for it and can find more any time."

His attitude of caution had changed to exaltation. One project had evaporated but another seemed to be coagulating. I could see now that he had the real love of an amateur for the theater, but also that he might easily turn into a playboy with projects.

remember
every face has two profiles
we like to face a face
face to face
but a head turns
and only gives you a measure in half
the nose is more expressive that way
but the look of the eye is lost

make the best of it
listen to the jitterbug
of the frog's lips croaking

Thank God the Viennese goulash was excellent and thanks to its taste I could swallow what I heard.

"I am also very eager," said Douglas, "to bring *The Threepenny Opera* to Montreal. We would play it one month in French, one month in German. I could not make any headway with this when I was in New York last. Could you please help me?"

211

"Of course, I have known Marc Blitzstein, the adapter, for many, many years—about twenty."

"Then you could talk to him about it, yes? Could you? Would you?"

"I'll gladly try, if he is in New York. Of course."

Young Douglas appeared transfixed in dreams.

Aslan and I flew home in capsules of silence.

August 13, 1959 Douglas Owen had said he would call me Monday or Tuesday after discussing with his father the agreement we had outlined. Today being Thursday, I let my old bones speak to me. They told me that if someone in America says he'll call and does not, it means unmistakably: "No."

I rejected my superstitious bone and decided to call him.

He told me, as I listened along the wire from New York to Montreal, that his father could not make up his mind to go ahead with the three-million-dollar project right now. The news shook me, particularly because I had staggered the payments for preliminary plans three ways to accommodate the father—the first being only $4,000, a nutshell of a payment harboring a great mass of work.

I reread some of his first letter to me, and some of his last, and I gasp for understanding, dear reader.

From the first:

"We would like to make some satisfactory financial arrangements whereby you could come to Montreal and examine some of the sites on which we propose to develop certain of our projects, and if you can spare the time and a definite agreement can be arrived at, I am sure it would redound to our mutual benefit. Our interests are not only pecuniary ones; primarily we think there is an opportunity in this unique city of ours to give the public something aesthetically and architecturally outstanding, and yet not be too daring or hazardous from an investment point of view.

212

". . . what is being done here . . . we think could be considerably improved by creative and functional planning by an architect of your stature."

And from the last:

"I would like to say at the outset that both my father and myself fully appreciate the consideration and interest that you have shown our project, and particularly the personal rapport that I feel exists between us.

". . . I attempted, and I think successfully, to illustrate (to my father) the alternate procedures that could be followed and the advantages and disadvantages of each of them. His final decision, after a careful analysis of every consideration, was to postpone action for the time being until the mortgage situation improves and his own personal financial situation is such that he can proceed with the new development without fear or trepidation."

It is inconceivable to me why he sent me a contract two weeks ago, and now postpones the decision for months to come: "Rest assured that when the office building shows good progress in renting, you will be the first to hear about it and our further plans for development." I knew then that the luminous content of a dream had turned to ashes. Business über alles. Including me.

"Be happy, you have more time now to do your sculptures," Steffi, my wife, said.

I thought again about retreating entirely from business-architecture to sculpture and painting, where I can have complete control over the realization of a project, independent of bankers, contractors and salesmen. But of course I would have to plan many exhibitions to put my name on the market, and become my own promoter—which I hate.

My inner voice was persistent and insisted that it was too early for such a change, that I must wait. I am a very obedient listener to the sound of my bones and even their silence speaks to me at crucial moments, with a most cordial determination.

How Things Hold Together

How "things" hold together is quite miraculous. It's too strange for us humans to understand the way molecules click, cells divide without losing hold of each other. We build by making joints after joints. Nails for wood. Bolts for iron. Welding for steel. Pearls, rolling all over the ground, we string together. Friendship has invisible ties as strong as iron. The relationship of family members is a complicated mechanism, yet natural to us. Links between those members are made of instinct, that is right, made of it, triggered by psychological impulses propelled by emotions. They shake hands with each other without touching. You see human bodies, you see intervals between them, but neither our eyes nor ears nor noses nor hands can grip the flow of the power that holds them together or pulls them apart. The intervals between them seem empty spaces, dumb voids.

The physicist tells us, presuming, that heavenly bodies, fixed or moving in cosmic space, unattached to one another by any material bond, are held together by a magnetic and gravitational field. It, too, is un-visible, un-heard, un-tasted, untouchable.

The painter's strokes on a canvas, put down one by one, closer or farther apart from one another, create an artificial field, gravitational if you wish, composed of an almost infinite multitude of paint bodies, and if the composition is right, they hold together; if it is not right, they fall apart. That is the artist's technique of holding pigments together; but what does he paint?

Painting and sculpture up to this century gave the illusion of three- and four-dimensional reality on a flat canvas. The space-intervals between figures and trees, the sky and earth, were only a recollection of actual experience which is lived in space. By creating a false world, the painter played God—or at least Icarus. And even in our century, painting has remained a variation on this same principle. Whether it is a Dutch portrait with the wrinkles of a face and the folds of drapery carefully detailed, or a Mondrian in which no object can be perceived, the difference is only in style and fashion.

My making several units of paintings, galaxies, separated from

one another at different intervals, is an attempt to make painting not an illusion of reality, but real. It is anti-art and pro-life. The galaxy replaces the single painting with several continuous images which can be read from left to right, right to left, or up and down, down to up or in any flow, inward or outward. The power which binds these units together is not composition-in-perspective but the observer, yes, that guy who stands or walks through a gallery, the collector at home who looks up from his armchair while reading the evening paper, anyone who passes by is a potential power of correlation.

Of course, the next step would be to have these paintings or sculptures or sectional architecture move. Be in motion, like a human being who can lie quietly, stand fixed, but can also walk, run, jump and come back to repose. It is not difficult to imagine a magnetic wall where such objects, carrying images on their forehead or on their back, would move, guided by a built-in electromagnetic force, either slowly or fast, or stop on premeditated orbits, run or move in such slow motion as the minute hand on our clock which seems, when you look at it, to stand still, yet within an hour has made a complete cycle of three hundred and sixty degrees. Now we can easily gear this power to a minute cycle, an hour cycle, or day and night cycles, and, although the play would be premeditated and properly set by a mechanism like the teeth on the valve of a music box producing a desired melody, it could also have the freedom of chance movement, chance produced by the mechanism itself, or imposed by an obesrver, at will. These "mobiloids" (either paintings or sculptures or practical objects) would create an indoor cosmos. The movements of the mobiloids would really be neither more nor less an abstraction from the orbital life of planets as paintings are a derivation from the daily experience of our natural environment.

But however inventive we might be, we must not forget that the artist-creator can never be extraterritorial. His territory will always remain his life experience. All art is, of course, only an abstraction of what exists. The binding force between art and life is the cohesive strength of the personality. This force is inexplicable. It must be lived to be understood.

Small Objects Lost

Friday, August 28, 1959

I wonder if there is an inborn habit, a law incorporated into small objects living with you in the house that cause them to grow increasingly important from one instant to another, from the moment you buy them, inviting their services, services which inevitably become part of you, like your nose, or your thumb, or your closest friend, or your cat or dog, but must, with years to come, disappear, and disappear in a completely inexplicable way.

Take, for example, my magnifying glass. It was quite an unusual piece, rectangular, with a very prominent upright metal frame and a voluminous handle set diagonally off in a corner so that it could be unscrewed, I suppose for transportation purposes. Its peculiarly large size and odd shape which, by the way, could accommodate the reading line of a book in its oblong contour, made this magnifying glass magnificently cherished by me. If I looked at a page with blurred eyes, I had only to stretch my hand automatically out into the nest on the table, and there was the lens.

But now it isn't there any more. Suddenly vanished. It simply cannot be found. All search remains in vain.

Yet I still carry the image of it resting peacefully on my desk. Its place is sealed in my memory. It had become a silent bystander in my daily routine, a peaceful relative, undemanding, always ready to serve when I so desired.

It is gone, perhaps forever, and I really feel it like the loss of a good friend. I am less secure. I would like to cry for help. I am much poorer today. And although I have so many things on my active mind, this loss constantly pushes through my thoughts; it seems I shall never forget the object. I hate to replace it by another one.

I give up, at this moment, all hope of a reunion.

Perhaps if I'll move out of my apartment one day, and heaps of notes and scripts, calendars and books will be lifted from their long-time resting places and that slum landscape of my desk will

216

be turned from disorder into order, suddenly the lost object will reveal itself.

I am pretty sure it has been patiently waiting, waiting, waiting . . . for its rediscovery, while I, drugged by occupational whims and irresponsible forgetfulness, a delinquent lover—will meet the eye of the lens staring at me and it will speak with a voice, sweet but slightly hoarse through layers of dust and dirt, and say . . .

"Where have you been hiding? You have abandoned me, but I have found you Master!"

Old Prometheus Grows New Wings

6:15 P.M., *Friday September 10, 1959*

It's done once more. Triumph!

The never-ending sculpture has reached another ending.

Two hours ago, I added a bronze shell to the crown. One more verse. The cat has had her litter. But are there still more kittens to come?

Can't continue writing . . . I am being picked up for a drive to East Hampton by Halley Erskine, and must be in front of my doorstep in a few minutes. No parking.

September 13, 1959

This is Monday. Here is the story I wanted to tell:

Three days ago when we, Ralph and I, arrived at the foundry, the sculpture was all assembled—for the first time. Quite a soothing surprise for me! Bob had redrilled the guide holes himself—and it worked. But.

I faced the sculpture squarely the moment I entered its magic cir-

217

cle. It seemed we both eyed each other. There was conquest in her attitude, but I resisted; gradually I became more and more aware that the sculpture was too confined within her contours. Still too self-contained in spite of my trying so persistently for so long to burst beyond her ostensible limits.

She needed extension. Yes, she did. No doubt.
I remembered a leftover flat bronze plate which had been cast for me three months ago. I had no use for it at that time (it was meant for a flat base if that should become necessary). It had disappeared. I asked for it now. The plate was found.

I marked a slightly curved line on it with a piece of plaster, indicating where it should be cut off, the square shape changed.

The cut-off piece was placed on two wooden blocks, set apart. I bent the bronze plate gently, coming down on it with a heavy sledge hammer three or four times. The plate caved in. The last blow bent it just as deep as I thought necessary for a proper curvature. What to do with the straight edges all around the plate? They looked machine-made, mechanical. To bring it to life, to have the touch of the hand on it, we hammered the edges down all around heavily in the old hoof-smith manner. With an electric rotary file I grooved three runic lines, front and back sides. We rushed it into the acid chamber, gave it a thorough bath and brought it back to Mother. Bob, standing high up on a ladder, welded the piece on at a sharp tangent to the other tangential units. It was rapid work. It had to be fast; the plate was heavy to hold up in a precarious position (by Ralph on a second ladder). I watched it keenly for its double inclination; no mistake could be made now.

It worked. Freed from the men and ladders, the new shell stood firmly in place, and reached far into outer space. Three cheers!

Social Islands Over the Atlantic

Over the Atlantic
Up in th airplane,
writing down a few notes
October 29, 1959

Everybody is up by now. But I was not the last to get out of my bunker-bed and crawl down the kiddy ladder. Altogether the sleep cannot be counted; we are 13,000 feet high, and how tall, after all, was Jacob's ladder? Not so far from heaven now. The point seems to be, whenever you try to reach heaven, it retreats.

The interior of the airplane looks at nightfall, that is, electric nightfall, like an abandoned battlefield, a trench. The bodies dead —thrown frozen, life arrested willfully, completely prostrate. Blankets have been put over most of them, others look hopelessly petrified, others melted into their stretchers. But you always find one colonel who sits up at attention reading the night through: *The Reader's Digest.* The miniature beam of the night light falls directly on the pages, indeed a good industrial design service, but the colonel, particularly in his so very upright position, does not realize that the glare of the reflection from the two pages creates daylight for those whose eyes are in sight-line with it.

This type of passenger never fails to show up when the lights are turned out.

I am still a little groggy from my three sleeping pills (two would not do the work), and refused breakfast. The little table has been clamped into the armrests of my chair ". . . so that you can write more easily," says the courteous hostess," since you are not eating."

I just notice that it is getting pale baby-blue daylight—no spectacular sunrise whatever yet.

Through my porthole I see, very steel-gray, the forbidding armor of the airplane's nose, a German steel helmet, except that the *pickel* isn't pointing up, it's aiming straight forward. Its bull's-eye cone is sticking out of the propeller hood very casually; could be in its abstract form the beak of Brancusi's "Bird in Flight." There it is: *the bird in flight!*

How the artist anticipates technological inventions, trends of what the bourgeois calls "progress." The rockets, space travel through-

219

out the cosmos, the moon in eighty days or eighty seconds (the difference is: eternity now, heaven later). The dismembering of empires in the first World War had been anticipated and fully demonstrated to a future-blind populace by the cubists in their breakup of solid forms. You don't need any fortuneteller with parrots and coffee grounds, or cosmologist with his ticker tapes wound around the navel target of your birth, to know what's coming; just look at the pictures of your best, the geniuses of your own time, and you can see the future as clearly as front-page headlines.

The captain's voice suddenly: "Ladies and Gentlemen, due to heavy headwinds over Nova Scotia, we are not proceeding to New York on this flight. We will land in Gander."

Yes, Captain, we already have our safety belts on.

I had felt the shock of being tossed about in the men's room just a few minutes before. I was unable to sit down and focus the target. I had to hold on to the vomiting handle with my right hand while my left held up my downward-rushing trousers. I had always wondered on previous flights if I ever would be forced to make use of those handles: they are plastic and inviting to the touch. Luckily, the cabin is very small, and practically held me up in a leaning position by its walls, until the shaking was over.

"I'm from Oklahoma," says my neighbor to me. "I haven't flown a lot, and yesterday, coming from Milan, we were hit by lightning."

"Was it rough?"

"No, not at all. But I saw it striking the tip of the left wing."

"Did it smell?"

"No. But I could hear it crackling right through the airplane's shell. And then, I could see it going out over the seven epaulets at the end of the wing. And that was all."

Yes, I remember having asked one of my last flight commanders what these tiny strips were for, always ready to plunge into the pool of space like divers with outstretched arms just before plunging down. "They're for accumulating electricity in the air, sir,

and guiding it outward rather than inward." Pretty good idea, these kobolds of safety.

Everybody given forms to be filled in for customs. I am hungry for breakfast. The last one to be served. The two hostesses are accustomed to me. One of them, very, very tall, when speaking to me gets down on her knees so we are face to face.

All the ladies are ready for the arrival. Their night paleness has vanished. Their formerly disheveled permanent waves are rolling in co-ordinated cascades around their faces, and the skin is industrially rosy. The men, who only a short time ago looked like tired hoodlums, are back in civilization, meaning with coats and neckties.

And that indicates the approaching end of my five-week pilgrimage to Tel Aviv, Jerusalem, Haifa, Rome, Vaduz and Zurich. I met my nephew for the first time in thirty-five years at his home in Liechtenstein, and I accepted the invitation of my two new friends from Jerusalem and Venezuela, Mr. and Mrs. Over, to visit them in Zurich. I accomplished my architectural mission, to relocate the Shrine of the Book for the fourth time. I conferred with Bruno Zevi about the possibility of building the "Endless" in Rome. I visited Dr. Curjel in Zurich and received Mr. and Mrs. Portner (who never got my theater material which they much desired for his book) and I found, at a late opening of a futurist exhibition in Winterhur, two of my oldest friends from the de Stijl group: Vordemberge Gildewart and the first Mrs. Moholy-Nagy.

Cash and Glory

November 11, 1959

According to Theodore Dreiser, the American Tragedy consists of illicit pregnancy which ends with implicit murder of the unmarried mother. But this is not the whole story. The unholy story is the desire of whole clusters of a nation to combine cash with glory, that is, wealth of love with riches of the rich. Love con-

quered seems not to suffice; success conquered seems not enough, be it in business, industry or the arts.

Song of the Phony
by Kay Johnson

I've got to be more than I am!
I've got to be greater
than I am!

Look, you see this jacket
I have on?

It's two sizes too big for me.
Someday, I'll grow into it.

Man is not made for double-size contents. There is only one content for each of us. The gods can only be fooled to a certain point. They are forgiving, but try to take continuous advantage of their good will and a loss is inevitable either on the side of cash or glory. There is either the security of love or the security of geld-gold. You cannot combine both.

Dreiser's boy murders his pregnant and poor girl to free himself to marry a wealthy one. This tragedy is still a personal one, of innermost subjectivity and of universal origin—but for a country to be hypnotized into gambling with love and cash is suicidal.

To murder in hate, in jealousy, is destruction incarnate no matter when and where man or woman is born, it is as legitimate as illicit sex, defying social dictates. Read the story of Heloise and Abelard. The father emasculates the lover of his daughter, but their love is not castrated. Contrary to our ideas of "practicability," their love grows deeper, higher, wider beyond gains of social or personal ambition. The demons of frustration are kept relentlessly at bay and irrevocably from their shelter of love.

The lifeblood of talent and of love can turn into pus. How is it possible that these essences can be so corrupted that the brisk red body-stream, ready to jump out of your shell at any time, time and again, that fluid which is ever-ready to show its red tongue out of a billion pores to keep an enemy out, to protect you from

poison and warn you—yet, and this yet is a *yes*, how is it possible that its bull-red radiance will turn into sour pus green with the smell of moldy piss, how the Hell and Love! is that possible? Well, it is, and is and is, and life ends in murder, death, or death-suicide. Yes. Go ahead and change the laws of nature. Glory turns sour on you. And only on you, on no one else.

No greater punishment is in store for us than the betrayal of our own gifts. Everything starts fine or not fine but finds itself sometime fine, dandy and dear. You make money, too. Finally. And flush. But is it enough to possess cars, houses, deodorants, safe deposits filled with the seals of life-securities? No. What after? What then? When does "then" end? No place. Not here anyway. Now that we have money, it's a bore. We have it. Ambition rambles on. Next is glory.

"Look at Franklin, the man with the kite. I can fly one, too. Just a kid that never grew up. What a racket they make about him in the schoolbooks. I can invent, you bet. Just give me a laboratory. Thank God, I don't need anybody's dough for it, I have it myself. That genius stuff is old hat. Let me combine money and glory. I'll be famous. I am a monument."

Ambition and fear become imitation and gregariousness in the creator-Philistine. Lack of beliefs creates parasites. A whole country has been lured into the race for glory and money, a dead-end trap-squeeze. The TV quiz. A man of fine ancestry, teacher of a university, fell for it, too—that is, for rigged answers to gain the nation's admiration and win the show's highest prizes. Charles Van Doren, the man who rose from middle-class honesty to the photo-finish of fake stardom and was finally doomed to dishonor.

The success and wealth of a nation have produced masses of opportunists seeking illicit glory. Pioneers turned into Philistines, and Philistines into artists of cash.

Back Home

November 24, 1959

Back from South America and Europe for about two weeks, I am again at my home in New York. The memories of my voyages to South America and Europe are still with me, particularly since I have, these past days, dictated notes on my experiences there.

Mrs. Wright, for whom I did the Venetian theater in April, 1957, wants me to think about a magical cover for the 800-foot open auditorium, in case of rain. Here is an excerpt from her letter:

"I would also like to consult you again on the matter of rain protection for our concerts on my estate. It has been in my thought as you know for several years, but I was not in a position to go ahead with more at the time, and besides, we want to avoid more building or filling the lawn with construction. So that I am afraid even your beautiful suggestion of a double colonnade must be revised.

Looking forward to seeing you, with a dream of a silken canopy rolling out from your theater in blue and silver colors on tension wires to the stairs in the back, perhaps electrically controlled.

> Yours always,
> [signed] *Lucie*

Amusing to see the change in her attitude toward architecture after living with my theater design. She suggests the very limit in ideas! Good client.

The Ford Foundation has offered me a grant for designing a "New American Theater"—I sent Ralph out today to buy bronze metal sheeting; he had patterns of a new sculpture to be put on the ceiling as the third part of the "Vessel of Fire" galaxy—Bob Foster, former draftsman of mine who returned from the Army, is to help a few hours a day in the studio, building new shelving to clear the cluttered space—VISITED Len Lye with Leo Castelli, to induce him to offer Lye an exhibition of his vibrating sculptures;

Lye has applied for a Guggenheim grant, must write recommendation—DR. Corey left her husband and will accept a position in a hospital—STEFFI is well established at the German-language newspaper, *Aufbau,* as assistant to the editor, writing theater, movie and book criticism, and seems, for the first time in twenty years, in her element—AM undecided what to do for dinner Thanksgiving Day; since a long time ago, we have had dinner with Alice and Lillian, en famille, will it go on?—SECRETARY Jackie is taking Friday off, to have a four-day free-flowing vacation—HOPE to be able to start regularly working at the studio to develop new sculptures, some of which I designed the night before last, and also to continue to the end the horse galaxy—Davidson Taylor sent me his curriculum vitae, since I intend to sponsor his nomination for the new post of head of the Graham Foundation in Chicago (this was suggested by Porter McCrae of the Museum of Modern Art)—AT office laid out two exhibition panels to be sent to the Architectural League for their Gold Medal competition and I had to teach our young designer the darned old-fashioned technique of crossing two diagonals in order to arrive at the proper enlargement; for the panels, two more views have to be rushed to a photo-finish: one of the water trough of World House gallery and one of its large parabolic exhibition wall—ALSO finishing cardboard model for hospital job, but we desperately need hardboiled consultant who can stand up to the Medical College's cross-examination about multiple equipment.

Looking out through the window at my terrace, it is raining densely; I see my old square metal table on the terrace still askew, not changed since I left for Rio de Janeiro five weeks ago. The white color of the tubular legs and the deep-green color of the top, which Ralph painted at the beginning of the summer, are astoundingly fresh. The lack of change in this table gives me a strange feeling of peace, a kind of relaxation from planning and rush, that rarely comes so casually, unexpectedly, and at the proper moment.

Close the Art Schools

November 25, 1959

Yesterday quit office at five thirty sharp with all the other employees of Park Avenue South, the automatic American business-end hour, disappearing into hordes of people streaming from offices into streets, subways and buses. In spite of the rush and push of escaping human beings, I was waiting in a drizzle of rain, on the sidewalk for architect Ed Barnes. He finally picked me up and we drove to Mrs. Gruen's for a meeting with the Industrial Designers' Group (organized by textile specialist Larsen).

Dean Benson of the Philadelphia Museum School of Art opened the group discussion with a long-winded complaint about the inadequacy of art teaching for his seven hundred students; also said that fifty per cent of the teachers are unfit to arouse the creativity in these youngsters.

After his half-hour talk, I cut in and said, "I must beg your pardon, but being rather old now, and experienced in teaching at universities and privately, I know that there is only one solution for the problem of the mass enforcement of art training upon demi-talents. The solution is simple: Close all the art schools!"

There was a moment of petrifaction, and then a burst of applause.

"That's not very helpful to me," Dean Benson said.

"But it's healthful," I said. "This way, the mass-students who fill the schools will eliminate themselves because only the real talents will have the perseverance to find a master to love and study with. And in my opinion, the only way to develop any creativity is to return to the principle of apprenticeship. Let a student attach himself to a master from whom he can learn for a more or less long time, by his own choice. In this way, his outlook on life can grow, and the character of the man become stronger, as well as his power to resist conformity. The various techniques of commercial art can be taught within a single year. Any more than that is wasted embellishment. The amateur can paint, compose, or interior-decorate as long as he lives without harming himself, his family and society. But to make professionals out of them is deception to the point of criminal irresponsibility."

The debate was still raging when I left and went to Elaine de Kooning's three-lofts-in-one studio, opposite the Grace Church on Broadway and Twelfth Street. Her atelier, as varied, expansive and inspiring as her personality, was filled with young women writers and painters. Out of the crowd came Mina Lederman, the onetime editor of *Modern Music*, whom I hadn't seen for several years. Without any preliminary greeting, she called out to me. "Darling, your sentence about Frank Lloyd Wright in *Art News* was just divine!" The quote, not entirely accurate, but nevertheless to the point, was:

"Architect Kiesler, it is reported, suggests that they remove all the paintings in the Guggenheim Museum and commission a good sculptor to make a gigantic statue of Wright that would fill the whole interior: his cenotaph, with crowds strolling down past majestic nostrils and shoelaces."

Elaine cooked meats and baked bread in a topsy-turvy kitchen, where open boxes of oil paint lay singly and in heaps, as if waiting to be roasted too. I was astonished to see her cutting slimy chickens into parts, mixing salads with oily and tart sauces, her fingers tiptoeing in and out of pans and bowls in the midst of remnants of the week's breakfasts and dinners—maneuvering in a new black cotton evening dress, and without so much as a kerchief for an apron. The black dress, the cooking and serving did not go together. The explanation I only discovered at the end of the evening.

"No, my poetry cannot be read aloud," a twentyish girl from the South threw at me. She was entirely naked in spite of her sack dress, her two large legs sticking out of the bag and also sacked into two black stockings; she had a snow-white powdered face and sky-blue eyelids. "No, I cannot read my poems to you. They are meant to be heard by the eye."

"I am afraid," I said, "that you are much too modern for me. I don't like to smell flowers after they have been pressed flat in a book."

Elaine and I sneaked out across the street and through a beautiful old iron gate into the small library room of the Grace Church. Here, a young pastor holds a one-hour session, twice a week, on interpretations of passages from the Bible and modern literature.

227

There were six elderly ladies present, the pastor's young wife, Elaine and me; a rather "charmingly gruesome" atmosphere, mixture of the Gothic and the modern.

The Bible section concerned itself with Cain. No question about it, as I gathered, he was the first to attack the authority of God, because God did not accept his sacrifice of agricultural goods, while his brother Abel's sheep, a gift from a nomadic life, were praised by Him. He murdered Abel to take revenge on the Almighty. And God did not permit anyone to kill Cain for this crime, as He wanted to have a crack at him Himself. He even led him to prosperity, so to speak, to have him die in the encumbrance of his own wealth. My good God and Lord, how cruel can You be?

But the spirit of revolt was started. God, made in man's image, also inherited man's insecurity and needed to assert Himself by dominating His children. Cain, by becoming an agriculturist, settled, while Abel, remaining a nomad, was entirely dependent on earth and heaven. He was slave to the whim of God.

Cain's rejection of haphazard living, his attempt to assure food and shelter for a lifetime, was most probably the beginning of man's attempt to conquer nature, and to superimpose his will upon it. His insecurity would be reduced to a minimum, his fear of death submerged in a wealth of supplies necessary for the survival of the species. And if he's able to control nature's abundance, he will have energy and time to spare for thoughts and God. Will he be able to resist the seductiveness of continuous accumulation?

It seems that man will again die in a surplus of goods produced by discoveries and inventions, and as he once wrested the fire, he now steals atomic power from the cosmos' secret chambers, committing suicide through his own creations.

The young minister was very tall, wore a sloppy office-worker's trousers and coat, a black shirt with an old-style Russian neck and the rim of a white collar peeping out; his face slender, Nordic, pale-blond, a Midwestern-looking figure from an Ibsen drama. True or not, I had a feeling of impending tragedy, with Elaine assuming the catalytic role.

After our discussions, he accepted Elaine's invitation to come to her studio across the street. He picked up a three-month-old baby lying in a basket on the floor of a nearby room in the rectory, took his coat off and, covering the basket-cradle with it, ran with us through the rain, across the street. The casualness of that minister running like a teen-ager from his solemn, beautiful church to Elaine's fire-escape-covered slum building astounded me. His young wife had slipped ahead without hat or coat, just as she was. There was no pretense, no holiness, but a straightforwardness which brought them very close to us artists as we sat drinking and talking in the loft.

Expenses

December 1, 1959

Yesterday a routine day, but an undercurrent of uneasy feeling had been working its way up for several days, and finally broke through the surface. I had a hunch that the economic structure of my monthly life was going to pieces. Yesterday I calculated my income versus fixed expenses, and quickly found that it *is* going to pieces! My monthly drawing account from the office of $800 has such customary burdens as rent at home and at the studio, $196 at home (minimum from wartime rent control) and $65 at the studio—together, $261. Two telephones bring it up to $300. A maid at $10 a week makes $44 a month. Together, $344. Since the grant for the "Endless House" costs is slightly overdrawn, I have to pay my half-day studio assistant, Ralph, out of my own pocket: $67 a week. Four weeks makes that $284 a month. Altogether, these unavoidable expenses amount to $628. This is not counting food, laundry, doctor bills or incidentals, for which only $172 is left! All in all, I'm down at the bottom and have practically nothing left: these expenses are the bone structure, and there is no hope for either skin or flesh with which to cover the skeleton. My only hope, therefore, is to go into the making of sculptures on a large scale, and prepare for an exhibition in October or November of the coming year. Without that, I cannot enter

the market, and the thousands of dollars which I have spent and will have to spend on castings will be lost. It is a serious situation, and after I talked with my partner at the office, I found there is no hope at the present time of withdrawing more, although we have a ten-million-dollar job at the hospital, and the Shrine of the Book: there will be no profits coming in until two years from now—if then.

I have already withdrawn most of my meager savings account, and I am not inclined to go on draining it. The situation is damn serious. My only savior remains: My work.

The Vessel of Fire (continued)

Thursday
December 27, 1959

Yesterday I received a gift of a sheet of Muntz metal. It's a never-rusting or skin-changing bronze alloy. Color: pre-Columbian gold. Matte—yet radiating. It was too seductive in appearance and physical elasticity for me not to immediately try to bend it. The form which evolved looked like a pigeon making a *salto mortale* in mid-air.

Surely the mother of these wings was my crown constellation of "The Vessel of Fire." It was a continuity, and it projected itself onto the ceiling where it would hang as an apparently independent unit.

Today I dashed off to the Modern Art Foundry at lunchtime. I took my Muntz model with me to be cast in wax.

"What are you doing here?" asked professional sculptor Ferber, picking at a tiny wax sculpture in his hands as I entered the foundry. (Apparently I am supposed to sculpt only in wood.) "Just inspecting," I answered.

He kept on working and did not come over to look at what I was doing. I molded three flat wax sheets which had been pulled out of cold water and sunk into basins of hot water to make them pliable.

230

John, the owner's son, helped me to reproduce the Muntz model in wax. I used red-hot steel sticks laid out in a radiant array. With them, I furrowed the surfaces, poking at them, flattening and searing them, particularly the clean-cut edges on which I ran back and forth with the sticks, the heat evoking steam and melting the wax which ran down the cheeks of the forms. Thus the form and texture of my sculpture gradually became richer and fuller as I moved the stick over it again and again to provoke the softening, weeping wax to give life to the surface.

It was closing time. All the workmen were leaving. But John, who saw my eagerness to finish (and being the son of the owner), offered to stand by past union hours. The bending, twisting and melting of the wax proceeded into a final shape and expression, all imposed on the material by a shock method. The heat gone, the warm wax cooled to proper form. A new ceiling sculpture had emerged with temporary finality.

"*Heloise*"

December 17, 1959

"The Vessel of Fire" was standing, solidly anchored to the ground yet breathing space.

Wherever the sculpture might be placed, it will have wall enclosures. And to give a desired distance between it and a background wall, I felt the necessity of adding a high-relief sculpture to such a wall. This time I designed on a piece of paper three sizes of bronze sheets. I mailed the dimensions to the foundry and two weeks later I hammered these sheets into shaps correlating to the whole complex of "The Vessel of Fire," welded the three pieces together and added a mechanism for hanging the unity to the wall.

It had independence, but would only come into its full being when actually placed in relationship to "The Vessel of Fire."

The new sculpture was slender compared to the mother, so I named her "Heloise."

231

She stands now in my house, threefold puberty: shyness, anguish, longing.

She is wrapped in snow-white cloud tissues, a heavy body of bronze inside.

At the foundry we had given her a last bath of acid because her highly glistening body showed finger marks of every hand.

Now she leans against the wall like a pony-tailed teen-ager against a small-town drugstore window.

We shall undress her as soon as Alice arrives to view her. It will be in half an hour.

The water kettle is whistling. I must go and prepare my brunch.

On the Concentration of Talent in our Universe

February 2, 1959

Ill-humored and disgusted with the way things were, God took two seeds of talent, wrapped them in a piece of paper, got into His hot rod, zoomed through the skies and dropped one seed (for the word) in Ireland, another (for art) in Italy, rolled the wrapping into a tight ball and tossed it up and made the moon.

The rest of the world He faced empty-handed.

Luster of the Sun

February 20, 1959

I wish I could be as happy with the luster of the sun as almost all people are, taking in the glory of her radiance through every pore of my skin, and capturing mighty bushels of rays with my eyes— but I cannot.

The luminosity of the day makes me sad. Not always. If I am already in a happy mood then sunshine reinforces it and I have no grudge against it, but when I am not, then the contrast seems too great, and I am resentful.

Today once more the sun hands out all her beauty with a reckless giveaway. What other comparison would be adequate than with Helen of Troy, who belonged to every one of the men of Greece. She was too beautiful to keep it all for one.

Like a woman, she dresses her beautiful body in tender veils of clouds, an infinite variety of sheer materials, tight, dense, loose, transparent, apparently shielding herself, in fact only heightening the mystery of her Truth, even covering up with furs of snow and evening coats of endlessly strung pearls of rain.

And then, after you have closed your eyes, blinded by so much hidden beauty, and have drawn the inner blinds over your retina to shut out completely, absolutely, what is outside, so that no slit can permit the intrusion of any rays into the deep and deeper contemplation, hoping that whatever the curtains, they will keep her body and its emanation of light hidden, and you finally dare to open your eyes after that long visual silence which has produced the Elysian fields of so happy a darkness, the unexpected shock is already waiting, provided for: the curtains lift, and there she is, in automatic radiance.

For everyone, and not for any one alone. A shameless nudity of beauty.

In Anfang ist Holz,
später ein Scheiterhaufen

March 14, 1959

Society (not the people—
they are innocent) buries
the artist alive. Decades
later it exhumes him,
dresses him up in purple,
sets a crown on his skull
and diamonds in the caves
of his eyes.

On the Seventh Day He Rested

March 26, 1959

And on the seventh day he rested.

That parallel is certainly ambiguous, but I only mean that after tomorrow, on Saturday, I shall be resting, too, after the creation of the world of the "Endless House" is accomplished. However one last detail I'd like to note here before closing the chapter: Here it is: I always felt that there should be a way of getting onto the roof of the house, because it has such lovely valleys, where one can sit or lie in full form in delicious comfort, sheltered on its plains and inclinations—yet there was no way to get at it.

234

Some time ago I thought the only way to achieve that was to cut a trap door into the ceiling so that one could slip out onto the roof by using a short ladder, as it is often done in brownstone houses in New York. Yesterday, late in the evening, after a very hard and tiring day's work in which I myself took a vigorous hand in finishing one half of the shell of the house in a rush of reaching the goal of completion (to be ready for Arthur Drexler, director of the museum, who at last is to come to view it tomorrow, Friday, at six o'clock in the afternoon), I suddenly discovered a seemingly natural way to walk up and out on the roof by inserting a small platform into the mezzanine which offers the most logical and the most sustained way of three points of attachment to straight-out walking on an even level, to the meadows of the roof! I called my assistants and smiles appeared on their faces, because it was too obvious, that solution for getting onto the terraces of the roof. Yet we had never found it.

I rapidly cut a piece of wire, fitted it into the free space destined for it, trimmed its four sides to exact measure of the location, and held it up while Ralph got the torch and at once soldered the three points of attachment to the already existing wire construction. Then quickly grabbing some lumps of wet cement from the pail nearby, I squeezed it through the new wire-mesh platform, tapped it from below and from above to flatten it out properly, extensively wetted the two points of attachment of the already existing structure so that the new wet concrete would find enough affinity to adhere, no longer an intruder, to the old family of the concrete shell. And there it was, conceived and finished, all in one, so natural in its place and service, its purpose so miraculously grown into being from nowhere in the last moment of the model's coming into its own.

Why was this solution not permitted to occur to me in these six weeks of molding the house?

Heavens, masters and mistresses of the Earth, gods of the underworld of the human psyche, Lucifers of the brain machines—why, why had you kept this secret away from me for so long? Wasn't I enough of an obedient servant to your commands all this time? Had your generosity once more to resort to the satisfaction of sadism? And why did you lift the curse only before it was almost too late, why?

The Reality of Abstract Art

To note quickly: Saturday night at friend Luba Petrova's; dinner with Leonard Sillman, the producer of eternally New Faces in the theater. But he has no courage to accept New Faces in other fields of art; the newer they are, the more ruthless his rejection.

Luba, Russian-born, American-reborn, a grown-up full-fledged doll. However, unborn yet to the profession of a writer which she so very much would like to indulge in, as we all have our side-dreams which only become real by the throw of specific dice. Therefore she has great sympathy for the little and big artistocrats of art, is inspired by them to the point of cooking the most delicious meals, single-handed, like performing a joyous dance to Russian and American tunes, and serving the dishes like flying saucers.

Ensued violent discussions after dinner, precipitated by the remark of a Frenchwoman, another guest of Luba's: "I hate Picasso. I hate his paintings. I hate him. His twisted faces make me sick."

Me: "He hates you too, Madame. But don't take it personally. I mean, he hates your type: that bourgeois twist of presumptuousness throughout the ages. The non-artist telling the artist what to do or not to do. If art could be accepted like sex and sex like eating, men and women would not feel like perverts, shamefully obscene in the presence of modern art or architecture."

Sillman, slender as a whip, blessed, in addition, with a cat-o'-nine-tails tongue, came to her aid: "I hate him too. Although I know nothing about modern art, I hate him, and I hate it. My sister's kids can do the same thing, only better, and genuinely. He's a faker. He takes the public for a ride. It's all due to promotion by dealers of an international art chain gang. An underground cartel. But I can't be fooled. I like Rembrandt. And what's the name of that Spanish painter? (Someone threw him the name.) Yes, Greco. I adore him. Picasso, I hate."

"He hates you too, dear Sillman," I answered cordially. "He makes you vanish in a puff of a cigarette and punctures you with its hot

236

black butt, all in good humor."

That dart stung deep, and I had to extricate it, although it was more painful than the initial thrust, and apparently everybody in the group started bleeding, as if stigmatized by its rebound.

From ten until two in the morning, the debate raged. During that time I managed to bring a small herd of bulls to their feet, one by one, taking them by the horns and bending them until they ate the dust of their own making.

"What all of you see in each of his paintings are only the distortions of life, not the new life he has created out of the mess and mass of the average.

The difference between the actor and the painter is that the real painter never imitates nature. Rather does nature imitate art, because we see life through the spectrum of art. As a matter of fact, nobody has ever seen anything in life and nature as it is. We only see and feel it through the sieves of civilizations, and, visually, through art, old and new. Sometimes, I agree, a painting might look like scratching. But, whatever scratching the artist does with his brush or pen, he is not scratching the surface but dredging new life out of the old. The performing arts exist only on an artificial stage, while the plastic arts are everywhere because they are part of the innermost subconscience, if you want, subversive, as far as the average life is concerned. These faces of new art might be disturbing, it is true, because they upset the routine of habit, but the 'New Faces' of your theater are superimposed masks which fall off when the curtain comes down. They are derived from scripts, hired directors, hired actors, types to fit the author's image, altogether a remarkable collage of human beings, from stagehands to stars, held together by hypnosis until they become, for two or three hours, the facsimile of the producer's New or Old Faces.

Yet, not one of our general public realizes that the chairs we sit on, the houses we dwell in, the beds we snore in, the toothbrushes we eventually use every day, our clothing and food which we produce hour by hour, are all man-made, man-conceived, man-executed, really created out of the raw . . . tradition built upon tradition. Human societies will accumulate goods and bads until they finally surpass the growth of the original pole of life, and the heavy weight of the masses, and people clamoring for the top, ambitious to go on

237

and on, will, at last, make that pillar of progress bend, crack, and crash.

That, indeed, will be our chance to be reborn in the image of the ritual of our inner life."

It was an irrevocably spontaneous occasion to tackle the three classical phrases in which arrogance is connected with wealth, ignorance tied to reaction, and self-deceit a weapon for desperate self-assurance.

Yet, these are the three sentences of a habit-neurosis, engraved since the time of Gutenberg on the tablet of Art-Public Relations:

(a) I confess to knowing nothing about Modern Art, but I hate it. I know what I like.
(b) My grandchildren can do the same thing, only better, much better.
(c) Abstract Art is a dealer's deal and you are the proud suckers.

The time has come for Moses to awaken out of his slumber of eternity and reappear to throw these new tablets to earth and smash them into thousands of fragmented pebbles to prepare for the coming of a new and better Flood.

"Which Way Insecurity?"
Sketch for sculpture

1960

Two Letters

January 5, 1960

Awaiting a call from Director Sandberg of Amsterdam's Stedelijk Museum, now in New York, who rang me four days ago when I was ill and couldn't see him. He and I had spent a lovely evening in Rio de Janeiro at the Hotel Gloria, looking out at the bay and looking inward at the plans of my "Endless House."

In an hour am leaving with assistant Ralph for the Roman Foundry.

Before that, an hour at the office.

Yesterday we finished the application and description of the Science Building for the Einstein College, to be mailed today to Washington for a grant.

Am taking to the foundry parts of my new type of ceiling-floor sculpture, flat wooden patterns and semi-curved wire-mesh units stiffened with plaster. Their bends and curves will combine into three plastic units, making one sculpture from floor to ceiling.

After the foundry, I shall drive to the studio to receive Mr. McGifford of CBS, producer of *Camera Three*, who would like to interview me for a possible TV program about the "Endless House." Is that making the grade or the degrade?

A young Armenian-American lady with burning eyes but frozen handshake asked me for drawings for her new gallery and a few lines of comment. She insisted, and I dictated:

"These are drawings written into space. And since my wet nurse told me that space is nothing but one cheek of time, I slap it on the other and there I am, and it is. The table is square and has four legs, and is as steady as I am unstable. Together we make a bad team, and, therefore, I never draw.

"However, an unexpected link between my work in cement and mud and lingering on the couch, watching my inwalking friends and my dervishing assistants, is the thread which makes me spin

242

in a calligraphic tongue, the saliva running out of the ball pen without end, a skein of lines intertwining into knots from time to time, and there you have it on paper."

Since the description of the "Endless House" in *Time* magazine on May 25, 1959, curiosity has been aroused about the "Endless" in many foreign lands. Pictures of my model for it appeared in *Harper's Bazaar* and *Vogue,* and yesterday in *Art in America.* It is spreading before I have even had a chance to build it. Typical of our time: artists and architects satisfying this hunger for novelty, and using for plastic inspiration, flat photographs of something that hasn't yet been realized. A hint of what could be done creates a hullabaloo.

Yesterday I received two letters which seemed to fit into the mood of the day. Here they are and here are my replies:

Rishon le Zion, Israel
4th July, 1959

Most honored Architect Ferenez Kiesler:

In the Canadian Arctic at Frobisher Bay a new town is now being built. As I have been informed, the perma-frost of the locality creates difficulties as the warmth radiated from the building melts the foundations. I have read about your wonderful IDEA to build houses balanced on stilts and I presume this would be the best solution to Frobisher Bay town. May I therefore suggest that you write to Mr. Alvin Hamilton, Minister of Northern Affairs, Ottawa, Canada, and inform him about your Houses on Stilts. I am sure that your Idea will be accepted and realized for the benefit of humanity.

May I also suggest that you study the possibility to build houses on STILTS (similar to the LACUSTRIAM) in Tiberias in the Lake of Galilee, Kinereth. These stilt houses could be surrounded by FLOATING GARDENS as on the LAKES near SRINAGAR in KASHMIR. TIBERIAS CAN EXPAND ONLY TOWARDS THE Sea of GALILEE and your IDEA gives the possibility to do this. It could expand towards KFAR-NAHUM (Caphernaum) and towards EIN-GEV also perhaps. The floating parks and GARDENS ON THE WATER of the LAKE and your beautiful PREHISTORIC—AND ULTRA MODERN LAKE DWELLINGS would emanate beauty, health and happiness.—I myself came to

243

Israel in 1926 from your neighborhood of Vienna, from OSLANY (Neutra) in the NITRA Valley of Slovakia.

Yours sincerely,
Pinchas Nasich
P.O. Box 77
Rishon le Zion, Israel.

The letter was addressed to me at "Manhattan's Museum of Modern Art, Greenwich Village, N.Y. USA." and it did finally arrive at my house, 56 Seventh Avenue.

Hello, charming man, most honorable friend!

Forgive me for answering you so late.

What a delightful and inspiring letter you have written to me on July 4, 1959, which, as you know, is the day of American Independence.

Perhaps I will be in Jerusalem in May for a short while. Then I will take the occasion to let you know about it, and we can meet and chat about our dream worlds, from Canada to the Lake of Galilee.

Fraternally,
FJK

The second letter:

10 August

Mr. Kiesler I would like to work in
 your and Mr. Bartos Office.

I am twenty years old and from a small town
on the Ohio River. I attended the University of
Cincinnati for two years. My only drafting experience,
 other than that in school,
 has been with a steel
company where I made shop and erection drawings

244

While at U.C. I came to be discouraged with my work
there they stressed Van Der Rohe
SOM, etc. and to me that didn't
seem to be the solution. I wanted to get
away and see what I could find on my own. After
deciding to quit, I talked with Mr. Deshon, my design in-
structor. He said that I had the talent and should not abandon
architecture completely.

The past six months I have lived
here in Manchester and it hasn't been a total waste
for I think I have grown more sensitive to Nature
and more seriously toward architecture. During this time I
have done some drawing and painting. Times I have considered
being a painter or sculptor but I'm afraid I don't have the gift.
Recently I saw the article about you in the
25 may issue of Time Magazine. It excited and stirred me
deeply. After reading the article
I felt if I could work under you it would
mean much to me. I realize my limits are
close to the horizon and I don't know how
I could serve you. but I would do any-
thing. Sweep floors, anything.
Robert B. McGregor
202 West Eighth Street
Manchester, Ohio

And my answer:

My dear Robert McGregor:

Sorry my answer is so late, but I have been away from the
United States for most of this time.

Seeing your writing and your way of organizing your page
and your sentences, I should think that you have talent
for architecture. You know, a talent for architecture
does not express itself only in buildings: it is the
whole sense for organizing a space, which is a deciding
factor.

You must not be discouraged, because there are many roads that
lead to architecture. And there is only one road that leads

to commercial building, namely, money interests, greed and competition. Architecture has nothing to do with that. It is independent of cheap endeavors. It is not a planet which lives from the reflections of other suns. It is a sun itself. The heat to produce it, you must generate yourself. So don't be discouraged, and do whatever the circumstances dictate you to do, but get really involved in the worlds of your dreams, and work on them by yourself. And draw strength for that from anything you might feel will support your aims.

Our office is now engaged in some large hospital work, which is not exactly a matter conducive to your studies. So don't wait for our firm, but work for yourself, as I always did. One day you will come together—you and the world.

Sincerely yours,
FJK

Dutch-Gypsy Loomer

Tuesday
January 14, 1960

A revelation in the broad night light of New York! Suddenly I am standing in the middle of a giant studio, the kind that I or any other sculptor always dreams of—and never finds.

Not a vision, not an apparition, but the reality of an enormous artist's atelier right here in midtown, a space of monstrous dimensions, three flights up, in a broken-down dwelling near the East River, in a God-forlorn and man-abandoned area, a workshop of such spatial delineation that you could not imagine it actually existing now in New York, where space is at such a high premium, but only during the Renaissance or as the private property of Peter Paul Rubens, embracing his large and fleshy, fur-covered model-woman.

A tunnel of a staircase led us up. A young woman in woolen stockings (without shoes), pigtailed, opened the door and let Thomas Bouchard and me into a skating rink of art. Floor painted black, two hundred feet long, fifty feet wide, all walls white, the ceiling skylight-ridden. An all-glass wall at one end.

Two looms, side by side, each twenty feet long from top to bottom, the strings spun between pipes like a super-harp. Along each of the looms, a bench on which the young woman sat later (at midnight) weaving in a dim light, a Vermeer painting come to life. In fact, she is of Dutch descent, as are her sister and the sister's husband, our host, who is chief loomer of the atelier. His Gobelins of naked Negro girls playing the flute, or apocalyptic horses, or abstract drippings, about six or eight of them, were hanging on the side walls, each lit by special spotlights transforming a city barn into a pseudo cathedral for self-adoration.

He, about thirty-five years of age, rather youngish-looking, with two teeth twisted inwardly, blond hair, blue eyes, healthy, physical uprightness.

As a kid of eight, lost in the Nazi persecution in Holland, cut off from parents and family, he was saved by a tribe of gypsies and lived with them until the age of sixteen. All those years he pushed along and over the borders of Holland, France, Spain, Yugoslavia, Greece and Turkey, a war nomad. There was neat order in his giant artist's studio, true Dutch-Cleanser hygiene. We never saw his wife, who remained upstairs, apparently as a matter of protocol. But he did invite me to come up and see his four Siamese kittens, last litter of the thirty-five which the mother cat had thrown.

Seeing these kittens I was reminded that eight years ago Yves Tanguy had given me two Siamese because my beloved alley cat Sing-Sing had died. The kittens were in a cardboard cake box, surrounded by paper doilies.

"When you get them home," he told me, handing me the box with the prostrate captives, "please keep them in one room for several days. That is the only way these cats can learn to feel at home and be peaceful."

After a three-hour drive from Connecticut, we arrived atop the skyscraper we live in and deposited the cake box on a sofa. We took the lid off and, with a glance at the two immobile creatures inside the carton, we left for the kitchen to prepare dinner, closing windows and doors behind us.

When we returned to the room after an hour or so, the cat con-

tainer was empty, the two animals gone. We did not worry much about it, since there was no way of escape. Later, after a search of many hours, which we gave up when every nook had been examined and no trace of them found, we began to realize that miracles can be performed by animals as well as by man.

We went to bed and fell asleep, exhausted. The disappearing act of the two Siamese kittens ended at daybreak when we heard a scratching noise behind our bookshelves, which rise from floor to ceiling. Hypnotized by the location of this unusual sound, we didn't get up, but waited patiently. The noise rose high and higher, until one of the kittens appeared on the top layer of the books. The other, apparently, didn't have the know-how to squeeze himself through the gorge between the volumes and the wall, and made anguished squeals. We rescued it by removing handfuls of books, and carried it down by stepladder.

These blue bloods continued to amaze us during the next few days. Their cat intelligence was topped by their ruthless adherence to the pursuit of their own imagination. Every evening at eleven thirty sharp, they started their life of a Siamese jungle. Each apparently represented a snake to the other and they were hunting each other, escaping each other, shaking each other, in the manner of a snake killer. It was impossible to stop their game which usually lasted for half an hour with undiminished ferocity.

But, alas, I had to give them away because I became allergic to their short hair, as I had with my former pet, Sing-Sing. One asthma attack made the decision inevitable.

> After looking at the weaver's kittens, we descended to the main studio. There we found another arrival, a man who was introduced to us as a public relations person with an idea for making documentary films about gypsy life in Europe, under the guidance of our Dutch loomer.

> The Dutchman produced some galley proofs of articles he had written about gypsies in which he recounted legends of great flavor. He had penetrating insight into the nature of the gypsy. He had written down the legends in the original gypsy language, a derivation from the Sanskrit, and also had done English translations of them. The Dutchman speaks four gypsy dialects and had taken Bouchard, the night before, to gypsy headquarters in New

248

York, where he addressed the people in their own language, making them feel at ease in the presence of foreigners.

The gypsies prefer horses to motor cars because a horse can fill up with its gasoline during the early morning hours when the farmers are still asleep. That's when gypsy horses are led to thieve the grass of others' property, to fill up on fuel that costs their masters nothing. The gypsy hides and saves his gold until death announces itself through a desperate illness. Only then is his money brought forth to hire a savior-doctor—at least to prolong the end, so that all members of the tribe, not only the immediate family, can arrive in time for the last breath. All cunning and greed disappear at the end.

Until then, money coins are acquired through shameless begging by the women, overdressed and wearing their hair loosely. The men lead an invisible life, taking care of the horses, fixing pots and pans collected from door to door, working as coppersmiths and as fiddlers or guitarists. They are always only half-dressed, casually, the aristocrats of the slums on wheels, true citizens of the wide world, unbound by laws of any land, the only traditional bearers of social independence.

There can't be any amateurism of Life as there is with us. You have freedom and you don't bargain with it.

Cultural Nomads

Friday
January 22, 1960

We are nomads again—cultural nomads. Or better: nomads of civilization. Moving from one apartment to another, from one town to another, or across borders into different lands.

Seeking opportunities and quitting them if they fulfill their promise fast. We live an emergency life, a deadline life.

To have a house is old-fashioned. To settle is old-fashioned. To stay master to one and the same problem is old-fashioned.

249

Nomads of civilization. What civilization? A civilization of contradictions which we try to weld. A chain of weak links.

Primitive nomads carried their houses and wives and children and dogs and traditions with them. The core of their lives remained the same. The core of the civilized nomad's life has been drained of its marrow. The core is hollow, and we gobble down anything to fill the emptiness. We don't stick it out. We have lost perseverance.

January 23, 1960 Professional artists should forever retain a state of amateurism.
This is important for mature creation.

Talk to Architectural League

Friday,
January 29, 1960 Gave talk at Architectural League. Traced my fight against "pictures on the wall," 1924, to World House, 1956. Other speaker Philip Johnson, goosing problems.

Day before, at Cazenovia Junior College for girls, lectured to matrons and trustees.

Day before, at Colgate University, discussion with President Case about converting old bourgeois nineteenth-century mansion into bold modern art museum.

Flew back to inspect animal quarters of large municipal hospital in Brooklyn. Office duty.

A sudden revelation to me of the simple method used by all commercial architects in planning hospitals, schools, hotels, apartment houses—simply: corridors with rooms left and right. Two or three sizes. Moduli. Put in beds, they are patients' quarters; roll in dozens of cages, they are animal quarters; put in equipment and they are operating rooms or laboratories; move in desks, and they are offices.

This is success routine. Try to change it and bingo, you're subversive.

Painter Pahlen

San Francisco
February 20, 1960

At painter Gordon's Zen-Buddhist home outside San Francisco, on a hilltop, hidden by dense forests, a secluded place ideally suited for meditation and conjuring memories, I saw over the mantelpiece of the living-room nave a painting by Mexico's Pahlen. Facing his painting, we drifted into discussing his fate:

Gordon and Pahlen had met in Mexico. At the end of the second World War Gordon moved to Mexico, and, searching for solitude, rebuilt an abandoned mill to house him, his wife, Jacqueline, and his workshop. There, he and Pahlen became friends.

I had met Pahlen only fleetingly in New York on his visits to the surrealist group which had assembled there under André Breton. But my connection with Pahlen had a deeper history.

I remembered vividly his grandfather, Count Pahlen, a highly distinguished Austrian aristocrat and Master of Ceremonies at the Imperial House of Franz Josef. However, my link with the count was purely visual. I caught glimpses of his decadently elegant figure arriving for sittings at the Academy of Fine Arts in Vienna for a portrait by Professor Schmutzer. I had been snatched away a year before from the engineering school of Vienna's M.I.T. by Schmutzer, who saw my renderings at a school exhibition and invited me to join his master-class of graphic arts at the Academy. I spent several afternoons a week for two years there on Schiller Platz, very flattered by this attention from a man who had been a pupil of Austria's renowned engraver, Unger, and was admired by all young artists for the quality and prodigious size of his "Joachim Quartet," a copperplate etching which measured four by six feet.

When we students knew of Count Pahlen's impending arrival for a sitting, we rushed into the corridors and lobbies and hid in corners and doorways, simulating serious occupations in a casual manner in order to become part of the colorful event. He arrived with guards of the Imperial House, who flanked his route through the vestibules, up the staircase and to the door of the professor's studio on the second floor. That was 1914.

251

After the second World War, young Pahlen was tossed ashore in the United States, married, crossed the continent to San Francisco, divorced, married again, and finally left for Mexico to publish his own magazine of his own ideas with his own illustrations, a man out of place, desperately trying to find his place, divorced from his homeland but not really wedded to a new country in spite of marrying again there, a surrealist dreamer striving constantly to become real.

The realities he achieved were being a painter and gradually becoming an expert on ancient Spanish and Indian works of primitive art, terra cotta, stone and gold. The financial status was still the insecure one of most artists who emigrate to a new land. He tried to remedy it by selling these antiques to museums and collectors outside the borders of Mexico. He tried valiantly, like his forefather Maximilian, to take root in Mexico as a new home. But the passages of his trade were lined with danger. His diplomatic ancestry helped him time and time again to keep above ground. His business, however, remained a life of tightrope walking.

Maximilian's fate was awaiting him.

One day he left his home alone and registered at a small hotel outside Mexico City.

In utter seclusion, he wrote sixty-seven letters, went out into the wilds, and shot himself.

To the horror of his wife, who found him only the next day, as a friend of Gordon's told, coyotes had already eaten away chunks of his flesh.

Pahlen was so much one of the last of great generations, whose inbreeding makes them so hypersensitive, that, although alert in the best sense to creative thought and effort, he was really unfit for the realities of a new environment.

Which, I ask myself, is worse—to adhere to a once-honorable tradition, now defunct, or to be the outcast of a new one?

They Did It—Doing It—and They'll Do It Again

February 23, 1960

It is Thursday, February 23. I must put down quickly, before oblivion strikes my recollection of the stand I took at the Artists' Club against mass automation in painting, according to the formula of abstract expressionism, by fellow travelers of the arts of both tender and arthritic age. It would be a waste of time merely to reject just another fashion in painting. But in the turbulent situation of the world today, the isolation of the artist has a dangerous aspect. The separation, the total independence of art from world affairs, has reached an impasse. This independence must give way to a new interdependence, that's how many of us feel today.

Locale: a broken-down corner at Second Avenue and Fourth Street. A house entrance bearing a Ukranian inscription in Russian block letters on the door, next to a relic of a drugstore of the late nineteenth century, hangout now of delinquent teen-agers and sympathetic bums. I enter with a feeling of intrusion. On the third floor of the building is a loft crowded with artists' friends, painters and sculptors, writers and *critiques d'art*, all ready for the "kill with charm."

Occasion: a discussion on "Emotional Architecture." Mathias Goeritz of Mexico, a sculptor, introduces me as the originator of that concept. I skirted this generous introduction and sailed into the broader aspects of the state of art, which has kept us all single-track-minded since World War II.

Emotional or functional, opposed to each other or aligned, every art style has crystallized only after many good and valid examples were realized, as now, for instance, by those American masters whom we can call the "rooters" no matter what country they originally came from (like Gorky, de Kooning)—Americans all, pioneers in the true tradition of our forefathers aiming at liberation from old European standards. But the new generation, it seems, can't wait for maturity.

253

All want to be ahead, ahead of themselves, and certainly of their elbow colleagues. But worst of all, they want to be the first imitators—even *before* a style is accepted. "Be before" is the new slogan. Imitation, application, cleverly disguised swiping of their masters' own styles are too often the norm of bandwagon artists today. Since our exuberant victory of World War II, there has been a free-for-all battle of imitators, not of initiators.

In the beginning of the last phase of modern art, in the years following 1940, a few imitators made *tabula rasa:* wiped off with one push all remnants of past and present Paris art and its techniques. Down they went. Down the drain of French history: the flat and oval brushes, the underpaint and overlays, the meager tubes and the succulent ones. With knife and fork, fist and palm, the Americans went to work, poured a porridge of paint and served it with or without turpentine and oil, mixed with plastic plaster, cement, and milk gone sour. What the hell, as long as it was freshly cooked and without recipe! They loose the furor of rebellion, breaking away from past and present history with instantaneous action, as a breakstorm pisses out of a blue sky. Down came the colors, splashing themselves far and wide over the canvases. They did it doing it. The artist's belly button sprang open at his magic touch and out popped a navel cord which the painter held in his hand and swung over the canvas, squeezing belly dew onto it with flash and splash. And when he so desired, it would jet out like a fountain or rise like a Hindu rope performing a snake dance on the canvas floor. Not thinking, not scheming, not sketching, as in the past, nor planning and tickling canvases until they giggled coyly: the artists screamed in an orgasm of achievement. Victory was and is theirs.

Of course there were predecessors, pre-eminent possessors of new laws, and they were well used by those pioneer Americans as steppingstones.

Grandpa Kandinsky of 1912 stood guard in the 1940's. Encased in his tomb, Van Gogh pounded rhythmic sounds to cheer the new dance steps on canvases. And the German expressionists, Blue Riders, detaching themselves from the apocalyptic horses of World War I, stampeded around the American painters, inciting them into a tumultuous orgy, shaking off the iron, golden, and plastic chains of realism even in the disguise of Cezanne. Yes, the Ameri-

cans finally became free, painting almost blindfolded, seeing with the inner eye from instant to instant. If need be, force the torch down, don't be frightened if the smoke bellows against your hand, it won't singe your flesh; hold the knife's blade in your bare fist, no handle—see! It doesn't cut your flesh. It worked. They opened doors where there were walls, and the very stones started to chant.

And thus the U.S.A.rtists created a new style. They gave it to the world.

Glorious achievement for a savage tribe of broom riders, witches who came down to earth bringing the gift of a new art to the populace of their land, nourished too long by pin-up prints and museum relics.

Drawing as the academic basis for composition has been kicked in the teeth, and false teeth they were. Compositions are no longer fixed in the centers of chassis, or left and right, but the total plane is the battleground for the game of painting, with shifting nuclei, wherever the moment demands.

Paris had to crawl along walls hung with American abstract paintings instead of its own.

A new wind blew across the Atlantic. The chimneys of Montmartre and Montparnasse toppled and buried the saucy French painter's kitchen in rubble. The center of youthful art was shifted from Paris to New York. A long tradition was reversed at last.

Since then, painting has been a victory dance, a continuous carmagnole. And in the basket of the guillotine the Americans found the head of the Emperor, Picasso.

Everybody joined in celebrating the heroic period. The audience grew; it spread and spread and spread, and founded new centers of American Art throughout the United States, particularly at universities where art schools existed or were newly established under the guidance of young painters of this conviction who had never taught before and had now a steady income and, thus, security to paint.

It was and still is a great movement of protest against the burden

255

of persistent Western tradition. Collectors have turned from European art to American contemporary art. Increased demand has lifted the prices higher and higher. For the first time in the history of art, young masters command prices neck and neck with old masters. Hand-to-hand deals were off between the artist and the buyer, the dealer wedged in. And in spite of heavy government taxation and dealers' percentages, there is still more left for the "bohemian" than ever before in the history of selling and buying art. Unfortunately, that has also established a veritable market.

Moreover, like Les Halles, where vegetables and fruits are sold by weight, Paris has become the supermarket of art where a painting is valued and sold by an established squaring-off in standard units of size, multiplied by the value assigned to the painter: an automation of prices.

That, indeed, is not America's contribution, the equalization of art with merchandise. This point system is the last barricade of the art-gallery empires which try to maintain *à tout prix* their dictatorship over selling and buying prices. The rule of the ruler.

Woe to a few well-known galleries if they do not accept youngsters or old artists gone young who have rejuvenated themselves by inhaling the new climate. Beginners simply invade empty stores and put their paintings and sculpture on display without fuss. An almost endless array of new galleries, chiefly in slum sections of New York, has opened. Often their *vernissage* ceremonies are, by common consent, at one and the same hour on the same evening. One can watch troupes of friends of the artists and the artists themselves wandering from basement to basement, from loft to loft, in celebration of this coming of age of American painting. Processionals of joy.

But in the melee of joy the artists have torn the many-colored cloak of abstract painting to shreds, making little flags of it, waving them at the entrance doors of their exhibitions. Europe has done it, too, and is still continuing the pattern, while most of us here are now conscious that the ground has been prepared for a new garden. Our present American masters have taken deep roots and are rising like oaks and pines.

The reborn body of art, robbed of its warm embrace, chilled in its nakedness, cooled by the sweat of its brows, desperately needs

a new cape, lest it freeze to death.

The tradition-smashing revolt has left the battlefield of art littered with fragments. The outward-bound forces, so victorious, must now return home to reassemble their strength before advancing again.

This is where we are. That is what we are confronted with now.

We must emerge from the isolation of our abstract life and unite with the environment of the American scene. Shift home from our travels abroad. Stick it out here. The life of this new land, its mountains, rivers, the heterogeneous population in its struggle to create a common goal—we must not stay apart as pseudo aristocrats of art. No one can question the artist's need for this first stage of solitude and concentration for the sake of finding one's self. But the time calls now for emergence into a second state of creativity: the absorption by art of the atmosphere and activities of our land, including its social and economic achievements which are, after all, testimony to the dreams and desires of our new life and new populace. Abstractions from no man's land have given us a breathing spell. And motifs, subject matter, in our paintings and sculptures must not return in the form of apples, flowers and guitars, faces and figures, clouds and mountains. There is a new world of objects that can become part of our visual language, and we have been blind to it. The land is so abundant with objects of such super-functionality—condensers of a practical imagination—that these new products of an industrial dreamworld can easily become a new reality through art far beyond the standard concept of traditional realism.

After such a second period of absorption in what surrounds us daily and continuously so, after we have strengthened ourselves with this fresh air of the suddenly discovered, we shall be prepared then to enter a third stage, that is, to conceive a man-made environment with all its diversified parts co-ordinated, produced by artists as well as industry, hand-made as well as prefabricated, living in a common relationship in a continuous exchange of influences.

Of course we know that the imitator-artists or imitator-industrialists will counterfeit as before, but that the creator will continue to dedicate himself to a cause that he feels is common to all who search for the essence of existence.

257

I then proceeded to tell the audience about an unforgettable experience in São Paulo, Brazil, three months ago. Participating in an International Congress on Art and Architecture in the new capital, Brasilia, I had afterwards a chance to see the Bienal exhibition of paintings and sculptures in São Paulo.

Driving in city buses to the opening of the famous Bienal, we delegates touched the edge of a tropical forest all along the route. Multicolored hammocks, for sale, were strung among royal palms. We rode by. A sharp turn and we faced an endless glass building, four stories high. Designed by Niemeyer some years ago as a World's Fair exhibition palace, it was now being used by the Bienal. The walls of three floors, each almost a kilometer long, or at least that was how it felt, were strung with abstract-expressionist paintings from forty-six countries. What an unexpected disillusionment! The paintings seemed to blot out one another, yet individually, whether painted abroad or in our U.S.A., most of them could very well be loved when isolated in a home. Here, en masse, they murdered one another; we all felt the same way. I felt guilty. Was it just because I was tired from miles of walking and being barked at by loud and louder paintings and sculptures, giant-sized work? Too much of the same thing? The quality diluted by conformity? Badly hung? Badly lit? Opening-night aversion?

Yes and no. Swaying between pro and con, there gradually developed in me an irresistible doubt of the validity of it all. Was art on the point of a *salto mortale?* Would it fall on its feet or on its head with a crash?

Unexpectedly, we all met outdoors.

The night was a welcome umbrella harboring us in cool air.

None of us wanted to talk. Silently we understood one another. If there could only be something now to distract us or absorb us away from that experience, it would be liberation. But what?

Opposite the gala entrance of our glass palace was a barrack. A sort of large, one-story garage, it seemed at first glance. We had by-passed it coming in.

"Have you seen the Bahia exhibit?"

258

"No," I said quickly, "no." I turned and looked at a guard. It was he who had addressed us.

I remembered at once that friends in New York had told me that if I visited Rio and São Paulo and Brasilia and *not* Bahia, I would not have seen the real Brazil.

"Where is it, sir?"

"Right there, opposite, in the barrack."

We responded instantly, and crossed the driveway toward it.

I touched the doorknob carefully. The door slid open with magic ease. I stopped as I was about to enter; so did my colleagues. The floor of the oblong depot was green, black-green, and covered from wall to wall with a carpet of what appeared to be live leaves. We hesitated to step on them, recognizing eucalyptus leaves in layers at least six inches thick, apparently unruffled by visitors inside, who carefully set down one foot after the other, as we did. A smell, tart and reverent, cautious on our nostrils, made us feel lighter in weight and walk as with winged ankles.

In the middle of the room, on ordinary wooden crates, were four ship bowsprits, full-size sculptures of men's heads with dog-faces, carved in wood, of no period or, if you like, the nineteenth century, or our own time, it did not matter: ". . . as beautiful as any of the Romanesque carvings," Meyer Shapiro spoke out. He was right. It did not matter: period, time, technique or even quality. They were. They were true to themselves, as trees or rocks, teeth or hair. They were. Yes. They were spearheading the bulk of the ships, kicking and pounding the sea, beyond the horizon of the Bienal. Inside the Bienal, it stank.

Beat after beat of music could be heard coming from the other end of the room, knocking relentlessly against the wall, echoing violently and feverishly like jungle outcries of warring tribes.

Cautiously we walked around the exhibits. We discovered children's toys, in clay, painted; pennants with paintings on both sides, religious in character, familiar themes of the Holy Family, insignificant in terms of museum quality but significant for a population with belief.

259

The wall which the music tried to penetrate was covered in its entirety with small sculptures, a vertical carpet of ex-votos naïvely formed, imitating human body parts, all carved in wood with the realism of memories nourished by daily observation: *expressive* in form, *abstract* in meaning. Hands, hearts, breasts, feet, arms and eyes vibrated on the wall, shaken into a specific rhythm by the beat of the music. The instruments were flinging sounds against the wall like pellets, forcing the religious sculptures into a pagan dance-tremor.

Finally, we lifted a curtain over a doorframe in the wall and hesitantly filed into the squarish music room. We were stunned by still another unexpected sight. Close, right in front of us, two elderly Negro women, wearing flowing ivory-colored dresses covered from neck to hem with white lace, sat on crates so low to the floor that their skirts were undulating in ripples like two silken lakes. They offered us warm dumplings on wooden spoons with long handles, dumplings they cooked between them in an iron pot steaming with boiling water over a tiny coal grill. A nearby basin was filled with dough. They smiled, and they served with gestures of inborn nobility.

Next to them about twenty people stood in closed ranks forming a circle, their backs toward us, obviously watching a dance. We sneaked up close, trying to find an opening wedge to peek through. What type of dance could we expect? The Bienal would probably offer us the latest application of modern art to choreography. But to our shock, none of that. What we saw ripped into all our expectations. Let me describe it.

Four of the crowd were beating tin boxes with sticks, and one had a tiny tambourine. They let loose a veritable stampede of the samba, which energized me and my friends to stand up for two hours watching the dance between a father and son, their intricate relationship expressed in acrobatics on the ground, in the air, in near-ballet steps, boxing punches, outcries, brutal attacks and tender arrays of two bodies. A flow of movement transforming folklore steps with spontaneity, a creative act from instant to instant. It became a new syntax of choreography. No theory but utterly real.

The old man had taken off his coat and was dancing in shirt sleeves and vest. The young man also in a shirt with the sleeves rolled up.

They wrestled on the floor, almost stepped on each other, jumped up (no pirouettes); victory or defeat changed their bodies' rising and falling, they pursued each other with leaps and arm-fangs outstretched, rejecting or drawing back the victim. They marched, gyrated, shook with syncopated steps, stops and gos. Each body a whirlpool. Then: caressing palms of hands falling like gliding leaves of trees, swinging on air, slowly coming down and bending the partner's body with their feather-weight, then melting away like snowflakes.

Again and again the rhythm of the music flashed short and on edge; but suddenly it rolled out, creating endless valleys of sound spaces, and with the hailstorm of beats it came back to us, closing in from all sides.

The dancers crisscrossed these spaces, slicing time to bits and pulling it together, elbows and knees shuffling like pistons, pushing slowly back and forth, creating time, exhaling, inhaling space. The square room had no end. One didn't know where the dance started, where the music. Perfect isolation and correlation. These were not Mary Wigman steps, not Martha Graham's, not Merce's, nor Lifar's, neither was it ballroom samba: it packed a wallop without theories or fashion.

It was true to theme and content, and a form evolved pure and direct as a naked body.

The communication was immediate and lasting. No artificiality or artistry.

Conviction, not fashion. Hypnotic effect of honesty.

Perfect balance of technique and task: a content was communicated in every split second of the dance. It was not a banal message, a storytelling, or propaganda, or a divertissement of abstractions. We had all lived through such relationships: father to son, parents to children, or grownups to youth. Here the agonies and joys of these relationships were transmitted into the form of the dance, not artificially delineated after old or modern patterns of a profession; they were indigenous to feelings, to the earth, and to the hopes of time to come. A truly creative act. In spite of the dance being fleeting in its character, the experience implanted itself to permanence in our memory.

261

We walked out in a daze of joyous amazement.

This dance expression gave me hope for all the arts, for a revival of art in which content is the prime instigator.

Yes, we all know we have talent. But is our valiant use of it valid? *L'art pour l'art* is gone, the road was long. *L'art pour l'artiste*, the state we are in now, is at a dead end.

The brush stroke, the chisel chip, smelting-torches welding steel, the technicalities of creating art products, of architecture, the inventive methods of industry—brilliant as they may be—have they succeeded in replacing content?

I mean our sense of reality, of meaning, of touch and go?

Content, content and I don't refer to anecdotes or propaganda or photo-reality, outworn formulas of now and past. We must create, like squeezing the fruit of life, getting the juice and throwing away the pits and skin. Is it not the very essence of art, to lead a world in disorder to order, as Camus said?

No superstitions, not folklore. But indulgence in destiny is our commitment. There is no formula for that indulgence to be push-buttoned out of vending machines. It is a matter of everyone's own process of growth: inwardly. Inevitably, the seeds push outward through the shells of conformity to reach kindred strivers.

I have stumped for a solution since the early twenties, and I gradually developed the concept of "correlation"; that is, abandoning the separation of paintings and sculptures from architecture. Just as in the social and economic strivings of the twentieth century, the self-indulgent division of countries, of social groups, wealthy or poverty-stricken, power-driven or withdrawn, must be overcome; so it is obvious that we have to find ways and means to get together and live together. Separating boundaries must fall. Walls must give way to arches and portals, and correlation between peoples made easier. Hence my paintings and sculptures and architectural units try to correlate in a continuous flow without being pinned down to a spot as if each lived in a separate prison cell. These galaxies, as I call them, I have exhibited for decades. They were and are my own effort to clear the way for endowing the arts

and architecture with a new purpose: correlation in continuity.

I was, and still am, pursuing this problem. There is no beginning and there is no end to the possibilities of co-ordinating art and architecture.

I can see and hear others who are also exploring the problem of continuity, not so much in the individual fields of painting or sculpture or architecture as in the theater arts, which, by their very nature, combine painting, sculpture, architecture, speech and, above all, movement into one continuous flow. Look at and listen to the "happenings" on the Lower East Side of New York City. Listen to and look at the performance of Dylan Thomas' *Under Milk Wood* at New York's Bleecker Street auditorium, now converted into a big barn after housing for twenty years Amato's Italianate Opera Company. This new performance is the best space ballet I have so far experienced. The word becomes the action.

The music of language emerges as an unending choreography of the happenings in a Welsh town. Thomas' lines are transmitted into meters, stanzas, verses of an audio-visual poetry. Men and women, stage floor, walls and ceiling are dressed in plain wool-gray. The poet's words provide the colors, flying off like exploding rockets, illuminating the present, the past, the coming. End never comes, beginnings lie centuries behind and before us.

We here in the U.S.A. are a happy lot, living in a land of so many varied aborigines, that to fuse their diversity in art—whether painting, sculpture or architecture—is not only a high challenge for any craftsman but an obligation to visualize the roots of continuity. We must reject conformity to the past (and present, for that matter) in theme, treatment, composition, framing, hanging, pedestaling, exhibiting.

The habitual way of a painter was and still is to cover a canvas from left to right and from top to bottom. This is done with oils, with water colors, with tempera; whatever the medium, it's used all the way through in a given painting. And further: these methods are used in all schools, whether realism or abstraction or non-objectivity. All the way through in a hypnosis of habit. That acquiescence with form and fashion has been developed with such skill that the skill itself has become the purpose.

The glass is beautiful but empty.
The lamp has body and shield, but
 no light.
The can has triple-color printing,
 but stale beer.
Tape recordings are replacing
 face-to-face talk,
Reproductions are substituting for
 production.

Each artist carries the burden of responsibility for the next of kin of art. The crisis between man and men is too obvious for artists not to feel akin to everyone across mountain ranges, oceans, colors and creeds. We cannot escape relatedness any more.

The artist is a leader beyond politics. Our ivory towers will rock and start to march, massed together in a phalanx of unsurmountable strength.

Billy Rose Party

Wednesday
April 13, 1960

Today, two days later, I remember Billy Rose in a new and oldish French mansion in the Nineties, east of the Hudson, east of Fifth Avenue, east of Madison, the Middle East reborn, a tradition kept alive here in a chateau of American architectural vintage. A curved stone façade of new-world baroque, colonnaded, an iron-door *visière*. Billy must be magnanimous to enjoy his porter-portier who opened and closed the door with retardando timing, both ready and lax to take off my coat, letting my hat rest in the palm of his hand, weighing with indifference the necessity of my visit, and led me past staircases, elevators, corridors, pictures, statues, chandeliers, a tour guided in silence, marching for minutes after minutes, no voices heard; finally, chatter from the end of a twisted corridor, and there he was, my host, a small, mobile sculpture, transforming the neo-classical-baroque-modern interior into a glamorous Broadway setting, being much at ease with himself and his guests. An unexpected relief after the opulent introduction of the architecture.

264

Noguchi, the sculptor of many continents, present on the same couch with me and with other architects and artists. Among them a curator ". . . hell, are you here again?" I volleyed at him: "You capable digger of unburied collections of modern paintings which you unearth for glorious burial in Levantine museums! I'd rather see you go back to school, become a scholar as you intended, for which you have talent, and then and only then be a croupier for your new casinos. I'd rather see you make history than repeat history." All in good humor, and so it was taken, and the ground broken for more serious discussion.

The discussion centered on the touching cheeks of two projects facing each other on a hill in Jerusalem, our Shrine of the Book and Billy Rose's sculpture garden. A tender touch between the sacred and the profane—the profane being Art, whether realistic or abstract, and the sacred being the spirit of the Dead Sea Scrolls. One calling for argumentation, the other for contemplation. A conflict apparently irreconcilable. To make a link between the two or not, was now the question. Of course time will help us to take care of it.

After drinks were served, Billy Rose addressed me (we had met over the years at pre- and post-theater gatherings, but slipped by each other): "I have greetings for you from Al Hirschfeld. Heard and read a lot about you. The New York World's Fair Director would like me eventually to head the amusement and theater section of that monster enterprise . . ."

I: "Of course, you're the man and the best choice. You'll take it, I hope, won't you?" There was a pause of nonchalance. Billy's face, till now softly listening, turned slowly into a sphinx smile and he asked the magic question: "Well, if I do, will you design the theater for me?"

Amidst all my colleagues and frenemies, I knew that I must avoid giving a direct answer. I was on the spot. An argument went on down deep in me, while my fellow guests were frozen now in various sitting and leaning positions, readying themselves for my reply. Finally I answered, banning all possible jealousies by tossing out: "As far as the World's Fair is concerned, the only suggestion I have for you is to garb the whole amusement section in a tent town drenched in color, light and sound, ever-ready to be burned down to the ground and rebuilt within twenty-four hours.

265

The tops in prefabrication planning. But listen, to be less practical, why don't you buy an island somewhere, let's say at Lago di Como, where we can retire instead of drowning ourselves in the raging waves of Flushing? Billy Rose, aren't you ready to do that after your turbulent life?" "Is that what you want?" he retorted. "Then let me show you the island." He turned in his seat, as on a swivel, and took from a desk behind him some black-and-white and color photos of a beautiful islet. He handed them to me. "I own it. It's in New York State. There are many houses on it, a peacock sanctuary, and a beach, and you can see the shores of Connecticut. There's good sailing and fishing. I'm going up for several weeks very soon. If you want to come, everything is ready for you. The only thing you have to do is bring your own fishing companion."

Many of the guests soon left for dinner parties. Before I entered the elevator, Billy embraced me. "Love to see your 'Endless House,' may I ring you?" "Of course, any time."

A pleasant outburst of warmth. He did not seem to me the hard-boiled, business-driven man of his reputation, self-sufficient and totally independent. Was it the benevolence of maturity, or the cordiality of the successful, or perhaps the first act of a play staged by a very experienced theater man? I really don't know, but I felt attached.

Thursday
April 21, 1960

The new floor-to-ceiling sculptures, which I have sketched in the last year and executed in wood and plaster, to be sand-cast, led me to an interesting experience the other day.

The four or five or six parts of these large sculptures are still separated, each cast flat in bronze, and have to be hammered into curvatures. This is how it's done: two heavy blocks of wood are placed beneath each flat bronze plate, which is then struck by a heavy wooden hammer. The distance between the blocks determines the depth of the bend in the plate. By widening or diminishing the distance between the blocks and turning them in different directions, and by continuing to hammer heavily or less heavily, the twisted and molded form of the piece is evolved into its final projected shape, which we have before us in a paper model.

I asked the Roman Foundry to give Ralph an assistant strong

enough to deliver the blows, and not too expensive a worker; as a matter of fact, I was sure an unskilled laborer would be satisfactory for the task. The foreman got one of his skilled workers away from his foundry duties, but after a few minutes he was needed to help cast a monument. I was left alone. A man looking very much like a Polish peasant then came up and said he had been sent to help me. The foreman arrived afterwards, and told me that the man did not speak English well, and he wondered if by any chance I spoke a Slavic language. I said no, and added that it would not be necessary for us to talk; we could probably communicate by signs.

The man started at once to hammer, and after a few minutes he proved to have a fine sense for the job. We did not talk, but communicated with gestures. He apparently understood my hand language. After half an hour, I was delighted with him—even more delighted than with Ralph, who is no longer an unspoiled craftsman with an instinctive sense of correlation, but too "artistic" to forget the paper model and just follow its inspiration.

This showed me how the love of using one's hands in a "crafty" way is inborn in man, and how we lose it through fringe education, through museums, and through an ambition which leads us away from the will of nature in us. I could not imagine a better person for this type of job. His blows hit the spot every time. Thank God! And so, in the end, Ralph and I could only assist *him*.

Herbert Mayer-Endless House

Friday noon
April 22, 1960

The chief of the tribe of World House Galleries wanted the "Endless House" to be built for him on his ground in Connecticut and ready on September 27th. At the same time, he would have an exhibition of my work at his gallery, thus promoting the "Endless House." Day before yesterday, a friend of mine who is a member of the advisory board of the Museum of Modern Art suggested that I write a letter to the Museum expressing my bafflement at their not

267

notifying me as to whether or not they had raised the money to build the "Endless House," thus leaving me and my building dangling. The Museum is busy raising twenty million dollars for an additional wing, and apparently cannot make a drive at the same time for only one hundred thousand dollars for my "Endless." The head of the Architecture Department can do nothing without approval from the chieftain, and he, overworked and harassed from all directions, must spend most of his energy on the money drive for the new wing. The board of trustees would have to be consulted, too. So I am like most architects, suffering from a chain reaction of indecisions.

Thus it has become too late for me to build the house this year. And after next year they are to put up the new wing on exactly the site where they planned to build the "Endless House," which annihilates forever the possibility of building it in the Museum garden, as planned and hoped for. Will my history repeat itself, or will there still be a chance?

I did not want to press the matter and interfere in Museum affairs. But that was a mistake. Nothing has ever worked out that I have not pushed myself. Fate spins out your life in the same color yarn; see how the dilemma continues, changing only its pattern. The weavers change but the yarn remains the same.

My friend on the advisory board thought I should withdraw from the Museum at once and sign an agreement with my World House client to build the "Endless House" in Connecticut. I agreed, the letter was drafted and I was to rewrite it. But the next day, yesterday, same friend phoned telling me to hold off with the letter because he had had a talk with a department head at the Museum the night before, and was assured that he himself was upset by the "shame" of the Museum, hoping, as did the chieftain, that somehow my building might still be possible. But will this fencing bring balance into the matter?

In the meantime, I had already arranged an appointment with the World House gentleman and had to keep it yesterday at four thirty. When I told him I might withdraw from the Museum, so he would be the first to have the "Endless," he said, "Oh, Fred, don't do that. I don't want you to lose the opportunity of doing it there on account of me; and besides, you know, I'm not in a hurry. I still have my house, and my children aren't going away to college

268

until two years from now, so I won't be in actual need of the 'End-less' for two years." I was shocked. I had planned the house for him on the assumption that he wanted it by September 27th of this year, a five-month race to the finish, but now he presented a new front. He continued. "I woke up last night thinking that if I could find a site in New York City proper and charge something, we probably could get the cost back easily, satisfy the public's curi-osity about it, take orders for the house, and if anybody is ter-ribly eager to have it, I'll be glad to move my own house to their plot. By the way, day after tomorrow I'm leaving for a three-week ski tour in the Canadian Mountains. Will you come with me?"

There you are, my dear readers, friends, enemies and bypassers. See what you can make of it, and scold me for not being more ac-tive in this matter. Changing faiths is a game I can't play. I feel lost and secure in my . . .

The cloth on the table in the kitchen where I am now sitting eat-ing my brunch is a checkerboard of white, red and black diamond shapes pressed onto oilcloth, which my good German housekeeper has glued to the wooden table. This cloth appears as solid as my life is not, and I envy it for its utter neutrality, for the way it lets everything rest on it with equal patience: the bread basket with its light weight and the smaller, heavier porcelain plates, the heavy jar of Nescafé, the Carnation evaporated milk with its sharp-edged tin can, the brown glass bottle of Squibb's "Theragran" vitamins, and the circular stone jar of Dundee's English marma-lade, all of these carried on the shoulder of the table and its cloth with infinite steadiness. Past and future are wiped out. It only lives now, and now only.)

April 26-27, 1960

Letter to Hans Arp, April 26,1960

the H-ARP is singing in the spring
but i can't hear it
my ears are filled with memories
which crowd out the tender sounds
or is it an ear-vision you are
speaking to me
and ear-blindness
which makes me deaf?
But I can see you as
sharp as my silverpoint
drawing of you made in
1947 in Mendon.

Letter to Jacqueline Lamba, April 27,1960

le temps passe
la passion d'amitié
n'est pas encore passée
passe-moi un mot

inventive love

Monday
May 2, 1960

let's go to bed and lay heads ear to ear,
gently interlocking those
marvelous ridges and valleys of our winged shells

ridge on valley and valley on ridge
what tender hardness!
we listen to the breathing of
our inner sea
blood is speaking from onear and afar
so dangerously close, droning whispers
suddenly pulling away
vanishing,
but ruthlessly returning with
steel tom-toms.

i lift the quilt of my bed
enter, glide in, and you'll be
sheltered

our arms are stretched along the shores of our
bodies like oars never to stir the sea again

we touch
struck magnets resisting their charge
in the grip of timelessness

The "Endless House" pre-visited

you can't count continuity, but
in continuity there is exact security no matter where you go
if you need it, you know you can come back to
the status quo
in our finite, dead-end apartments there
is no escape into continuity from the status quo!
it is frozen
a refuge perhaps—but if you want or need
a change you can't have it
you are locked up

we should learn to live not only on *the floor*
but with *the floor* (*outdoors we are*
comrades of the earth)
we've been living with walls only
and doors flapping open, banging like bats' wings
on the ceiling we hang lamps,
on the walls we nail pictures
set windows in, the nostrils and eyes of our rooms,
on the floor we stack chairs and tables,
the basement has excrement from the
digestion of our house-life,
the attic is the graveyard of
grandmother's childhood
she was always sweet to me
perhaps we should incorporate
the attic into the Endless
there should be something done
to keep tradition alive
of course

Monday, May 9, 1960

When frail Mrs. Hughes flew in from California on her wings of
meta-madness, I was, for the afternoon and evening, her devoted
escort. After she had visited my downtown studio to scan the
model for the "Endless," she seemed to climb a staircase to heaven
while riding up and up in the elevator to the twenty-second floor,
to my *mansarde*, finally alighted on my couch, viewed my sculp-
ture, "The Vessel of Fire," a configuration in wood and bronze,

272

fell into meditative muteness and, awakening, invited me to accompany her to see Valentina, a miraculous dressmaker of Russian birth, married to Chevalieresque Baron von Schley.

We entered an exquisitely interior-decorated, almost Imperial Petersburg apartment on East 55th Street, facing the trawler East River, where stars appeared, through slits in the triple-lined satin curtains, like frozen snowflakes above the Neva. Persian rugs scattered generously, an abundance of Louis XIV, XV and XVI fauteuils; behind all the pieces I almost detected ghost-guardsmen, refugees of Napoleon's lost army rehabilitated in New York, mingling with East Indian ladies in saris at this cocktail party, all surrounding a typical society-figure in jazz-purple. Everybody was lounging about an intarsia tea table, which, instead of holding a gleaming samovar, was covered with various glasses, the icy contents frosting their shells. The bartender was a young lady in black trousers, odd-looking black cotton socks, black pantoufles, and clad from waist to chin in a simple, green-black turtle-neck sweater out of which grew a face, a profile, and eyes reminiscent of Greta Garbo's. It was Greta Garbo.

She marched back and forth between guests and a corner table-bar, mixing drinks for the visitors, sitting down silently, listening, getting up. She asked me to light her cigarette. So close to me, her hand appeared dominant. I could not link the heaviness of it with Garbo's face of now and yestertime. At close range, I discovered in that saga-face of tenderness a nonchalance in the curve of her eyelids, accentuated with darkness, and an edginess on the ridge of her nose. When she addressed me in her blue voice, I felt the coldness of shadows.

But the myth of Garbo's unearthliness persisted stubbornly. My eye and ear and brain were unable to destroy it. At the same time that true judgment attacked the image of her past, my memory tried to rediscover the grace of her face and figure, to restore, to superimpose the old dream on facts to the contrary, in fear of losing a beloved remembrance.

As we were leaving, Garbo guided us into the foyer with our hosts, as if she were the daughter of the house, and seeing my hat of moss-green velour, she said, "May I put it on? I've always liked Tyrolean hats, but alas! I do not wear hats any more, except in rain and snow."

273

She lifted the hat from my hand to her head and looked at herself in the mirror. And there, in the glass, she and I saw for a moment the old, that is, *the* Garbo we all know, divine in beauty and forever young.

My struggle was over.

I was defeated, and felt happy.

Decisions Sudden

Friday, May 20, 1960

"When my father died fifteen years ago, there was someone left on this earth to become my new father. That new father is here today, at this gathering. He is probably the most distinguished citizen of our country, and his age is nearing ninety. Ladies and gentlemen, I introduce to you my second father, Bernard Baruch."

I wanted to ask what the second father felt about his new son, but I didn't. Billy Rose's words went on; he introduced more eminent guests, and revealed the purpose of the meeting at his mansion on East 93rd Street, where red plush folding chairs with steel frames painted gold carried on their knees, like Sunday babies, a hundred guests at this special service.

We were all embraced by a salon-cathedral, a sensuous room, visually perfumed with cherrywood panels, a keyed-up elegance, part English, part French, the walls garlanded with blackened carvings. These were echoed by dull black and creamy white heavy linen draperies in tall window niches; a white ceiling with Italian stucco ornaments, superimposed, from which dangled two Venetian crystal chandeliers.

In this hall, Billy Rose looked even more diminutive than Willi Metternich, but more compact by virtue of his density of self-confidence.

Many guests had donated paintings and sculptures for an auction to be held in the autumn to raise funds for the sculpture garden

274

Billy Rose wanted to build on the slopes of the Cross of the Valley in Jerusalem. The gathering this evening was an infusion meeting.

". . . and now you can touch the man with your eyes, if you want to, with your hands, because he is here, so that one day later you may tell your children you have touched the greatest sculptor of our time, Jacques Lipchitz."

Jacques spoke humanely about this gathering of New York "foreigners" interested in Hebrew Jerusalem and the peaceful purpose of creating an art center at a time when Khrushchev and Eisenhower were clashing at the Summit Meeting of politicians in Paris, to the brink of war. "We Jews hope for peace through art," and Lipchitz ended with a quotation from Isaiah. He was moved to tears, looked tired, and almost stumbled back to his seat. The sculptor looked like a biblical vision.

Afterward, in the melee of people passing through the mansion lobby, an incident occurred unseen by Billy Rose. An easel holding one of the first donations, a still life by Monet, was accidentally kicked by one of the donor ladies and fell to the floor. The picture, knocked off its ledge, was pierced by the easel's steeple, and remained impaled there. Aghast guests quickly lifted the painting off the easel's hook, looked for a closet to hide it in, and made the easel disappear too. An omen, perhaps, but I don't think it will have the power to squelch Billy Rose's drive.

The registers of different voices, the bubble of flowing champagne, the staccato of porcelain supper plates were sinfoniettas pre-sounding a happy ending for the gathering. Billy Rose, in a jovial mood, introduced the evening's speakers to various groups of guests and happened to tell the story of the birth of the sculpture garden.

He admitted frankly that he had never thought of donating any of his sculpture collection to anybody or of paying outright for the expense of establishing a sculpture garden in Jerusalem until one evening a year ago, when a man unknown to him suddenly emerged from a crowd in a theater lobby, like an apparition:

"Mr. Rose, I know you have a big collection of modern sculpture, and beautiful it is. What do you intend doing with it?"

275

"I don't understand you," Billy answered. "Who are you? What's your name?"

"I understand you don't understand, but what I want to know is: how old are you?"

"I'm sixty."

And Billy Rose continued, to us, "Don't laugh, but it suddenly dawned on me that I'll have to die, too, although I'm quite a rascal and know how to get out of tough situations, believe me. But life isn't Broadway, although Broadway was my life, and as I remained silent with these thoughts instead of answering him, he guessed the impact of his inquiry on me. My face had probably changed color, too. The man then said, 'I can help you.'

" 'What do you mean, you can help me? What the hell do I need your help for? I don't know you, man.'

" 'What I mean is this: I have friends in the government in Jerusalem. I'm flying over there tomorrow. I know they intend to erect a Museum of Modern Art on a beautiful hill in the middle of town. Why don't you build a shrine by donating your collection for a sculpture garden in Jerusalem? You don't want to sell art, do you? Leave it to the world. You have heaps of money and no children. It will do you good to do a great deed. Suppose I let you know in a week or two what Mr. Ben-Gurion has said about the idea? O.K.?'

"I was stunned. I bowed my head to listen more closely. When I looked up, the man had vanished as unexpectedly as he had appeared.

"Ten days later, I got a long wire from Jerusalem, offering me four acres, free, on the hill of the Valley of the Cross as a donation from the City of Jerusalem for establishing an international sculpture garden. Now, my dear friends, who could resist such an offer? Jesus, Moses and me on the same hill!" He laughed, with humility and pride. "We three, all together in the Valley of the Cross, surrounded by a phalanx of sculptures, and archangel Ben-Gurion protecting us from the anger of orthodox groups admonishing us for the making of images of men. Art is beyond profanation.

"That man's idea was a godsend. And I agreed to create the sculpture garden."

There was hand clapping and the guests turned to one another amiably. The only silent watchers were three French aristocrats in massive gilded frames: a lady and two gentlemen, painted in the mid-nineteenth century. In their bearing was still the glamour of the eighteenth century, which they had lost to history; beneath them, a tall fireplace of frozen white marble, and, beyond, the void of an empty foyer seen through the high archway of the salon.

Only an hour before, I had been deeply involved in emergency work on two drawing boards at the office. I discovered on one a deviation from the parabolic curvature of a ceiling for the All-Nations gallery's new sculpture room, which had been almost imperceptibly changed by the dratfsman into a symmetrical curvature drawn by joyfully swinging a long-armed compass. "There is a world of difference in such deviations. If you never learn to feel that, you might just as well work in a coal mine instead of with a charcoal." We superimposed his drawing on my original and could then clearly see the difference. That difference indeed is the difference between the old world and the new one, where precision of instinct is replaced by the precision of mechanical instruments. He had simply conformed to the compass to save time and individual effort, for the sake of a speed-up.

On the second drawing board, I discovered that the top of the hill of the Valley of the Cross, where our shrine is to be located, was too deeply excavated. As a result, the shrine would be set too low and not appear as planned, as the dominant feature of the landscape. The drawing of this elevation, which my assistant had worked on for several weeks, had to be finished today. No delay possible. The error had jumped out at me boldly as I took a last look before closing up shop. It was evident that the height of the wall had to be reduced in volume, a Caesarean incision had to be made to evolve the new proportion. "Is it really necessary to spend so much time and money on a whim of proportion? Can't we let it go?" "No, indeed, it must be changed. And I'll stand by until it's done."

And two hours before that, I was cordially battling at a St. Regis luncheon with Austrian-born René d'Harnoncourt and the American Arthur Drexler of the Museum of Modern Art. It began

277

casually with chitchat about the Grundl Lake of the Salzkammer-
gut in Lower Austria where he used to spend summers with his
family. This region, the Austrian Corinthea, where Celtic* tribes
left marvelous ruins, on which are superimposed fragments of the
Roman Empire, witnesses now the emergence of modern architec-
ture.

I finally jumped to the subject of the "Endless House." The Mu-
seum's campaign for twenty-five million dollars for its new wing
might only be ended next year. That would leave me not more
than one year to exhibit the "Endless House" in the garden before
the new wing is built there. I could not accept this. Arthur Drexler
suggested a way to save the "Endless": build it on the roof of the
new wing and change the present design for an eight-story build-
ing to a two-story building which would cover the whole area of
the present garden. It would, however, take three more years to
build this pedestal for my house.

"Too late; the time is now . . . and now is too late, too," I said.
"We agree," the others answered.

It looked pretty grim, but Arthur Drexler had still another idea,
which he now put forth: "In September we plan to have an exhibi-
tion, 'Visionary Architecture,' which will open on the twenty-
sixth. You know that I consider your 'Endless House' the most im-
portant project in this exhibition. Suppose we build a half-sized
model of some areas of the house, elevated about four feet from
the exhibition floor, with a corridor cut through it so that visitors
can walk into the house. That way they will get the real feeling of
your spatial concept. I have reserved two bays, twenty feet by
twenty-one each, for your section."

"Would that mean that the 'Endless House' as projected for two
long years would never be built full size?"

"Not at all," René d'Harnoncourt interjected. "As you said your-
self, it wouldn't be worth all your labor to have it built in the
garden for only one year. And we must start excavations for the
new wing not later than after next year. But this exhibition could
help to promote the building of the 'Endless' and to raise proper
funds, which we cannot do now, due to the drive for the new
wing. We could try to arrange to build it in scale at another suita-
ble location."

278

"I appreciate your suggestion. Let's hope it comes to pass. I think your proposed exhibition would help us reach the goal of building an 'Endless' in full scale. However, the space of forty feet by twenty-one feet allocated for the project is much too small. As a specific spatial concept, which it is, the new 'Endless' on the half-shell would require much more room. The original plans of 1923, plus models and present drawings to make it complete, have to be exhibited, too, and that would require more area than two bays. But, if you cannot afford me more space indoors, why don't you erect a small tent in the garden and place it there? The other exhibitors would remain indoors." (The others were to be Bruno Taut, Frank Lloyd Wright, Buckminster Fuller and Le Corbusier.)

Arthur Drexler: "I can see your point. If you, Kiesler, will agree to build this new midget model within three weeks before the opening in September, I should be able to extend the exhibition area to seventy-five feet by forty feet, to make a proper spatial display possible. We can also heighten the expanse by an elaborate lighting system. Would you accept then?"

"I would."

A decision clicked unexpectedly. There was not much time to lose. I'll have to start at once planning the new "Endless." I shall go to Venice for the opening of the Biennale in two weeks as a short vacation. Perhaps with Leo Castelli. I shall stay not more than ten days. Then back to New York to work. This decision dawned on me, too, in a lightning moment.

None of us had realized that everyone else in the dining room was already gone. A tastelessly colored mural hung over a long bar-counter, staring at us. Two waiters were standing immobile near our table, waiting for us to settle the check and go.

We left the St. Regis and walked over to the Museum to look at the allocated area for the exhibit, on the third floor. And I saw it, and I felt relieved. So did everyone else.

The letter I had written before this conference, with my statement withdrawing the project from the Museum, remained in my pocket. It had aged in these two hours to ancient history.

Marmosets

No wonder the South Sea Islanders and the deep-down Africans and the Pacificans had gorgeous masks and costumes for their various rituals, carrying forests on their heads and painted rivers on their bodies. They lived with jungle centaurs, birds of paradise and mammals hellbound, and they jerked and twitched and convulsed, crept, hopped and crawled exactly like the two monkeys I saw yesterday, marmosets, at the flat of Jasper Johns and Bob Rauschenberg near Wall Street, New York, where I met a kinkajou, too, who leaped like an old-fashioned bridge jumping from post to post across a river. When Jasp lifted the kinkajou, it wound itself around his hand and arm, its body like a doctor's pressure meter circling the arm, a rubber tube tail gripping tightly and the bellows breathing like the kinkajou's belly.

But the marmosets had thin tell-tails, decrepit and worn looking, with the hair lost and skin discolored, like dried-out branches in a jungle, totally useless for holding on or for sport or defense, not like the kinkajou's tail-hand. The monkeys' tails looked by now as useless but inevitable as an eighteenth-century wedding-dress train. Their heads were as tiny as ping-pong balls, black-brown-gray and squashed as if by the blows of a golf club, with tiny black buttons of eyes popping out. On their skulls they carried enormous fountains of cream-white rough hair which rose high and fell in a wide cascade, a jungle wig. Why did the tribesmen only copy nature to produce masks rather than conjure their own configurations? We all: men-monkeys, creating imitations.

The kinkajou was hopping around the loft in leaps and bounds, measuring space by spans of hops. How many from here to the moon and back? How silly are inches and centimeters, petty, or do centimeters come from creeping centipedes?

On the long, scrappy wall of the white-painted loft, four new paintings in progress by Bob Rauschenberg. Silvery lamps attached to the barren ceiling. A chair in front of one of the paintings was split into three colors and the colors flowed from the chair into the painting. Good old Kiesler, I remind myself, made a portrait ten years ago of Cuban painter Wilfredo Lam in a sitting position, with a sculpted stool on the floor in front of it, in

280

miniature size compared to the life-sized portrait in back of it on the wall. The stool looked as if it had been picked up from a far-away perspective and put down in front of the painting. It stood away from the wall, but jumped automatically across the space to the painting. The discrepancy between the natural and unnatural sizes created a contradiction to our habitual idea of sitting and thus provided a shock, although in reality the body and the stool were only separated by time. I also cut out the face of Wilfredo Lam, whose head was painted in natural size, and replaced it with a miniature face set into the depth of the hole. This new face was much smaller than the original one and looked shrunk into perspective.

Lam was born of a Chinese father and a Negro mother. This, plus his having lived in Cuba, Paris and New York, not only give me problems with his personal appearance but also with space and time elements of past and present that had to find expression in a plastic documentation of Lam's personality. The content of his life created my forms.

The plans from the Museum of Modern Art just arrived. Arthur Drexler indicated the area reserved for me and expects me to make a layout for the proposed exhibition. Not now—I'm off to the first promotion dinner at the Einstein College of Medicine. My partner and I have to arrange for the exhibition of our plans and models.

I'm glad the medics won't vivisect kinkajous in the animal quarters of the laboratories we designed for them. They have seven hundred dogs, cats, snakes and rats for that purpose.

Scarpita Endless House

Thursday
May 26, 1960

Last evening, first visit to Scarpita's new apartment at Eighth Avenue and Eighteenth Street, in the midst of a Puerto Rican neighborhood, surrounded by religious prognosticators, tropical fruit stores, tropical flower stores, delinquent children playing Russians and Americans in street battles.

281

Scarpita gave me a blistering lecture on why I should not agree to make a midget model of the "Endless" for the exhibition at the Museum of Modern Art, particularly with all the lighting effects. It would lower the purely architectural standard of my project to the level of a theatrical display, he said, and could only gratify vulgar public taste. He thought it analogous to making a cartoon instead of a full-length film. He suggested that I use the large space to build a super-galaxy, a sculptural idea, an abstraction of the "Endless House," in the manner of my large bronze pieces, giant in size and violent in concept, spreading from wall to wall, floor to ceiling, reaching out west, east, north and south, a cosmic space for man to wade in and dream in. I should never, he warned me, leave a sculpted work without the imprint of my hands on it.

"Give them a section, a cut-out piece of the total concept, but in full scale, rather than the total concept in miniature. Your work must always be hard and uncompromised.

"If you have a sturdy oak table and cut off the legs, it's down to a platform. You can just as well hang it on the wall like a painting and call it 'a table.' But it isn't one any more.

"You knead your 'Endless House' like a ball of dough that fits the hollow of your hand like a big breast, but don't squeeze it to peanut size and let the rest fall through your fingers like negligible overflow. There won't be anything left of the original wealth of life, which made it what it was—only scraps of it.

"It's like pruning down a tree and giving the branches to the public instead of the trunk . . . you must never allow that to happen with your 'Endless.' "

(Reading this notation now, two years later, I remember that I did make a "super-galaxy" in shells, to give the space-time feeling of the "Endless House." The Museum had generously provided enough area for the exhibition, but my concept proved to be too abstract. The idea was abandoned.)

Crown of Lead

June 1, 1960

At noon before going to the foundry.

Yesterday a dense day like a crown upon my head made of lead but inlaid with sparkling semi-precious jewels.

At the office, the pre-cast window frames for the patients' rooms in the projected hospital now to receive air-conditioning boxes set in lower window openings, therefore changing the rhythm of dimensions. At another drawing board, small gallery for primitive sculpture which the office had laid out and I'd gone over and over again, yet it didn't seem to jell into our style. I did as much under the pressure of a deadline as I could. Particularly a light trough running along the ceiling in the middle of the long gallery seemed to be effective, looking like a long-stretched cobra, spilling light left and right from the flanks and downward through its belly. It could easily contain all the lighting effects necessary for niches, showcases and free-standing sculptures. Artie working on the big free-standing basalt wall of the Shrine with a square opening hewn out for entering this portal over a water trough which runs all around the free-standing wall, accenting the high rise of the wall. Discovered that the slab, forming two bridges twelve feet wide, did not have a railing, so that Philistine pilgrims might tumble over the edge into the water. Had to conceive a balustrade that is not a balustrade. Rather difficult and painful. The verticality of the high wall will be robbed of its upright contrast, being pierced by a flat slab laid over the water. A near compromise. I am crossing swords with myself.

Had to decline invitation to see Giraudoux play, *The Enchanted*, with painter Al Copley's little daughter playing in it at her school. I phoned regrets. That eight-year-old, snow-white-skinned girl with blushing cheeks and pale north-light-blond hair is bewitching in her charm, speaking English with a French accent, and Icelandic with her father's German tinge.

Rembrandt or the Immaculate Seduction

June 2, 1960

In a taxi roaring toward my studio, the day before yesterday, came to mind my sidereal conquest, by intellect alone, of a woman unknown to me, before a multitude of guests at Amato's Southampton house, my home for the weekend. She was sturdy of figure, almost thirty-five, with hennaed brown hair, stocky ankles, a sensuous mouth; by accent and build, of Baltic derivation. Her companion was a sexagenarian Central European architect, well known, but his face and name forgotten by me.

This produced an uneasy situation which I tried to overcome by asking with embarrassed cordiality, "Are you an artist?" He dropped our handshake and, looking over my head, said "oh, no, I'm a Wall Street man." "Me too," I retorted.

His lady companion was infuriated by my failure to recognize this famous personality, and wheeled sharply away. I felt that while he seemed prepared to take my forgetfulness casually, she took it seriously. Her glistening eyes were glued to me in open contempt.

We all sat down around an oval table. The wooden island was covered with reed mats, cream-colored plates, wooden bowls filled with garden apples and bloodthirsty tomatoes. An old-fashioned iron stove with a rising pipe bending its neck into an almost-free-standing indoor chimney painted magenta. A low modern bench at the base of the only un-functional partition, on which hung circular copper pans of different diameters, made in Sicily, homeland of our host, all with their flat bottoms turned toward us, scattered like flickering moon-lakes across the vertical surface of the wall, reflecting the sinking sun deep orange. I did not suspect the bench below would have a special role to play.

Surreptitiously, the Baltic lady tried to force me into an argument—strangely, not on architecture but on painting. She took an indirect approach, but drove relentlessly toward a showdown. The needle this woman jabbed into me entered slowly, first subcutaneously, then intramuscularly, but it could not pierce my

284

bone shell: the chemistry of my thoughts coated my skeleton with iron. When she tried to push harder and harder by retracting slightly and thrusting forward with stiffer anger, the needle's point apparently bent and thus lost its insidiousness. That was the moment she withdrew the steel. A spell of relief and pain. By focusing my eyes on her from across the dinner table, I gradually pushed her back until she had retreated into the depths of her chair. I felt she had understood what I thought she must do: give up. But after a moment of withdrawal, she rallied and began to harangue me again.

"No matter what you think, I still don't like Rembrandt's early period. There are altogether only a few paintings of his that I like, and like very much. The rest could just as well have been done by someone else."

I said nothing, like my neighbors around the table. One heard the murmur of bread-breaking and the crackling and swishing of dinnerware caught unaware by the silence.

Abruptly, her companion-architect tried to come to her support with the wrong arguments. He had too large a head for his medium-sized body, a mouth like a baby hippopotamus' and an aggressive sunburn on his forehead. Whatever he said I could not listen, hypnotized as I was by the pink sunspots on his skin, which got under mine. His forehead clashed so strongly with his cheeks that the rest of his face looked like bleached cotton.

Both fired arguments at me, and simultaneously, to break me down more easily with their combined strength. I let their verbiage run out and then, with emphatic politeness, took on the discussion:

"It seems to me quite inappropriate and unjust to judge the younger or middle period of a great artist apart from his whole development."

She answered: "But it's obvious he wasn't good at that time. Just no good. He was only average."

"You're almost right. Almost. You see, later, as we know, he turned increasingly from the outward show of drama and emotion that had meant so much to him in his youth to the silent dramas

285

enacted within human beings. Rembrandt once wrote this couplet:

An upright mind
holds honor above estate.

Only gradually did he open the shells of traditional paintings, that is of composition, technique and storytelling to allow the meaning of life to overflow everyday realities. That light of Rembrandt's vision was soon to appear in great concentration and illuminate the darkness in which most of us live. Every painting of the later Rembrandt is actually creating the world anew, as it is reported in the Old Testament: 'Let there be light'—and God divided the light from the darkness!

"Only in this luminosity of day and mystery of night, in the parting and linking of these two elements, is Rembrandt the artist he is."

"If you understand the influence of a period and a local environment on an artist, you can see every bit of it in his themes and techniques and retrace them to facts and data, people and places. You must think of the early period of Rembrandt, which you are now rejecting, within the context of his life and personality, and remember the history of his clash with the world."

I finished eating the piece of lamb on my plate. Everyone else had done so earlier. Mrs. Amato was now serving the salad, very green. I don't eat salad and was served cheese instead. The bustle of the changing course gave me some moments of peace to close in with arguments as strong as I could make them.

But she was faster than I. With a lightning glance at her friend, she turned toward me. "Neither you nor anyone else can deny that his early works like 'Christ Driving the Money Changers from the Temple' betray a crudeness, as a well-known art historian said, and even downright shortcomings in composition . . . it's obviously a direct imitation of Italian paintings. He shows a complete lack of personality, of plasticity, of individual technique. I can't see any reason to defend either his early works or his personality, particularly when I think of his marriage to Saskia, which meant he was marrying money—granted, he loved her, too—and turned into a high-class bourgeois . . ." Her friend

286

cut in, his parchment face blushing with anger. "And he became a collector of antiques, presiding over a great household with servants, parties, dogs, cats, horses . . . a socialite with the courage to paint his wife in the nude, setting a corrupting example for his Dutch colleagues, like Rubens, who draped the naked flesh of his wife in costly fur . . ."

"There is no need for you to come to my rescue with silly arguments like that," the Baltic lady threw at him. "Artists have always delighted in painting the nude, male or female. Of course, you, as an architect of steel and glass, have little feeling left for the sensuousness of skin, the depth of materials like stone, or the tender smoothness of marble. Believe me, I can take care of my own arguments, even with Kiesler . . . it seems to me that in defending Rembrandt's early period, Kiesler is defending his own thirty years of time wasted . . ."

She jerked back and waited intensely for my reply.

I caught the gaze of her hatred, bent my head toward my dinner plate and began eating the Camembert, scooping the soft part carefully from between its two hard rinds. The acrid smell of the runny cheese affected me like a perfume.

The conversation of the other guests went on parallel to our interlude. They deliberately and tactfully tried to ignore our battle.

When I looked up from the carcass of my cheese, I found her still in that sprinting position, ready for the kill, waiting for my reply. I obliged: "Curiously enough, a painter's work can easily become a mirror for the observer. He sees himself in it, that is, he sees those parts of the whole which are more akin to himself either through affinity or revulsion.

"A picture can tell more about an observer than about itself.

"You pick what you approve of or you pick at what you don't like in yourself. As a matter of fact, looking at a painting might teach you more about yourself than about the painting.

"The way people look at paintings, either in museums or galleries, is all too often dismaying. It's an offense to the artist and a kick in the face of the work.

"Galleries are like art groceries. You go by, look, pick or not, and off you go. Same thing in museums, except that the pictures are labeled, and that makes you stop once in a while to read the inscription halfway through—and then pass the picture up. Now, you don't want to be part of such a merchandising display, do you? I'm sure you don't.

"If you disapprove so violently of Rembrandt's early period, then it could be that you unconsciously disapprove of an important aspect of your own early life or work. Those evil spirits that dwell in all of us are difficult to exorcise. They're like tics, only much deeper."

Our eyes locked. I could see and feel myself micro-minute in the dark well of her pupils. Eternity seemed to be born anew. But a flush of heat suddenly moisted that black mirror, the image blurred, and died away. I withdrew cautiously from the embrace of her iris.

As if no one else were present, I resumed: "You analyze pretty well, but analysis won't take you far into art. One can easily vivisect it, but then one can't put it together again. It's fallen apart. Don't depend on art historians, who can't give it a *raison d'être*, nor on art critics, who can't create art; they live on it like sharks on live or dead flesh. Exceptions are Élie Faure and Jacob Burckhardt, who re-create the evolution of art in the image of their own phantasy, transcending history's 'standardization of errors,' as Vilhjalmur Stefansson defines it. But these men are even rarer than good artists.

"It seems to me that art is not a matter of understanding. It is a matter of living, of love, and illicit love at that.

"There is no love of art at first sight, but of many sights. Above all, there must be no prejudice, so that tolerance can follow naturally and allow the artist's vision to enter your being. Of course, it is not easy to achieve such a state of independence from the curricula in the case of an artist one has heard or read about; to make a *tabula rasa* of your own superficial information, to wipe it away for the time being, or better, to subdue it, is difficult indeed. It needs training, consistent training, a sort of character yoga, if one is not born with the ability to forget; but only such an attitude opens you up to the compassion that might lead to pas-

288

sion and to love. This is the way to face a work of art, and give it a chance to become your friend and eventually your lover. The relation must be reciprocal. Each painting is a living universe of its own; it's not just a flat canvas covered with paint and imagery. You cannot penetrate art by preparing it, shaving its hair and cleaning its surface with alcohol, making it spotlessly hygienic for the incision of your scalpel intellect.

"Neither knowledge, with all its possibility of wisdom, nor faith, with its blind devotion, will help you unite with a work of art. Knowledge will work in the world of sciences and everyday practicality, just as faith will strengthen you with mystic powers drawn from the binding forces of the universe, but they are insufficient in themselves to link you and the work of art. And it seems that art is the only domain where a unification of both, of knowledge and of faith, produces a lasting bond between the observer and the work. It amounts to love in the purest sense, platonic if you like, impractical as far as profit is concerned. One doesn't operate on art. You love it, or you don't."

It was the first time she did not riposte. She hid inside herself. Her eyelids dropped. She did not touch her salad. The fork leaned against the edge of her plate and loomed as big and expressive as a pitchfork. She looked reluctant, yet forlorn. I wasn't sure which. She roused my curiosity. A change seemed to occur in her. I sensed a switch whose direction was veiled. I got set to lift the veil. Instinctively her friend bellowed at me, the salad leaves in his mouth turning to so many more tongues. I had no ear for him.

"Since you have tried to define almost everything in art except love, and since love seems to be the most important link between art and its observer, could you perhaps define it?" She didn't answer. "Could you?" I dared her. "No, I couldn't," she said slowly, without raising her lids.

I hesitated to go on. Her friend swallowed and turned his head, like everyone else, toward her. She had changed. She looked almost beautiful in her weakness. I followed up: "Will you then allow *me* to try a definition?" No answer. "I have had a long time to feel my way through to it, and today I can, perhaps, condense it into one word. It's almost funny that the most important concept in our world could be defined in only one word. But how many

bombastic sentences have sentenced me to helpless frustration and delayed my understanding of the truth! Finally life spilled out the right juice of content into the right container of syllables. You must drink it like sweet-tasting poison, and not die. If it kills you, life wasn't worth living."

Her eyes remained fixed on her empty plate. The other guests shifted their gaze back and forth—to her, to me—with unmasked curiosity. In that tense interval, I shot the word: "Surrender." I couldn't hold it back any longer.

I waited for her reaction. There was none. She seemed hard of hearing. There was dead silence all around, and I had to fill it fast.

"If you permit, I can make the definition clearer by adding one more word.

"That will make it more complete and foolproof, with no exits, no escape possible—only entrances. But, believe me, you're bound to succeed then, once you become a prisoner, a voluntary one."

She stared ahead, unchanged. Her eyelids quivered.

"*Unconditional* surrender," I offered.

The words stopped in mid-air as though cast in silver.

Mrs. Amato, with her black hair parted like an Italian madonna's, fixed her eyes on me with restrained bewilderment. Friend Amato at the head of the table stiffened his little figure, became taller, his face masked with a smile in an attempt to disperse the clouds filling the room. He, a born Sicilian, believed in both the *mal occhio* and the healing stigma of a smile.

Our Lady-in-Art sat motionless. In the middle of the table the large wooden bowl still contained a few crumpled leaves. Its rim gaped wide.

Everything had suddenly vanished around her, even her figure. Only her face remained in the midst of the crowded room, crowded with people, brick walls, shelves stacked with dishes, the sink, the lit burners, the oven, everything. I could recognize only

her face and it was pale, but with a pallor that looked like alabaster illuminated from within. Translucent. Yes, translucent, that's the word. Even her hair, which had seemed to me brown, a sort of chestnut-brown with a sienna tint, was now dark, very dark (like a deep background or a mourning veil), but at its contour lines it glowed red—Titian. Her Baltic features took on the slim elongation of a Beardsley portrait, a transposition of physical character which astounded me, especially because the carving of her cheekbones and the ledge of her forehead were uniquely Slavic. But more than anything else, the change that seemed most magical was in her expression. The transformation from vigor, conceit, aggressiveness and the desire for sadistic revenge had changed to melancholy reverie. Her lips looked as warm as the month of June. She had withdrawn into herself completely. At any moment she might have had an orgasm—or so it looked. And she did, wearing a mask of benign transfiguration. She was immobile.

We did not dare move in our chairs. All silverware lay still. Suddenly her friend sputtered, gripped his fork and crashed into his salad, making an awful squawking sound on the china plate. A general, rather self-conscious conversation followed, while I waited for a chance to address her, and to be heard. The ripple of voices awakened her. The enigma of her expression ebbed away, and although her eyelids remained lowered, she soon looked her old self.

With a new effort toward action, she reached for her fork. Everyone turned to watch her.

I cannot account for what I said next, but I said it. It dispersed the silence into a void which almost emptied the room of all air to breathe. The sentences which I spoke rang out with a metallic sound and, once pronounced, frightened me.

"I don't think, I really don't think the salad will agree with you. It's so green-green. Please don't eat it."

We all fell into what seemed a trance, but Mrs. Amato got up, collected the plates, then the bowl, and prepared, with ostentatious clatter, to serve the dessert.

Just as the air seemed to return, our Lady-in-Art lifted her head with a sudden shock, her eyelids opened wide, and out came a

quick sentence pronounced with great exactitude. "May I have my salad back, please? I will eat it now."

Mrs. Amato re-served the salad. The Lady bent over the bowl as soon as it reached the table, and started to lift out its contents. I watched her with apprehension.

She swallowed the greens avidly. And she ate them all. The plate was removed.

We started to chat and throw incense into the air with our words. She didn't participate. I saw that she was becoming increasingly pale. She seemed to have difficulty sitting up.

"May I please lie down on the bench?" She addressed Mrs. Amato.

"Of course," Mrs. Amato answered, getting up.

She: "Could you please bring those large yellow couch cushions from the living room and put them on the bench?"

As soon as her body hit the plank, she fell asleep.

Her architect-companion began a violent argument with me about Jerusalem's synagogue, which his friend, Raugh, also of German origin, had built. He objected to its style because it did not conform to Arab, Egyptian or Bauhaus tradition. He was right: it represented the shell of a crab resting on the floor, with arched cutouts as entrances; the only original building in modern Jerusalem. He kicked Frank Lloyd Wright in his grave for his Guggenheim Museum. He knew of my design for the Shrine in Jerusalem, had seen the plans, but deliberately avoided comment. He tried to destroy me by criticizing the "Endless House," in his opinion a return to the cave, an abandonment of the success of steel-and-glass architecture, a private assumption of the responsibility for a new style in construction and design which he thought only group work could achieve. His arguments rolled over me but I remained unharmed, resting comfortably on my conscience.

Two hours went by. She was still motionless on the yellow cushions, a pale-blue pillow under her head, and with her moss-green sweater and tomato-red trousers, she looked like a Matisse

melted into the golden background of the wooden bench. She was gone.

We had kept our talk down to a murmur, although we knew she was sound asleep. It had grown late, and going home was on everybody's mind.

"I can't drive, but she can," her companion said. "I'll wake her now."

He got up and approached her cautiously, bent down and started to talk, whispering near her ear, but met with no response. He moved a stool next to the bench and sat down at her side. With one hand he shook her strongly until, while we watched, her eyelids started to part. She did not move her arms, legs or body. She remained limp, as if comfortably paralyzed.

"It's late, dear, we must drive home."

And now she spoke as if in a waking dream, softly, yet audibly to all of us: "Home? I don't want to go . . ."

"I'll make some espresso," Mrs. Amato comforted.

"Oh, no, no, it's not necessary, thank you," she revived herself, saying finally, "I'm all right, I'll get up." She lifted her upper body, but remained in a sitting position.

We started to talk at the table. She rose to her feet, rejecting any helping hand, and nodding gently toward us at the table, walked across the room and out of the house. He followed. Her figure was quickly blotted out by his stocky body, as tall and wide as the kitchen door was low and narrow.

The following day, I met her and her companion unexpectedly in the corridor of the train from Southampton to New York.

We sat opposite each other, she at the window facing New York, I at the window facing her. Her architect sat next to her, and opposite him a student of architecture at Harvard University, who was caught in the jam of the aisle and was invited to join us.

Sitting opposite her, in that neutral corner of a window seat, I

293

had a chance to observe not only her face but her figure. She was neatly dressed. Her moss-green sweater had white mother-of-pearl buttons. The two humps of her breasts strained the button-holes, which opened their lips in wide smiles. She had revealed a warmth, as if autumn leaves had given birth to roses. She was all body, intellect evaporated.

When the ice-cream man came by, I bought four chocolate-covered popsickles for all of us. She opened her bag, extracted two Kleenex tissues from it, passed me one to protect my hand from the melting chocolate icing, and while I wrapped it around the wooden stick, she spread the other deftly across my lap.

The monotony of the train's rhythm made us relax. She and I hardly talked during the three-hour journey, but our eyes explored each other's bodies like searchlights. The companion-architect looked attentively at her profile from time to time, and sidewise at me.

Later the three of us rode up the escalator at Pennsylvania Station to the main floor, one behind the other—her, me, him.

Arriving at the upper level, each of us, holding a weekend bag in one hand, stretched out the other for a goodbye shake.

"I hope we meet again!" we uttered in unison. We knew we never would. The weekend was over.

It was good to know my one-room ivory tower, my home atop 56 Seventh Avenue, was waiting for me. I shall happily vanish into its solitude.

Big Sculpture Drawing

June 2, 1960

When the taxi drove around the corner of Broadway and Ninth Street, I was thrown over to my left and woke up from my day-dream about "the arch." Up in the studio, life was buzzing:

Lillian carrying flowerpots from the watering shed of the kitchen to various places in the studio; Ralph sawing on the bandsaw; Beverly trying to transform her sculpture of a voluminous woman into a voluptuous one; Pauline sitting at the desk framing drawings. I didn't disturb anybody and strolled past the beehive of apprentices. My eye fell on the pattern for the first shell of a gigantic new sculpture which was to be like an arch of rocks rising from the floor and bending over to the wall. A sculpted rainbow to walk through. Its first support was a shell cutout in cardboard. It struck me as not correct in its outline and proportion. I went to get from among the desk debris my first sketch of the arch which I had made a week ago at Howard Johnson's on a paper doily, and found that my feeling was correct: the cutout deviated too much from the original sketch. I called a halt to the other activities and together we all decided to redo it. We couldn't find a single piece of cardboard large enough. There was not enough brown wrapping paper either. I finally tore off two long strips of the paper wrapper that covered my galaxy paintings of several years ago, and asked Pauline and Beverly and Ralph to help tape the two strips together and hang them from the ceiling, making a curtain-wall. It was ten o'clock. By midnight I had outlined the fifteen shells of the arch. It was difficult to draw, but I was obsessed by the idea of finishing the sketch. With one hand holding a piece of charcoal on a long stick and in the other a second stick with a small bag of powder eraser, I drew the arch.

The paper shook back and forth, offering no resistance to my strokes. Ralph and Lillian stood on ladders behind it and braced my drawing lines. The couch was soft, too soft to stand on and design with security, but I balanced myself. A large plank which Ralph had thrown onto the couch for me to stand on felt worse, because it rocked like a boat. Two or three little tables which I pushed back and forth gave me more stability. Climbing up on them and down again and sideways from one to the other, and down and up again, I kept going until the whole composition was done.

It was twelve thirty when we left the studio and went to the Cookery on Ninth Street and University Place.

Everyone had ice cream.

295

Back From Italy

August 5, 1960

Returned three weeks ago from my exhilarating trip to Italy where I had seen for the first time—at my age—Venice, Perugia, Ravenna, Vincenza, Assisi, Spoleto, Naples and Positano.

Back in my multi-world New York to take care of the office in the absence of my partner; to rush to East Hampton to rent a summer place in Amagansett, a beautiful remodeled barn and also another barn where I could finally create the galaxial paintings for exhibition at Leo Castelli's; and to work at the studio in Manhattan with Ralph and Arthur, modeling the shells for my arch sculpture. After a meeting with Drexler of the Museum of Modern Art, I will prepare the "Endless House" models for exhibition at the Museum on September 26.

August 10, 1960

I came in from Amagansett to acquaint partner Bartos with the progress of work in the office, chiefly that of the Kamer Gallery on Madison Avenue. The new working drawings for the Shrine of the Book in Jerusalem have been further developed, too.

Unexpectedly, gallery man Sidney Janis called me a few days ago and wanted me to look over some new quarters which he intends to rent for his gallery. It seems that today we will sign an agreement for you to be the architects. I'm glad to be able to bring one job to the office, however undecided it still is.

Needed a vacation badly and this new job has broken it up. The house I rented in Amagansett is empty except for weekends. Money wasted.

Mr. Langley's salary for photographing the "Endless House" has been reduced from two hundred and fifty dollars to two hundred. There will be many side expenses connected with my preparing the "Endless" model for the Museum of Modern Art. With a project-in-progress, it is so difficult to anticipate all costs that might arise. Yet budgets must be made far in advance. And there is rarely hope of increasing them, however justified. Almost all cultural institutions in the U.S.A. depend on philanthropic sup-

port and are really poverty-stricken, drowning in their expenses, praying for help. What a disgrace for a land that supports the rest of the world with cash, men and machinery but not art.

Time, young man, time!

Amagansett

This is Thursday and my birthday, and next Wednesday is the birth date of my "Endless House," the opening of its exhibition at the Museum of Modern Art, but only as part of twenty projects of "visionary architecture." What a downfall from building it full size in the Museum garden as originally planned. Thirty years ago I would have preferred not to show the model in lieu of building it full scale. Yes, scale is the thing, and full scale at that.

These last three weeks in Amagansett, Long Island, a living-together with the American-Italian painter Scarpita and his friend Stephanie. They were my guests for two months. At midday beaches and night parties, I encountered regularly some or all members of our gang: blue-eyed, white-haired, pink-cheeked Bill de Kooning; Roman-bearded Marca-Relli and his Machu Picchu wife Anita; Zogbaum, newly a sculptor and his new mate, Marta; Lucia and Roger Wilcox, he a scientist, she a Syrian-born painter who appeared twenty years ago at my New York apartment with Fernand Léger; Mike Goldberg, his two shepherd dogs trot-racing each other tirelessly on the beach; Norman Bluhm, with an H; Lassaw, sculptor and Zen-Buddhist buddy; John Little; Mr. and Mrs. de Havenon, she whose first husband, Kapell, I knew at Juilliard where he studied piano to become America's Number One pianist, then died so prematurely in an airplane crash, also her little red-haired daughter who inherited his talent and her mother's beautiful hair, auburn deep in its shadows and golden in highlights; and my host and landlord, the photographer Beadle, and his wife, holding an unseen shotgun in her arm like a pioneer woman, her four young children on swings or on horseback or sculpting and

297

building sand castles. I don't want to forget to mention a chestnut-brown horse, old but good-looking in spite of it (like me), in a corral of split-wood fences facing our house, a fur-white Persian cat sitting atop the grazing horse like a performing monkey. Twice we met "Echo," the artificial meteor-balloon cruising starlike in the night sky, quite a sight with no insight into human nature, only into politico-ballyhooing, a balloon ballyhooing science which will deflate like all blown-ups and spray its sparks upon the earth burning flakes of radiation.

The landscape of Amagansett is more woody and green than its big sister East Hampton, and you sense the presence of the almighty ocean, only a mile or two away. You feel it, you smell it and you see it.

Crumbs of black-brown earth have managed to creep into the sand dunes and form tufts where elm trees, maples and firs grow, with beach plums in abundance. The sea brings up washed-out golden powder from its bottom on wave after wave, breaker-busters, stopped only by the bluffs, those hilly cheeks of land rising just high enough to kick back the hordes of invading floods.

Farther inland, the landscape of Amagansett in its green dress, like a panorama of those Dutch lowlands painted in the late seventeenth century.

The sky above is vertical and foggy-white or sunny-blue or empty-black at night, with a handful of confetti stars thrown upon it. The sky is high like an endless wall. It never curves and seems to bend over your head like a giant bowler hat which we are accustomed to wear with a blue lining. And when it rains, the waters run along this wall straight down and dry fast and clear. Water as sea, water as rain and water as fog are performing regularly since—since. It's peaceful, sounds have nothing to bounce echoes off, the land is low, the houses are low, the barns are low.

But once in years, and suddenly then, the wind blows not only eleven or thirty-one trumpets through thousands of mouthpieces, but also leaps from behind the horizon and performs *salti mortali* with ever-increasing velocity and the leaves tumble and roll on their edges like hoops. They flee. Many a tree is ripped into

298

splits. The immaculate streets become disheveled and the sea vo‍
its yellow foam. The people barricade themselves in their houses
and live by candle flames holding desperately to their wicks.
Many go hungry because their electric lifewires have been ripped
apart. The crowns of all forests, massive or frail, sway in twist-
ing waves like the churning sea, and are afraid. Yes, there is
fear everywhere and inside the houses and inside hearts too. The
trees, the waters, the houses, the people, they are dwarfed to
fear. There is not much discourse, only whispers. The air trembles.
Everything listens to everything. The wind has the word.

But even the rage of a god like Boreas subsides.

I step out of the barricade house.
The air washed clean.
I breathe the scent of a June gone by.
The torrential invader has ravished the
earth's body, leaving the flesh of his
mistress devastated.
But after her sleep of exhaustion,
she will once more appear
resurrected innocence.
None of the torrent's marks will remain visible
and the morning dew on her body
will announce a new spring of forgetting.

"Endless" Opening at M. M. A.

September 28, 1960

Today, the day after the opening at the Museum of Modern Art
which is to open the possibilities for my "impossible" building,
up the "Endless," to be built—somewhere, somehow—floating on
water or elevated into the air. It seemed to have been a good start,
just having the model exposed. The black figures of people
crowding into a black-painted room with white photostats on the
walls, like windows looking into outer or inner spaces, my model
was cruising like a flying saucer of reinforced concrete full of
holes and gaps to look through, people sticking their heads in

and getting nothing out of it—with of course the exceptions, those exceptions on which the creative world has been resting, since Grecian times, men and women with progressive ideas and mentalities who have been trying to change the apathy of the general public into support for these ideas and visions but have not succeeded yet in spite of November, October, March and July revolutions, all of which fall short as far as the arts and architecture are concerned, up to the present. Change it, man.

Yes, the mother of all the arts, architecture, is the step-daughter of our social structure, but when this structure will change and our short-changed life finally comes into its own, then shelters will be created that are solid and impervious to routine destruction and beautiful by the new canons of living. Yes it can happen here. Sorrowfully, it has not yet.

There was enthusiasm about my "Endless House" and there were smirky grins, as usual. But *The New York Times* today, through critic Canaday, said: "It begins with a historical section in which Leonardo da Vinci appears as an early theorist of the perfect city, and concludes with full-scale enlargements of Frederick Kiesler's Endless House, so installed that you can imagine walking into it."

There's no use denying that an artist is tenderized when he is the only one mentioned out of a group show, but it remains to be seen what will be said by other critics throughout the following weeks, and whether enough support will be found for the realization of my "Endless House" here or abroad. Doubts and hopes are playing hide and seek with me.

After the show, we went to P.J. Clarke's bar on 53rd Street and Third Avenue, that wonderful illegitimate cross between the cafés of Rome and Paris, managed by Irish wits. About twenty of my artist friends and some "normals" like Bernard and Becky Reiss, the collectors, and Peggy Jackson who came from her Delaware River home to be with me. Peggy, born in China where she lived until her fifteenth year, now, at an age of forty, is the most civilized, most unfussy, fact-warming woman friend I have. Roger and Lucia Wilcox came from Amagansett to be present and those missing were present in my mind, namely, Luba Harrington and Sidney Janis, my former student, dealer and buddy. But Leo Castelli, who had arranged this bartender meeting after the show, was there

300

Endless House—early sketch

and Bob Rauschenberg and Jasper Johns, who were struck by the precision of my curvilinear concepts in ink of the original (1924) Vienna plans for the "Endless." Their enthusiasm is probably my greatest success, because, although these crest-riding talents are naturally possessed by their own ideas and successes, they broke down facing this work, with delight in their defeat. I have always felt that the real measure of success does not derive from the reaction of the public or critics, but from that of one's colleagues. And so it was now.

The Cut

October 21, 1960

"I wish," I said to assistant Ralph, "you could get a plank of birch wood and not of clear pine. Pine is too whitish. And since I intend to cut sculptural frames from it for my galaxial paintings, the color of the wood should not be too light-bright but rose-brown and dusky. It has to be a big plank, twelve inches wide, two inches thick and six feet tall. I know birch is hard to find, but please get it. You know that to wait when you are eager to put your ideas into shape and form means to lose the very drive of the idea, its strength and spontaneity. If you have to postpone the execution of an idea for a day or two, it might mean the total loss of it."

Two days later I was again at my studio, that is, yesterday.

On entering, I was met by commotion. Ralph was building a trough of light which is to illuminate a big wall panel upon which I had hung my galaxies while painting them. He was close to the front of the wall, climbing up and down a ladder while attaching the light trough to the ceiling, trying to find spots to drive nails and screws into the inner structure of this old brownstone house. Alice, who is now my afternoon assistant, was cutting paper patterns over white chalk marks which I had designed as frames for the units of the galaxy temporarily tacked onto the panel wall. She was balancing on a smaller, aluminum, ladder. The radio was going at medium blast, producing some tunes

302

which appealed to me although I could not identify them very clearly. I finally had to ask what kind of music it was. The rhythm enchanted me and spurred me on. Ralph said, "Why, Mr. Kiesler, it's rock 'n' roll."

"If that is rock 'n 'roll," I replied, "I like it a lot. Let's keep it going!"

I needed that stimulant because I had undertaken a touchy and daring business, namely, repainting one of the sections of my galaxy, the colors of which had been too much absorbed by the paper and had taken on a stale look. It was a hazardous task, redoing a whole section of a painting which had already been finished for several weeks, and the circumstances under which I had to work were not the most advantageous ones. I had to squeeze my way between the two ladders (with Alice and Ralph going up and down them), holding pastel chalks, darting my hand to and from the wall, aiming at the painting often through the rungs of one or the other of the ladders. Acrobatics of inspiration.

The ringing of the telephone cut again and again into the sounds of the music and the commotion of our movements. I decided to call for a break with coffee.

We three assembled around a low square platform, sat down and waited for the water to boil.

Ralph suddenly got up, disappeared into the hallway of the staircase and reappeared with a heavy plank of wood which he leaned against a wall. The six-foot rectangle was so precise in its dimensions, expressed through its clear-cut sharp edges, that it pulled me up from my seat to have a close look at it. The surface of the plank was of light mulatto-brown, beautifully grained like French moiré silk, and I could not restrain myself from touching it. The texture felt fleshy.

Neither Alice nor Ralph could resist either, and they both came over to lay their palms on it.

"What kind of wood is it?"

"Rose oak."

303

"Ralph, I don't think I can cut it. I don't think we should cut it. Just let it stand there. I wish we could have the plank standing erect by itself there in the middle of the room, a 'Stonehenge' in one piece."

I stared at the surface of the wood like a water buffalo finding a fresh drinking hole in the midst of dry land. The landscape of bric-a-brac surrounding the beam was a jungle. Old work lay around like carcasses and almost started to smell. A tired light crept in and out of the crevices and caves of this landscape, divorced from the memory of the brilliance which floods the studio every morning through its east windows.

Looking at the plank in this halo of semi-darkness, I wondered where it had come from. It was evidently the result of a prolonged process of civilization, really too long to be accounted for here, having grown in some forest far away, cut by lumbermen with long-handled axes in wide arm-swings, shipped on the waters of tumbling rivers, kicking the banks here and there, bouncing off to further travel, hauled out with short- and long-styled hooks and hauled and overhauled into carriages, open boxcars and . . . and . . . and . . . How we forget the life stories of objects we live with day by day!

What about the sawmills that sink their teeth into the round bodies of wood, and the electricity which is spun across roads and lands to other trees yet uncut, to drive with steel-power saw-jaws into the flesh of the tree? Have modern composers recorded the grinding sound of this final stage of splicing the trunk into planks? As the fat is peeled off and the thigh of the pork cut into tranches of ham, so the bark of the tree is removed to shape the edges of the plank, Parthenon-clean in measure and precision of proportions.

"No, Ralph. Please order another piece from which I shall cut the frames for the galaxial units. I won't cut into this one. It's too beautiful to be made useful.

"I really don't care if it stands in the middle of the room unused. As long as I know it is there. That's all I ask from it."

The Atomic Bomb

It's three o'clock in the morning. I am stretched out on my bed. I turn the knob of my night-table radio. I am listless, and I tune in to WOR's program.

A discussion about a book in which total disarmament is propounded as the sole solution for saving this planet not only from complete destruction but from a most horrible form of destruction.

Patriots object to total disarmament, wanting at least a flying police force to cope with madmen who can set us afire by lust for play. But, it is said, to bomb New York or Moscow is no longer proper strategy. The perfect tactic is to drop an H-alpha-omega bomb into a huge lake, river, or bay so that devastation may rise from the sea as poisoned vapor, be absorbed by the air, and therefore not only destroy the peoples of our land but, if dropped at the proper moment, with certain prevailing winds, the deadly fallout can be carried over many countries, mate with other bomb explosions and thus form a chain reaction which will encompass the earth with an inescapable, breathless, but invisible plastic bag. The packaged globe will go along in its customary orbit. The cosmic air currents will caress the bag as if it were the earth. In outer space, the ballet of heavenly bodies will continue in the stride of eons.

No, we don't need mass productions of bombs. That's a waste. If a few are dropped at the proper moment, that will suffice to destroy the human race without damage to its buildings, that is, to architecture. Our planet will in no time be transformed into a single apocalyptic Buchenwald gas chamber. Thus the cities will remain graveyards of a past civilization. Our skyscraper-tombstones to be identified by visiting Martians according to their hieroglyphs such as IBM, RCA, Good to the Last Drop.

Half an hour later, and at another station, a program filtered into my room concerning the appearance of a book, *Woman Confidential*. The fate of womanhood is argued. It is claimed that women have lost their inherent destiny since the instigation of social freedom for females started by England's suffragettes. The move-

305

ment of emancipation was, according to the author, chiefly formed for the prevention of war, by women who thus became the keepers of peace, as opposed to men, who were the traditional barbarians and slaughterers of brother man, warriors and tricky mass murderers. But now woman is in competition with professional man, participates in wars and ends up as bystander to planned devastation. A double betrayal! Betrayal of womanhood and betrayal of "keepers of the peace."

The next morning the following item appeared in *The New York Times* of November 16th.

Headline: "ATOMIC SCIENTIST DIES IN LONG ISLAND CRASH. Car Is Struck by Truck Full of Radioactive Waste—None Leaks or Spills"

Story: ". . . Dr. John B. Gibson, 33-year-old associate physicist at the research laboratory, had been driving to work from his home at 8 Pearl Street, Bellport, L.I., when the accident occurred at 9:15 A.M.

"The truck had just left the laboratory enroute to Oak Ridge, Tenn. Driven by William J. Patanjo, 45, of 15 General McLean Drive, Bellport, it carried the used fuel in seven containers that weighed a total of 31,500 pounds. . . ."

Routine Mathematics:

31,500	pounds of radioactive "waste" bounce off a
33-	year-old "eminent" physicist near
8	Pearl Street at
9:15	A.M., killing him, the
one	father of
two	children and
one	wife.
one	driver of trucks
45-	year-old William Patanjo of
15	General McLean Drive, who carried the used fuel in
7	containers

Sum—total of wasted lives: data, figures, documentaries, all camouflage death

Wouldn't it be more honest to develop a bomb that destroys all buildings, all architecture in the world, but doesn't harm the human being. Then at least social planners, architects and industrialists could get together and start from scratch—skip shelters and go into architecture right away. What an opportunity for mass mathematics, calculations and planning, brain machines and automation.

It is amazing to see how, during the first and second World Wars, governments were so eager to protect the architecture and art of Rome and Paris. Yet at no time has any government in any century cared to preserve the lives of the artists who create them. They let the artists die in poverty and isolation, yet they try to preserve their work. What a contradiction. Could we not finally develop an explosive whose radiation would change the spirit of society and its governments, would preserve not only art and architecture but also their creators.

Two Candles for Bennington

November 28, 1960

En route to Bennington, sitting deeply inclined in my airplane chair, fingering my breast pocket, unable to extricate the right slip of paper. Sitting so well hugged by the chair back of sponge rubber depths, I have to shoot myself out onto the edge of the seat, my hand still inside the pocket, and now with one pull, I finally produce the right slip. On it are the opening lines of my lecture:

"I just want to make one point clear before I proceed with my scheduled discourse. It is an important issue and I hope we agree.

"This is the point: Is speed-progress absolutely necessary in the structure of architecture and, if so, how many miles per hour per second to conceive it? I say, It is not necessary if you have enough wisdom about life and can slow down to essentials.

307

"You don't think that Socrates needed fluorescent lights to illuminate his thoughts, or that Plato needed electric typewriters to communicate his, do you? And you don't believe that Gandhi required Bigelow carpets as a base for his passive resistance, or Emerson and Thoreau bedrooms of steel and glass to germinate introspection? You don't—or do you?

"I am not putting myself in the same class as these gentlemen, but I assure you, believe it or not, that I could live very happily in a log cabin with a stone fireplace, brick floors and a water well in the kitchen—if I were wise enough.

"But unfortunately I'm not. Not yet!

"So, as long as we aren't, and the less we are, the more we need all the plumbing possible to brainwash our souls."

Later, at Bennington in the auditorium, I continued the question of the house:

"The 'Endless' is finite as to mechanics, and definite in its destruction of boundaries between areas of eating, sleeping, playing; between outside and inside, strangers and home folks. Privacy can be produced in any section of the 'Endless' and continuity of space equally as well. Swinging wall sections, folding, rolling, fanning overhead or sidewise—that's a cinch in our ball-bearing age, space on pivots and time on coasters. Cubicles for the standard functions in our daily life (bathrooms, kitchens . . .) are deadening experiments in the long run. If all spaces are kept open and free-flowing, and can be shut off at will, they are inspiring. The strait jackets are burst. Life has a chance to become inventive. You, as the inhabitant, then become the real architect of your house.

"The 'Endless House' is thus a correlative power to encourage the search for everything behind the merely functional needs of everyday living. We don't want cellophane between two pairs of lips; we want the naked touch.

"If we're broiling a steak on an open fire, we want to hear it sizzle. We like to watch it turning brown-burnt and to feel a slight ache in our bent back before we straighten up with a steak on our spiking fork. We don't want interference with direct contact.

Direct contact is the thing: in short, the delight in individual craftsmanship as opposed to mass mechanics. Interference with direct contact is now extended to all household equipment, including remote-control garbage disposal whose grinding smash is too brutal a sound for any human ear. Often there are very desirable labor-saving devices. But mustn't we stop the march of the machines before they become our masters?

"It's not a return to primitivity I advocate. I hope only for a conversion of our life habits to fundamentals. What price do we pay for our lack of resistance to conformity, whether in labor-saving devices or human relations? The answer to this question becomes more and more paramount for each of us, for our society and for the nation as a whole. Art and architecture can and must contribute to the clarification of this issue for us slaves of indirect living."

Before my lecture, I ate dinner in one of the smaller college dining rooms. Eight girl hostesses sat around me, the hostage, at a circular table. It was six thirty. The chatter of scores of students around the tables was reverberating relentlessly but not loud enough to smother our questions and answers.

"You must fight conformity," I said. "You must use your learning to strengthen your resistance. Most college students seem to be growing white beards and snowy hair, compared to oldsters who are young at heart. You have no guts to go after, yes, go after—what? Can't you see it for yourselves? Must every necessary direction be pointed out to you with a whistle and a stick? You are imitators and short-cutters. As painters you drip like Jackson Pollock or collage like Schwitters. You still can't draw a nostril, an ear, an eyelid, but your canvases already gossip worn-out melodies of 'art moderne' of yesteryear. Your art is drowned in techniques and your techniques are those of decalcomania.

"Unfortunately it is not everybody's lot to be a pioneer. But it is everybody's duty to fortify the roots of his own persona, no matter what turn it takes."

My attack was strong, but left the chance for a good discussion wide open. During the ensuing pro and con, I noticed that two girl students serving as waitresses in our small dining room had

309

cleared all of the food refuse, milk glasses, salt and pepper shakers, and swept away the paper mats, preparatory to shining up the table tops—all except ours.

They had approached us several minutes earlier, standing at attention and eager to lay hands on our plates, messy with dinner garbage; but the arguments were in full swing, and I felt we should not be interrupted. The student waitresses stood in frozen postures.

"I know," I said to them, "that you have your responsibilities, and with everybody gone except us, we must permit you to clear the table so the kitchen help can leave within union hours. Please go ahead and collect our dinnerware, but do leave the paper mats; their whiteness seems to form a visual chain among the nine of us as we talk. I also have been told that you must put out all electric lights at eight o'clock and empty the dining room of people—but could you possibly provide us with some candlelight so we may continue another half-hour here before we go up to my lecture in the auditorium at eight thirty?"

The student waitresses hid their embarrassment with smile masks. Some of the girls at the table grinned; others became deadly serious.

"I'm afraid we have no candles here," one waitress finally whispered, "and I doubt that we have a flashlight. Someone would have to go and search one of the dormitories."

"Thanks for the suggestion," I replied and after a moment's pause: "I think we'd better forget about it. I conform."

We all rose, and the paper doilies were snatched off in a whiff.

The next day, for six hours, I visited the studios of sculpture, architecture and ceramics. Once more, before leaving at nine thirty for the airport, we gathered in the students' lounge and I answered many questions.

After an hour, I felt my duty was done. The night had drawn a curtain over the sight of hills appearing gently through the windows of the lounge, and I too was ready to close shop. It was seven o'clock. I was taken promptly to dinner by another group

310

of eight girls at the same table in the same dining room.

To my surprise and delight, amidst the bristling electric lights of the ceiling and walls, two green candlesticks were standing in the middle of our table, slightly apart from each other like the horns of a ram; or better, like the victory sign ready to glow.

On my return trip, the seat of the airplane held me like a cradle without rocking. I didn't want to get up. I let the sponge rubber bulge around the outline of my body and imagined its softness was down.

Tired as I was, the airplane hostess scared me at first because she had a long and protruding nose, which reminded me of the nose of the plane. But her lips had a surprisingly charming smile like the open wings of a twinkling butterfly.

Talking throughout dinner to eight females had absorbed my strength, and a hunger rose from my stomach incessantly.

"I think we have one portion of dinner left from the serving at six o'clock," the hostess said in answer to my appeal for food. " 'Twas chicken . . . 'm 'fraid it's cold now, and it's against regulations to serve it this late; but I think I can take a chance and heat up a can of soup, if you'd like me to?" Of course I said yes.

She returned shortly and served me. Holding on to the seat in front of me with her right hand, and bracing herself with her left hand on the top of my chair, she appeared, in that outspread position, to be the only one in the plane who was flying through space. I took a long look at her. That nose certainly was the cockpit of her face, but her smile twirled lustily like a propeller. Her sienna hair reminded me of mixed tomatoes, milk chocolate and honey. It had gone off into many lines and was ruffled, as if secretly windblown inside the air-conditioned space craft. She had gathered the scattered odd-ends of the tendrils and forced them inside her G.I.-shaped cap, which sat jauntily between her eyebrows. She watched me cordially.

I could hardly balance the steaming plastic cup in one hand and in the other the cold chicken, her warm-hearted breach of allegiance to the New England airline. The consommé felt boiling hot.

311

Gulp after gulp rolled down my throat like heated bullets. The memory of Bennington became benign.

The Eagle

December 15, 1960

Steffi said today, "Scientists are the F.B.I. of nature, detectives of nature's secrets. But poets are creators because they investigate the unknown, yet ever-present, and lift it out from nowhere to here-now. Our aims are double-barreled.

"Dig any story out, any document of reportage and you can see, smell, hear and touch not only the material functions but also the myth of man's struggle with his destiny. Here is one:

"The eagle is noted for its wonderful eyes which can see at a great distance. When it flies so high in the air that the eye of man cannot discern it, the eagle can see the small fishes in the sea and will dive down and capture them in its claws.

"When an eagle reaches old age, its eyes begin to dim and its feathers to wilt. It then seeks out a fair fountain in the forest and from this it flies aloft and straight into the sun. When its feathers are singed and its eyes burned from the approaching sun, the eagle dives into the cool fountain and there its eyes are washed clean, its feathers restored, and its youth regained.

"In a somewhat similar fashion the eagle tests the worth of its own young. When they are still unable to fly, it lifts them up and flies toward the sun. Those that can look straight into the sun are deemed worthy and are returned to the nest, while those whose eyes water or who look away are thought to be worthless and are cast down." *

* "Cloisters Bestiary of the Metropolitan Museum," a calendar for 1960, week of December 4.

312

Some people believe—wrongly—that the eagle is a creature to be feared, since it cares only for living flesh. The image of "functional robbery."

But the poet feels differently about the eagle. It's not the power of his claws he admires, but the weakness of his pride.

The poet asks, Is the eagle created only to pull the veins from the living animal he captures or does he follow a lure to explore the infinite in space flights, ad infinitum?

"I wonder," I began, "if science will ultimately make use of its machines not only to penetrate deeper into the inner structure of the atom, but also to try to discover the link between facts and dreams." Detecting devices are so super-sensitive today, I would not be surprised at an experiment like this: attaching a roving camera to a "sitting duck"; the sound and action of the struggle would then be ear- and eye-tracked during the flight of both animals, the eagle and his prey, all the way to the conqueror's nest. There the instrument, with its time clock properly clicking, would detach itself, its mission fulfilled, and parachute to earth where it could be retrieved by our hunting scientists.

Indeed, it would be a cinch for our recording age to add another reel of fact-farting to our canned life.

It is said that all dreams have roots in reality, but what makes them rise is the true question! The eye is here to see, but we care more about the "look"; the nose grows to breathe, but we care about its nobility. The navel is nothing but a healed wound, the severed end of the tube that leads from the mother's navel to the belly of the fetus; but the Greeks called the female navel the "pomegranate" because the rise and hub of that crest was beautiful and juicy to the bite of the eye.

I wonder, too, if the Spartans learned from the eagle's blinding test their habit of killing sickly children. Or was it pure inspiration of the human beast? In either case, the poet is left in abeyance.

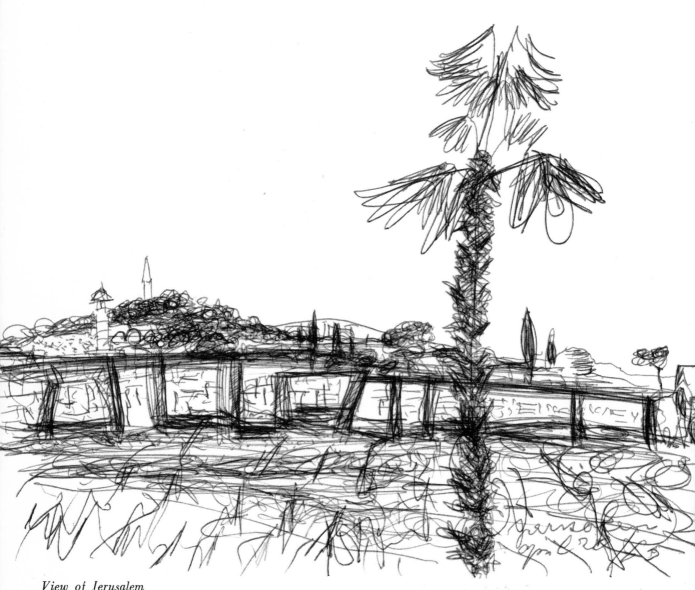

View of Jerusalem

ISRAEL

JERUSALEM, TEL AVIV, HAIFA, ACRE, CAESAREA, VADUZ

On a Hill or Bulge

Jerusalem,

on a hill or bulge of the earth, is still patiently holding up its buildings and mosques and roots of olive trees and cypresses and umbrella pines, as it has since the Red Sea became red and the Dead Sea became dead.

But that support by mother or grandmother earth is not enough: the migrating ant-men have built a rocky wall around the city, with square towers as reinforcements along the belt of chiseled stone blocks, to protect the chastity of their beliefs: Jewish, Christian or Moslem.

This is the very character of the total city: closed downward to the ground, dug into the very skull of the earth, a honeycomb of arid caves, yet still open to the menace from the sky, where white herds of sheep clouds graze, moving step by step throughout the ages, indifferent to religions, tribes or races below. The human being remains the only bomb-proof shelter of the spirit.

Once last Monday, on Yom Kippur, I saw an enormous cloud, white and torn, zigzagging from west to east with super-jet velocity, only inches above the roofs of new Jerusalem. Frightening. An omen, surely, in biblical times; now only remarked with ". . . look up, Zvi, how ferociously she moves . . ." I stopped in my tracks.

That cloud looked to me very much like Jehovah's beard, torn to shreds in anger, striking at the roofs of Jerusalem.

Its shadow fell upon the town only for seconds—a sinister eternity.

——————————— ———————————

It vanished as fast
as it appeared.

We continued our stroll through the furrows
of the streets plowed throughout the land
of this new city of hope incarnate.

Looking through My Window at Jerusalem:

> **What would Architecture have done without War?**
>
> **What has created the bastions of this outer- and inner-walled city, stonebarrier after stonebarrier?**
>
> **What would Architecture have done without religion?**
>
> **What has created the cupolas and minarets, heavenly shelters on earth?**
>
> **War and Religion!**
>
> **Eliminate both and we are in the Garden of Eden, naked and fearless—**
> **without Architecture.**
>
> **It was called: the paradise.**

Dead Sea Scrolls

Jerusalem
May 19, 1958

The Dead Sea Scrolls unfold a new
life for me, architecturally
speaking—demanding a blunt reality,
not a theory.

Scrolls in a modern setting—
setting a new pace, architecture
linked to past and
future, skipping the present.
Conformity to glass and
steel, yes? No.

How to unfurl the scrolls
to a wide world which cannot read
Hebrew, whose letters, to the
layman or good-natured
Hybrid-Hebrew, are only decorative
ciphers, yet these signs have
shaken with their content
the somnolent religious
world of the cathedrals.

Evidently a new architecture
in spirit, form and materials
will have to be found. I must
retire to the no man's land
of my inner sanctum waiting for guidance.

Only a belief, and not the
intellect, will help
to find a solution.

One day of three days of June, 1954, New York's *Wall Street Journal* carried an advertisement regarding certain Dead Sea Scrolls, newly found after almost two thousand years of burial. No one knew who inserted this announcement:

> *Miscellaneous For Sale.*
> The Four Dead Sea Scrolls, Biblical Manuscripts dating back to at least 200 B.C. are for sale. This would be an ideal gift to an educational or religious institution by an individual or group.

Miraculously, the ad was seen by the only one who could help.

The scrolls were bought by the New York philanthropist—Gottesman, head of the Gottesman Foundation.

On March 17, 1955, the scrolls were presented to the Israeli government at the Israeli Embassy in Washington.

Our firm was chosen to design a shrine for them, a shrine on the campus of the new university now under construction. My partner, Bartos, and I flew to Tel Aviv. We rode up the hilly road to Jerusalem, and on the following day we sat with many faculty heads as well as the president of the university and listened to the story of the origin and discovery of the precious documents.

President Mazar: Separated by almost twelve centuries from his eighth-century counterpart who followed his dog into a cave near Jericho and unearthed a cache of old Hebrew scripts, a Bedouin boy named Muhamed adh-Dhib (the Wolf), pursuing his stray goat, wandered into the Qumran Cave which for two thousand years had effectively concealed the earthen vessels containing the Dead Sea Scrolls. The warm mud of the Dead Sea earth sealed off the caves and maintained dry air in them. The large terra-cotta vessels in which some of the scrolls were found gave additional protection against humidity and vermin. The writings were found in excellent condition. They are inscribed on lambskins, that is, on the shaved-off side of the hides. The texts are often in columns similar to our newspapers. Once in a while the ink has eaten through and the letters appear as if nagged by time. Otherwise they are well preserved. The skins, rectangular, about six inches by ten inches, were sewn together to make a long scroll which was rolled up for storing. That's how they were found.

319

This account seemed to me beyond belief, but, as I learned later, was factual indeed. The earth had given forth seeds of truth.

I: Forgive me, Mr. President, for interrupting you. But how long did you say the scrolls were buried underground?

He: Slightly less than two thousand years.

I: And how long was Israel, if I may put it that way, dispersed in exile, underground?

He: The question is poignant. The independence of Israel was also entombed for nearly two thousand years. As a matter of fact, the Dead Sea Scrolls, although found in a cave at the edge of the dry salt coagulations of the Dead Sea in Jordan, were first and ultimately deciphered in Israel and their age determined. It so happened that one of our great Hebrew scholars, Professor Eleazar Sukenik, head of the Hebrew University's Department of Archaeology, was confronted one late November evening in 1947 by an Armenian antiquities dealer who showed him a scrap of leather from a Dead Sea Scroll. He handed it to him across the barbed-wire fence erected by the British to separate Israel and Jordan, strife-torn in the birth throes of a nationalist war.

when the gods are fighting
the people don't know

when the people are fighting
the gods are watching
built-in geiger counters
computing
blow by blow
for the day of reckoning
thunder, sun or snow

These were trembling days and nights and weeks. But it seems that once more, the spirit of truth, as always, penetrates, climbs, rises above fortifications, gods, rifles and helmets, to carry its message to the heart of the people where its destiny is fulfilled.

The envoy asked for an opinion on the age and validity of the writing inscribed on the piece of skin. The fragment was accepted by our scholar and the messenger vanished. Mr. Sukenik started to scrutinize this first sample of the Dead Sea Scrolls. On the evening of November 29, 1947, the family was assembled in a room adjoining Father Sukenik's study. They were sitting around a radio set listening to a session of the United Nations in New York, where the delegates were taking a final vote on the independence of Israel from the English mandate. Professor Sukenik's young son, Marti, ran into his father's study and announced: "The motion was carried!" That established our nation once more—for the third time, to be exact, after a lapse of 1,881 years.

One wonders what brought the scattered exiles of Judean tribes together, again and again, into formations of new revolts toward freedom and independence.

In the year 66 c.e., the Jewish rebels had the conquering Romans on the run. In 70 c.e., Vespasian committed his best-disciplined legions and sent his son Titus to besiege Jerusalem. His legions, after five months of siege, finally breached the walls of that city and conquered the inhabitants by slaughtering one million Jews. The remainder of the population fled. They were pursued by the Romans. In 73 c.e., the Jews' last stronghold, the Rock of Masada, fell. The bloodthirsty Roman hordes were disappointed because they discovered that the tribe of 960 men, women and children had committed suicide rather than submit alive to the conquerors.

At that time, there lived near Qumran a sect of ascetic and pacifist Jews, the Essenes. Some of them had joined the revolt since they considered it a just fight to rid Palestine of evil. However, when the struggle appeared to be hopeless, they concealed their sacred writings, written on scrolls, in the natural limestone caves nearby, and dispersed.

However, the slaughter continued, and in 135 c.e., Hadrian broke all resistance. Another half million Jews died.

321

Antidote to Numerologic

66 C.E. A.D.

70 C.E. A.D.

73 C.E. A.D.

135 C.E. A.D.

1881 past the present

1942 C.E. A.D.

1943 C.E. A.D.

1944 C.E. A.D.

1945 C.E. A.D.

1965 C.E. A.D.

if mysticism would not be

the halo of reality

we could discount

the interpretation

of the passing time numeral

 1881

made up of 2

 18's

the equivalent in Hebrew of

"Hai" implying LIFE

1,000,000 butchered, crucified

 500,000 put to the sword

6,000,000 gassed, asphyxiated, smothered

7,500,000 killed, nipped in the bud

But the spirit remains indestructible.

It is now 1965, '67, '68 . . . ad infinitum-carnivorous.

Man of any blood and color

choose between

greed and creed!

I have. And

the crest of life blossoms

continuously the gush

of white carnations.

I (breaking in): Mr. President, that wondrous coincidence of the reappearance of the Dead Sea Scrolls, coming out of the darkness of their caves, coinciding almost to the day with the emergence of Israel from the darkness of its underground life into the sky-light of today, that coincidence is very inspiring to me. It is like a happy writing of the *mene tekel* on a glowing rainbow of re-birth, spanning from the Middle East across seas and continents, toward the East River of New York. If you, Mr. President, want our firm simply to arrange an exhibit of these scrolls in showcases in the new university library, I must say that such a display would be of no architectural interest to us, particularly since your cam-pus has a group of gifted young architects who could easily han-dle such an assignment. It would just be a matter of getting enough donations to put in a marble floor and walls, bronze showcases, heavy rubber plants in the corners, Miës van der Rohe chairs and couches throughout, and air-condition the at-mosphere—that would be the "modern" way, in the great tradi-tion of the Bauhaus. The new buildings on your campus give testi-mony, as I said, that you have a number of young architects, talented in the tradition of Miës and Corbusier, and there is no reason to import architects to do the job. But honestly, we, as a New York firm, would not want to do it in that standard manner.

There is much more involved here than the display of rare manu-scripts. The timing of these two events, one near the Dead Sea of the Middle East, and the other, away on the shores of the East River of North America, this extraordinary simultaneity of fus-ing events is a hypnotic inspiration which I feel very strongly and would like to follow up.

I wonder if one could find a plastic expression for the idea of "rebirth"—that is, an architectural concept that would make visi-tors feel the necessity for each person to renew himself while yet on this earth. *To give birth to oneself*—not to be satisfied with the birth by a mother, but to re-create one's own being in the image of his own life experience. This is not, of course, rebirth after death, but rebirth during one's very own lifetime. Perhaps, a Sanctuary of Silence, with the flow and return of water suggesting to every-one the Second Coming of himself. Such an architecture would in-deed be worth searching for.

My words were followed by a silence of enormous expanse. Fi-nally, the President addressed me: "Would you like to try it? And

how much time do you think you will need for your new concept?"

I: We would like to tackle it, yes. But I cannot give an exact time limit at this moment. However, I hope that the conceptual time will not exceed three or four months.

The president continued after an instantaneous and intense contemplation, which to me seemed an eternity: "We shall be glad to wait. Otherwise, we'll have to return to our original scheme of dedicating the main foyer of the new library building, as a hall for the rare documents of the Dead Sea Scrolls."

Two days later, on the flight back to New York, unable to sleep, I turned the overhead pinpoint light on. I searched my jacket for a paperback book which I thought I had with me, but I didn't. My friend and partner was breathing regularly in his sweet sleep next to me, and I felt I couldn't very well step over him to search the rack of magazines for some reading matter. Bored by the standard environment of the airplane, but still overstimulated by the meeting at the university of two days ago, the idea of "rebirth" demanded my continuous attention. I finally fingered the inside pocket of my coat and extracted two or three old letters. After reading and rereading them, I put them back, but kept one out, turned over the envelope so that its backside was shining brightly in the spotlight, and, with a short pencil found deep down in my side pocket, I quickly designed: a double parabolic dome. The drafting went rapidly, and when it was finished, it spoke to me with conviction, as a plastic representation of "rebirth."

After we arrived in New York, I started to put the doodle into scale. Our office worked frantically to produce the first plans and prepare budget estimates. The idea of the dome-vessel crystallized and persisted with such vigor that we decided to retain it despite the menace of costs. Those were exciting weeks between the heaven of ideas and the earth of costs. With almost blindfolded persistence, we finished a set of drawings that could clarify the "concept of rebirth" translated into architecture.

And when we returned to Jerusalem, the concept was fully approved by the faculty. The gratifying fact was that no further explanations were necessary. The plans were exhibited on the walls of the conference room. Everybody seemed to understand. We were given the go-ahead signal.

324

The sanctuary proper would be a vessel. A double-parabolic, old-time wine vessel. The lower parabola, bulging outward from a cave of the earth—the container, "the vessel." The upper parabola, the lift, the open neck, the mouth exhaling and inhaling space.

Think of a jar. Imagine the shape of a carafe. Now, place it with its wide part on a table with the neck up in the air.

That is more or less the form of the sanctuary of the Shrine which will contain all of the original Dead Sea Scrolls. Other biblical exhibits would be distributed throughout a number of correlated buildings composing the entire Shrine of the Book.

The difference between this container and the traditional domes is that it consists not of a cupola resting on an understructure (a colonnade or a circular wall), but of a continuous, one-shell construction on a concrete bed which will be one-and-a-half stories underground.

As a matter of fact, it swings from the bottom parabolically outward, and then, inward and outward again to the top. There it ends abruptly in the cut-off opening.

Strange, how ideas occur. Flashes caught and imprisoned.

To hold it prisoner long enough, in order to become fully aware of what is what, is the very talent. I, for once, had at this moment forgotten that the idea of a vessel had already occurred to me during my night flight from Jerusalem to New York. It came back suddenly as new. It had an intoxicating fragrance, as if never smelled before.

Troubled by the costly width and height of the cone, the thought suddenly came to me to chop off the cone's peak, letting the daylight filter down into the rotunda below. My pencil went left and right over the cone, like a hand saw cutting through a trunk. When I lifted the pencil off the pad, the body of the vessel, with its guillotined top, seemed correct in spite of the many lines engraved into the paper. It looked inevitable and final. I stopped. Exhausted, I had to get up from my seat and turn away from the table. I went toward the kitchen. It was way after midnight. I was hungry and thirsty. I walked into the dark hallway and farther

325

into the dark kitchen. I unhooked the refrigerator door and the automatic light went on, glaring at me. I extracted a bottle of cherry soda. The form felt ice-cold. The cap was missing, and there was the open hole of the cone-shaped container, staring at me. I drank the red fluid right out of the bottle. Then I slammed the door. The bang of the Frigidaire closed a chapter. The sound was a final blast. The darkness quickly enwrapped me. I reached for my table lamp. The click of the light switch was like the echo of the door-shot. I groped, through the night, toward my couch. That's all I remember.

Anytime We Had Meetings

New York
November, 1958

Anytime we had meetings
based on drawings, every time
all questions were settled,
time and again
they were brought back
by someone for a
new scrutiny from the
inner or outer circle,
shaking the core of
solutions already accepted.

Once more under discussion was the construction method for the Dome-Vessel of the Sanctuary. These conferences had been going on for a year and I was pretty sick of them, mainly because most suggestions, if not all, were chiefly concerned with detail variations of no significance, and could not be accepted ad hoc without ultimately inflicting damage to the Dome-Vessel and to the principle of continuity.

It was an early afternoon. We were all still quite fresh at the office. Sitting around the table were three construction engineers, chief draftsman Louis de Michel, Arthur Jacobs, young architect and right-hand man, my partner Bartos and myself.

326

To my surprise, our chief engineer had, on his own, made a basic structural change which was a flagrant distortion of the shell construction invented for the shrine. I was forced to adopt a strategic cordiality in order to further the real issue, rather then let it die by stings of details.

Biblical times are here again:
The eternal fight between the
Pharisees and the Tribes of the artists
is reawakened. There seems to be no end
to the struggle of the artist here in
the deserts of the Middle East or
across the shores of the Mediterranean,
the Atlantic, the Pacific, high-rise
mountains or sheep valleys of Europe.
The clash is still inevitable.

Dome's First Act

New York
January, 1959

The Sanctuary's first act of planning:
Moving inside an existing building cube.
Converting prison walls of tight
enclosures into freedom space.

Imagine a five-story building in solid concrete, a huge library a whole block square, already planned and the excavations started. Then we propose the insertion of a dome with its peak piercing the third, fourth and fifth floors, growing narrower and narrower in circumference and finally emerging on the roof as a circular core, open for the light of the sky to filter down. The wide main-floor lobby was a natural for this design. As the dome diminished in its upward rise through the area containing the bookstacks of the library, the displacement and loss of storage space also decreased. We did not interfere with the squared-block look of the building as a whole. No one outside could guess that the sanctuary was sheltered within. It was a breakthrough and was quite appreciated by our council. But the Jerusalem architects objected

327

politely and we heard that we would have to move out. It seemed that the parabolas of the shrine were considered to be guerillas invading the cubicles of the Bauhaus.

The shrine's second act:
a new solution based
on a new location. The
vessel however persists, determined
not to be lost within the complex of the Shrine units.

The shrine was gently pushed out
from the interior of the new
library building to the outside
in front of it. Exiled.

After the second, there came a third
new location.

Taken by surprise by this new turn of events, I was willing to fly to Rome for discussions. I could not afford to proceed to Jerusalem. In Rome, I was joined by Dr. Mazar, Zvi Cohen and my associate. I then remained in that city for three weeks, working on the new scheme. My labor resulted in part of the shrine being on the ground, part of it underground, a patio, an underpassage corridor linking the new library with the shrine. But there were also two open staircases leading up from the Monastery of the Cross directly to the shrine. I liked the location. It was off-center and had its own environment, monumental and intimate at the same time. I did not know that this scheme would also have to be abandoned. Two ravens were sitting on my shoulders, one on the left, one on the right, witnessing my new efforts at the drawing board. I thought they were pigeons.

After returning to New York, we spent the hot summer months at our office toiling on the structural implications of the new location.

Around the dug-out hole for the dome-vessel, our consulting engineer put up a ring of reinforcement. This would have been all right, had he not also designed a solid circular wall below, which would support not only the opening of the plateau but also, from underneath, the upper part of the dome. This violated the struc-

tural fluidity of the shell construction from top to bottom; it had to remain independent of any outside support of a routine, mechanical nature.

There was another aspect of this circular wall which in my opinion was a threat to the longevity of the whole structure:

When the engineer did what he did to solidify the support of the upper half of the shell, which became thinner and thinner as it rose to the top of its neck, the lower part was curved inwardly and rested against this ring of concrete on one half of the side while he left the other half leaning against a concrete filling of the excavated rock. This was in complete violation of the equality-of-stress around the foundation.

If we had cared to make the upper half of the dome in shell construction and the lower part simply supported by a colonnade or a circular wall, there would be no need to pursue the principle of continuous tension in construction, and I could have accepted, in a lackadaisical way, the old post-and-lintel support and everybody would have been happy.

I often wonder why consultants who hear structural problems developed and clarified in endless discussions and drawing demonstrations later come back with suggestions so diametrically opposed to the very core of the inherent idea. Their behavior must derive from the basic psychology of their status as "consultant." They are halfway with you, and halfway absent.

It seems that apprenticeship has been driven into the corners of past history where in earlier times it formed a firm foundation for the integration of an old and new approach. That, of course, needs time and thinking in abstracto, while today everyone from draftsman to designer, to engineer, to client, to builder, to contractor is a pseudoexpert in routine solutions. The innocence of facing an architectural problem, unprejudiced, is gone.

Airplane Flight

We flew super-jet New York to Tel Aviv, but we had a three-hour stopover in Rome, making Israel in fourteen hours. A rather tiring flight, with no berths (not on jets) for resting. In Rome we were welcomed by painter Dorazio and driven for the interregnum period to the Pope's summer home town of Gandolfo. There we sat eating pizza on a terrace tratteria facing a crater lake with a deep blue sky-shell over it. The Pope's castle looked to me like a tooth sticking out of the crater mouth. It was mellow summertime after my air-conditioned cabin. One felt transplanted from an artificial shelter of deliberate comfort, like a seed which has dropped casually from the outer space of time and become an unexpected bloom in the Pope's flower garden.

"Next summer, the Olympic water sports will be held on this lake," friend Dorazio pointed out. My vision transformed the calm water. The surface became furrowed, choppy, hissing with spray. The Olympiades and the Pope, Rome and Jerusalem. What world citizens we have become, thanks to jets—without indulging in or absorbing any of its parts.

Anticipation.
Antechamber.

Antelope.

Its horn
changes to the
ram's
and trumpets
beware
prepare
antidotes

We rode into Jerusalem in the dead of night. A government official had awaited us at the airport of Tel Aviv, two hours away by car. It was the third time in two years that we had landed at that modernistic barrack to pursue our elusive project.

My partner and I had been stunned at the news, heard earlier in

330

New York, that a full-size model of the dome had been built on the campus without our having been asked permission or even notified. It was too late to argue about it. The battle of the Pharisees again, this time in secret. There loomed the danger of our losing the project altogether.

On the way to the King David Hotel in Jerusalem, locked up in the automobile, our official host delivered an exposé of the situation. He told us that the model dome was located on the edge of the university plaza.

"You know the spot; it's on the university field just above the Monastery of the Cross. It's really on the crest of the valley."

He started a barrage of politely apologetic sentences, reporting all the doubts about the validity of the former location and of our design. An honest account of hearsays. He was solidly covered with the mud of gossip and so were we after a while. "I know you will have to cut the cost of the building in half. I'm sure that you will do your utmost to accomplish that . . ."

Then he tucked in his main points, wrapping them in the cellophane of a weary smile that glittered even in the darkness of the Jerusalem road: "Perhaps the dome is too big; perhaps the dome is too high; perhaps the dome is too wide; perhaps we should abandon the idea of the dome altogether; perhaps the form of the dome is too oriental in shape; perhaps you could find another shape. Of course, we shall try to keep the entrance corridor . . . you see, we don't need too much space; after all, there are only seven scrolls and some other biblical documents to be exhibited . . . perhaps it would be wise to approach the problem fresh in a new location, and I am sure the architect of the new museum—he's a very nice fellow—will be very helpful . . ."

"My dear friend," I addressed him, "forgive me for interrupting you, but at this point, and I'm sure I speak in the name of my partner, too, the patio, the corridor and the dimensions, size and shape of the dome-vessel must under no circumstances be changed. Otherwise, I shall resign from this enterprise and leave it to my partner to make any decisions he wishes. I'll be out. We have been indulging changes, dictions and contradictions for two solid years in order to create the concept and its details. We believe in it, and had the impression that you did, too.

331

"You must understand, my dear Chief Archaeologist, that archaeology is the art of digging the past out, while architecture is the art of digging the future into the present.

"One is digging out, the other is digging in. The archeologist can never tell about the future or the present, but the artist can—and will. 'You must dig that.'

"So, whatever the artist, sculptor or architect of today is creating can never fully be judged by the archaeologist whose business is the bygone. If from now on, two thousand years will have passed away, the future archaeologist may dig our present out then. This is the law of digging in and digging out. They are inexorably divided through centuries or millenniums. It is only after one or two thousand years from now that the archaeologist will have a chance to dig through layers of crumbled earth and cities to find some things that may be something.

"Therefore you better let us dig in so that your future archaeologists might have a chance to dig it out.

"Think of Schliemann, certainly an archeologist of great repute, when he announced to the world that he had finally found the old city of Troy.

"But what has happened a few years after his death? Dörpfeld, his own assistant, discovered by examining the plans of Schliemann, "the old man mad for gold," that his plans had missed completely the real Homeric Troy. Hissarlik, where Schliemann was sure was the spot of Troy, was actually leveled by the Romans to make room for the new Roman city of Novum Ilium. And let's not forget that the deciphering of the famous Rosetta stone, tried by oh, so many scholarly archaeologists, was deciphered only by the very young Frenchman Champollion.

"Unquestionable scholarship, pinpointing exactitudes, comparative historical studies are evidently not enough to dig the truth. What is needed is a genius with a heavenly inspiration.

"The genius is the engine, the rest of the train are the coaches, Pullmans and boxcars. If you like it, it is quite the dream of a pastoral of archaeology. If there are such incongruities of dig-outs of the past to a simple image of history, how much more difficult is the task to coordinate dig-ins of the present to a true image of the future." I stopped. I had nothing more to say.

332

We suddenly heard the tires gripping the road, the wind brushing against the wheels of our climbing car. Inside there was silence, the immobile silence of separation. With, "I understand, I understand," our host picked up his thread which I had stepped on.

I released it calmly; I let him spin it again. It was evident we were riding toward Golgotha. There was no escape from it now. We were ready to be crucified with rusty nails.

Just before reaching the King David Hotel, we asked to be taken to see the sham Dome. A few minutes later we arrived at the campus shrouded in night. It was two in the morning. We had difficulty advancing on the plateau. The darkness was charcoal-foam. And before us, suddenly, rose the outline of the upper dome. It looked like the gigantic skeleton of a crown set upon a rocky skull. The outline of the dome helmet was made of two one-inch black rods, bent vertically and crossing each other at right angles, flat. These contours were partly spanned with chicken-wire mesh and partly with black muslin, most of it in tatters and dangling. A ghostly sight! And how ghastly it must have looked in the daytime.

We stood numb
each person by himself, as at a grave.
the shreds of cloth flapped and fluttered
billowing coattails
flying bats on the loose.
tapping feet beating the earth like tumbling rocks
they whipped the air into lashes of whining sirens
slapping our faces incessantly
breath choking.
the sight and sound reminded me of Hasidic
figures dancing a black victory dance of joy, and
wailing at the same time over their
phari-foreigners
arch-invader-architects
who try to steal
the fire from the burning bush
and drown the scrolls
in the Dead Sea

oi, oi, oi
what joy
the building
is forloi . . . brimstone, steel and glass
to join the sand of the desert
blown to dust.

the dance got wilder, menacing.
it started to encircle us closer and tighter.
touching would have meant prostration.
we withdrew,
with open eyes we were blinded by a nightmare.

We were defeated,
defeated not only by these ghosts and realtors
of intrigue, natural in any land, east, west, or middle east, where
architects, authorities, authorized and unauthorized contractors
and scalpers are involved getting into, or at least under the skin of
a project like ticks. The base of the sham dome hung in mid-air.
There was no fill in the area where it was to rest. No time and
money to demonstrate foundations. The square pool was omitted,
so was the plaza surrounding it, as well as the two monumental
staircases leading up to it from the lower avenue. Nothing of all
that was even vaguely indicated. A caricature of a project. Fla-
grantly ignored was the correlation of all the various parts of the
planned buildings, both above and underground, not even the spa-
tial volume of the main vessel, above and below could be imagined.
Totally missing were the architectural ritual of one area following
the other, the prevailing dusk of the light and the inspiration to
enter into the worlds of the past and the future: thus, the heart of
the project was cast out of the body. It was cloak-and-dagger mur-
der, the blade anointed with garlic. No wonder they became dis-
heartened, terrified, and spoke of a monster building.

We turned away. The project was dead, they had buried it alive.

It would have to be exhumed, and resurrected.

The air was full
of foul designs
brought on
pushed off
art vendors' pushcarts
corner the arts
selling is hard
bidding brisk
traffic flip-flops
red-green green-red
stop or yield

————————— —————————

the night moonwhite
pallid my face
stars are
twitching black
blinding ice

334

After two days of searching under the cordial protectorate of the government, we found a new site: the fourth. The shrine was now to be on a hill called Nave Shaanan (Peaceful Habitation), twenty-five acres donated by the Israeli government, across from the university and above the Valley of the Cross where the historic Crusader Monastery stands. It would be part of a galaxy of museums. We hope it will be the final location, in harmony with the Isaiah Scroll which speaks out: ". . . thine eyes shall see Jerusalem a quiet habitation."
Pace. Pace. Shalom.

Mexican Industrialist

Jerusalem
October 10, 1959

Unexpected encounter with a Mexican industrialist living here in a mansion designed by a student of Master Frank Lloyd Wright. We were introduced by a bidding contractor who had built this house and wanted to demonstrate through it his high quality of craftsmanship.

We were invited to their house-home for coffee, and when I arrived, I rang the bell, putting my finger on a gleaming black spot, a button, rather slippery. The glass wall in front of which I was standing was divided by vertical steel bars painted black-gray. It was veiled by semi-transparent lace-and-organdy curtains, like the face of a mid-Eastern woman, beautiful and occult. Obviously not a Bauhaus design. I could and could not see through this mummery into the interior. I found myself virtually standing in no man's land, unable to hear the sound of the doorbell, which I had pressed pretty hard. The time seemed timeless, and in that emptiness of waiting, the door suddenly opened and a maid bid me enter.

The Mexican and I were spending time waiting for his wife, who was resting. I gathered that he resides partly at the Dolder Hotel in Zürich, partly in Mexico City, partly in Jerusalem, and partly in Vaduz, Liechtenstein, where my nephew lives.

335

"What a coincidence!" he exclaimed. "I own a miniature factory there. It would be wonderful to meet your nephew and, since you tell me he is an international banker and an old resident of Liechtenstein, he most probably can give me good business advice. That little land is one of the few hideaways of international finance, and perfectly legally so."

I: "He is charming. Had some painful experiences as a prisoner in Russia. His wife finally fished him out and brought him back to the Vatican where she had been living in refuge during Hitler's regime in Austria. She had been invited to stay there in memory of the many years of Sunday afternoons spent by her mother sipping tea with Cardinal Innitzer of St. Stephen's Cathedral in Vienna. Like you, he has several residences, one in Vienna, one in Vaduz, and a summer place in Positano, near Naples. I am sure he'll be delighted to receive you."

He: "Then, why don't you come with us, as our guest, to Zürich and we'll all motor over to your nephew together. You tell me you've never been to Vaduz?"

I: "No, I've never been to Vaduz."

He: "Are you accepting my offer then?"

I: "I accept with pleasure."

He: "Fine. Now you look around the house and excuse me for a while. The builder will explain to you the various locations of rooms and materials which he so excellently handled."

I: "Thank you. As soon as I return to the King David Hotel tonight, I shall write the letters of introduction, as I promised, to Mrs. Welcher-Gideon who is a brilliant writer and the wife of art historian Gideon. Both of them live in Zürich. Also a letter to a friend of my wife's, publisher Kurt Wolff of Pantheon books, who has shifted his headquarters from New York to Zürich. If I remember correctly, he lives at the Dolder Hotel where you have invited me to join you. I shall arrive there in a few days."

He: "I've seen your plans for the Shrine of the Book. May I interest you in designing a symphony hall for Jerusalem? I have received preliminary drawings for it, but can't find my way into

the composition and am tempted to abandon it. It was a prize-winning design but I have no obligations, legally speaking, to carry it out. I'm free to make my own decision."

I: "I've never built a large theater. It's a field of architecture I've much cultivated since my Vienna days and I would love to do it. But, under the present circumstances, that is, being a foreigner here, I can't. However, if you come to New York in the autumn, as you said you would, it will be a pleasure to show you some of my theater designs."

We parted. Soon the lady of the house came in and sat with me. She chatted with animation in her double-height living room, a multi-niched chamber with luxurious cypress wood flooring, mosaic-frescoed walls, bronze-hooded fireplace, ochre-orange and dull-green-cushioned black and white couches, and a full window-glass-wall looking out onto the low hills of Jerusalem where the interracial sun had just set, leaving its glow behind to enhance the appearance of a radiant woman.

A touch of pink upon the gold rose along the rim of the horizon, changing upward into a soft brown-green, and reached its culmination before the blue aura of the sky. The star of Bethlehem, as I had discovered days ago, would soon make its nightly curtain call. A solemn and intimate interval of nature's play between day and night. We stopped the talk and inhaled the sight with fixed eyes.

She, the lady of this tropically modern house, has dark, very round eyes, an upturned nose, a poet's fluffy bushel of hair, vividly moving fingers with mauve-glistening nails, a personality alert and akin to all practical questions at stake, yet of a pioneering spirit bordering on pure idealism, apparently ineradicably implanted in her heart at the time when, as a refugee girl from Germany (her parents dead) she lived in Denmark and finally grew up in a kibbutz in Israel, her promised land reached.

She was refreshing in her sultry surroundings, like a mountain spring after years of plumbing water.

Battle of Yom Kippur

Jerusalem
October 11, 1959
(*Yom Kippur*)

Unexpectedly—a battle was won on Yom Kippur.

The victory was over the contractor in eliminating air-conditioning from the Dome-Vessel and from the underground corridor leading to it.

For two years we have been waging war with the mechanical engineers, who automatically impose the cancerous growth of ducts on any building small or large, religious or profane. Cafeteria-and-skyscraper air-conditioning is invading our homes and churches. Artificial air is the fashion. I am sure they are propagating air-conditioning brothels from Rio to Damascus.

The glistening skin anointed
by natural sweat is tabu—
powder-dry doll-ness is the
order of the day . . . and of
the night . . .

An air-conditioned sanctuary for Dead Sea Scrolls sounded embarrassingly contradictory. Functionally speaking, it is simply this: the air of Jerusalem (unlike that of Tel Aviv and Haifa) is sparkling dry, like champagne; the sanctuary is half underground, partially buried in rock, earth and fill. That provides for natural cooling in summer and warming in winter. Furthermore, the dome is open at the top and so shaped that the warm air is pressed upward by the cool ground. In addition, we have provided a circular spray of fountains over the upper part of the dome; they provide continuous cooling which can be diminished or strengthened as the summer heat demands. To add mechanized dehydration and frigidity to the air would be a sheer waste of equipment and money, and, worst of all, artificial in this atmosphere of antiquity. Churches, synagogues, mosques—domes of any sort throughout the ages in the East, the West, North and South, these man-built caves have been the very natural refuges from the confinement by summer heat.

The decision not to air-condition the shrine artificially was made yesterday. Today was another victory in the making. It concerns

a new type of a giant free-standing wall, with an unusual method of joining the chunks which form it together. This huge barrier would be built up of boulders of basalt in the raw, just as they came from the crater, one piled upon the next, leaving openings between them while forming a vertical open-lace stone shield. The chunks would be joined by heavy bronze rods gnawing into each other, with no concrete patch-up of joints. This concept was the result of the new and fourth location, since the plot is entirely open on all sides to the views of the Jerusalem hills; in addition, the white dome demanded a counterbalance in shape and color. The black basalt wall seemed to be the answer to it.

Jaffa
October 12, 1959

We followed a dinner invitation to Tel Aviv. Chaim, the taxi driver of Yemenite descent, chatted us over.

Remembering the vistas of American and Swiss canyons, or the Austrian Alps, I recalled how unimpressive the Jerusalem-Tel Aviv road seemed in every respect: landscape, elevation, buildings, sky and panorama. (Jerusalem's air is baffling in its sudden pick-up of purity).

How excited Patsy, my blond, cool-blooded, Boston-born secretary had been a year ago, while riding this road, exalted by the thought that Christ, the Crusaders and many kings, pilgrims and prophets had walked or horsed the same route yard by yard; she, although we arrived at dark night in Jerusalem, could not be kept from reeling over our bodies, from one car window to the other, as if out of that Cimmerian shadow these figures might reappear. But nothing happened. Poor Patsy! Her unrealized, naïve expectations became a disappointment to me also. Our present-mindedness is a real prison of the imagination.

When we finally arrived at the King David Hotel—it was four o'clock in the morning then—the only *real* person who came in sight was a watchman. His face was bare of any trace of tribal history. It was cast in a mold battered by thousands of years of wandering, and the seeds of many a race have been mixed in the chalice of his body. With half-closed eyes, he finally managed to turn the key in the entrance door.

It is really significant how insignificant the road between Tel Aviv and Jerusalem is, considering the history of events over so

339

many hundreds of years when this road must have been a long-lasting gateway. Neither its width nor narrowness, nor its inclination, steep or downhill, is memorable, nor the landscape left and right, the trees, the bushes, all casually high or low, dense or scattered. The light in Jerusalem, so sharp and illuminating, or at night by a mirror-moon so mysteriously hush-hush, lingers here lazily. The only outstanding touch is the sight, as unexpected as turtles in the desert, of war tanks, decaying bulks overturned during the war, their carcasses left on the roadside to rust to death. These tanks stretch their wheel-legs upward like dead horses. Their metal hoods look truly like blown-up bellies of cadavers. I wonder why these tanks are left unburied? Could they not be dragged off like dead bulls out of the arena after the massacre? Or are they memories of the battles for liberty?

Tel Aviv is an anthill of people. The city proper, approximately only fifty years old, compares with Jerusalem the aristocrat, and Haifa the bourgeois, Tel Aviv being the nouveau riche. Business *über Alles*.

We drove our car, literally, through throngs of people, people in constant action even when seated in sidewalk cafés or clustering on the pavement and streets.

Jaffa, our goal, on the outskirts of Tel Aviv, although a very old Arab and Mameluk town practically destroyed during the last war, represents the sick old great-grandmother who is tolerated in the household as a living relic of the family.

Jaffa, which I had already visited a year ago for dinner in a modernized cave with Dr. Yadin, reminded me in one part of the South of France, of Antibes. It was that warm intimacy which that image re-evoked.

On one edge of the shore, Jaffa stretches forward into the sea with a tumultuous array of rocks and boulders, carrying on top of the pile a sort of castle, half fortress, half mosque and synagogue, a monumental build-up in stone walls, enclosures and towers, like a conglomeration of rock masses very remindful of *les ramparts d'Antibes*, built during the fifteenth century, a fort sticking out its hand into the Mediterranean, which now houses the Picasso Museum. But unfortunately Picasso is missing here in Jaffa, and with him that eternally regenerative temperament which res-

340

urrects the dead, rejuvenates the old and renders the spontaneous eternal.

The ramparts of Jaffa

Visit to Haifa

En route to Haifa: the maidenform breasts of the holy landscape of Jerusalem; the slender, tightly pressed cypress trees like hand-rolled cigarettes of Turkish tobacco.

Haifa
October 13, 1959

We—Karl, Armand and I—went to Haifa, invited by the architect of the new art museum in Jerusalem, whose neighbor, the Shrine, will soon be within the galaxy of museums.

341

After a two-hour ride north from Jerusalem, we reached the coast
and rode for another hour along the gradually rising Mount Car-
mel, whose range begins with virgin cones like innocent swellings
of earth playfully sculpting the surface at first, but then growing
rounder and rounder and higher and higher, and after an hour,
stiff rocks shoot up and form a continuous mountain range which
finally engulfs the gulf of Haifa with its terraced heights, enclos-
ing a bay and port of considerable expanse. The lights of the port,
even the most miniscule, were shining brightly when we arrived;
they twinkled their signals of waking through the whole night.
The air was crystal-clear.

Haifa is a mountain. At close range it seems a perfect mixture,
if you like, of the biblical-old and the Macy-new. The streets wind
their way up and up, studded with squarish modern houses, small
and large, which are interspersed with semi-tropical trees. The
city staggers up the mountain with setbacks to the very top. The
rows of house-blocks recall old Arab villages, here wearing con-
temporary disguise. The shelter principle of cube-dwellings pro-
vides a link between the ancient and the modern. Solid cubes,
voluntary prisons, which are now changing into glass blocks
where the inner and outer world promote a visual brotherhood but
are perpetually split asunder by drawn curtains of various de-

342

signs, materials and weaves. Privacy is still the immutable sanctuary of the dweller.

Before entering the suburbs of Haifa, our archaeologist of Art, treasure hunter Karl Katz, pointed to the dark holes in the uprising hills of the Carmel range, calling our attention to two of them and informing us, with the factuality of a young historian reared on "classical cave life" in his Columbia School of Art, that these were caves which had housed the earliest man-known species in the Mediterranean basin, approximately 1,500 years before Christ. Unfortunately, he said, it would be too hard to climb up the embankment to go inside the caves and swipe some old bone-dust or flints. "Buy them on Madison Avenue," he said.

We continued our forward stride in a routine way, while inside our heads we tried to travel backwards in time, to imagine life in those caves so long ago.

"Most probably," I ventured, as if speaking to myself, "after the moon bomb has flattened the earth's cities to a single crater and filled it with atomic saliva, the Venutians will land here and look into the caves of past architecture, only to find flints of IBM computers. The bones of our decrepit races will have mutated

343

into oscillating particles so minute and powerless that no Geiger counter will be able to restore their origin. No radar will catch the images of the past. Gone. And for good.

That evening after midnight, Armand, Karl and I decided to walk out into the city streets and have a coffee or a drink. The last Haifans were dashing home. When we reached a tiny bar-café, the square in front of it was practically empty of people. I remember vividly a pack of stray dogs of nondescript species, ten (we counted them several times), roaming the plaza incessantly.

Unexpectedly, a pack of roaming teen-agers then appeared on the sidewalk and stopped abruptly at the open door of our café, with rowdy attitudes, delinquents in the making. One of them, leaning his body way backward, pointed at me with his hand, his finger outstretched, as if to say, "Boys, look!" They threw their laughter hilariously at us and left as quickly as they had come. Apparently, my short figure, my short-brimmed hat, had struck their fancy. We laughed too. But we had already been amused, seeing on the ceiling semi-transparent, flat sheets of plastics in pale-green, red and yellow-white, as shields for the lighting fixtures, cut in curvilinear contours of Hans Arp sculptures; by a full-sized mural of Brigitte Bardot smeared on with Fauve fervor and by the owner serving us Italian chicory coffee with French phrases. The glittering espresso machine at the edge of the bar-counter hissed wildly after long intervals of dead silence. Art, manufacture, modernism, antiquities, folklore—still in the boiling state of mixing past and present.

Haifa
October 14, 1959

le pigeon sur le balcon
mouchoir blanc flottant
bouleversant
le calme de l'infini
s'assied
sur la balustrade

pigeon sur le balcon
se transforme
en nuage
sculpture gonflée
image de la solitude
enclave
344

Looking out of my modern hotel window, I saw the old-modern-Arab-Abok houses in white, with Italian tile roofs, perched up on Mount Carmel, the diagonal background of the largest port on the Eastern Mediterranean. My remodeled slum hotel window combined the latest model steel shutter with an old-fashioned wooden awning in the style of Italy and Spain.

Straight across from my window I could see the top floor of a modern, balconied, four-story house. The top balcony was wide, a veritable outside room. An open door gave me a glance into the kitchen where a hefty Jewish woman was busying herself at a small table. A window next to it had its wooden shutters hermetically closed, brown-green. Outside, underneath, was an icebox, manufactured white lacquer. Laundry, mostly men's shirts, hung on a line in front of the balcony wall. One brilliant red blouse and an ochre one completed this suspended balcony ensemble with smaller items draped over the ledge of the railing.

But the remarkable feature in this scene was an open, wooden bookcase hanging on the wall next to the closed window. Each of the three shelves was divided into seven boxes, making a total of 21 caves for sparrows and pigeons or any other feathered refugees. The plank below the bottom shelf cantilevered out, forming a platform on which I saw pots and plates frequented by feathered creatures. One of these, a very voluminous black-and-white pigeon, was asleep; it looked like a miniature pillow upon which crouched an all-white pigeon, evidently her lover asleep. Another rather slender black-and-white pigeon fed at a plate, while a sparrow, perched on the edge of a cup, dipped his head down and up with a rhythm as cautious as a desert pump. Other sparrows flattered and fluttered around sparrow matrons who sat immobile, blown to twice their normal size.

A home-made aviary amidst all that pseudo-modern, pseudo-Arab architecture delighted me. Mating after all remains international, no matter what creed or color.

The city itself makes a rich bourgeois impression, with streets of modern apartment houses and family villas on roads winding continuously uphill; its open-air cafés overlooking plazas or the bay or both are equipped with ultra-modern lighting fixtures, chairs and tables, designs and interiors of Mondrianesque memories. One can practically hear the growing pains of this city,

squeezed between Arabian culture and Western industrialism.

In the evening we visited our host's house, entering through an open patio covered with a natural carpet of rich newly green grass, which was surrounded by a stone wall of Mediterranean memory. Nearby rose a tree, high and wide, as I was told, a eucalyptus, which had been transplanted only three weeks ago and bloomed happily, although in barely three feet of new soil.

The interior of the living room was industrially modern in shape, materials and furnishings, exactly like an illustration-come-to-life from the *Architectural Forum* or the interior section of the Sunday *Times* magazine. I resented finding, in Haifa too, Sweden's wooden chairs and Japan's paper lamps and all the other paraphernalia of industrial internationalism. Even here, at the top of Mount Carmel, in whose range we found the very next day, on our way home, the oldest caves of the Mediterranean, where men of 1500 B.C. had gathered with their families, and ate and slept comfortably on the floor, without feather cushions and bubble mattresses.

The real find and event of the evening was a page-sized picture standing among books on a shelf opposite where I sat eating. I eyed it immediately, and did not abandon it until after dinner, when I lifted it out from the bookshelf. In spite of recurrent doubts, it had looked to me all the time like what our host finally said it was: an Ingres. And signed by him, dated 1827. Paris in Haifa!

Karl, our museum director, Armand, the art lover and I, once a student of drawings at the Albertina in Vienna, we all agreed that it was unquestionably a genuine Ingres. Our host confessed gladly that he had bought the portrait-drawing about ten years ago in Tel Aviv, for the sum of five dollars. But the fact that this perfectly preserved drawing might today be worth several thousand dollars was not so impressive as the quality of the design, small, done solely in silver-gray pencil. It outshone all of us living people, the latest models of furnishings, the tropical planting and the delightful food.

Caesarea

we promenade
the top layers
 of past
 civilizations

strollers over
Persia
Greece
Aztecetcetera

 we dig
 profiteering rituals

we dig
with bleeding hands to
find
bric-a-brac of the bypast
and put them into
cages of translucent gold to shrine them in philanthropic amuseums

no present has
learned
from
humans of buried centuries
who lived hopefully
for a better world of ours

but none of us
cares for the teachings of
Lao-tse, Leonardo, Lincoln
Christ, Gandhi
Buber or Buddha

we dig the earth for brummagems of
gone-by living
instead of digging
our own time
to search and find
the inner core
these men have lived
for us:

Acre and Caesarea
October 14, 1959

the fight for non-fight.

Here, Now, and Everywhere
a reversal of
outer-into-innerspace
OM SHANTI

Acre, some miles north of Haifa, was reached by us three, Armand, Karl Katz (museum director) and me, in full sunlight at four in the afternoon. Dry light, a taut sky, and sharp shadows. What a delight to walk into an Arab village after Brasilia's monumental municipality some months ago! Catch-as-catch-can, architecturally speaking.

Here, as in Brasilia, desert around the town, except that in Brasilia the earth is terra-cotta-red; here, sandy and stony with candelabras of cypresses springing up casually, surrounded by their ancestral *vieillards* of crippled olive trees, mourning figures in the lonesome desert of Israel.

"I have been here before; the market street is dirty in smell, in looks, and the flies seem more abundant than the people.

"No," I said, "no, the flies, as I now see, strolling through the narrow streets, are part of it, harmless brothers of the air, daughters of the earth, like the cats who run here in the Middle Eastern towns, Arab or Jewish, not along walls, but across the alleyways, going back and forth continuously—like neighborly visits by rats in the U.S.A. No," I said, "this is life as it has been for ages. It has survived many a 'gadget.' I feel among these one-story houses, stone, wood or tin, one leaning against the other, bent by age, a chain across the centuries, well protected and not overpowered by tall skyscrapers and dwarfed to human dust. No, I feel at home. I could live here forever with these cats and flies and the mummied figures of women, the white-hooded Arabs with faces carved in ivory, and the Jews bent from counting their merchandise in pounds or piastres."

Where the town takes a deep breath of perspective you enter a plaza. The alleys and thoroughfares accumulated by centuries open up vistas with the sea of the Mediterranean peeping in, and in the middle of the void rises a mosque. I took my shoes off, resting my feet on a plank elevated only six inches from the floor at the entrance to the mosque, for which I was scolded, because this plank was reserved for the sandals of the Arabs and not for unlacing Western shoes.

The mosque was empty and looked newly repainted, I liked very much the dark colors outlining the contours of the walls and pillars and of the dome, a complete surprise after the sandy

348

monotone stone block of the exterior.

No pews. No chairs. No benches, no cushions on the floor, only straw mats. That makes for an uninterrupted feeling of space. Kneeling down, one feels the protection of the cloak of the dome around one.

But the mats did not match; they were disturbed in their array, tossed asunder. Why? Had there been murder in the cathedral?

The gardened court was cloistered by a monasterial arcade; each arch was topped by a tiny dome, a row of girlish breasts proudly displaying their full-fleshed youthful forms pointing toward the sky, waiting to be seduced by sheiks descending out of a thousand and one nights.

The mother dome is silent. It is enormous compared to the daughters' buds. It is as if all women of the Islam population have donated their breasts and condensed them into one. That makes it abstract, holy and untouchable.

The sky, over the narrow market street, is under-covered with jute, old and oldest pieces of cloth to provide a tunnel of shadow for the promenading population. Shop after shop, carpenters, basket weavers, tailors, squeezed into narrow caves of dark rooms. The footwalk is silent, because most of the people wear sandals or are barefoot. Their mouths are either tightly shut or open-loud for bargaining. I could not resist buying two Arabian hoods,

called *kephias*, one white for me, and one black for painter Scarpita of Sicily in New York, seeing ourselves entering the artist cave of the Cedar Bar in New York where our abstract-expressionist colleagues provide the proverbial swarms of flies (Sartre, Aristophanes) with their words of argumentation.

Only one mummified elderly woman, her face covered with black muslin, walked through the market street erect, an exclamation mark of time passing by.

And here, too, not far from Transjordan, a young Arab teen-ager, barefoot, carried a transistor radio—with a jazz tune playing as loudly as a mechanized street vendor's shouting.

"Stop feeling at home here! Come, we must leave right now," Karl was determined, if we were to inspect Caesarea on our way home to Jerusalem. "That's where I dug, and 'dig we must,' as students of Meyer Schapiro of Columbia University."

"What did you find?" I dared to ask.

"Oh, you are like all the others! Find! Find! Of course, nothing. Everything there has already been found. But I learned to dig."

"And what did *they* find?—the English, I mean."

Porphyr Statue 2 or 3⁻ century A.D.

"A tiny Forum Romanum, and two seated emperors, super-size, one in red porphyry, the other in white marble. But the remarkable thing is that they were found without heads. As you will see, the statues had interchangeable heads. There is a deep hollow where the column of the neck nestles. When a new emperor arose, the old head made room for a new one. Pretty good idea, wasn't it? You, of course, think that only you have astounding ideas! And for Romans to be thrifty is really something."

"Yes, I agree with you on both counts, Karl. But tell me, what do you think will remain, one millennium from now, of Rockefeller Center? The golden fountain head?"

"Oh no, sir," said a young man in khaki pants and in English, apparently an American student, "the only thing they'll find will be a stainless-steel skate buried in artificial ice."

350

While we were walking along small railroad tracks, sealed embankments and rubble rocks at Caesarea near the sea, I skidded, or lost balance, and my heels unearthed from the gravel some pieces of pottery, and my curiosity was aroused at the rich abundance of crushed civilizations. I kicked harder and deeper, and finally undug two handles of clay pots, which I carried with me to Jerusalem, to Rome, to Zurich, to Vaduz and to New York.

Here on my desk, they are welcome paperweights, resting once more in peace after a voyage of 1,500 years.

Thank you, Karl, for Acre and Caesarea.

Lunch at Hotel

Jerusalem
October 15, 1959

I had lunch in my bathrobe at a tiny hotel table placed in front of the open balcony door with full view of old Jerusalem. With me were architect Zvi Cohen, reporter Allen Podet of the *Jerusalem Post*; and builder Fefferman (who most probably will build the Shrine), his face eaten away by wind and concrete dust of the arid plains and hills. Reporter Podet, at a meeting four days ago, was so baffled and upset by a photo of the "Endless House" that he had to leave, literally speechless. Today he had read the articles in *Time* and *Harper's Bazaar* about the "Endless House" and seemed suddenly intoxicated with curiosity. He came back.

Later, since I could not supply a photo of myself, the contractor photographed me for the *Post* on the stone against a glass wall amidst the wasteland of a nearby hill. I clashed with that age-old figure of an Arab, so startlingly biblical in the surroundings of modern architecture. He, with white turban, white beard, a flock baton in his hand, trousers and coat of worn-out American army manufacture—an apparition who became more and more reluctant to pose with me, confessing, with a short grin, to superstition. His conviction and steadfastness hit me squarely. "Thou shalt not create the image of man." I was pleased with him holding fast to the tradition.

351

Jerusalem
October 16, 1959

The day before leaving Jerusalem, a flurry of meetings with University officials, with Karl Katz of the museum; visit to Air France caused by difficulties in getting a seat for Rome on my new schedule, making an appointment with a doctor to look at my air-conditioned cold; meeting with builder Fefferman and architect Zvi Cohen; and, in the garden of the museum, a hurried interview with the supervisor of the university library building to learn his qualifications for eventually becoming the Shrine's "clerk of construction."

I am now resting for a while, awaiting the arrival of the doctor.

The doctor came and departed quickly. Only a throat infection, possibly due to too much talk and cold air, as I had anticipated. He spoke German and disclosed that he had treated Gropius, having been the official doctor of the Bauhaus in Dessau. "Then," I said, "you could have changed the course of architecture, by feeding the Bauhaus teachers with anti-functional vitamins!"

Morning glory of breakfast time of the U.S.A. served in Tel Aviv: American corn flakes, instant Sanka, but Israel's sweet orange juice fresh from the Negev desert.

Avia Hotel, Tel Aviv
May 28, 1961

The Avia Hotel is of contemporary design, that is, prevailing straight lines, vertical and horizontal, with façades all around consisting of strips of steel louvers which one opens to any width one desires to shut out the heat-sun and sand-wind or to let the cool night breeze come through. A most surfunctional concept. My living-bedroom has very sensitive proportions: the double-bed part cut off by hand-woven straw curtain; the placement of the furniture most sensible, no overcrowding; altogether a casual atmosphere deliberately calculated.

There are molded chairs, split-seat chairs, low sunken beds with lemon-peel-colored wool skins as covers, low closets (very low, thank God, considering my height). My bathroom (again thank

God) has an old-fashioned glass shelf above the washbasin—chromium-steel-held, cantilevered at both ends from the wall—a slick glass shelf so designed that all the paraphernalia for shaving, mouth-washing and hair-brushing can be reached at a swift grip rather than having to be hauled out from built-in wall cabinets whose doors open into your face, or, if they are the sliding type, hide half of their contents, and interfere with reaching accessories urgently desired in a sleepy, dazed mood at morning or night. Look, dear people of all the places in the world, here in the middle of an arid field, flat, with scattered kibbutz block houses in the distance, you find a shelf which answers my years-long complaint against the entombment of morning and night utensils in mirrored wall cabinets totally contrary to simple usefulness, habit and sensibility. Taking out and replacing accessories right in front of you is a back-and-forth routine of servicing oneself (while one's mind is meandering into the hours of the coming day), an unthinking procedure, rather reassuring when automatic, but harassing when interrupted by openings and closings of a door which at the same time, mirrors your half-shaved face so that you see yourself floating forward and backward—a highly disturbing factor.

I assert with all emphasis, being more than professionally disgruntled, that industrial designers should be compelled by law to live with the object they design for a period of one month to several years, according to its type, so they may themselves learn the validity-in-use of their concoction before the tool is put to mass manufacture and the public at large forced to accept and struggle with it.

This demand applies of course to architecture, too. Architects should be made to live some various seasons long in the houses they have planned so they may know how it feels to accommodate one's living habits in a new wall-environment, glass or otherwise. Fines (or perhaps gentle incarceration in softly padded prisons) should be imposed on the architect, not for faulty contsruction alone—that is partly the builder's responsibility—but for defective concepts of design.

Make no mistake, architecture, particularly in housing, has too often become a gamble with people's standard habits and peace for the sake of fashions and fake-fame.

I'm sick of it. It is prostitution of a profession I love, a profession

353

which most architects love at one time or another until they fall a prey to Mammon.

Tell-tales from world
industries told on the
Israeli ground of Tel
Aviv. There is no escape from modernism
repeating itself ad infinitum.

Salt shaker from Italy; small belly-indented flower vase,
short neck, gray-blue, rose-petal-painted, from Japan;
anodized aluminum ash trays of native manufacture,
naïvely proud of their imitation aiguière *glaze pasteurized*
in the U.S.A.
These derivative aesthetics are so much more disappointing
here.
Imported novelties in an old biblical country
uprooting down-deep buried seed.

The waiter speaks French, but no English; companion Zvi tells me he is "evidently from French Morocco." The table we are dining on is of Swedish manufacture with table-top-pressed formica, German-American; the bright yellow molded plastic chair an imperfect imitation of American Saarinen design; the curtain of Japanese bamboo, Israeli woven. Ascetic chicken, roasted poorly in imitation American style which is already imitation French. Thanks to the orthodox baker for the bread, white, very tasty, flavored and baked in Tel Aviv. The worst lack of indigenous quality is found in the desserts: fluffy jellies, chocolated, vanillaed; cake airholed, blown up like sponge rubber, adieu bakhlava! Sandy coffee, pit-flavored, or local-Swiss Nescafé. *Nes*, I am told, in Hebrew means "miracle."

It's difficult to detect originality in objects any more, almost anywhere. The manufacturer today is more and more a bastardizer; he doesn't import directly but just imitates and cashes in on. Pride in craftsmanship has lost its market value, just like virginity.

Free-for-all profiteering, and legalized at that.

Tel Aviv
Saturday, May 27, 1961

It's three o'clock in the afternoon, the sun is high. I find myself in the middle of a pseudo desert on the fourth floor (room 429) of the Avia Hotel, ten minutes drive from the airport. The sign "Do Not Disturb" on my door is obeyed, and I am grateful for it. Sleep in the morning hours is still my need. I could not be anywhere else (as I would have liked) because the intertwining of a night meeting in Jerusalem and the Hebrew holidays marooned me from Friday till Monday at ten in the morning, when I will take the only outgoing plane from Tel Aviv to Rome. The dinner meeting with builder F. had to wait for the arrival of sponsor Teddy Koleck, right-hand man of Ben-Gurion, to sign the final agreement for building the fourth version of the Shrine of the Book on the hill opposite the university campus across the Valley of the Cross. The Sanctuary on its new location will be part of a museum cluster with the Museum of Modern Art, the Archaeological Museum, and a Sculpture Garden. This is late Spring of 1961. The ground on the hilltop has been unearthed. The excavations completed. And the foundations begun.

Koleck appeared finally at 1 A.M. He seemed pressed for time even at this late hour because he had to leave at six this morning for New York as avant garde of Ben-Gurion's meeting with President Kennedy. The same airplane was to have taken me and my partner back to the U.S.A. This would have meant arising at 5 A.M., giving me only three hours sleep. As it turned out, I was unable to sleep at all, in spite of two pills. I decided at the last minute to stay on at the hotel, come what might, and rest for two days and nights. Through government channels I was able to cancel my reservation (the airport was prostrated with holidays. It had been occupied by the Gods). My voluntary imprisonment at the edge of sand dunes gave me these blessed two days, lonesome as I was.

The shrine was mine only in design it actually kept me prisoner of my ideas professionally segregated I felt in quarantine

I contacted my friend architect Zvi Cohen in Jerusalem and invited him to spend with me a day and a half here at the Avia Hotel. He came. With him, our Supervisor of the shrine structure. I had a lovely time discussing detail after detail of the plans and also details of our private and social life. What an opportunity to connect humanly without interruptions, justified or unjustified. Gradually the calm of the wide spaces surrounding the solitary hotel entered me. I felt at rest with myself. The future could be tackled with refreshed strength.

... *but the Snake Swallowed the Apple*

A room was reserved for me by Arita, at Old Rome's Minerva Hotel, monasterial shelter for traveling priests. I did not object to her selection because, in the middle of its plaza, backed by the view of the Pantheòn, stands that unusual monument of a baby elephant carrying on its back the erection of a giant Egyptian obelisk.

That sky-rocketing obelisk atop the baby elephant had always looked to me very dangerous and seductive in its artificial balance. As a matter of fact, during the early morning hours of the following night—it crashed.

What could be a more romantic and inspiring beginning to my introduction to Rome, better loved by Arita than her native Spain?

From New York to Paris, she had always dreamt of being my guide through Rome. But I had lost contact with Arita. I did not know where she was—Milan, Rome, Florence, Naples—and I was marooned in Tel Aviv at the Hotel Avia. Due to holidays, the airport was in a religious coma.

I was tired from all the meetings, but exalted at the thought of seeing Arita in Rome. She who flew from New York to meet me, sweet black-winged white dove, for a few days in Italy. The second night at Tel Aviv, soundproofed to an Arabian night by the vast desert plains, I was suddenly awakened by the shrill ring of my telephone. I was undecided as to whether I should interrupt my sleep and stretch out my arm to finger and pick up the receiver. The ring persisted. I lifted the earphone: "Fred." I heard my name, and the voice was familiar. It was Arita. How. had she known where I was? We had missed each other for two long days, crossing wires from Tel Aviv to Rome-Milan, Milan-Jerusalem. But, finally, in the awakening morning-of-the-East, I heard her voice, teleported from Jerusalem to Tel Aviv. She did not know that I was waiting here, hidden at the Avia Hotel, just to be near the airport and readying myself for the departure for Rome in two days.

Finally arriving at Fiumicino Airport, I spilled myself out of the airplane, the very first one. And, walking across the empty air-

*Le sourire d'une femme
c'est du soleil
dans la nuit du jour.*

field, I saw her, standing atop the airport roof, wearing black sunglasses, her arm raised high in greeting, covered with a long-sleeved black glove. There was no one else around. She held her arm continuously up and smiled with the whole array of her white teeth which boomed: welcome, one by one. Entering the airport, I lost sight of her. However, only half an hour later, I met her at the edge of the baggage counter. We embraced, she guided me to a car, and we drove toward Rome, sitting tightly together, holding hands like school children, and not saying a word. My expectations were like a midnight balloon, pitch black, blown up to its limits, and filled with the luscious blue scent of morning glories.

Before my departure from New York, unable to fly to Milan, she had melancholically despaired of realizing her dream of a business transaction concerning some Etruscan antiques.

It seemed for her so far, far, far away—unattainable, that I invited her to fly to Milan. My father always used to tell me: "Money is the cancer of society." So I took this chance of throwing it away. Gladly.

After a few days of wandering over centuries through Rome, we would then cling together in mid-air and fly, side by side, back to New York.

I looked so much forward, like a baby boy, to be taken on a tour by a beautiful female cicerone, falling from time to time behind her, watching the hips of this tall figure, two half moons, swinging from east to west in that tantalizing rhythm to which Adam had already, long before me, succumbed. However, after having arrived in Rome, she never strolled with me through the streets or piazzas of that eternal city, which I had never visited before, except for one day, on a stopover during one of my flights to Jerusalem.

Arita had arranged a dinner party at the home of the mother of a dear friend of hers, on a roof terrace overlooking Piazza Navona.

During the day, she avidly visited many friends of hers, and I was at her side like a faithful dachshund.

What could have been more Roman that evening, more entrancing for a flight into the imagination, than the coloratura sound of

Bernini's fountain, flowing unceasingly over the parapet of our terrace, a distant trill of enchantment whispered into our ears.

The night breeze changed from brisk to mellow, and to pauses of infinite stillness. I had no idea that a catastrophe was in the making.

After dinner, Arita's young friend showed us precious Venetian textiles. A firebrand-red fabric attracted me particularly, and I suggested that it be cut immediately into an evening gown for Arita, be draped right on her, trimmed to size and form as I have done so often with opera costumes at the Opera School in New York, a task I always tackled spontaneously when model and material came together. But Arita swiped the silk out of my hands, which were left gasping in mid-air. She had decided to do it herself.

We were driven back to the Minerva by our Italian friends. They departed tactfully at once, and we were left alone to our own rooms on the same corridor. Arita invited me to join her. I came in while she was already taking her bath and I tried, in the meantime, sitting on the edge of a vast lawn-bed, to decipher the headlines of the Corriere della Sera. Although not understanding a word of Italian, I played a game of conjuring up meanings. Without Arita, every minute felt like eternity in that eternal city. As soon as my lady appeared, we quickly crossed paths, condensing the agony of waiting to be together. I hastened into the bath, a vast room sheeted in black marble. She had emerged transformed into a Botticelli apparition. Her black hair fell in the classical manner over her shoulders, undulating daintily in meanders into ever-diminishing curls.

The evening atop the Piazza Navona—the sound of voices in their native tongue, so foreign to me, but fascinating, like jungle chatter of colorful birds, uniting with the rhythm of the cascades of Bernini's horses vomiting icy water from the far-away Apennines, were compassionate.

My shower ended.
I quickly stole into our common chamber.
To my great shock, I found Arita deeply asleep.
No whisper could awaken her:
"Arita, Ah-ri-tah—"

358

The silence became haunting, and finally deaf. She had been so very vivid and alert the whole evening, now immobile. I could not understand it. I was puzzled. I waited. I did not want to awaken her. She looked petrified in her sleep, remote in her world of dreams of which I knew nothing.

I lay, stretched out flat on my back, gazing at the ceiling covered with ornaments of Italian stucco, for several hours. I saw the night slowly but unequivocally dispersed by an incandescent morning. When daylight appeared, its majestic entrance made Arita open her eyes. "Did you take a sleeping pill?," I finally addressed her. "You never do."
I turned toward her.
"I did," she said.
"But you did not tell me a thing about your intention. Or did you?"
She looked, half dazed, past my face.

In a lightning flash, I remembered that she had not addressed me a single time during the whole evening, chatting and convoluting with the various members of her adopted family friends.

During our return drive home, the animated conversation in Italian and Greek had continued unabashed. I had been out, the foreigner.

What was I doing here, it suddenly dawned on me. I left the bed hastily, grabbed my clothes from the chair in back of the bed. She now sat up, watching me.

"What are you up to?" she muttered.

I then delivered my first and only blast at a woman. It seemed to last for a long time. In actuality, it probably did not endure more than two or three minutes. But it was replete with contempt. In a tongue lashing without pauses, I spilled the venom from the depths of a hurt pride.

I ultimately quit and my departure was inexorable. Luckily, no one passed through the corridor while I was crossing it. I found my key hanging on a doornail, entered my room, locked it with two sharp turns, telephoned downstairs not to be disturbed till four in the afternoon and went to bed, with enough sleeping pills to put me to death.

At four o'clock precisely, the phone rang. I picked it up mechanically. It was Arita's charming young host of the previous evening. "I have been trying to reach you all morning. May I stop up to see you? I would like to talk to you. Arita is in our shop and has been crying since nine in the morning."

He was too openly warm not to be invited.
He arrived within minutes.

"Arita came with me. She is in her room.
May I ask her to join us?"
"Certainly."
She appeared pale, haggard and remained mute.
I ordered champagne, and we drank "adieu."

She, as my guest in Rome, was supposed to return to New York with me that same evening. And so it was. I could not leave her stranded. We walked down the maze of stairs, through Rome's new airport, until we reached the exit door of our plane.
We waited, standing together until it opened. In the plane, we sat next to each other.
At Idlewild, I walked at her side to the checkbooth for passports.
Behind her, I stood at the baggage counter. An hour later, our taxi stopped at her house, midtown. I helped her out. We shook hands. I said good-bye. The adventure was over, our relationship shattered.

I continued home. I left my bags in the hallway and turned into my bedroom. I fell into the forgetfulness of a sleep deep as a dead log, dressed in the old bark of my garb.

Buchs, St. Gallen
October 22, 1959

The letter paper which I asked for in the mountain-brook restaurant was brought to me on a porcelain platter.

The melted butter for my blue trout (Bergbach Forelle) is served in a *tout petit* green *poterie de chambre* over a portable flame to keep it hot. The copper oven sits on a wet linen napkin, which rests on a small porcelain plate. Everything is served with visual tidiness to heighten the tourist's appetite.

To provide the traditional lemon drops for my naked fish, I am served a slice of lemon inside a squeezer, a metal clam whose half shells, each with a handle-horn, you squeeze together. The juice flows out of the little machine without wetting your fingers.

Mountain girls, rocky figures with rosy cheeks, their hair gathered in sheaves of corn-blond stubbles—in spite of attempts at permanent waves—are dressed in city-like black serge with black-dotted daisy-white aprons. Their flouncing walk reveals an array of petticoats, evoking memories of folkloric Sunday dances.

They bring hors d'oeuvres, garnished with a collection of forklets, and knifelets, the *Räucherlachs,* with capers, green mayonnaise, sardelles—a corsage of preliminary food. Paper doilies on small and smaller saucers—poor relatives of the age-old hand-woven, hand-washed, hand-ironed, hand-folded doilies—and tablecloths bed-spreaded underneath in two layers over a lawn of white felt with the scent of June. A fresh "Inland Guggeli"; the secret of preparing this delicious chicken in a puddle of opaque sauce the owner would not divulge. His mastery of food had already impressed us optically. For instance:

Potages
Veritable tortoise au sherry
Kangaroo tail soup

Cocktail de homard aux perles d'astrachan
Poularde truffée Maréchal
Queues de langoustine à l'Indienne

Specialités de la chasse
Perdreau sur crouton à l'Alsacienne
Noisette de chevreuil "Minerva"
Selle de chevreuil flambé "Huguenin"

These mountain girls go about their business of serving with the most modern food mechanisms. All primitiveness of peasantry and naturalness are gone; only the mountains remain as they have always been. On the main roads cut out of bedrock, carriages without horses race back and forth like forlorn ants of the valley . . . but the forests above remain steadfast.

There is only one change in their life; their foliage costume is shed when the Sky descends in white flocks; they then receive Him with open and naked arms. But before that happens, they put on

dresses of gold and bronze and copper; the seasons, year after year. It is man's prerogative to attempt to outdo nature by creating fashion changes ad infinitum; his seasonal gowns derive from Dior, Beluga and Pissarro.

From Zürich to Vaduz, the sun wears her tourist smile; the autumn rug is spread all around the mountain valleys, auto bugs racing through without a goal. Speed and nature to me seem deadly enemies.

<div style="display:flex">
<div>Zurich
October 26, 1959</div>
<div>Diese Schweitzer Knorpel-Gesichter und Wurzelgestalten—

Ein grünes Untertassen-land
serviert Kuchenberge mit Sträussel Schnee.</div>
</div>

Brueghel: Census of the Population of Bethlehem

<div style="display:flex">
<div>Liechtenstein
October 24, 1959</div>
<div>I wonder if someone has pointed out how Chinese is Brueghel's method of composing pictures? Probably someone has. But I was never aware of it, although I practically lived with Brueghels in the Vienna Museum; only today, as I lay in bed the day after seeing his painting in Vaduz, it came to me like a revelation.

By his method I mean that Brueghel's storytelling is on so many documentary and psychological levels that he places people, in groups or singly, houses and trees, as seen *from above*—thus gaining a deliberately increased distance from each group-unit which his anecdote illustrates. The floor is thus the yardstick of physical depth and inner space. They are interlocked.</div>
</div>

362

The normal European perspective is, on the whole, expanded horizontally, left and right or toward the center, forward and backward. The Chinese, rather, develop their own storytelling perspective vertically, from up down, but never from left to right, or in whirling circles. They are not imitators of depth or of space or of motion. They are realistic abstractionists. Their perspective is rooted in their hearts, not in their eyes. I must agree with them that the heart has a better memory than the mind, because its imprints are constantly enriched by the awareness of similar experiences. These memories of whatever you have seen or felt in nature are not kept in the cold storage of the brain.

The linear perspective and vanishing points of Western art carry with them modeling in light and shadow. That is missing in Chinese paintings. What we would call shading is replaced by a formalization of the inherent movement of the object, be it a cloud or mountain, trees, man or animal. Cubism tried to do the same thing. But in addition to omitting light and shadow, the cubists had to break up and demolish all forms, to make you forget, at least for a while, the derivation of their images from nature. Indeed a subterfuge. The Chinese don't need to employ such under-the-table methods. They made: *tabula rasa*.

While not imitating reality, they describe nature in an age-old handwriting which surrenders its tools for the creation of an individual expression; in spite of and because of a strict tradition.

Time has passed out of their pictures. They have condensed it into eternal presence.

We run after time, and time runs out on us.

Brueghel—Painter of the in-between spaces. The empty or the fill-in with background vistas, never ending at the edge of the paper, just pausing.

Rubens: Venus at Liechtenstein
That flesh of Venus is so luminous
it puts the sun to shadow!

I wonder
how he would have painted a
dark Ubangi Venus? My goodness and Goddess!
That flesh would have made
black jet crystals blush
with paleness,
like the memory of a moon.

The night of her flesh would
have the opulence and opalescence of
liquid diamonds
whaling their melted way,
a tossing river. His
bed is too narrow for the temperament of her body—
no matter how wide the shores.

Peter P.s' blond Venus
makes a man's phallus rise to his head;
and the elasticity of the flesh is so
> *heightened by*
the transparency of its skin,
that it makes the canvas and
its frame nothing more than a platter
on which the body of this woman
is served—saignant.

Yet the distance through Art,
that ruthless purifier
of nature into abstraction
is guardian still
from the cave
to the grave of time,
forever keeping reality
a secret.

Liechtenstein
Venus 1614
Oct 24/59

New York
April 11, 1961

the rocky earth
has opened
up a gorge
and all the
river-children
somersault
hide play and seek
in mother's
water lap

the mountain
flanks rise
high and higher
christmas trees
candle-lit
with snow

churn, turn
twist with
spray and mist
mountain brooks
nerve in vessel-veins
waters
gush in
to mother's
river bed
playing
huddle-cuddle
fetch and catch

the baby Rhine
is promised
milk of wine
by mountain crests
from jungfrau's breast
in sensuous bulges of eternal ice

melting caps
plunge
rapid streams
headlong
a crevasse
pounding walls and
beating rocks
cataracts are
scooping
ever-deepening hollows
deeper
ploughing
molding
water tunnels
peak-to-bottom-seas
streams cascading
screaming
hell and hades
voice and echo
drown each other
until
mellow
valleys
gently tame
a madness
into thousand trickles
oozing eddies join the
riverain
thus
the brooks
have swelled
to Wotan's Rhine

the shores have castles-grown eternal stones
and from their crown
the muses bless
the vineyard wines
the poets sing a
destiny
fulfilled
DIE WACHT AM RHEIN
DIE MACHT AM RHEIN
DIE SCHLACHT AM RHEIN
DIE NACHT AM RHEIN

1961

New Year's Day

New York
Sunday, January 1, 1961

New Year's day, the first born in rough weather with snow battling its way through a gale, continuous rain, wind and sleet, flashes of lightning shooting off, and all that at high noon, the zenith sun hour. What an overture for the 1961 World Theater.

At five-thirty this afternoon the dark sky was split in two, high and low, by an oncoming gale; the old year chased off by bellowing ghosts. Duck and flee!

A mountain range of indigo clouds, a soft wall of mist rising from the lead-gray houses of the city. Above, the sky dome brown-gray, in between the rose of morning and pale green of the fading day. The jaws, the colors of the upper and lower skies, will soon fall close with night. The first day is done with.

Apollo will do the awakening. The jaws will open again until the all-clear signal for the whole sky sounds. Man can neither stare straight into the sun's eye nor see through the curtain of night. He sways between the lift of day and the gravity of night.

It looks as though he will continue to do so for some time, without ever being able to send down solid roots in a world of continuous dying and awakening.

The Exhibitioneer

January 11, 1961

Another Day of Judgment, mine. This time the opening of the doors at 4 East 77th Street, New York City, the gates of the old family mansion of Ileana Castelli, for a show of my work. These, my paintings, sculptures, and architectural models and drawings, were loaned for three weeks to be inspected by invited guests and casual strollers, and I have no right as their father to take even

one of my children back, because it is the law of art exhibits that the man who shows has forsaken all rights to his brood for the duration of the show-off.

You wait for the comments from friends and frenemies at the opening-night-in-late-afternoon, when dusk makes truth and lie indistinguishable. Alms are dropped into your ears, and the day following you wait for alms from newspapers to be taken in by your eyes. As the end of the show approaches, you wait and wait with tense patience for additional alms to be dropped into your hands by hypnotized buyers, but with the sound of real coins this time. When the donation doesn't occur, your empty palm clenches into a fist. Oh, we artists, success-stricken beggars for appreciation tokens!

When the last day approaches you prepare for the time after the closing, when the most carefully displayed paintings and sculptures will lose their co-ordination, descend from the walls and pedestals, and together convert the neat art boudoir into a storage slum. The hearse of the trucking company is waiting downstairs.

The motorized horsepower will transport the earthly exhibition remnants back to your own studio, where their homecoming will not be greeted joyfully. They have suddenly become strangers in their old environment, and you'll line them up face against the wall like traitors to be shot.

Behold! A sucker is found, ho-yo-to-ho! He buys, and buying is the stuff paintings are made of. Yes, if a painting is not from time to time sold, it was never worth its chassis, they say. But sold, the chase has ended. A red star is the capitalist seal of acceptance. The decoration is proudly worn on the breast of the picture.

That work will never return home where it came from. It has been adopted by foster parents, and they have paid for the right to keep it for the rest of its life—unless it is resold, like a bartered concubine. Art must be bought to exist in our society.

The patron-madame of the art gallery sits in the brothel of art, and waits. Waits for customers. The wallflower girls are dressed in gilded nakedness. Eventually the devotee, the bourgeois, or the speculator comes. He then is ushered into the *séparé* office where

371

the exclusive types of merchandise are displayed, and a deal is made.

The artist walks the streets with unrest. He cannot be still. He must move. He does not know exactly where. But he must move, on, on and on. When he gets tired of it, he returns to his bed or to his easel. Sleeps or works. He feels high, sinks low, like the rising and falling sun. It's his routine. One day he'll have another show surely, and then he'll sell. And everything will be fine. The fine arts, too.

What a hellish life of waiting and wandering is the artist's lot! The professional whore has at least the permanent dwelling of the street. Yes, man, think, every street of a city is her home. The art prostitute has not even a permanent hole to cover his ass, not to mention his head. His mind is eternally wandering. And the product of art has no permanent home either. It leaves the studio forever, moving on from collection to collection. Once sold, it wanders from home to home in search of its creator-maker. He never lost it, but it has lost him.

Lucky are those who land in the vaults of a museum.

The exclusive ones are buried alive with the pomp and ceremony of catalogues.

But beware if directors change. The picture, the sculpture, might fall into disgrace and be relegated to deeper catacombs.

Decades later, it might be rediscovered. It would then arise from the dead and be hung upstairs. With that hanging, the artist's glory and public history begin. His name and his work will be carried through schools and capitals of the world like a sacred monstrance, and eyes and hands laid on it for healing thieves, the rich and the poor, and some will kneel and kiss it.

Segregation of Painting and Sculpture

January 11, 1961

So much talk about segregation, slashing with social knives and waiting for the wounds not to heal. Segregation of the blacks and the whites and the pinks and the yellows and the curly-haired ones and the straight-downs and the out-combed Loreleis and the baldly shaved ones. Now let's switch over to the segregation of painting, sculpture and architecture.

It has been going on for three centuries and no one complains. We take it for granted.

Yet all the arts have been in close embrace with one another, since the beginning with "homo plasticus" unexpectedly standing upright with his forepaw-talent molding dirt and splashing images and scratching caves, storytelling and yelling poems with open jaws. What a ritual of spontaneous creativity! Trees make a good audience, the leaves swish, the sky expands and the rocks echo thunder. Now we have become high-faluting Hi-Fi-Fine Art-artists. Yes, dearie, them still sitting on high-stools and cuddling their segregation in gilded frames and marble niches. How about getting them to kick their habit? What happened? All is silent, mum. Everywhere, in the market galleries, the snobs' homes, the museum dump-depositories, the same segregation persists.

Let's take these old habits and tie ribbons around them and put them away like packs of old love letters. That should be Act One of a new era of sympathetic correlation. Isolation gone.

The greasy canvas will join the dry-point print, the oil brush will join the rubbings of dada-tache and so forth. A permanent wave of integration will roll right through the arts—there's no end to new beginnings.

Ma-painting, Pa-sculpture and Granny-architecture, they will have stopped their aging: they will play with the landscape of time and breathe cosmic space like children who blow their cheeks to balloons whenever they like and zoot the air out with a whistle.

Enough of sacred segregation. Let's turn it into a pagan feast of marriages among the arts.

373

Truth—Continuity

January 19, 1961

After a discussion with an architect-student from Mexico City:

Truth is not relative. The naked truth is not two, it is one, there is only one truth and it is the awareness of continuity, the once-was, the now-is, the will-be.

Truth is correlative, but always linked with a nucleus which is the consciousness of continuity. From that core, truth bursts into spontaneous adaptations and adoptions, and presents unusual masks, but underneath them all there is still the same old face.

He asked, How do you provide for down-deep creativity in your work?

You have to give it a chance. You have to bathe in the stream of continuity, be aware of it all the time, and then you'll emerge from the dirt of the day like Venus out of sticky sea foam.

Sunday afternoon
January 20, 1961

It's the second Sunday after the opening of my show at Leo Castelli's. Sunday afternoon, the hour I like so much, that is, after dusk. The sun walks off and the night moves in before the last rays are withdrawn. My room is filled with the glow of two lamps, reflected from the papers scattered like the leaves of fall months on my writing desk, and from the low table next to my bed where the tiny radio squats as my companion during the late hours when I fall gradually asleep every night to the sympathetic blabber of Long John's circle. One more week to go. And the question is: after the closing will only my work go into hibernation, or myself as well?

The Electric Switch or the Switch
to Process Architecture

January 24, 1961

Variability is one of the most important aspects of architecture, but most of our colleagues know almost nothing about it, because they freeze every building in specific functions. Their offices are frigidaires of inertia.

You don't need to be called a "Renaissance man" in order to be laughed at and left out because you are not single-track-minded but interested in all processes related to vital functions. They will ridicule you anyway by imitating your ideas obliquely—before you ever have a chance to build them and prove your point, simply because they have routine commissions to construct and you haven't. You are a once-in-a-blue-moon man. It's good or bad luck: to have or have not a job.

What is called "emotional architecture" is nothing but architecture as opposed to just "buildings."

Anybody's life is variable in many directions; you don't eat all the time, you don't sleep all the time, and even one and the same function changes—like a menu or a sleepless night. Not the same ever; very rarely is it, can it be, will it be, the same. Most variable indeed are the correlations of any function to the environment of nature and to your own changing personality. The bombardment of man by varying surroundings, and vice versa, these reciprocal impacts are constant and most of the time subversive because you are not fully aware of their impact.

A bench is restful
a rocking chair is more
but correlated to a desk
a straight chair is better

Glass walls give more
light than stone
but kill privacy.
The growing demand for privacy will
ultimately kill the glass
and create a new wall.

While social rituals such as control of emotions, laws of prohibition and laws bypassing laws, have been preached to us since mother's-milk days, and while we are all stumbling into sharp corners or social traps in our own daily experiences, we never, except at the very end of our lives, accept with exquisite consciousness the laws governing the interrelationships of forces that constitute our daily existence.

So, it appears now that the laws of *correlation* must become the *new content* of our observations. Particularly the need to deepen our awareness of processes which we as human beings embody. We must realize that we are all products of links between certain inherited pasts and inherent futures, expressed in the present from split seconds into seconds seeming eternal and beyond calendar time. Science has it easy, and calls this complex system a mutation of life-and-death *continuity*.

Now, how can we possibly design habitations for man without continuously observing the spinning of interrelationships of humans with man-made machines? It is a must, to put it mildly, and we know it, but do not do much about it. It seems that for too many of us, people are more or less alike, alike as mountains, alike as trees, alike as fish or whiskey. But to some of us, people are not alike even if they seem to conform. I am one of those who smell the differences from far off; and there were some before me and some will be after me; indeed many. We are a minority, however; that is true. I can see a difference where someone else cannot, and one discovers that these, even minute, differences contribute to the very individuality of a human being. It is part of his specific personality and exactly the part which is most precious to him, it is: Him. Yet, the majority of our professional architects, artists and historians have no time to study the variability of people and their specific need-functions. To study these, even to study an isolated function, takes detachment and enormous amounts of time. Particularly at moments and hours when they (the functions) are not supposed to function—like sleeping during business hours. Who, in our hellish rush, has time to do that at *that* moment? Well, the architect should have, must have. Of course you can call him emotional because he then does not conform either to standard methods of work or to standard methods of observation. He might even get excited by the way one person holds on to a rail and the other hops freely from one step to another, although older than the youngster holding on to the rail. Important? Yes, very im-

portant. Once we abandon observation of life forces at work, we quit being architects and remain solid business-building men. Nothing wrong with that, except the architecture. Pick almost any technological detail of a house or its equipment—you can probe your outlook on life simply by noting what types of objects you select or reject. Did you pick spun-glass curtains, Venetian blinds, or shutters; or perhaps all three?

To have or not to have the best kitchen equipment is not the question. The idea of quality is altogether a remnant of feudal times —today it's nothing more than a bugaboo of sales slogans. Quality is not absolute—it's relative; or, still better, correlative. Correlative to what? Are sales catalogues answering this question for you, or TV hypnotics, or you yourself? The point is: Whatever you are cooking, what counts is your choice and taste. The best steak broiled is still the one broiled over charcoal. The best bread, the one baked daily by yourself. Going backward in history? No. Going back to fundamentals, yes. *Hic Rhodus, hic salta!*

Pick another detail, almost any detail. Let's pick the electric switch on the wall. Yes, it belongs to architecture too. Strange that such a detail can have an importance to the concept of architecture. Strange that it can, retaining routine or breaking it. In the first case, you are blinded by habit, in the second case you have vision-perception.

Remember when you came home rather late, "early night," so to say, and you tiptoed into the bedroom so as not to disturb your sleeping wife, remember how the switch snapped on with a sharp click? A shot rang through the night, its echo wiped out by the sudden flash of light. The click of that tiny bar sticking out like a nasty tongue, well, they (the industry) have silenced it. For their own sake, or for the sake of architecture? But what interests us is, how much does it really mean in the total mechanism of the house? Almost nothing, at first click, or will it unleash a whole network of design planning? That is the question. Industry goes ahead anyway. Now, one does not need to snap the little switch any more (an uncomfortable twist, that vertical pull with one finger, anyway). You just lay your index finger on a plastic full moon and by remote control the light, the elevator, the broiler, goes on or off. Miraculous. Great. And time- and energy-saving, too. The next thing (because we progress, whether we like it or not, incessantly) will be a hole, not too deep in the wall, just a little

377

hollow, into which you put your finger and the light goes on while you get a manicure.

I remember at my family home the advent of light in our lamps. The housekeeper (an elderly but handsome and roundish female of Ukrainian origin) brought the seven table lamps into the large kitchen. She took off the green and milky-white shade-globes and the glass cylinders, put them cautiously on the table, one next to the other so they would brace one another (you know how easily they roll off a flat surface); scissors in hand, she trimmed the ragged wicks clean. She put a lit match to each of the wicks and the flame rose to its full flicker, which she carefully tamed. She then replaced the translucent glass cylinder over the wick, adjusted the flame carefully to a steady glow, reset the opaque globe over the lamp in its circular metal rack, and, with one lamp in each of her hands, proceeded to place them in their traditional locations in the various rooms of the house. It was the ritual: awakening the evening.

Of course, there was labor involved in it, but it provided an opportunity to feel pride in a job well done, however repetitious, and in being needed. By restlessly furthering mechanization and automation, where the project itself is the starting point and reason for progressive development rather than any inherent need, in such cases, we are eliminating more and more the pride of craftsmanship and, above all, direct contact with the materials and functions we delight to create.

Now, the light of those lamps was not electric or fluorescent light; not too white, the spread of illumination just right, the glow warm, the light softly condensed, with the milky-glass dome shading the eyes benevolently.

My friends, don't think I am suggesting a return to kerosene. We can create right now whatever you desire. You need not choose bulbs or tubes. You can have metal panels radiating light, invisible, soft as the whisper of a cypress. Define your need—it can be taken care of. You don't need to submit to industrial dictatorship.

These are not new ideas I am expounding. I am only recalling the teachings of some of the great feelers and thinkers—Lao-tse, Socrates, Gandhi, Einstein—who strived (in vain) to vanquish the in-

378

fantile vanity of civilization, with its blindfolded championing of fake progress. And, speaking of wise men, let me quote the poet, Artaud:

"Generally and in principle I do not believe in science, learning bores me, and I am convinced that the true scholars are those who throughout life ignore their science and will unfortunately remember it only on the other side of the grave; true knowledge is a neuro-muscular thing, it is silent, but at just the right moment it looses the simple, necessary gesture that redeems things which were never in the hands of the initiates, but of a few humble unschooled men who by chance also were men of good will."

A culture never progresses—it either is or is not. It's a matter of inner space and not outer space rocketeering. If a civilization fails to serve fundamental needs, then it is a prostitution of human standards. Satisfying these needs doesn't mean accumulating tools, machines, electro-robots—such accumulation will not guarantee freedom; instead it enslaves us more and more to mechanized processes. To choose your own freedom means to choose your own slavery: a dedication to extra-functional perception. The truth is that the heart of architecture has never changed, never changed in centuries, and never will nor can. Its scent is always the same. It penetrates any kind of packaging. In short: Purely technological progress creates only fashions. But when the packaging becomes the inner lining, instead of remaining the wrapping—well, we are where we are because we aren't *there*, where we once were, that is, inside the lining.

Strict definition of human needs is the key question of architecture. Without definition of fundamental needs there can be only conglomerations of steel, stone, glass, and plastics, any excrement of industry—not architecture. The discrepancy between what people *really* need and prostituted needs is the measure between natural growth of tooling and artificially speeded-up technology. There can be no equal absorption of the insinuated express service of such tooling, since the pace of human acceptance is retarded by a natural resistance to change under pressure. No mysticism here, just mastery of a situation.

The question is: if I AM and not if I B.M.

One wonders how the Chaldeans, the Babylonians, and East In-

dians could calculate the movement of the stars, originate calendars, predict celestial events without brain machines.

The IBM machines are, of course, valuable tools for calculations speeded up to a degree where the natural flame of thought is turned to lightning, but they also contain the danger of charring to death the creative act. These machines are the cartels of brain banks. The multiplicity of factors in technological calculus is of a super-galaxial extent, yet we may expect the machines eventually to compress light-years and cosmic space into a matchbox. Of course, these ingeniously working machines cannot be spontaneous, except by default. They are perfect executioners, but they must be fed by man in order to perform.

Why not go further and create genius artificially? I cannot understand why, after the infantile neo-Dada attempt to make machines for the production of paintings, none of the industries has closed a pact with IBM to produce machines for the planning and redesigning of architecture.

The ingredients of emotion, strict function, equipment, everything could be fed into the machine, according to contractors' laws of economics of course. All the nasty bundles of blueprints, the nightmare of charette labor, the mountains of printsheets would be reduced to three file cards of high tensile strength—one for the floor plan and two for the elevations—perforated with loop-the-loopholes of various shapes. By projecting light through the holes of any one of these cards, you can produce on any sensitized screen the actual design of a building. If you project through all three cards simultaneously, you fix a perfect perspective of a building for any wise guy or client-fool who wants to see it before even all plans are completed. It's that that sells a project: a perspective showing the prospective income, complete with trees, cars and clientele.

Let's cut out the playfulness of sketching, rendering, because montage projection can give your client the grip-and-grapple realism he needs so badly to become hipped on a project. True, the architect as draftsman might become a fossil—but he will the more readily transform himself into a design correlator (which we architects, after all, are), a correlator of basic forces. Let tradition and imagination do the work—leave fake facts to the gangster machines to produce profits. Architecture still needs man as

380

man and not as a machine. Enmesh yourself in life forces and observe yourself. Every second is a universe ready to be discovered anew. Without your continuous observations you have nothing to feed your own brain.

To get a fresh, independent look at familiar matter is a heroic undertaking; to bury your habits of thinking, feeling, and creating demands relentless, down-deep spade work.

And speaking of down-deep work, let's talk about the floor plan as a tool for the conception of a three-dimensional structure, the house. I quote myself from an article in the *Partisan Review:*

The floor plan is no more than the footprint of a house. From a flat impression of this sort, it is difficult to conceive the actual form and content of the building. If God had begun the creation of man with a footprint, probably a monster, all heels and toes, would have grown up from it, not man. (He might have been without head and arms, to say nothing of his internal structure.)
Fortunately, the creation proceeded otherwise, growing out of a nuclear conception. Out of a single germ cell which contained the whole and which slowly developed into the separate floors and rooms of man. This cell, owing its origin to the erotic and creative instinct, and not to any intellectual mandate, is the nucleus of the human edifice. It is a strange compound; while still a gelatinous mass, it contains the future man, his mind and his instinct, his sweat and his dream. It is as though nature cast the first ball into the arena of life, and then stood by with folded arms to see what the play of circumstances would make of it. Whatever sort of creature results, it is never deflated, but three-dimensional, like a ball; it seeks co-ordination. With all its senses it breathes contact. It is connected by an infinite number of ties, bonds, rays, waves, molecular bridges, with the visible, the tangible, that which can be readily smelled and equally with that which cannot be so readily smelled, that which is not immediately tangible, the invisible; and it puts forth myriad threads of its own in order to entangle itself still further in life. It cannot live without others. Its life is community. Its reality is a co-reality. Its realism of realization is a correalism. Its reality is a realism of co-ordinated forces which condition, limit, push, pull, support one another; which leap together and leap apart like groups of acrobats in a circus, who transform themselves from one unit of two or more bodies into another unit, without losing their balance. In life, this balance can

be lost only once. And then there is no net to catch one, as in the arena. There is only death. Correalism expires.

Functionalism is determination and therefore stillborn. Functionalism is the standardization of routine activity. For example: a foot that walks (but does not dance); an eye that sees (but does not envision); a hand that grasps (but does not create).

Functionalism relieves the architect of responsibility to his concept. He mechanizes in terms of the current inherited conception of the practical, and little more; only simplifying and rendering ascetic what is already traditional. Actually, however, he does violence to the freedom and self-realization of the basic functions of living man. The species is known by the total co-ordination of its functions, not by its esophagus. Modern functionalism in architecture has its roots far more in contemporary abstract painting than in the "functionalism of living." And the curved forms that are now appearing in furniture and buildings did not originate in "psychological" functionalism but in the formal idiom of surrealism. Some architects have confused geometric forms with abstraction, have taken simplicity (or planimetry) for functionalism, and called it "organic architecture." It was a stroke of luck that "abstract" simplicity fitted in with the principles of hygiene, fostered at that time by industry and labor.

In reality, the true functionalist will accept no standard as final. He lives through the existing standard, and by this experience becomes independent of the standard as such. Then, by the force of this constant materialism (1) and of his imagination which has thus been liberated, he crystallizes the new objective (2) and the new object (3). Not only does he now gradually come to master the conditions amid which his new object must be born, but through his new real objects, he changes the conditions themselves (see Metabolism Chart Home Library). The new idea has now become material (1) and the creative cycle begins anew.

By a change in the preponderance of the life forces, the center of interest and attraction may shift from material fact (1) to the idea (2), from the idea—to the object (3); and in this continuous flux any other shift of emphasis is equally possible.

Thus, two of the three components always assume a secondary place in the total structure, and even the potential relation be-

382

tween these two will vary according to their correlative position. Nevertheless the strength of all three components can never be equal, for if it were, continuity would end in a static balance. The process of rebirth would be impossible. It would seem that perfect balance cannot exist in nature, and ultimately one force must become predominant over another. This "function" appears not as a finite fact or standard, but as a process of continuous transmutation.

The "abstract functionalist" was a master of self-deception. With the honesty of a fanatic, he deceived his fellow men (clients) and himself, by "improving" on the "accredited" standard of function along more abstract or super-fantastic lines, without realizing that the function which his work represents is, in spite of technical and decorative improvements, still the old hereditary residue.

If we could switch from pseudo-functional
design derived from the dried-out herbaria of
architectural fashion

if we could convert our static functions of design

into design-flows of life forces

and thus replace defunct functional architecture with:

Process Architecture

we will have done our share as social beings

and conceded our conceit as

pseudo functionalists,

ready now to take part and actually be
part of Chardin's "rich and potent
pattern of variety-in-unity."

Dance Script

At Shirley Broughton's Studio
January 29, 1961

I remembered Shirley's dance figure performing, she knew I would remember, she must have noticed my gaze and attitude, how I had beheld the columns of her legs, embracingly round, and how the fingertips of my eyes had poked at her muscular flesh, rebounding as from a trampoline of skin. I accepted the invitation to speak at her school.

Yesterday, a Sunday afternoon, New York usually at its saddest. The blabber of business has swallowed its own tongue. After walking through the streets of my neighborhood, empty tunnels low-vaulted by rain clouds, I finally pushed open the door to a two-story house and broke the Sunday silence before the storm did.

One flight up, I hear human voices, the shuffling of chairs, shouts of greetings, partly for me, a half-loft filled with people standing, lingering in various groups. I am awakened, in that dimly lit flat, to the fact that it is now that I have to fulfill my promise to speak, and that I can't escape it. Myself pinned down. Soon I'll be on, in a corner of the room-ring, a dance spot focused on me, and I'll speak to faces veiled with darkness.

No time to discuss have we, me, you, riveted by appointments. Events of thoughts bereft of the chance to evolve. But hammering a nail down, bang, bang, noise and pause, noise and pause, then the last stroke comes down on the steelhead, you look at it, there is silence. It is done. The muteness speaks; and it is the answer.

"We all have to work in order to make a living. Serious dancers, like serious composers, can't earn their keep through their artistic efforts; they have to do some handy work in order to pay the rent. You have to steal time from space-time. And I doubt if we have enough of it available to break through tonight to the core of our subject for the evening, the dance. I'm sure we all have other engagements tonight, and tomorrow is another day of schedules, and so it goes, on and on and there isn't even enough time for our particular profession. We don't know how to condense and expand our lungs of time, to take the deep breaths which we so

desperately need for a passionate survival. Even if we did have endless hours for discussion, the only real hope for results would be in talking out our problems to bitter exhaustion, when silence would finally have to prevail, the type of silence which is a relaxed condensation of everything that has been felt and done and said over a long period of time, the sphinx of silence to guide us securely without words.

"The paraphernalia of language of which we humans are so proud is of very little avail in the arts. I do believe we would all do better if we were mute. It also would help keep peace in the world, and misinterpretation through talk and print would have no chance to occur. The deeds would speak. Not even the most noble description of a painting or of architecture can reach its heart. I wonder if our scientists, so deliriously involved in fabricating destructive bombs, could not develop the burst of a nucleus that would mushroom above the earth and bless us with a fallout to make us all mute. In the meantime, we'll have to continue talking. You expect that from me.

"Perhaps the thing that I, as an architect and sculptor, can talk about best to you, as dancers and choreographers, is the way in which time is related to dance and space is related to choreography. So let us group our discussion around the theme of the architecture of the dance."

My memory reeling back to Vienna; so much time passed since then, and now here and before there, sidetracked to Berlin and Paris, and descending into New York, I am off again, drawn into that whirlpool of timelessness, inhaling future and exhaling past, the present lingering lazily. Even keel.

"You know, it's quite funny for me to talk about space today because in 1924, when I called my space-theater of Vienna the 'Endless,' I was caricatured for many years to come as a space man, and was called in print 'Doctor Räumlich,' sort of 'Professor Emeritus of Space.' Today everybody around the globe, from Cape Canaveral to New Guinea, has become space-conscious, and by now any slightly arched flat-footed man feels a weightlessness that soon may lift him to skies, seen, unseen or even unthought of. So today it is much easier to talk to you space boys and space girls about the architecture of space in dance than it was thirty years ago to the toe-and-heel dancers.

"From early childhood on, the boy and the girl have a desire to test the flexibility, the weight and weightlessness of the body, and it is a very natural thing. Not only to walk, as necessity demands, but to hop, jump, twist, climb, and push—to feel their physical selves in a manifold way. To speak through their bodies and to receive messages through their bodies. This delight in feeling themselves and communicating physically is, along with singing, one of the oldest methods of expressing man's feelings. Later it grew into rituals, then was refined by heightening and selecting from all the movements those best fitted for ceremonial court dances; and at the highest cultural stage, the attempt to transcend bodily and emotional feelings into the abstract realm of the nonfunctional. Finally not the dancer but the choreographer became the master builder with human bodies in space and time: our modern dance.

"In the primitive stages of dancing or music, there is no special theater necessary for their performance. The child, too, does not care for an audience; it is pure pleasure. Later in the development of self-expression through bodily action, there is more and more tribal participation of co-believers who, from time to time, take active part in the demonstration. Yet even at this level, there is no particular stage necessary. It can be done anywhere, in the open or indoors, in the round or in the square, on the steps or on the ground, and the audience informally stands or squats around the dancers. In our civilization, which has strictly defined social orders and technical laws, the ballet as well as modern dance has built platforms of its own in the theater of the proscenium stage and has lifted itself up from the ritual ground. Audience participation has thus become formalized through separation. For better or worse, this is the way dance has evolved and we can't bring back the disorder of the past. And how can we inaugurate a new order of the dance today, when the forms of the past have been used and abused to their limits? What are the possible roots for the evolution of a new order?

"At the outset of this discussion we should be aware that spatial composition is impossible without a sense of continuity, and of course the sum total of continuity is the continuum. The continuum has always existed, because that's where we come from and where we go back to, in one way or another or in many ways—every day and throughout generations, throughout centuries, even before the birth of our earth. The continuum will continue to exist

even after the blow-up we are preparing. But I do think the very meaning of our existence in this world has, in different epochs, different forms of consciousness. All, however, are different expressions of the same continuum. Now the continuum in our time has driven deeper into our consciousness thanks to the impact of several events. Probably the greatest stride in breaking the traditional framework of man's consciousness and expanding it to undreamed of dimensions was made when Marconi spoke without wire connection across miles and miles to someone he could not even see. Hearing voices across continents, without physical contact, was unheard of. 'A whole new world of communication has emerged from the tropospheric scatter. For the first time, voice and teletype messages could be clearly received far beyond the horizon at all times, regardless of atmospheric or electro-magnetic disturbances.' *

"Today we take radio for granted—we might wonder a little about it, and might confess that we don't understand the technicalities of it, but we really are not apt to want to learn them, we prefer to leave it to the specialists, repairmen, and science owls. Although this discovery and its evolutions have and will shape our lives more and more, we submit willingly—although scared of the trick, as the pagan was of lightning. The fact remains that the sediments, if I might use that term without misinterpretation, the sediments of such discoveries constitute the fertile mud of our cultural heritage, the primordial mass (erbmasse) from which personality and being grow, rising toward new transformations.

"The daily is the excrement of this process of transmutations. The primordial can be defined as the desire to create and through creation to continue beyond the present. The primordial is not something primitive and of the past, it is ever present, now and tomorrow and thereafter. Out of the opposing poles, that is, the past lived and the future imagined, we create the present. Now we understand that the present is not permanent, static, and definite, but in continuous transformation; however sometimes this transformation is so slow we believe it to be a standstill.

"Painting a painting is transfixing continuity. Forming a sculpture is transfixing continuity. Conceiving architecture is transfixing continuity, and setting choreography is also transfixing continuity.

* From *Scientific American*, September, 1959, page 129, advertising.

"Obviously the method of transfixing continuity in the arts is difficult, particularly in painting and sculpture and architecture which, by their very nature, are static. Dance, however, is an art form of continuous movement. In spite of that, its effect on the observer can be static, too, through the repetitiveness of worn-out patterns of choreography as well as of dance movements. On the other hand, a painting, although immobile, can move us and can continuously (by memory) carry on its effect almost ad infinitum.

"It does not matter if the artist recounts a content or if he abstracts from a content: the important thing is the awareness of continuity. Whether it is storytelling, as in former times—the beginning up to the climax of a story—or, as in modern times, the development of psychological pitfalls and uplifts, both conceptions have a distinct beginning and distinct ending. Both forms are locked up in a capsule containing the past and the future. Therefore neither fits into the new concept of art as based on awareness of the continuum.

"We have learned that there is no ending of life forces which is not also a beginning. Once one knows that, it becomes impossible for an artist to plan a painting closed up in a frame, a sculpture in its singular shell or architecture in cubes or balloons. The range of artistic expression becomes now much wider, reaching out in content and form. This art, being more than ever attached to the perception of its own moment, its own time, automatically expresses timelessness. It makes the link between past and future only transparent—not solidified."

Always the search for the practical. Damn. It's a merry-go-round of the chicken and the egg, the mind and the body. And at the beginning was the end. Bahia, Brazil, Indians and Negroes of a tropical jungle safeguard art for modern man.

"I know you would like me to give you a practical example of the new way of transfixing continuity in the arts. I am happy to do so by describing an experience of mine in São Paulo, Brazil, a couple of years ago when I attended the International Congress on Art and Architecture at Brasilia. Perhaps some of you have heard the story before, because I have used this experience to illustrate my ideas about the new content and form in art and architecture. It has full validity for the dance also, so let me repeat it for you.

"We delegates were standing on a concrete slab in a small barn, a space about as big as this loft, among some forty or fifty people congregated in a ring watching an old man and a young man dance. They wore no costumes, no tutus, no leotards. The older man had just taken off his coat, the young man had removed his vest as well. It was a dance illustrating the relationship between a father and a son. It appeared as if these two were improvising, but this improvisation was not self-consciously so, deliberate and mannered. It grew out of the past from a great tradition of the land and, most important, out of its recurrent meaning handed down from generation to generation. This dance tried to concretize the relationship between a father and a son, their feeling of being drawn together and their desire to pull apart. To build the choreographic architecture each had only a torso, two arms and hands, one head, a pair of legs, and space-time.

"The music came from the traditional samba, but was no longer The Samba. There were four young musicians—if you could call them that. They certainly couldn't be considered a small orchestra. Three of them had sardine or cigar boxes, one a tiny tambourine. These four music-makers gave the most complete devotion to a performance that I have ever heard. They were neither separated from the dancers nor from the audience. Physically outside the dance, visually peripheral, emotionally in it. I felt that any of these players could step forward at any minute with his instrument and dance its sound.

"Steps and movements of father and son had almost the pirouette quality of the ballet; they used syncopated steps to an extraordinary degree, gymnastics, walking, striding, stopping slow, stopping short; struggling on the floor, defeating each other, first the son and the father, then the father and son; they were pulled apart as if by hate, soon magnetically drawn together, but all the techniques and their variations were not mere illustrations of a theme: they were the subject matter expressed in space-time plasticity.

"It could have gone on indefinitely. And the end was not an end in a climactic way. It was as though the dance had been cut off from an infinite tape of the father-son relationship. The transfixed continuity of this relationship was the context of the dance.

"I've been looking forward not only in your field, but in architecture, sculpture or painting, to some synthesizing, to some conclu-

sions, to some development of new canons after these fifty years of experimentation in the arts. Like many of you I have been disappointed with the frazzled results of our impatient efforts, and particularly in the dance. That does not mean that valuable efforts have not been made, and are not being made. But I do think that we artists have lost the contact, which earlier centuries had, with the fundamental meaning of existence.

"Once there was no doubt about content. Religion was a matter of tradition continued from generation to generation. They believed in it. It gave the artist a base to build his individual work on. By now official religion has lost its grip on us. Of course, I do not refer to applied religion, mass-manufactured rituals. Coleridge reminds us of the original derivation of the word religion, which is *religare*, meaning to bind, connect, fasten. Kenneth Burke, referring to Coleridge, says, '. . . his theory in this instance would concern our way of tying the particulars of a work together in accordance with the over-all spirit . . .' It is that over-all spirit we are seeking now. Paganism or magic, we have not replaced it with any other fundamental belief or disbelief. Our involvement with content is halfhearted. Technology is not fundamental truth, it is a skeleton that has to be fleshed out, and science is not a religion but rather a magic drill for the investigation of facts. Think of the Renaissance without faith in God and the Church, and there wouldn't be the type of art we call Michelangelo's or Raphael's. Similarly the baroque, without its lust for life, could not have culminated in the architectural drunkenness of the rococo period."

Oh, when the pioneers began to get smart about apples they did, indeed, pick out the best strains and learn how to propagate them. But an apple to them was something that was good, not something that looked as though it ought to be. When we, in business, industrial America, began to get smart about apples, we packaged them and packaged them and packaged them until the apple itself became the package.

"Came the great industrial advance, and it developed pragmatism to a near science. We moderns followed up with Science proper. But we know now: Science is not a religion and its technology is not the savior of the world.

"Here we are at the end of two new beliefs, science and technology, and thus we live in an interregnum, an empty interval between the

past, which might be called great or pseudo-great, and a future not born yet, but in pregnancy.

"The artists have a great duty to perform after having dethroned the traditions of their crafts. Impressionism and cubism broke the image of the past to smithereens. Surrealism tried to pick up the odd ends and weave them together into a dream image not of this world or of the world beyond, but of the subconscious. The vacuum of the interregnum allowed Mondrian to probe from the abstract into the non-objective. His paintings are brilliant substitutes for architecture not then built, only defined. We take refuge in objects, lacking objectives. The artist, from the impressionist period on, said that 'art should exist for art's sake,' away from content. In our time, for the past twenty-five years, we have withdrawn further into the credo of 'L'Art pour l'artiste,' art for the artist's sake, that is, to satisfy his personal egocentricities. But this emergence of art for the artist's sake formed a world of isolationism which is now luckily coming to a fast wind-up.

"Techniques, no matter how brilliantly applied, do not make art —dancing included. The flow of technical inventions has now spilled over from industry to art. Welding metal in sculpture or a new method for casting, or painting on the floor instead of on an easel—these are only a means to an end. But the end is not in sight.

"The same situation exists in architecture. We all probably agree, or most of us, that New York's Park Avenue is chilly and tiring with all its new buildings clad in the same cloak of aluminum, stainless steel, and glass. In Rio de Janeiro, you see the same Park Avenue architecture, in São Paulo the same, in the new capital of Brasilia the same. This conformity does not issue from one and the same credo; it derives from fashion, and fashion is propagated in the communications media.

"Most architects anxiously await the monthly publications (*Architectural Forum, Architectural Record, Progressive Architecture, L'Architecture d'Aujourd'hui, Das Kunstwerk,* etc.) to see the latest. The university has lost its educative power. The real 'Informers' today are the professional magazines and their advertising pages. I think this is very tragic. My discussions with students at Columbia have usually ended thus: Do you really believe that, if there were no reproductions, photos and texts available,

391

art would stop? and architecture would stop? and you wouldn't know what to do? how to design? how to paint? how to build?

"Art education has become a matter of vogue. William Butler Yeats was right in his 'Second Coming.' Let me quote him:

" 'Things fall apart; the center cannot hold;
Mere anarchy is loosed upon the world;
The best lack all conviction, while the worst
Are full of passionate intensity.

" 'Where is the knowledge we have lost in information?' asked the American poet T. S. Eliot. Where's the wisdom we have lost in knowledge? Our pomologists know more about apples than the pioneers ever dreamed of. Yet the wisdom of apples is gradually becoming lost.' *

"Everybody is very eager to hear what's new. Now that is one of the great castastrophes of today: that art is news.

"The dance movement also has its sheep psychology. There's no question that, with Martha Graham as the basic force of discipline, many performers and dance groups have achieved superb training of the body through very honest striving. The artists most devoted to their profession are not the architects, not the writers, but the dancers. I have admiration for your perseverance, your stamina, the way you work very hard at any kind of job during the day in order to be free in the evening, or at any other stolen time, in order to join your dance group. You do not complain. Sacrifices are felt to be gifts from life. You strive for a bewitching goal, but what is the content of that goal, besides the satisfaction of developing your body gracefully? To express what? To move graciously, to vary that movement with exact co-ordination of the various parts of the body is fine, but that is only technical training.

"In the modern dance, which has detached itself from the tradition of ballet, everybody is on his own. Fine psychologically, but where does it lead dancing as an art form?

"There was at one time a new start. I mean the exploration of

* From "Love of Apples," Percy Seitlin. From *Der Druckspiegel*, Stuttgart, Germany, 1960

392

space by Mary Wigman, based on the principles of her teacher Laban. Yes, it was a break-through. I remember very well the impression her choreography made on me and the discussion we had about it. Her aim at the time was to define space deliberately, no matter how big or small, to involve the onlooking audience with space-time. That seemed a very legitimate contemporary approach to the dance. There are, of course, varied ways to do that. Personally I have not yet seen any dance group here or abroad which was able to develop it further and thus set new basic standards. If I am wrong, please correct me."

Instinct is reliable. No invention of man can kill it. Inspiration is automatic, fed by instinct. Brain forms it. Technique presents it. The way of all flesh—Art.

that automatic contact with
the doorknob, the electric switch,
pen point and paper—
touch-off after touch-off—
each touch-off
releasing
imponderabilia

same subject, you, I
same objects
searching touch-touch
breaking invisible doors
and heterogenuity is thus
made homo-genius

"Space exists in slumber until we awaken it. It is so fundamental to our being that we are not aware of it, as we are not aware of walking, breathing. Our pulse also beats without our will and without our being conscious of it. Yet breathing and pulsating are the very core of our being. They are such life-necessities that nature grants them to us as free gifts. Space, on the other hand, can only be perceived by inventions of our consciousness. Space hides in a double existence: visually and physically. In painting and in the dance, we deal with the two types of space representation. In painting, space is entirely illusionary, and in the dance it's real. I shall deal with choreographic space in a moment. Let's have a look at pictorial space first.

393

"We can give the illusion of space in painting through the use of perspective, or even without it. (A Chinese painting, for instance, has no linear perspective but, through isometric parallelism, achieves the illusion of depth.) With Mondrian, the illusion of depth in painting through perspective came to a dead end. The recording of space-distance was taken over by radar. Thus science gave us a new perspective of distance far and wide. It has beaten us to the punch.

"Space, so hard to define, is so translucent in its endlessness that until coagulated into solid form, it cannot be perceived. Space in nature always seems to be a void—an emptiness encompassing solid bodies. The endlessness of space once had meaning only in connection with the "outer cosmos." But modern research taught us that space can also be endless in the inner sanctum of the micro-atom: you think you have come to the final unit and then you find you can split that "final" unit—and a new world is disclosed. The inner perspective of the inner sanctum is a new enigma for us of the twentieth century. The cyberneticist can calculate the effects of such inner doings and undoings with great precision by enlarging his natural senses through keener machines with perceptions far beyond our inborn capacities. Remember opera glasses, manufactured to extend your natural vision? And telescopes to bring the outer world closer to us. But now we have electronic microscopes which are telescopes in reverse; they peer into the inner world. And so when science tells us now that it is possible to envision a world of the 'inner cosmos' almost as endless as outer space, we can hardly believe it, but it is a fact nevertheless.

"What does that all mean to us as plastic artists? It means that in a single sculpture, for example, we could present the infinite totality. That does not necessarily entail being a realist or non-objective, it means condensing continuity by using the specific techniques of one's craft. The point is not to get stuck in the material and its technique, but to express the force that holds the parts of a composition together. Thus the artist creates a new gravitational field, into which the observer is drawn. The second possibility is that you conceive of a sculpture, a painting, a building, a dance which expands from the nucleus of an idea to such vast dimensions that you can 'live with it.' Art itself becomes the environment; in other words, the work steps down from the pedestal where it was an illustration of some idea or some memory and

expands to become a living space. Thus it defines total space and induces endlessness in a concrete form.

"It seems that sculpture has taken the greatest step toward this new consciousness of plasticity. Also, the mere terminology of 'living space' would guide you to architecture. But since architecture is so intertwined with practical functions, let's turn to the no-practicality of the dance. Although fluid, yet not as ephemeral as music, it also vanishes the instant it is born. Still it has the two-way structure, the inward and the outward drive—the ruling principle. The artist creates by imposing limits on endlessness."

You wander into habits thoughtlessly because they offer guidance to security. Insecurity, however, is what we search for. We want adventure, adventure to upset the balance of men's seasons. We like tradition for the security it offers, but at the same time we retain a sneaking hope that the unusual might happen at the usual moment. It is the artist's role to conjure that happening.

"I saw one attempt by dancer Paul Taylor, I believe it was a year or two ago, where he tried, in one number, to break away from packaged space content. There were only two girls standing almost immobile throughout the piece, two dancers, one toward the horizon, one closer to the footlights. Once in a rare while, they moved on to another position, and that was about all. Here was a dance composition which made me aware that there is tension in space, undefined until you put the definition into it. This is what he did: you felt the perihelium of a dance-space as if it were in a trance waiting for the awakening by the minutest touch of a foot moving or a slow-motion twist of the torso, and felt this impending space made concrete by an echo movement of the second dancer. Within the totality of an area, at the beginning amorphous, the choreographer had expressed a specific feeling of expanse and contraction with a minimum of tools.

"Of all the issues involved in composition, the one basic law of all the arts, a principle as old as cave paintings, is to do the most with the least. In the dance, one always has to ask oneself—are this many dancers necessary for what I want to do, or do I need more, or less? The number of persons used within a given space, with a given idea, should be the most precise number needed—an amount with which to express the most with the least. The Taylor dance of these two girls was in many respects an attempt to define

395

an area and an expression with the very minimum. The minimum after one is two. Incidentally, the fact that these girls were not dressed in leotards or in ballet skirts, but in street clothing, was very important. Important because their everyday dress was again a reduction to the least required. In other words, if the two girls were posed skinned in leotards you would expect a certain standard dance style. This possibility of the spectators' lazy withdrawal into a comfortable memory of the past was thus neutralized. It was a chance to start anew. When one expected them to move and they did not, it gave the audience a jolt, preparing them for an unexpected experience. So it is important that you— well, I don't want to dramatize nor do I want to make specific suggestions, I speak entirely theoretically, but it is important that you clear the ground to make way for your composition of the far-and-near past, for a new configuration of the dance."

Squaring the circle, Mondrian, circling the square, Kiesler, everybody à pointe, *tiptoe or headstand, swaying into balance, the artist creating from the vagueness of every-place, selecting, combining, artiness into artifacts and artifacts into the ordered facts of art.*

"Mondrian defines the square of his canvas in the most economical way possible. He draws two black lines in the square, one verticle and one horizontal. This square is thus divided into four white areas. If he places both lines through the middle, one horizontally and one vertically, all four areas are of the same dimensions. If he moves one off center, the equalization vanishes.

"If he starts to shift both lines of division, he opens up an endless world of co-ordinated parts. Now how far in any direction does he move the lines, and where are the limits? How thick will he make the lines, because the thickness consists actually of two parallel contours filled in with black and made into one line.

"Mondrian worked on the thicknesses of his black separation lines for weeks and months, day by day, just as you rehearse your pacing again and again. I watched him at work over the years, and I will share with you the privilege of that memory.

"He put his paintings flat on a table. When he traced a black line, he used masking tape to space the borders of the line a hair's width thinner or thicker. He would then move the painting upright, sit in front of it in silence. He tried to take it in. Meditation

to the point of mesmerism, hypnotizing himself as well as hypnotizing it. Walking over to the painting, he would take it down like a monstrance and place it back on the table. Removing and shifting that tape was really like tearing his skin off. That was his method of becoming aware of the co-ordination of diverse parts into one unit. Think of it.

"Of course there are many ways of composing, and it doesn't mean that to be economical a composition has to be in units of one or two or three. It's entirely up to you, based on your aim. Just to move in space, just to walk, just to twist your body, just to bend, just to raise your hand, just to pass each other or intertwirl—no matter how gracefully and professionally executed—is never enough. Overemphasizing aesthetics was the defeat of the ballet. And I cannot find in the modern dance sufficient striving for new laws to justify so much training.

"It is admirable how the ballet condensed all movements of the human body into a very few positions—a standard Order—accomplishing its job brilliantly as early as the seventeenth century. All dance movements of the human body known up to then as folklore, ritual, and court dancing, were reduced to five strictly defined positions, an amazing feat of selection.

"They are, as far as I can remember: *First position*—Feet together, bringing body to its center-unity through straight spinal column and invisible line from top of head through front of body down between ankle bones. *Second position*—Feet one foot's length apart and turned out; arms are open to echo position of legs. *Third position*—One heel nestles in arch of other. As usual, legs opened out from hips. *Fourth position*—One leg opened out a foot's length in front of other; opposite arm extends forward. *Fifth position*—Legs are formed into a cross, with knees turned as much to the side as possible. Arms are down by sides of body, or both extended on level with diaphragm, or arched above head.

"These were the ballet dancer's pivoting points for further patterns. There was no freedom for private, off-beat invention, although there were endless variations possible within the confinements of the self-imposed laws—just as the piano composer combines the notes of one basic octave into a world of new compositions.

397

"But I think if any one of the dancing groups could have had the courage, the daring, the talent, the genius, to add one more position to the five standards, it would have redeemed the ballet and justified its living on into our century. Assuredly, it had to be not just an extension of positions, but one daring, single, step—an instant shock transforming the vast world into a unified new being, born out of the chaos of weary traditions. I realize that it would have taken more—too much—daring to have concentrated the evolution of the dance into a single outcry rather than gradually to have thrown overboard everything from the past, producing a scramble of contradictions.

"The chance of that one shock has been lost. We are floundering. The chance has been lost just as at the time when Alexander the Great retreated from the shores of the Ganges, giving in to the pleading homesick soldiers, and did not cross the river although in full view of it. Thus he never conquered India. The dream of a unified East-West world vanished in that moment.

"Of course, to evolve order from the movements of the human body is difficult, as far as the modern dance is concerned, because order must be an abstraction from nature, and at the same time a condensation of its essentials.

"Take for instance the position and movements of the human leg. One action alone, such as the use of the knee, can have so many variations. For example: the kneeling in Chinese ritual, placing the kneecap on the floor and holding the toes flexed; the Hindu kneeling, resting the hip on the calf; the Big Apple's knocking of knees. These are only a few positions of one segment of one part of the human body.

"No wonder that Laban, before trying for a definite order, attempted first to document his observations of human movements, their succession, repetition, juxtaposition with other parts, and so forth, in the hope that this record would provide basic study material for establishing a new order of the dance. Listen to one detail of Laban's descriptive cycles, his 'Labanotations,' in which he attempts to record the dance in standardized graphic symbols. He speaks of 'rules regarding simple jumps, length of time in air, middle-level jumps not stiffened, nor high-level jumps, as knees and ankles must have natural resilience.' I quote just a bit more to indicate his ardent desire to standardize and make laws for

398

more liberty, listen: 'Aerial steps, the five basic forms: running, lengths and level of steps. Jumps, leaps, scissions, hops and *assemblées* in different directions. Rhythm with pauses; even and uneven rhythms—the five basic forms of aerial steps (possibilities of leaving and returning to the ground).'

"What have you dancers done in that respect? Possibly somebody or anybody has tried a trifle and more, but no new general laws have been formulated—and I don't think there is much hope for that, because in the plastic arts today the emphasis is on freedom and not on discipline. Freedom is defined as infinite license, while true liberty is 'the right to choose your own slavery.'

"I think you must face the following facts: The present content of the dance is dis-content. Modern dance has turned from the aesthetic of the ballet to the animalism of the tom-tom. It glorifies love as make-up and tries to conjure sex with free-for-all movements:

Limb to limb, arm along arm,
back to back, front to front,
rubbing, twisting, twirling,
repetition of the same movements in duos,
trios or
in mass hysteria
pushing pistons of extremities and torsos
like cogwheels
fitting teeth to groove
turning the stage into a machine shop.
The coming together of bodies without coming together
the castration of desires
representing a world in anguish.
Soon we'll go the limit,
imitating fornication on the stage
with the sole purpose of demonstrating
the physical impotence of the male
and the pride of the female
in avoiding orgasm.
What after? Return to
a neo-classic ballet with artificial aesthetics?

pas des deux
n'est pas eux
ni Dieu
ni moi
une voix
de pas d'quoi
je m'amuse

"We find artificial co-ordination all around, executed with skill and ordained with complementary substitutes.

"The intricate laws of the human body in action demand the support of its rhythms by sound. The flow and pulse beat of our blood are as basic to the dance as the setting of the pace by the feet, the twist of the torso, the swinging cadence of the arms—they must be matched with the intricacies of the grammar of music. This marriage of body and sound is difficult to perform and poses profound problems. Yet, no dancer can escape trying for a solution. It is a need deeply embedded in the necessity of correlating performer and audience.

" 'Music,' as Erich Kahler clarifies it, 'is a language of its own, it is the complex articulate sound. The articulation consists in the differentiation of pitch, the rhythmical division of differentiated pitch, i.e., of tones, and the interplay of the different grades of pitch and their sequences . . . the tone has in itself no meaning, it receives a meaning only through a sequence or group of tones.' *

"To make things more complex, the choreographer works with a 'third degree' interpretation of music: First, there is the composer's transmutation of his imagination into particular canons of music; second, the additional factor of the interpretation of the performing musician; and, third, the final superimposition of the choreo-dancer's own space-timing of the original score.

"Today's modern dancers use Corelli, Bach, any of the sixteenth-, seventeenth-, eighteenth-century composers as inspiration for the contemporary expression of their choreography. Certainly a contradiction. Of course, they also use modern composers like Bartok, Varèse or jazz, and do not hesitate to employ even the drums of ritual Africa: in short, any music will do as long as it fits their personal idiosyncrasies.

"We are aware of how much more genuine the alignment of music, player and dancers is in Eastern civilization, where all performers concerned develop one pulse beat, although at first, to the Western ear, it sounds quite improvised. In fact, the Oriental

* "The Nature of the Symbol," Erich Kahler, from *Symbolism in Religion and Literature*

dance is based on *points d'appui* of fundamental themes, rhythms and canons of movements of the body.

"The American dancer Erik Hawkins tries to develop a similar principle of correlating composer, player and dancer in the architecture of his Western choreography. His composer, Lucia Dlugoczewski, rehearses with him from the very beginning of a new dance, playing various instruments, mostly percussion. By working on and off as a team from start to finish, choreographer-dancer and composer sustain and further their mutual respect, the need for collaboration grows, and the individuality of their craft develops to equal importance.

"Together they strive for the annihilation of the strait-jacket boundaries of their individual techniques, in order to define and rise above the physicality of the dance. At moments Hawkins does reach that strange evocation which William Blake describes as '. . . the infinite in love with the production of life.'

"On the whole, modern dance reaches this state only rarely. A new basic order is still missing. Content remains no-content, a take-over from the abstraction of the plastic arts.

"However, full credit must be given to the contemporary dancer for having made one great discovery: *the torso*. It has become the new fundamental instrument for body expression. The ballet based its inventions of design chiefly on legs and arms. Our own dancers have mobilized the spine. They have broken the rigid mold of the five positions, a mold which dealt with a torso actually in corsets during the sixteenth, seventeenth and eighteenth centuries. How much unknown land of our own body can still be explored!

"But truthfully, the flexing of bodies has now become only a mirror reflex of actual live conditions—faster, slower, microsized, macrospaced, distorted by fancy or hate, but failing to transcend the documentary life routine into a new order of dance movements."

don't sidetrack
endlessness
stop space—
your power, dancer!

space will
submit

time will
harness
the step of
your measure

space
unhappy void
made concrete
and strong
through you
starving no more
for food of form

kick it, dancer, to a
limit
time it in
leaps and bounds
in stops and
sly walks
cavorting with
spellings of
each of your
toes and
wheelcarting
like a
windmill's
spikes of arms
throwing time
into space

the infinite bound

hounds of dancers
prancing proudly

Various Positions in One Body

Outer-Space

February 14, 1961

The term outer space is wrong, misleading. There is no outer space as far as the universe is concerned—it is all part and parcel of the same composition.

To speak of outer space is to return the aspect of the cosmos to the pygmy perspective of man.

How Much Prefabrication?

February 21, 1961

It's amazing how over the centuries we've gotten accustomed to daily living with, let's say, the floors we walk on in our homes, floors we have not built, with doors and knobs and hinges we have not made, locks and keys we or our ancestors never helped fashion, with stoves, coffee cups, spoons, bread, rolls, fish, fruits and meat pre-pared for us, not to speak of flour for baking our daily bread. By now we are completely out of direct contact with the creation of any of our daily gears for survival, with the ever-increasing desire to save more time-energy, a progressive breakup into specializations! Yes, if anyone could calculate the savings in energy hours and the erg frequencies saved from the time of Christ until 1960 in the labors necessary to round out only one year's activities inside a one-family house, compared with primitive pro-cedures and products, we'd find an amazing saving in effort-time —but hardly any gain in leisure hours, not to speak of the satis-faction through individual creation. This status is too evident to-day to dwell on; what is disturbing is the division of our lives into labor hours, pleasure hours, and boredom. There is a longing for what you don't have, and what you have you don't be-long to. That's the split, destroying us day by day. It's killing our love of creating, feeling alive, and being needed in both direc-tions: pleasure and work. Stunning how much we have enmeshed ourselves in the network of inventions we don't need and don't really want—equipment, gadgets, wall and floor materials, dec-orations and endless arrays of products which arouse our desires

404

like ice cream cones the dream wishes of toddlers. Today it is almost impossible to extricate oneself from these "grafted" needs. To abandon most of them would make us feel like giving up the hope for paradise. Besides, there is either good or immature workmanship involved in machine production. I would like to have it clearly understood that by craftsmanship I do not mean handicraft in the "granny's attic" sense. The toolmaker in a machine shop, or the rider on a reaper or a harvester, is either a good or a mediocre hand mechanic, just as a plasterer in old or new times makes the plaster stick or crack and peel off.

Of course, we cannot go back to the iceman (he isn't around any more anyway—and when the iceman cometh we shall depart), nor do I advocate that. But a strict selection from the abundance of industrial output must be made, not because we haven't the money, but simply because we can live just as well, if not more fully, without most of it—based on the study of processes of life, rather processed life-habits. We must learn not only to face the facts of true life-necessities, but above all must muster the courage to face ourselves. That's where the ethical question comes in for the architect and industrial designer. That's where the stamina of morals—not in a psychosexual way, but as far as the character of man is concerned—is of fundamental importance, particularly in our time, a time of fragmentation where one doesn't know any more how one part fits the other to mold the whole.

The Object and the Objective

March 23, 1961

He came. I mean, Dorazio came from old Rome. My new New York friend. In my tower apartment enwrapped by the river bands of Manhattan's bracelets of water: the Hudson, the river East, and the Atlantic breakers to the South. No wonder the island's evening lights battling the setting sun set us in a mood for going deep to the heart of matters, and from it grew an overstating and underpinning of thoughts which normally would have sailed safely on, strato-jets in straight lines. The circumstances we found ourselves in gave us the courage to let go in our discussion. Thus we

forgot the social habit of restraining exuberant praise. Forgive me, therefore, for putting into my journal the word-by-word transcription of our conversation without trimming the curlicues of overpraise. The discourse would have been much more in place at the Café Rosati terrace in Rome.

For easier identification of the three members of the cast, let me give my Roman friend the insignia *Do* (to make it slightly more impersonal) and the lady friend who dropped in, the insignia *Li*. Myself we shall call *Me*. The casualness of the visit changed to formality through Lady Li's questioning and setting up the tape recorder.

Do: Well, I'm not used to talking to tape recorders and I'm really afraid of machines because they're too faithful, and also I'm afraid that what I say to the machine may be changed in its meaning or might have only one meaning. When you hear it played back, it's not like when you hear a human being.

Me: It's a real enemy, the machine, a devil . . .

Do: Yes, because a sentence said to a person may carry along parallel meanings, you know, which a machine cannot convey.

Me: The machine is single-track-minded. . . . What happened to you when you saw the large sculpture in the other room? I had the impression you were a little upset about it. Why?

Do: Well, I came in, I did not know that there was a sculpture, so, since I'm used to the details of the place, when I walked in, the first thing that struck my eye was the fireplace with the Christmas cards; then I saw a piece of sculpture hanging on the wall. Then you insisted that I retreat to another spot, so I backed up and saw the large standing piece with the wood base and bronze top and then when I sat down, I saw the third part. You lit the flame in the center of your large sculpture and this brought the whole three sections suddenly to life. The primary thing I noticed was the progression from the first sculpture to the last one. The first part is very light and lively, having a type of existence which is not physical. The second is entirely corporeal. It begins with a wooden base, and the fire itself brings it to a burning point, to unmistakable physical tracings. And the third part, I would say to you, is the enigma. I would call it the conclusion of the road

which the eye travels, beginning at the wall and ending in this enigma. When you look at the last piece, you say, What is the problem. No? You say, This is a phenomenon I have watched growing into being and this last piece on the ceiling is like a question mark. A question which I pose to myself on everything. I don't remember what I told you then about the sculpture. I don't know if I could repeat it, because the immediate reaction to what I saw then and what I would say now could not possibly have the same value. That was one experience and this is another, and we are conditioned by successive experiences. What counts, and that is why I think your work is really important, is the continuity between our experiences: now-past, post-present and pre-future. What I find most telling in that sculpture is the unity, the unity of one phenomenon divided into three moments of existence, of experience.

Li: When I first walked into the living room earlier, and you were telling me your reaction to Kiesler's sculpture, one of your outstanding comments was when you spoke of its individuality and its effect on you. You mentioned pleasing the eye, a quality one looks for in most work, and you very specifically and pointedly said that the effect of his work is not pleasing to the eye per se. You also said that Kiesler spans successfully the past, the present, and the future. I'd like to know more about what you mean by these statements.

Do: Well, I must go back to what I said before. I said that most art I see produced today seems to have the aim of pleasing the eye, and therefore it becomes formalism.

Li: What do you mean by formalism?

Do: By formalism I mean the practice of art based on the cult of form, in which the artist tries to develop a form by itself, not a close relation of form to content. Kiesler's work, on the other hand, the thing that makes me react very much to it, does what I believe art today should do, that is, represent the quality of life, not the quality of form. Our present world exists on different levels. This means that any one period of the present is made up of a continuity of a series of experiences, of different characters, of different natures . . . this is not very clear perhaps.

Li: Yes, it is clear. You're doing in a sense what I believe Kiesler

407

does: the spontaneous; creating at the moment with a reference to that which happened in the past and which will verify itself in the future.

Do: I mentioned the past because when I came he showed us his portrait of Hans Arp. In this drawing, the bulk of the portrait is the head, as solidly drawn as by Dürer. Kiesler is trained as a classical draftsman, like most artists of his generation, and thus he accomplishes almost by second nature what others labor on. I think his drawings have been very influential on other artists, on myself for instance. I remember the first time I saw them. I first had a really good view of his work when he came to Rome about 1957 or '58. He had brought along a bunch of his studies.

Li: Oh, yes, that was the time when he brought the plans for the "Endless House" and the shrine for the Dead Sea Scrolls to Rome on his way to Jerusalem.

Do: I had met Kiesler in New York in 1954. I remember I had a little show at Rose Fried's and he came to it. Afterward we had an interesting conversation which was very provocative. I liked him immediately.

What I said about his drawings is that the line, the sign, has a quality, like any sign. If you talk about handwriting, for instance, the mark, the sign, contains a quality which can be referred to as the character of the person, his culture, his psychology, even his rhythm, yes? So the way K's line moves, the way his line has a kind of asymmetric liveliness and development, reveals many specific elements, among them a consciousness of the tradition of drawing coalesced into a visual expression of to-day's feeling, of today's sensibility. He has the capability of translating a vision of this world into actual design.

Li: Speaking of his lines, of his drawings, last night after the open-ing at the Museum of Modern Art—of Rothko's show—we were quietly sitting at a table and I saw Kiesler do something that as-tonished me. He took his index finger and moved it around from right to left in space, and then made an outline in the air, going slightly up and slightly down. He wasn't paying attention to anything in the room. Not to me or anyone. He was on the inside of himself and trying to evolve something and demonstrate with his finger movements. Then suddenly it seemed as if there was a

408

light turned on in his eye, and he said, That's it. As I learned later this movement solved a problem of the auditorium for the new theater he's designing for the Ford Foundation. He was actually guiding his body by his finger through the auditorium. Now it's my theory, more than that, I sense it, that he actually experiences architecture with his body, through his physical senses, and not through any theoretical or abstract notion of architecture. Perhaps this is why his drawings have immediacy and the involvement which is much deeper than a formula of any past or present tradition. He's part of the past, but he transforms his own body into the life of the moment. I wonder if you share this opinion?

Do: Yes, very much so, and you can see—well, if you take a group of his drawings, such as I saw last year when we went to his studio, and you skim through them, you have a whole repertory of lines. Let's say you take the line as the expressive element, as the communicative element of drawing . . .

Li: Do you think it's a repertory of lines that makes the quality or something that happens spontaneously?

Do: It's the same thing. Whatever the moment, whatever his psyche, whatever his feelings, whatever is demanded at that split second, he must find the right mark for it. The important thing is that he has the vision, but then he has the capacity of bringing it to reality, translating it visually by means of drawing, by a line. The idea takes form through a repertory of endlessly possible marks: sometimes he has a nervous, curvy and sinuous line, extremely nervous, almost trembling; or he might have a very light, extremely light line, almost like a hair on a piece of paper, a very fine trace, or he might have a heavy mark. It's not that his drawings represent what he wants to see, that's not enough for an artist. There is a relationship between the quality of his line and his vision. The drawings represent, for instance, his idea of the "Endless House" very well. He could have explained this "Endless House" to somebody even if he could not draw, and this person could have drawn it for him. But this would not have been the same thing. What makes him an artist is that when he delineates the "Endless House," whatever it means to him is also contained in the quality of his line. His pencil makes his ideas as vivid as they are in his mind or his body, putting them onto a piece of paper which thus becomes a phenomenon of life. Not of art.

409

Li: Are you saying that he is subject to changes, like all of us, changes so varied, so swift that whatever happens in that split second of change, whatever that energy, whatever that odd quality, whatever that peculiar happening—his work instantly becomes the spontaneous reflection of it?

Do: That's it, yes. It's the artist's immediate correspondence between sensibility, imagination, experience, and knowledge. A co-ordination of all these faculties with the capacity of expressing himself, visually and plastically in unison. There are very few who can make such a combination.

Li: First comes the instantaneous seizing by the senses. The actual perception. This marvelous incandescence where the thought or the feeling is so linked with the happening that the intellect doesn't interfere until later.

Do: Well, you see, any artist has first of all to be a realistic man. He picks up an imperceptible value, that is, most likely imperceptible to the majority of us. Yet he is capable of making this undiscovered fact apparent with a drawing, painting, sculpture. Our life experience has so many simultaneous movements of important happenings that it is almost impossible to convey their multiplicity with a single stroke. Kiesler's talent seems to lie exactly in the capacity to do that. I think these sculptures here are the most complex I have seen in a long time.

Li: What do you mean by complex?

Do: Where the most elements get together, elements of architecture, psychology, mythology, ritual. You know, that sculpture-galaxy composed of three different pieces becomes unified in a new type of ritual when he lights the fire. And why not, why can't sculpture inaugurate ceremony? Today a man cannot go into a home and see a ritual, we have very much lost this sense. It's not a mystical idea. It's giving yourself a chance to concentrate on something which is there for you, to come to a different type of existence than the one you are used to. This is the way art should influence people, that is, to a different consciousness of themselves and of the world, through artifacts or objects of art.

Li: Are you saying that this particular sculpture breathes life into life, that it has the quality of quickening things for us in

some strange way that we don't know?

Do: I must repeat what I said before, I was very provoked by this sculpture.

Li: How do you mean provoked?

Do: Provoked, that means that I was put immediately into another type of awareness. I was displaced from my ordinary state of being into a nowhere so I had to find myself again. This is what a work of art should do. It should take you completely away from routine existence, there should be a kind of blackout when you see it, and then you have the problem of recovering —if this work of art is indeed a work of art, if you are sensitive and cultivated enough to use it. Most people do not know how, or they use it without knowing what they are doing. When I say that this sculpture made me go nowhere and then come back with a new experience, that means it produced a slight change in my knowledge, in my sensibility, in my ideas; it made me think that something else was possible besides all the things I thought were possible in the world.

Li: Would you say that it caused a slight change of your habits?

Do: That's another way of seeing it: a change of habit, and art is a good lever for lifting habits.

Li: A change of the habit, for instance, of looking at paintings on a wall one after the other, like in an exhibition. Kiesler changed this in his show at Castelli's, combining all exhibits into a single large co-ordinate. As you were looking now at his sculpture, you carried over the effect of having seen his galaxies at Castelli's. I'm sure that was acting on you in some way.

Do: No, not exactly. The sculpture was an independent experience compared to the show.

Li: Weren't you prepared for the sculpture in some way by the show?

Do: Of course. Yes. But in this case, I'm talking about the sculpture per se. I don't know, I'm making a terrible confusion on this machine because she only records words. It makes me quite un-

411

easy. Let me clarify. Last year I saw the model of the "Endless House." It is the most complete object I have ever seen, representing or containing, or whatever you want to say, the visions of art—of sculpture, of architecture—and of its philosophy. It is a piece of poetry in a way, it really is something that I can't describe here, something so complete and full of diversities, like an Encyclopedia Britannica of Art. You have to consult the details one by one and then, you know, it leaves you thinking about the truth of relationships. What, then, is truth in art? You are forced to ask yourself this question. And that's against the current idea of pleasing the eye. Is it art just because it disturbs you, but in a catalytic way? Yes, it's all right if it disturbs you and gives you a chance to construct a different kind of reality. Not like some art we see which disturbs us and then leaves us cold and we have nothing, we go back to where we were before because we have not enriched our consciousness. I think I would very much like to see a big show of Kiesler's work put together, so that everything he did would be a document in the development of art becoming life.

Li: Could it be defined as continuity, integration, completeness . . .

Do: Yes, perception grows from experience to new reality. Makes you think of a different world, makes you think that it's possible for you to handle reality in a different way. For instance, I remember in the "Endless House," there was the concept of the floors which are treated in such a curvilinear way that they seem to be moving under your feet. They are not flat and, when you walk barefooted on them, the lifting and setting down of your body, plus moving at the same time, is like discovering your potentiality of flying. This is one example of reconditioning our reflexes; our life is conditioned by whatever we create around us. Just this one idea of a new floor would bring us much closer to truth within nature because we would be using our feet not to walk on shoes and through them on floors, but to walk on the very soil of the house. Not merely on the floor.

Li: Which would provoke a new response . . .

Do: Yes. It's not that I think we should go back to nature, but we should stay as close to it as we can. By nature I do not mean that we must sit under a tree, I mean that we must *live our individual*

412

make. Be it physiology or psychology, whatever terminological dialectics we use, we should not suppress any of the parts of which man is made. The feet. I recall this detail of the "Endless House" about the floor because such a floor would even condition our physiology, our legs and our feet, to a type of movement and development closer to the way we were made. Well, there are so many things to say, yet no matter how much we say, it is only small change from the wealth of nature.

Li: Then it is up to the artist to select, isn't it?

Do: Well, I think that the creative act of the artist is to make you conscious that every phenomenon is made up of different levels of experience. That also seems to be Kiesler's basic statement. Then, the idea of relating each one of the works to the next or to the prior work so that there is a sense of development, a sense of life growing from one work to the other is an important new stand. You know it's really difficult to put it into words. The presence of the machine, so hard and factual, confuses me.

Li: You're not talking to the machine, you're talking to us. It's clear, never mind the machine.

Do: What Kiesler really does is design prototypes of new life-visions through architecture.

Li: Visions put to work.

Do: The way things could be better. And he does it in a very realistic way. I remember when I went to see his "Endless House" with some friends I was very interested in the other people's reaction. I talked to one and I said, "I could very well imagine a community living in a group of dwellings such as the 'Endless House.'" Well, this would be a happy community, not only because the people would have a house for themselves, which already is something, but each person would have within the total dwelling the space of his own individual world. The house would respond to their individual physical and imaginative needs. I mean, they would live the life of their own bodies and the life of their own dreams—of their very own imaginations, no matter how secretive—in an "Endless House." If we take a brand-new modern construction such as I lived in in Rome recently, we can't feel comfortable until, perhaps looking out from the bed, we

413

find something, a crack in the wall or something which brings life into the place.

Li: Then imagination is stirred by accidents.

Do: To get back to the "Endless," I recall other details of the house, like the water and the fire. The use of these elements in a home, you know, is of such importance. I myself would like to dream of living in a place like this. For instance, think of what looking at the fire means to our complex nature. Think what it can do for a child to watch the flames instead of looking at television, or to look at the water flowing in a stream around the living room instead of turning on a faucet. Think what it means to wet your feet in a running stream. It reminds me of the way shepherds live in Italy. You know, they don't have houses, they have huts which they erect as they move on each season with their animals, a movable little community. The first thing they do is to dig a hole for the fire in the middle of the hut. Also, in a village which I saw in Sicily, you find each hut of circular form with a fire hole in the center. I think such needs are elemental. They are part of human nature. The world is made of fire and water.

Li: This is what we reach for—warmth, something we can feel with our skin and our eyes. We must not cut off the gratification of the senses. The hot and the cold, the dry and the wet; these are primordial needs and sources of human response. We must relearn to run their gamut. I suppose man was born with that knowledge and then learned to fortify it with his intellect, but by now he has almost killed it with an overgrowth of equipment.

Do: You, Kiesler, seem to have a consciousness of the fundamental values of human existence, from the very primitive degrees of perception we've just discussed, like being aware of water and fire, to those highly developed ones such as the movement of a line, the difference between one texture and another, the impact of color on flat and curved surfaces and, of course, natural and artificial light controlled and directed—in short, the combination of the primitive-fundamental and the order of the abstract. There is so much more that I could say, but I feel the tapes going around and around, so I can't give myself enough time to think. You know, this is also the problem of correlation. I'd like to co-ordinate the rhythm of my thoughts with the rhythm of the machine.

Li: While the machine is going, something is happening to you, just this thing you're describing, the moment you yourself take over and your feelings become much stronger than this mechanical thing.

Do: This problem of continuity, of correlation between my judgment, how to express it in words and say it in rhythm, in time that agrees with the time of the machine. What happens here is putting together different elements into one thing which will be the voice recorded and the meaning imprinted by the machine. This is today's problem in everybody's existence. Everybody lives conditioned by what he has around him, by the society, the hemisphere we live in, our century, knowingly or unknowingly. For instance, when you hear people speak about liberty in the seventeenth and eighteenth centuries in France, it's not the same liberty as ours, because that world was made of craftsmen, peasants, and aristocrats. Our time has blurred these contours and made a cocktail of all these strata.

As you remember, I visited you after seeing the Rothko show. I feel there is a basic difference between you two in attempting to solve the problems of art and architecture. Since I have respect for both of you, I can speak honestly. For Rothko the problem was still truth in a form of harmony. A harmony produced by current values. Values, however, must evolve new values. Now, I was saying before that, what we look for—no, not what we look for, what we work for—is truth. Today we no longer have values guaranteed to us by a king or by a priest or by any kind of external authority to convince us that it's the truth. Because there is no established moral value, there is no established political value, no established economical value, no established social value—every man has to look for his own truth in order to exist and he has to find his own behavior. His truth is really his behavior, the connection between his past, his present, and his plans, so truth is the consciousness of the continuity of existence. The only value in which we believe firmly today is our trust in this continuity. This is why we believe in history, why we believe in the development of humanity, why we believe in progress, the only type of progress, and this is why we do not conform to any kind of pre-established morals or economy unless we are forcefully conditioned by it. This is why artists try to change what is already established. So, I was saying then that, for instance, in the case of

Matisse the truth was still of an aesthetic order, of harmony; the truth was harmony produced by disagreeing values. Now, later on, Klee finds a truth inside the process of stimulation produced by some colors put together or by some little marks put together or by some dots. His truth was that you become conscious of existence because you are stimulated by those signs, those momentary elements. Now what is the truth today? We have the need for a more complete notion. The dots are not enough by themselves. They were sufficient at the moment Klee was doing them in the 1920's. Today we live in such a complicated world that we need a truth which satisfies the whole arc from the instinctive to the highly spiritual attitudes and back to the instinctive. What I forgot to say before more clearly was that your work is a determinant statement for the development of many forms of art because it points out *truth as continuity of existence*, as continuity between the elemental fire and the most developed technology. It points out the truth from the very simple pen scratch on the paper to the ultimate combination of marks in the portrait of Arp; you know, the perfect functionalism of the pencil. So this is important, I did not make it clear before: Your work is of today or tomorrow because it is based on continuity as a value in any human relation. It has moral value, physiological value, psychological value, sociological value, and therefore an artistic value, because art is truth, when art is art. Today art has so many problems that you have artists of different stature. You know, you can have an artist who finds a small truth which, of course, is as important as a more general truth. I don't know, maybe an engraver finds his truth in engraving. But your work contains suggestions that show the possibility of development in many fields. There is in the "Endless House" such variety of elements that ten architects could take and develop in ten different directions, into different kinds of realities which would be without doubt better than the one we live in because they would be more varied, more respondent to the needs we have discovered we have. The problem is how to keep in time with our growth, how to provide community development to match the individual's diversity.

Well, I think we can close it here, all right. Truth is, of course, the immediate expression of existence. For example, the action of painting. I make this mark on paper. I prove my existence by making this mark, so truth is the possibility of expressing my existence in the most immediate and sharp and quick way possible. Well, this is a relative truth, it's valuable, but it's a relative truth, it's not

416

a vision. The artist's truth has to have a general value, an objective. A work of art must be an object that, once made, belongs to everybody. It should not concern the author any more. He is then detached, detached completely. The object becomes an objective. When someone looks at a painting in a museum, he doesn't think of what the author looked like, what he ate, or what his hair was like. He looks at the work of art on the wall and that's all, and all he can learn is right there. The rest is up to him.

April 1, 1961

The show is over. Nothing has been sold. The whole shebang will come back home. But the bleakness was sparked by a dazzling aftermath.

A Florida lady appeared at the last hour of the last Saturday afternoon of my show. A newcomer to the gallery, she called for Mr. Castelli and said, "What's that?" Her finger pointed to what seemed a shell sculpture in concrete. Castelli answered, "It's a model for the 'Endless House,' a small version." "An endless house? Endless . . . I would love to live in it," she said. My friend Castelli held his breath. He suddenly felt the possibility of realization, could hardly believe his ears. She: "Who is the architect? Is he in New York? Can we all have dinner together ten days from now to discuss building it in Florida? It can only be in ten days because I'm going to visit my daughter in Ohio. Could we make it definite for Monday evening, March twentieth, at seven o'clock. We can meet then, have dinner, and discuss the possibility of building the house in Florida, where I live."

Mr. Castelli's voice quivered joyfully on the telephone when he called me. The unexpected had happened: out of an art exhibition emerged the chance of an architectural project. This development was bewildering for him and intoxicating for me.

We met on the twentieth at La Fonda del Sol. I behaved with discretion, talking about the design of the restaurant, which combines modern and folkloric styles perfectly; I refrained from speaking about the "Endless House." Nevertheless, a letter agreement was drawn up a week later.

417

A check for making the initial plans came from her—dated April 1. The letter agreement which I had sent to be countersigned was not enclosed, however.

"Now don't be superstitious," Muriel, my secretary, said, fearing that I might interfere with fate. "Don't offend the gods!" "You mean the goddess? You're right, Muriel, I shall not. No, I must not. Just go on."

Hotel Algonquin

11:30 P.M., Tuesday
April 17, 1961

The revolving door pushes me in. I enter. That door is new, I don't remember it. Barely settled down, I become aware, aware, and more aware, a consciousness that runs from that moment on throughout the whole evening, parallel to all my discussions and sights, a nagging awareness of the blackened skin of the wood paneling of the lobby in the Algonquin Hotel.

It was ten years ago and the paneling was caramel. A memory enters me. It carries me through a dimly lit corridor miles, miles long; somewhere along the way, to the right, there is a hotel desk with a background of pigeonholes for letters and to the left a man-high wood partition, and at the far end the open eye of the hallway which looks into the bright light of the most snug private dining room for the literati and the theaterati of New York's Greenwich Village and Broadway. What lovely luncheons and suppers I gobbled up there!

I sink into the cushions of a lobby couch, soft like old times, nothing of modern foam rubber, rather like Venus' lap.

With me, after a movie-watching, are Gordon Onslow-Ford, San Francisco's monk of art, his Jacqueline nothing but a voice of tenderness like a faint tissue sheltering a bouquet of yellow roses, Lillian, and twenty-year-old Adelaide de Menil, daughter of Mr. and Mrs. de Menil of Houston, Texas, whom I visited a year ago, indulging at Sunday luncheon in a giant chocolate soufflé with a lacquer-brown dome.

418

How dark, dark, how sunken-dark the wood paneling of the hall walls has become since I first sighted them! Even the veneer covering the tall columns contrasts heavily with the ceiling, spanned like a taut snow-white tent.

All the wood has aged, burned to umber by time, is charred, and its sunny forest glory has discolored to midnight smoke.

Nothing can distract me, peel me off from that change of color; it plays Hades with me. And presently I know why. It is here, there and everywhere—chair, couch, love seat—that I once often sat with John La Touche and J. P. McEvoy, with Marie Carmi (beautiful Princess Matchabelli—Mary of Reinhardt's Miracle play*), all of them guardian angels of my life in the lost life years from February 28, 1926, to depression-time 1933. I realize now, all three friends are dead. My three best friends are dead, are dead.*

Their passing: first, J. P., then Maria and only five years ago, John.

The impact of each death, one after another, has buried itself deeper and deeper into the wood of this hall they liked so much. They were at home here, as in a cave of their hopes.

The wood is mourning. It has shed the color of innocence.

Varèse-Kiesler-Meredith

April 21, 1961

Last Sunday afternoon at four sharp my telephone rang. "May I come over right now?" "Yes. Certainly. Yes." Edgard Varèse arrived fifteen minutes later. He remained standing in my dim foyer for another fifteen minutes and, gripping my right hand with his right, he handed me with his left a manuscript, explaining that it was a play by a good friend of his, Elizabeth of Fiesole, as he called her, residing in Italy.

Varèse, now slightly over seventy, is still of impressive masculine

build, with a devilish face and thunderous rolling hair. His forehead seems always to press against the wind, thus producing storms even where there are none. A Zeus ex machina musica. "I haven't read the play. My wife told me what it's about. She knows it in detail. The main character is a witch. She's a bitch of a woman who imagines she is responsible for every airplane crash in the world. She becomes so convinced that she is making all those planes fall from the sky that she finally is overcome and petrified by guilt. That's all I know about it but that's enough for me. Now you read it." With that courteous demand, he left me.

Three days later, I met him at his house for dinner with Burgess Meredith, who had promised to direct the play if I would do the stage designs and Varèse compose the music.

Varèse lives with his wife on Sullivan Street, south of Washington Square, in one of those four or five southward-running narrow channels of streets harboring dreamers, bums, and expatriates from the Mediterranean. The rear of his basement apartment looks out onto a community garden, a relic of colonial times. In this hidden away quarter is the workshop of our most modern composer. Several Chinese gongs hang from wooden constructions like fruits of sound. On carpentered tables of planks and horses are the master's scripts, books, music notepaper, scores, loudspeakers, and the low-ceilinged walls bear mementos from Alexander Calder, Miró and other artist friends. In the tiny adjoining bedroom, which looks like a mansard dropped from the roofs of Paris, a student's couch is crowded in by recording machines. It's the magician's nest for switching night to daydreams and days to nightmares of heaven.

Winding our way up an intercommunicating staircase, we arrived at a slender foyer; on one side a large living-bedroom, on the other a kitchen, separated by a partition from the dining nook in which Meredith and I sat with Varèse and were served by his wife, Louise. After an hour's discussion about the play, Burgess finally discovered that neither Varèse nor I had read it. He managed a twisted grin and sputtered, "It's always delightful to talk with you both. But it's important that you study the play before we can agree on the staging of it. Since I have the feeling that neither of you will ever read it, I'd better come another time and spell it out for you."

The following Sunday, Varèse and his wife appeared at the appointed hour of six in my ivory tower, but by eight o'clock Burgess had not yet shown up. I tried to reach him by phone via Information, since I had left my address book at the office; the operator wouldn't divulge his private number. It looked like a lost moment of truth. But Varèse and I gained strength through the presence of Louise. Her erect torso, clad in a high-necked black dress, radiated confidence. On her chest a Chilean silver cross, its carefully detailed design heightened by the blackened patina in its grooves, contrasted impeccably with the steel-white of her hair. Resting immobile, her hands folded in her lap, she involuntarily willed us into taking a stand and starting the discussion.

"Let's talk about the play anyway," Varèse broke through the silence. "We'll tape it, and since you have a tape recorder, he can hear what we have to say later at your place. Alors! Okay?" I agreed, and we recorded our ideas word by word.

Meredith never appeared that Sunday evening. Monday morning I phoned him, got him, and he was distressed to have forgotten the appointment. "I'll come positively tonight at six P.M."

"No, please," I answered, "I'm working late with my staff. Come at eight and I'll be free then."

He showed up at seven, looking tired.

"Lie down in my bedroom," I told him. "Rest. I'll have somebody play back for you yesterday's discussion between Varèse and myself."

And this is the recording Burgess heard:

Me: Varèse, where is our great friend Meredith? He hasn't arrived. I hope he didn't crash, like the airplane in the play. We'd rather work with him alive. It is quite strange that although neither you nor I have actually read the thing, only heard about it vaguely like the roll of distant thunder, we apparently have quite a definite feeling about it. It is only this feeling that we can try to put into some form. Form, yes . . . but what kind of a form?

Varèse: It seems to be a surrealist play . . .

Me: Surrealist or not, we have to create stage realities born from the core of the play—not from a style.

Varèse: Let's not wait for Wizard Meredith. Let's go on without him and without the script. Elizabeth gave me permission to change scenes as we see fit.

Me: That's an unusual concession. She must know that we won't change the heart of the play. And if we don't know everything about it, it will be easier for us to invent what we feel should be added, or to eliminate.

Varèse: Sure, and then the play will adapt itself to what we have done.

Me: Nevertheless, it's a dangerous thing, Varèse, to interfere with an author. And it can only be done in good faith—not with an attitude of superiority.

Varèse: Don't worry. She gave me the go-ahead. *T'en fais pas.*

Me: You're right. She can always reject and correct. Glory to her for not forcing us to be stage illustrators of a printed text. Shakespeare and Molière were spontaneous conceivers on the stage. Later on, their actions were recorded and today the lines are hardbound. If you and I have permission in this case to loosen the rigid binding of the script, we can give rebirth to the play within.

Varèse: Let's plunge into it. *Merde!* We'll swim all right.

Me: It is said that the play is the thing, but the thing is to play. Let's begin our game with your ideas for the sound· I know you're in love with all the dynamics of sound. Those plane crashes —what an opportunity!

Varèse: Oh, there are lots of possibilities with electronic sound. That I can provide. But the problem is to get the equipment, the loudspeakers and the amplifier, the control board, the engineers . . . sheet music is shit material compared to magnetic tape! Stereophonic sound costs money, and, believe me, it needs different tonalities coming from different directions. Well, money can buy sound, but a theme still has to be invented. And for that, I need time.

Me: I'm sure your genius and experience will take care of that. But don't you think it would be a marvelous short cut if we could mechanize the control board, too, and not only replace the conductor with the engineer, but the engineer with the machine?

Varèse: Yes, you can bring it up to total automation, but the point is that the action of the actor has to be . . .

Me: Absolutely geared . . .

Varèse: Yes, absolutely geared to the timing of the equipment. If there is no conductor, it has to be pretimed.

Me: That's right—mechanically.

Varèse: My music for Corbusier's pavilion at the Brussels Fair was mechanized. In fact, the whole thing—the different strengths of light and colors as well as the sounds—were synchronized, you see, by pushing buttons. But a live play is a question of co-ordinating machines with human beings. The actors can't move a moment too soon or too late. Otherwise this serious play could in no time become very Dada . . .

Me: There would have to be a new time-space synchronizer supervising the whole performance. You never can tell what will happen with machines and people when you aim at strict co-ordination. There is human frailty to be considered—actors might not come in on time, or too late. The stage manager would be able to step in and do something about it. A live man must still be on hand to safeguard continuity and to condition the whole atmosphere, the climate of the play. The elasticity of the performance must not deviate from the established basic concept. It definitely can't be an unconditional surrender to automation. Not yet.

Varèse: Don't rely too much on him.

Me: I think this method would be very good discipline for the actors, for their voices, their timing of cues, of entrances and exits. Still better would be to go to the limit and automate not only the music and the light, but also the actors—which means marionettes. That has always been a dream of Gordon Craig.

Varèse: You're right, it would solve a lot of problems of animos-

ity and exhibitionism. If you take a singer, for example, it's the same thing: he has to come in on the beat of the conductor, not on his own.

Me: Absolutely, yes—except here the conductor is invisible but he's not inaudible.

Varèse: The conductor would be very present although he wouldn't really conduct. Not like a temperamental Toscanini, whose hand had a vaginal contraction every time a musician missed a beat. We have to eliminate the intermediary, in other words the conductor, as much as possible—better altogether. Good composers don't need any interpreters.

It's right in the score, dots, commas, periods and intervals. Electronic tape recording could do all that to perfection. The peacock conductor will be phfft! I remember a discussion with Toscanini in which I criticized him, and he tried to justify his strange interpretations, off-beat beats, on the grounds of forty years' conducting tradition. I said, "Don't confuse tradition with forty years of bad habits!" Anyhow I told him, and I really had to: "*Je n'aime pas les gens qui font le trottoir sur la musique des autres.*"

Me: Of course, Edgard, there's also the opposite approach. The pendulum is always swinging from one end to the other—from tight automation to loose improvisation. Taking a chance, letting instinct do the work for you. To hell with the brains. The audience or any of the performers could throw a theme at the musicians and the actors, thus evoking their ambition to co-ordinate a drama, an opera, a musical. From that moment on, the performance reels along with no end in sight. Even after the audience is gone, they continue with their jam session of the theater. Happenings after happenings. The key word is chance. It continues out on the street, into the bar, the café, the home . . .

Varèse: Sounds like a sort of *commedia dell' arte.*

Me: Well, let's stick to automation for the time being—and let's make the most of it. How long do you think it will take to record your composition?

Varèse: It's not a question of recording—it's the composing. The recording is nothing, it can be done in no time, you know.

424

Me: You will need two or three months to compose it?

Varèse: Oh, at least! You not only have to have the right theme, but your material, your intensities, the duration, all co-ordinated by cybernetic relays, because the machine will only give you back what you have put in, nothing else. But then, when it's there, press your button and the thing takes off. It's up to the live performers to co-ordinate with the score. But don't forget, the music would remain only a sporadic intervention in this play. It swings in and out during the performance. The synchronizer could use a stop watch to control the ins and outs.

Me: We could also devise a light-signal system—completely automated.

Varèse: Of course.

Me: Before we go further, Varèse, in defining these details, I think it might be a good idea to sketch out the whole concept of the stage and the audience's participation in a form normally called the setting. Then we both can more easily conceive the distribution of the elements of the production. We can plan our stereophonic field, not only for sound but for action too. The movement of the actors! Yes, that gives me an idea. A stereo-field of action. Action in three dimensions. Let me get a pad and pencil. Just a minute . . .

I see a large rectangular auditorium with two stage platforms, one on one end and one on the other end, stages A and B. Running through the middle of the rectangle is a large aisle connecting the two stages. Along both sides sits the audience, in two sections facing each other, on pretty long rows of benches. These rows will be elevated, like bleachers. In such a theater, the two stages can be used alternately. The actors can walk from stage A to stage B down the center corridor, or go in back of the audience by way of connecting ramps.

Now it seems to me that what the witch feels can only be based on a belief that man's basic ill will determines all developments in life, and the particular milieu of a situation has no importance. Therefore the same actors will play different parts in different settings; only their costumes will change. If a scene plays in a courtroom on stage A, the actors will walk through the middle aisle to
425

the second stage, B, which, let's say, would be preset as a home interior. While they are crossing, they find in the center of this middle aisle, on a round table, the costumes laid out for their changes.

Varèse: You mean, they change in front of the audience?

Me: Yes, in front of their very eyes, that is, walking across, stopping at the table, and continuing. So much for the floor area. It also seems to me that since the play deals with airplanes, and therefore with the sky, the ceiling of the theater is of great importance. It should be made part of the action.

Varèse: How?

Me: It could consist of a dense netting suspended about two feet from the ceiling, dropping at both ends of the rectangle to the platforms of the two stages and, in this manner, forming the two curtains of the two prosceniums. It becomes quite practical from every angle, my suspended ceiling, because above it you can have not only lighting but also amplifying equipment. There will also be room under the bleacher seats for your loudspeakers and more lights.

Varèse: That's exactly what I want: to envelop the audience and actors in sound. Your netting would facilitate placing a lot of loudspeakers against the ceiling without their being visible. I wouldn't be surprised if some industrial concern donated equipment for sales promotion. It might also cut expenses if we could interest some laboratory in the sound and Century Lighting in the lighting.

Me: That would be damn practical, and save a lot of money.

Varèse: Then let's spend some money now and go eat. We can pin a note for Burgess on the door to meet us at Pappas' on Fourteenth Street: *où nous allons casser la croûte.*

While Burgess was listening to this tape, I returned to the living room to work on plans with my assistant, then I joined him half an hour later. This is the recording of his reactions and our subsequent discussion:

Meredith: Well, the Lord kind of watches over these things and I think one of the best things that happened, although I apologize for it, gentlemen of the jury, one of the best things that happened was that I didn't appear, because otherwise that extraordinary conversation wouldn't have taken place. It is out of discussions like this that written plays can grow into genuine concepts of play production. The ideas kind of awe me in a way. I like the automation and the automatic aspects of it indeed. I just wonder whether we shouldn't go all the way and think in terms of puppets or marionettes. They are magnificent actors. When you make a gesture with a marionette, it's spectacular, almost gigantic. If you've ever seen the Japanese theater and the puppet theater, you know what I mean. With human beings, you might get an actor with a cold, or you might get a director that Varèse disapproves of, like Toscanini with that vaginal problem or whatever he had. There's a kind of wonder about puppets that we ought to consider—it could be spectacular. I'm not sure of this, we're all just thinking out loud, lying on the couch, so to speak. My first impression of this talk was that, in a sense, it was a godsend that I wasn't here. It kind of kicked off the ball in a way that wouldn't have been possible if we'd all three sat and read the script scene by scene, word by word, entangled in text.

I'm still in some doubt about the play itself. I found it hard to make out. Somewhere in it is a shocker of an idea, and that's good, but it hasn't the nobility of either Varèse's or Kiesler's direct theatrical approach. However, once the script is returned to the author with our suggestions, she might kick it back to us with an equally noble reconstruction. So let's take it quietly. Let's also realize that I have been trying to get the right kind of producer to put up enough money to get it done. As unessential as cash may be —it means nothing more than what people are going to do with it —a certain amount has to be put down. We're not just conceiving a thing in a hayloft someplace. Over and out, thank you.

Me: As you know, yesterday when I discussed the play with Varèse here, neither of us had read the play, but we started to conceive the stage for it, and I made a plan. Let me show you the sketch I did yesterday. It's a strange combination, a kind of stage-auditorium. It has two prosceniums, parallel rows of the audience facing each other, a gangway in back of the audience on either side and an aisle through the middle of the auditorium connecting the two stages—all these constructed of simple sections (like

427

bleachers) with folding underpinnings and fitting flat tops. This auditorium can be set up anywhere. I haven't designed a set, but a *setting-theater*, complete with ceiling, seats, and stages. You got the gist of it on the tape you just heard. Let me just point out one or two details which have bearing on our plans.

Look at the drawing. Right here, in the middle of the corridor, there is a round table wide enough to have a deep circular recess in the center. That table has a double function: First, it acts as a repository for costumes; second, its base hides projection machines that shoot images onto the ceiling. And see here—the two stages are connected along the walls with ramps running behind the seats of the audience so the choruses or the actors can circulate from one end of the auditorium to the other. A scene can begin on stage A and continue on stage B.

It's a combination of a theater-in-the-round with two proscenium stages and a Japanese ramp. A multiple theatrical concept, to allow for the variety of happenings which are the essence of this witch play. My setting-theater, or "scenic theater," is a very simple thing which can be done in units—that makes it easy to transport—and inexpensive.

Meredith: The only thing I want to know as a practical stage director is how would the audience see what's happening on the ramp in back of them?

Me: The spectators don't sit in chairs but on benches like stadium rows, so they are free to turn. Chairs would be hampering. It's not just a physical matter, however. You must also have the proper staging, speech, acting. You cannot put old-type acting into a theater of new design.

Meredith: I like that table in the middle of the aisle to stack the costumes on. When the actors who play religious people in one scene come down to it, they can change, let's say, to judges, right in front of the audience and then continue on to the other stage. That's very good. It suits the play.

Me: Yes, for this play the audience should see the characters as the same people, with only their skins changing. The chameleon-like nature of these humans prepares the audience for the violent physical turnabout, the catastrophe which should climax the play.

428

A big crackup can be reproduced in this type of theater. Here is how it can be done, Burgess:

Members of the audience sit facing each other. The whole ceiling is underslung with a gauze sky. You remember, on the floor below is the round deep hollow in the middle of the dressing table from which a film projector can shoot up onto the gauze sky images such as moving clouds, lightning and, of course, a giant airplane. Suddenly the plane grows larger and larger; the music becomes more thunderous, and everything climaxes at the moment when the airplane actually crashes down upon the audience by the release of the curtain pulleys. The audience is blanketed by the billowing waves of gauze, actually touched at some points, before the ceiling is raised again and serenity restored.

Meredith: Wow! That's exciting. Let me have a go at it. That cloth, you can raise or lower it any way you want, or certain parts of it. When the plane comes crashing down and the lights go haywire, the curtain actually drops on the people, and then rises —and everything is peaceful again.

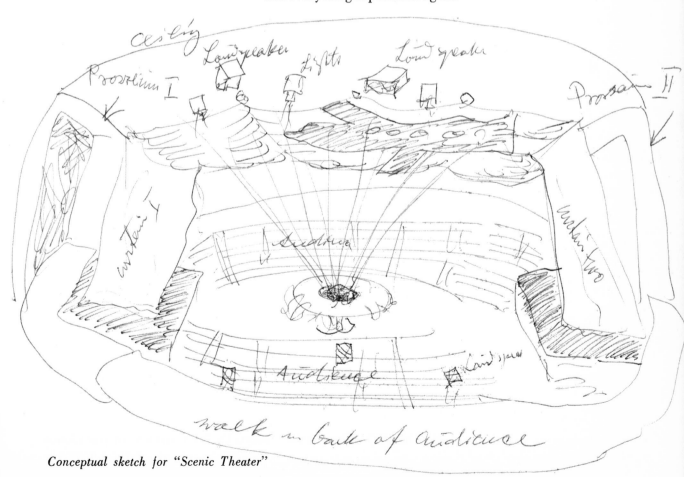

Conceptual sketch for "Scenic Theater"

Me: It's inexpensive, technically speaking.

Meredith: You must raise the ceiling quickly because there is always a possibility of real panic. It's a kind of fourth dimensional Aldous Huxley thing—the feelies.

Me: The feelies, that's right. It's really as if the whole world is coming to an end. With Varèse's music sounding from above and below and all around, it should be like a preview of Judgment Day. The obsession of the witch, the projected nightmare of her ego, is thus turned into reality.

You know, in principle you could change the imagery not only with the projector in that table, but from all around the auditorium. The sound, too, can be varied in its direction. Also, you can drop the ends of the ceiling which form the stage curtains for the two prosceniums and use them as projection screens.

Meredith: Damn good theater. I wish I hadn't read the play either, but alas I have, so I can't be as free as you have been this time. But next time . . .

Me: Now, how much of an audience would you like to have, about six hundred?

Meredith: No, you can't do that in New York. That's the trouble.

Me: Three hundred, or to be lawful, two hundred ninety-nine?

Meredith: Yes. If we did the play in another city, we wouldn't be restricted by union problems. But the off-Broadway limit is two ninety-nine.

Me: We can manage here. If you like, we could try to find a space with a plain floor, good for setting up the bleachers, in one of these large concrete modern buildings that are going up all over.

Meredith: Rather than renting an off-Broadway theater. What about the acoustical problems, as far as Varèse's music is concerned?

Me: We can solve the acoustics with this fabulous material hang-

ing overhead. The sound will be controlled by the inclination and density and tension of the cloth.

Meredith: Now what do you mean by a building that's going up? If there happened to be a big unrented . . .

Me: An office building with vacancies, yes.

Meredith: Wait for a depression, and we'll have plenty of vacancies.

Me: That's right. I remember. Then we could also have a permanent location. But in this time of prosperity, we could make a traveling theater which would spread out all over the land rather than being tied down to big cities. It's very easy to transport the whole thing. A mobile theater—one needs only platforms, bleachers, ceiling curtain, lights and sound equipment. We can take them like a circus from town to town.

Meredith: Yes! Now tell me—could the center stage be elongated at will?

Me: No, its limits would be fixed by the two proscenium stages at each end.

Meredith: And they are right on floor level?

Me: No, three feet above floor level. And there would be a few steps leading up to each stage from the middle aisle. You see and hear better with the elevation.

Meredith: I understand. Since you mentioned the circus, I know the Ringling Brothers, perhaps they could lend us platforms. I'm sure they have plenty.

Me: That would be fine. And save money.

Meredith: Now, it is very curious that in the *Hamlet* I did, we kind of imitated Varèse's music (I actually asked Varèse to do it), and we used a very steep, about forty-five-degree inclined stage. All the action shifted from here to there and the audience took it in from seats that revolved.

431

Me: You can do that too, yes. But you lose space with revolving seats and they would be more expensive to construct for a small-capacity theater. The bench system costs less and is much more practical to transport and to erect.

Meredith: Yes, that seems simpler—dammit, let's do it. Now to go back to your idea of staging the play any place but in a theater . . . I'm intrigued by that.

Me: It's about time we had the courage to break the rules of Broadway and off-Broadway theater. Squeezing plays and operas and concerts and dancing into the same architectural strait jacket seems to me altogether old-fashioned. Our theaters are like caves which have been monumentalized—and stylistically they are all derivations of baroq-coco or the arena. For every play there should be a new theater erected—temporarily. God forbid that it be solidified, even if it's a great success. Let's keep everything fluid, transformable, adaptable to changing social and poetic conditions.

Listen, the play could even be in a tent—they're available in all sizes—they can be made to order within two weeks, to house four thousand and one people, and flown in from the Navy Yard at Norfolk, Virginia.

Meredith: Well, if it's in the winter, that would cost us a few audiences.

Me: Of course, that's right. A few audiences and lots of heat. But we can find heated places, there's no question about it. You know what we can do, we can set up the tent in one of the armories. They'll rent you space. And there is central heating there and all public facilities. These armories have different-sized areas, even giant ones.

Meredith: It's a wonderful idea. Gee I'm glad you didn't read the play.

Me: We had a great time, Varèse and I.

Meredith: I . . . I'm just astonished by it, because, as I told you, I myself came very near the same concept in this *Hamlet* of mine which Baker directed. We had a three-in-one Hamlet; me and

two alternate Hamlets that were always behind me and kept repeating psychological things. One was the military aspect and one was the Oedipus, and one was the Crown Prince—me. We based it on Frederick Wertham's idea of the matricide Hamlet, that he really desired to kill his mother. The concept was unusual, but I see a whole new dimension that nobody ever thought of in your costume table. This seems to me a way of getting plasticity in the production as you get it in the theater with your architectural concept. Your whole approach seems terrific for the theater of today and for our play in particular. By the way, I just left an art opening, and Jack Houseman was there.

Me: You mean John Houseman?

Meredith: John Houseman, we call him Jack. He said, What's going on? and I said something's going on, call me in the morning. You know, he might be a good man to sponsor this play . . . we'll see.

September 16, 1961 Today, hearing the tape once more, I have a postscript to add:

In late May, I had to leave for Jerusalem, and on my way back I stopped in Rome. I was intercepted at my hotel there by an envoy of Elizabeth's, who had heard that I would be coming to Italy. When I exited from the lobby, the lady herself was patiently waiting to receive me in her car and drive me to her house in Fiesole, above Florence.

Riding over this famous stretch of road, which I was seeing for the first time, I became more and more apprehensive about accepting the hospitality of the author of that play I had never read. I couldn't pay too much attention to the landscape; my embarrassment was nagging.

A charming dinner party had been arranged. The guests were already there, but Elizabeth invited me into her library and closed the door behind us. Naturally she was eager to know all about the discussions of her play by Varèse, Meredith and myself.

I tried to postpone the inevitable. "To make our ideas clear to you, Elizabeth, let me sketch out this new 'Scenic Theater' which I in-

433

vented for your play. I just need two pieces of paper and a pencil."

She motioned me to her desk, where I sat down, waiting for the paper and pencil. Glancing out the French doors and over her terrace, I was struck by the magnificent view into the deep valley of Florence. It looked to me like the Promised Land—of escape. But the glare of the white paper she laid down brought me back to reality. I slowly sketched the floor plan on one sheet and the section on the other, with every possible detail. She stepped up close to look at the sketches over my shoulder, and I explained it point by point with as much suggestive interpretation of the play as I could muster.

"But tell me, Mr. Kiesler," she began ominously, "how do you see the staging of the second scene of the second act, you know when . . ."

I interrupted and stood up. I knew I was on the spot, but I sensed a way out like a trapped fox.

"Dear Elizabeth, your hungry guests have already tried once to break into our conclave. I hear the clatter of dishes. Don't you think we ought to join them? You have enough material to sleep on, we'll leave further details for another time, don't you agree?"

"Of course," she said, "there'll be lots of time. Let's go in and eat. You had a long voyage . . ."

May 5, 1961 *What is eternally young?*

Space.

Live space

and you'll feel eternal.

A genius is a man
who uses only
common sense.

Of course—
his common sense
is
unusual.

434

Near Palm Beach, Palm Beach

Palm Beach
3 A.M., May 14, 1961

Wresting a moment from time for my very private thoughts, like stealing a bud from the hedge of jasmine at Palm Beach, to reflect, here on my hostess' grounds, on what has or might happen to me and my "Endless House"; taking refuge in that moment snatched from outer time and converted into inner space. I rest immobile, become nothing but thought floating on a sea of emotion, trying to conclude in advance (foolish attempt, but nevertheless attempted and attempted with anguish) the possible course of coming events; tempted by that invitation to build, what wonders could be achieved and what failures could be in store for the "Endless" and myself, questions tossed out to all the winds incoming and outgoing, the inevitable questions when someone opens the door to a Palace of Hope, where inside you may find the long-winding corridors leading to chambers of splendor or, after the door has opened, the façade traversed, no house there at all but the reign of the void.

The lady who received me as I stepped off the jet last night was gracious, wore a dainty *chiffonade,* no hat, and black sunglasses at midnight. I rode in her Lincoln from the airport and I was soon shown a double bedroom next to her Venetian-style quarters of Danieli sumptuosity. "But what are those shotguns doing here," I asked, "the three shotguns leaning in the corner by the connecting doors?"

"Oh yes. Here they are, my beloved shotguns. They're for target practice. Now, there is the air-conditioner, here are the towels, choose any color you like, you'll find everything a man needs. But let me also show you the cottage at the end of the garden pool, you might prefer it for your stay."

She led me on. I followed her down the stairs, through the opulent living room, across the terrace in front of it, and then along a petty Grand Canal flanked all the way with low-shaded, Japanese-type lanterns, electrified however, doubling their light in the water. I watched her high heels, losing the sight of one and then the other in a hypnotic rhythm while she marched ahead of me, talking backwards as I followed her step by step. Her voice accentuated each sentence with an interval of silence like an exclamation mark, inviting no response. I entered the cottage of Kyoto echoes,

435

bed-and-living room squarish in shape, which I like, and thus made my choice even before the question was put to me. Her presentation of the spic-and-span kitchenette and mauve-curtained shower bath became irrelevant. I quickly put down my diminutive suitcase on the floor covered with a Chinese-dragon-patterned rug, and was ready to return with her to the terrace where the other guests had in the meantime arrived, and could be seen in the distance as vague form-figures against the glitter-clutter of a slightly sunken living room lit by a Venetian crystal chandelier.

Physically present, my ears resounded with the discussion of some months ago which led to this adventure:

"Is that a house?

"A house really? I love it.

"This model is by—whom? Kiesler, is that the name?

"I'd like to live in it."

"Of course, you understand that no one can enter 'The Endless House' with shoes on. Neither should men enter with their Huber e Bronner on or the Lady's with Acy's dresses on. That goes for the family as well as for guests," I said.

"Well what will they wear then . . . ?" the Lady asked me slowly and doubtful of belief.

"It's very simple. And natural too. 'The Endless House' is built for the inspiration of a more enchanting life than solely to be the container of brick, glass, pipes and conduits (which we all can take now for granted on *any* price level).

"To be specific, there will be dressing quarters close to the entrance of the House for men, women, and children with an exuberant wardrobe of capes, saris, panchos, in many colors, textures and weights, and sizes; to be worn loosely or tightened over the body. That will be at the disposal of all visitors, en masse or singly. It was interesting for me to hear of a silk and shoe manufacturer from Hong Kong, who offered at once to deliver, free of costs, slippers without soles, just covering the arch, made with many-colored feathers or silk, velvet or furs—because I made it

clear to him that everyone's home is a sacred place, and a silent walk is imperative. The floors of the "Endless" would, naturally, have many textures, such as pebbles, sand, rivulets, grass, planks, heated terra-cotta tiles; so that everyone can by touching the floor of the earth be stimulated by the touch."

"I'm all for it," the charming lady said. "It seems suddenly so natural; I shall want walking through my house like strolling in the open indoors."

"Let's have dinner ten days from now and discuss it. Can you arrange it?"

I'll wait for the answer, to be sure.

That, Leo Castelli had reported to me, was what she, the Lady from Florida, had said when she came to his gallery at the last hour of the last day of my exhibition. Not a single drawing sold, but this most unexpected offer—indeed, a miraculous turn.

And so I had flown here with Castelli, assistant architect Len Pitkowsky, and Lill to take a look at the three thousand acres put at my disposal for the "Endless."

"An acreage blessed with eight swamplike lakes which you can expand and deepen or combine. I leave it to you. Let's start construction in October, that is, five months from now. I hope it's enough time," she concluded, toasting champagne to our project.

After setting her glass down, she continued. "It is the first new concept in architecture for at least five hundred years, and I just love it. You know, we are forty-five miles from Cape Canaveral here, and are trying to reach the moon from there. But when we build the 'Endless' on my grounds, we will have brought the moon to earth."

I loved her for that, anybody would have, and I was glad I had rocketed to Florida, if only for one full day, because in two days I must be in Paris (overnight) on my way to Jerusalem. I was high, almost drunk with expectation.

Safari:

One Lancia, one jeep, open front and back, sea-cooled breeze running through. In ahead-of-us car, I see rocking friend Castelli in a wide-brim straw hat, the art dealer with the perfect-farmer look. The jeep, in its tempo and compactness, as if ready for big game hunting on African plains.

The Floridian Land Escape:

So often I have heard of this wonderland, almost a promised land of soft climate for the northern cooled-off Yankees.

Now waking in daylight, I see the stinging contrast between the natural *terrain vague*—apparently the result of erosion by heat and wind and storms from the temperamental Gulf of Mexico—and the conjured paradise-parks sprouting out of this infertile land around every villa, booming and blooming with tropical vegetation.

The *real* estate:

The land is swept-flat, sanded-flat, flooded-flat. Patches of desert. Patches of grass. Patches of palmettos. Burned tree trunks, forlorn.
The horizon of the sky spins like a carrousel, never ceasing.
The hoop of the earth has a giant radius.
AMERICA.
Cattle appear like white, brown, and black flowers,
moving buds of the prairie
desperately holding on,
waiting, marking time,
for the slaughter by man or climate.
They don't eat or drink. Just vegetate.
On a hunger strike.
So emaciated their wooden flesh.
Scrawny pines, once part of a forest of dense growth,
eroded now to lonesome clusters huddling together, or sticking out, lost, like single strands on a bald head.
Our iron cart wheels give off sand fumes like jets.
A no man's land of architecture.

438

The humdrum of the rolling jeep bounces me back into memories of this morning.

Olivia, the Lady's maid, native of the land but without Mexican flavor, had propped a rectangular carton against the terrace wall addressed to the Lady from a sports company in New York. It seemed to be waiting urgently. The package remained unopened until the next morning, that is today, when she asked Castelli to undo the knots. He struggled with them and with the gum tape and after ten minutes of patient manipulation, a sheath of mellow doeskin emerged, revealing a resolute shotgun.

The Lady, enchanted with the arrival of her new baby. "This is my latest one. I'm taking it to the ranch with us. I hope you'll enjoy shooting with it."

She asked her secretary to call one of the ranches and tell the resident farmer to have ammunition ready. We would pick it up from his shed when we arrived, on our way to inspect the grounds.

At the ranch:

The local surveyor and the local contractor, father and son, the Lady had invited as planned. We three were buried in discussing foundations in that sandy, swampy, shellcrusty land for the "Endless House." I sketched for them the plan of the house—facts to produce figures of costs. "Mr. Kiesler, we've built lots of fancy houses. We're ready for yours. No problem."

Meanwhile, the Lady to L.: "Now come change your clothes. I have plenty of hunting pants, shirts, boots, and hats. You know it's quite an excursion, and I want you to feel appropriately dressed for the occasion."

L.: "Do I really need to change? Aren't we going by car to see the grounds, or are we inspecting it on foot?"

The Lady: "We'll be out in the wilderness. Your white shirt and high heels are fine for the sidewalks but not for there. Come with me . . ."

She made a generous gesture toward her closet, offering L. its con-

tents. When L. opened the door, she found pair after pair of women's knee-high boots, arrays of ankle-highers, and regular moccasins. The choice was difficult.

The Lady: "Here are some heavy slacks," which she carefully laid out on the bed, "and here, my dear, is a clean hunting shirt."

It was thickish yellow hop sacking, and looked too heavy for the hot climate. Perhaps it was professionally correct, L. conjectured. As if to verify her thought, the hostess undertook the ritualistic dressing of a devotee of hunting. She oiled her face and skillfully wound, around her head and below her chin, folds of bandages which she carefully safety-pinned; over them, she wrapped a long chiffon scarf, whitish; then she donned a khaki-striped hunting suit, slipped on leather gloves, perforated front and back. With a last touch, she put on a large Panama, red grosgrain ribbon around the rim and crown.

Lillian resolved: "I'm afraid that I, the reluctant bride, will persist in wearing my silk stockings underneath the hunting pants. I can't bear coarse cloth against my skin, particularly since the temperature steamed up to a hundred and three degrees this afternoon. Perspiration is constant."

The Lady: "Now let's fix up Mr. Kiesler. I want him to feel comfortable in this climate. Please try to find him boots, pants, shirts, a leather jacket. You know best what he can wear. In this other closet are all the men's clothes."

L. found: several pairs of men's hunting boots, but so high that K., L. thought, could move in none of them comfortably, that little man; leather jackets, the sizes big enough to make an overcoat for him; flannel shirts of many variations in stripes and colors, all to fit a hunter nearly seven feet tall.

The Lady: "Do you have everything?"

L.: "You know, Mary, Mr. K. is not comfortable in any shoes except his own. He has diminutive feet and his shoes must feel like gloves."

The Lady: "But you're imaginative—can't we pad his shoes with Angora socks so he won't swim in them?"

440

L.: "I wonder if it wouldn't be wiser to leave it to him."

The Lady agreed. I was grateful for it. It's an interesting fact that we Europeans who remained in the Old World into our late youth hardly ever change from street clothes to working clothes or back again, whether we work in offices or studios. Even painters and sculptors almost always keep the same trousers, the same coat, the same shirt throughout the day. Once we've put it on in the morning, we just go through our daily activities, private and official, in the same outfit. And after working (and it might be for long hours), we hardly bother to wash our hands unless they're damn dirty, smudged and sticky. I have often wondered why, after thirty years, I haven't adapted myself to the habits of this country, where every laborer, after six o'clock, turns into a bank clerk who, in turn, is transformed into a sporty executive—all dressed in prefabricated fashions. I'm afraid I'll never learn to convert my social status by way of clothing. Sidewalk or desert, no change of clothes.

Before the Lady stepped back into the Lancia, she ordered her secretary to telephone the superintendent of the next ranch house again to make sure that ammunition was ready to be picked up. Mr. Gilbert, gentleman-farmer, placed two large rifles into the car with ritualistic caution—one beside Leo Castelli and one between Len, my assistant, and L.

The Lady to Leo: "Always keep the gun pointed away from you —although it's not loaded now, of course."

The jeep went first. The Lancia followed. We picked up the ammunition (ten boxes of various sizes and calibers), stored it under our feet, and we were on our way.

No one spoke. The cars continued monotonously, going no place because one and the same scene appeared everywhere. The constant driving made me aware of the goal of this journey—to find a spot for the "Endless House." After half an hour in the stingy desert, we suddenly approached a clump of cypress trees and a few low pines. My chin came up and I pointed toward the oasis. Quickly I said, "Let's stop here."

The Lady: "Wonderful."

We took the guns out and the ammunition. "Let them shoot at clay
441

pigeons while we look over the ground." I tried to find myself by finding a spot for the house in that marshy, boggy, quaggy landscape.

"Come," I asserted myself, turning to my assistant, "give me that large yellow pad we took along."

I tore off the sketch of the "Endless House" which I had made for the engineers two hours earlier.

I glanced over the terrain and walked straight to an isolated bush, far off. There I hooked my drawing onto one of its brittle branches. It was needle-sharp, and pierced the paper easily. My drawing hung straight. No breeze.

In the meantime, Mr. Gilbert, the superintendent of the ranch, was winding the machine to hurl clay targets into the air.

The Lady handed one gun to Castelli and took one herself.

She shot each and every one of a dozen birds. Her aim was perfect. She leaned like an arrow rooted into the ground, fused with the rifle. She hit the pigeons at the high point of their parabolic orbit. Leo came either too early or too late. Never cracked the clay.

It was now my turn.

"Please, a gun."

Mr. Gilbert came and handed me one.

I put it up against my cheek, while the Lady gave me counsel on how to hold the heavy gun so that the recoil wouldn't crack my jaw.

I aimed, and shot the "Endless House."

The entire group ran over to see what I had done to the drawing. I had killed it squarely. It was riddled with innumerable holes as though hit by a rain of cosmic particles.

Wednesday
Three days later

I am in Paris (overnight) on my way to Jerusalem (tomorrow) and sitting tiredly on the edge of a fabulous double bed (or quadruple?) at the Hotel Crillon, en voyage with Partner Bartos, who on the brink of midnight has just left me to search for a tube of shaving cream.

Having failed to reach on the phone my dear old friend Marie Cuttoli and also Ileana Castelli, who I remembered must be staying at the Montalban Hotel, Rue du Bac, I use the emptiness of waiting time to order a late supper.

The waiter brings me a ham sandwich on a *petit pain*, a dish of fresh strawberries, and tea with lemon. The hot water in a sister pot to the essence is, to my surprise, without *couvercle* and therefore apt to grow cooler and cooler, losing heat and flavor, a serving typical for New York but not for France, and especially the

443

Crillon, and I wonder if it is not part of an underground influence from New World visitors, that tourist army carrying the bacillus of equalization from land to land.

In my thought back to America, which I left only seven hours ago, I still feel reverberations from the shock which the lady of the house-dream gave me in the evening after our safari when she said emphatically, "You see, Mr. Kiesler, in order to have enough liquid funds to buy or promote Art, which I am now interested in doing, I must make practical use of the three thousand acres. Your out-of-this-world 'Endless House' will draw attention to the ranch and help to sell large acreage, I hope, easily."

"Then you do not think of it any more as an ideal living quarters for yourself? Do I understand correctly—it is to be chiefly a magnet for property buyers? I see, it is a promotion scheme, and that is not what I thought it to be, but naturally that must have been a misunderstanding of mine."

I tried to get a grip on myself. I fixed my eyes on her right cheek and let my gaze rest there. It left my mind free to wander. The veranda was strangely silent, as if holding its breath.

". . . but being involved in my 'Endless' for such a long time, I assumed others, one at least, one like you, would feel the same and like it for its own sake. I realize now I am continuously dreaming. *Trompe-coeur*. I apologize."

Getting up late the next morning, I wrapped my dressing gown around my shoulders, held the lengthy coat tight with crossed arms, and pacing my room like a prisoner-of-dreams in a bamboo cage, my arty habitat, I walked right into myself searching for a niche, a path, a hollow, to concentrate on what to do. The decision must be either to quit or accept the challenge to be just an architect-developer of terrains, a state of mind I never knew or have been in, but which most, if not all, of my colleagues are *scafandered* in.

No, no . . . Yes, please . . . No, get out of it . . . Yes, be wise, crack your hardened crust, quit your past, accept . . . or stop and get out—and fast. Jet-style. The Japanese straw curtains, semitransparent, still down, did not help me to find a decision. The half-darkness penetrated me like heavy mist, dusk and dawn

were mixed in one, with the *no* of night gone and the *yes* of day shut out.

I finally opened the door. The dilemma of no exit and no entry had coagulated. I shook the shock out of me. Stepping out, I faced a man waiting on the veranda. He looked fiftyish—upright, capped with silvery hair, diplomatically tailored. He flanked my hostess on her left. Her eyes were black with sunglasses.

"Mr. X—Mr. Kiesler. Mr. X is my lawyer. He is here to put into legal terms whatever we agree; he is not advising. It's up to us."

"That's good."

The natural pause which followed this encounter I used to apologize to my hostess for my impatience at last night's discussion. We sat down. The moment of truth had arrived. I realized now that my alternate proposal which had suddenly occurred to me—to save the "Endless" by lifting it out of Florida and onto the seashore of Long Island—was also out. It was too far removed from her sphere of interest. But not only that. I had thought that once the "Endless" was built on her grounds, the idea could be further and further developed into a community of "Endless Houses," all within the realm of her three thousand acres. Now I suddenly knew, knew, knew: that to build a single "Endless House" on Long Island would also be an abstraction and out of context with the community. Ariadne, princess, how your thread entangled me in a mesh of contradictions—to build or not to build—aims out of wedlock and imprisoned in the habits of rigid habitats.

"First time I've seen you working sensibly. Decisions, unsentimental and direct," Lill said as we boarded the Lincoln to be driven to the airport of Lauderdale, one hour away; but, we found, our flight was canceled. Had to wait two hours. Time had already stretched to a feeling of endlessness for us through the agony of viewing the hotel chains of Miami and Palm Beach, the Sodom and Gomorrha of Floridian architecture.

Finally hovering over New York, we could not see land and the mist was dense as steam. We arrived (hours later) in Philadelphia, where we had to short-change our wings for wheels and take a three-hour bus ride to New York. A taxi brought me to my home door at four in the morning. The sky started to blush blue, an-

445

nouncing the new day. A night lost. The accumulation of air, car and bus travel had made it a total of twelve rattling hours from Palm Beach to New York, the usual time being only a fraction of that. Fatigue, that twister of nerves, made me hate the trip more than I should have, because the total experience had taught me, with divine definitude, to focus my concern on art rather than on myself, to unify my life with the nucleus of my talents (in this case, architecture), to shelve personal pride. It had dawned on me, through my agonizing dilemma—to build or not to build—that: thou shalt not build.

All the more correct do I find my decision as I continue to write these notes here away from Florida at two in the morning, at the King David Hotel in Jerusalem, after landing two hours ago in Tel Aviv from Paris, picked up by builder Fefferman with whom We shall confer tomorrow about our going ahead with the sanctuary for the Dead Sea Scrolls, a project finally ripened to that enviable state of digging into the Holy Land for the erection of the Shrine. Hallelujah, ja!

They Have Lost Their People and Homes and Are Camping in Museums

On the BEA plane
The take-off for Rome
Sunday, May 21, 1961

Looking at and then looking out of the airplane—the shape of every window is a circle but strangely ellipsed, that is, it is neither pure ellipse nor pure circle, just an off-beat ring—I remember arriving the other day in a Caravelle plane, its window another off-beat loop, also ellipsed, just a trifle different; both of them, curiously enough, in form almost exactly like the floor plan of my new Ford skyscraper, a circumscribed heart shape.

The toilet seat in my fashionable Tel Aviv hotel bathroom looked at me with the same almond-shaped eye as these windows, but was
446

cast in green pea-pale plastic. That toilet ring right in the midst of the biblical desert where, in Pharaoh's time, cacti needled your behind during a night's pee; but I suppose you got immune. Now the stubborn crust of the eternal sand is irrigated with Americo-English plumbing, the design-flow of the engines flushing the toilet compressor as evenly as the faint vibration of the plane I have boarded. Its operation is as smooth as English flannel, as the plastic seat.

The plane starts to lumber past blocks of stone houses flanked by solitary cypresses, planted guards standing at stiff attention; the airfield opens wide to an infinite disc, the runway bends to the left, the metal dolphin rolls cautiously onto the straight of the take-off, and, sucking in a deep breath, it seems to pull hard, shaking with strained power. Suddenly an interval of silence, with all of us in a suspenseful wait, but what appeared to be a come-down is actually the beginning of the take-off and the wings are soon climbing smoothly upward like arms raised to salute the sky.

From the air now, a shore line of ochre sand against the misty-blue of the Mediterranean sea; then land, sky and water melt into a single haze of silver. We are heading toward Athens, one hour and twenty minutes away.

We, alas, will have only a bird's-eye glimpse of the Parthenon, the airfield is too far away. Still, its image remains with me since I saw it for the first time three years ago.

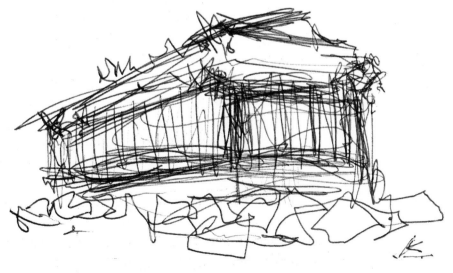

I fall back into my seat and try to settle. The window-eyes on both sides of the plane form a long perspective alley, their shapes are apparently stamped out from the same mold in an international assembly line and distributed with supersonic speed all over the world. WC seats, TV dinners, BB hairdos. This trend seems to be rising more from the core of a century, a society, than from the pencil of a dreaming designer. The will of a new style is planted into the soul of an artist, who calls it inspiration but is actually only following a command uttered in him. He is blindfolded during his creative act although he might claim to be boosting functionalism or some anti-ism. In truth, he is the willing slave of the unknown, selected from among a populace of millions by the grace of chance for duty on the chain-of-design-gang here or anywhere in our lands to produce what we then call "designs of progress."

The anodized aluminum cave of the airplane is almost empty of travelers, only ten instead of one hundred sixty-eight. Several have stretched themselves out across two seats, lifting up the armrest in between, getting two nifty pillows from a charming hostess and Scotch wool blankets to cover their feet which lie in distorted positions. All of them trying hard to rest, taking advantage of the level-headed jet flight.

I alone am sitting upright. I can never sleep in an airplane, a railroad car, or an overland bus, in anything that carries me by propulsion.

The chairs in front of me have an opening between them due to the wide armrest which separates them, and through this break I can see, to my surprise—being used to utter blank cleanliness in plane interiors—I can see on one of the seats a newspaper folded in half, of the same make-up and tabloid size as the *Mirror* in New York or the *News*. It looks truly abandoned, a leftover from another traveler who apparently disembarked at an earlier stop.

I pass my arm stealthily through this slit between the two backs until I am able to grip the newspaper and pull it into my lap.

I open the fold and see to my amazement not the *News* or *Mirror* but the daily *Cyprus Mail*. From the land of the beatitudinous Archbishop Makarios, a picture newspaper written in English, a cultural leftover, I suppose, from the English protectorate. With

448

it the Cypriots have inherited the whole decadent spirit of Western profiteering, of economic and political speculation.

"CHAGLAYAN BAR KAJMAKLI OPENING," reads one headline, and "FORMICA NEVER NEEDS RENOVATION" (the butter from my sandwich snack splashes over the front page, leaves a gray smear). "FRANCE HASTENS PEACE IN ALGERIA" . . . "RING OF STEEL AROUND DE GAULLE" . . . "FIDEL OFFERS MEN FOR BULLDOZERS" . . . "8000 POLICE TO GUARD TOP MEN IN VIENNA" . . . "DOCK YARD AT MALTA WILL BE 'THE BEST'" . . . "INDIAN JEWS RESENT IMPURITY CHARGE" . . .

". . . Bombay, May 20. The Union of Indian Orthodox Jewish Congregations has expressed 'great resentment' at the reported decision of Israel religious authorities to classify Indian Jews as 'impure.' Described as 'impure Jews' . . . refused to grant them licenses for marriage with other Jewish communities in Israel. The Union's Executive viewed with 'grave concern and horror' the report from Jerusalem . . ."

I am now flying above the Parthenon, the legendary Piraeus and the Acropolis. We are slowing down for a landing. The ship starts rocking descending on steps of cloud as steep as the terraces of Mount Olympus.

I find on page four: "THE MARBLES SEASON IS ON AGAIN," and I am pleased to find an important argument about art discussed amidst the stock-pile prices: "The old controversy around the Elgin Marbles has burst into flame again . . . the Marbles themselves, strangely named neither for their sculptor, Phidias, nor for their subject, the Acropolis, but for their purchaser, Lord Elgin . . ."

Here we have the money cancer of art, money eating into the bodies of the societies of East and West alike, a cancer which cannot be cured any more by deeds or deals, but most likely only by the ruthless thrust of knives into the foul bodies of museums, those mummifiers of paintings and sculptures, cold-blooded and passionless money-changers. And here

". . . are the mighty remains of the frieze of reliefs around the Parthenon, bought from the Turkish occupiers of Greece 160 years ago by Lord Elgin and now one of the most treasured possessions of the British Museum."

We have landed. Over the loudspeaker inside the airport the town crier babbles announcements in all directions . . . "Passengers transferring Istanbul-London Gate Three . . ." I turned to the gift counter. What an abundance of imitations . . .

I am shifted back into my BEA plane, locked up in the air. The take-off is swift, remarkably smooth. I open my belt and start counting the first minute of fifty-five Athens-Rome time particles, sixty seconds to each: one and two, and one and two is three . . . so relaxing is the bulk of the foam-rubber cushion under my head, which has fallen against the tall chair; the sponge never felt more pleasurable, a comforting companion indeed for my counting which goes on and on and on. I am fingering a time abacus with my mind till I will step down the staircase of the plane, walk across the airfield and up a ramp, finally to embrace Arita, who I am sure, must be waiting for me now, scanning the sky.

". . . divine wreckage of headless bodies at feast and of horses plunging through heaven on scattered feet, the Elgin Marbles have forced generations of shy British aesthetes to acknowledge [hear that my readers!] the glories of physical strength and nakedness. Unfortunately [I would say fortunately, dear Zeus, for the Britishers] the Greeks want them back . . ."

450

The article continues: "Next day the London Times . . . *roared at the top of its voice that Britain had paid the Turks for the goods [notice the term 'goods,' meaning sculptures] which therefore were British. It is, said the* Times, *hard to imagine a morally cleaner title to possession."*

——————— ———————

do we, dear public, still believe that Art
 can be bought?

no, it cannot.
like beliefs, it cannot.

those slaves of art, imprisoned in museum-camps,
those tag-branded sculptures and paintings,
constitute the last vestige of
obsolete colonialism—
a subterfuge of
pseudo culture,
parliament-blessed packaged and sealed

those exiled sculptures
exiled paintings
uprooted
looted

must, yes, must return to
where they came from
to live there
until washed away by wind and age
there not here, wherever, no, there

Mnemosyne bore Zeus nine daughters
in nine nights of love, the Muses.
sky-winged Pegasus stamping his hoof whenever
he alighted produced
spring on earth. so it
was, and still is, a poet's world

but to learn the truth about
art's origin and influence,
you, scholar, boy student-and-scout, must
travel-walk
> *travel-ride*
>> *travel-fly*
>>> *to the specific places of their birth*

not seek them
in the artificial environment of museums
but live the very climate
which bore the work

thus you may, lucky creatures, live one by one
the same hills and waters
groves, temples, huts
and be embraced by the warmth of the same sun
or hide under the cloak of the moon's cool nights

don't believe that we have to visit each and every one
of the places of antiquity
to assure knowledge of
their achievements
no one has to circle the globe
in jets or rockets
to snipe at cultures of the past
the way we do when speeding through museums
swallowing Rome, Athens, Peking
each in two hours of day-and-night- savings-time.
none of these sights
can give us insight

but one enduring visit
to a place of origin
be it Greece or Italy, China
or wherever
they were born
will fully bear witness for
other civilizations not visited.

such is the universal power of
a single
creative act
implanted in a work of art continually
echoing its message for a stranger
with patience.

Mnemosyne, mother of
the Muses, will guide you
wanderer
to the sacred springs of conception . . .
blessed indeed was Troy
 2300 before Christ
blessed the second Troy
 before Christ
blessed was Carthage
blessed Babylon Assur
blessed Hammurabi
until exhumed by
blue-eyed city-and-grave pilferers
uprooting columns
columns bereft of
their plumage capitals
human torsos
heads broken off
trunks penisless
arms lost
feet
cut-off breasts
and Tutankhamen's
golden caps
sheathing toes and fingers
stripped

see them lined up all helter-skelter
in day-or-fluorescent light

453

awakened
from their eternal
peace of death
trophied
in show-off cages through
plexi-lucite-safety glass
ready for inspection

if it must be
let all museums
of all the hemispheres
have plaster casts made,
plastic decalcomanias of the originals
have them
pedestaled, labeled, isolated,
for study or curiosity
of onrushing teachers
and students
and Sunday strollers, single
or in flocks
ok Yaphank

those who cannot travel too far away
or those who are homebound by destiny,
their awareness and love for the creative
can be easily satisfied by
craftsmen of their own environment,
local artisans,
artists who too depend on their community
and on whose spirit the community is dependent

an artistic life
educated by illustrations and print
provided for by the
artificial selection of the
whims and peculiarities of editors
is a life-of-art lived by reproductions
rather than by productions
of painting, sculpture or architecture.

they were originally created for
a living space in the natural media
of their craft—
only these works, only they,
have the true validity
to awaken [unadulterated] curiosity
and to impart growth in education.

we must not forget
that the sources of a valid work
lie in the fundamental correlation
of man to his total environment
and are not dependent
on profiteering intermediaries
of black and white
or color print,
films, slides, captions or
footnotes

that only leads
to imitation,
fads and fashions,
and finally to flying exhibitions
through museums and galleries
displaying
the inert exhibitionism
throughout no man's lands

but the main issue of the fate of originals of the plastic arts
remains statically unresolved
and I fear
that before the prison spell is lifted
and dispersed to oblivion
the gods, Greek or otherwise,
will make
art- and money-changers' heads
roll
like marble balls

providing thus the beat
for the exodus of the stone-amputees
unilateral

quadrilateral
torso-basket cases
at last to be
rehabilitated to their old habitat,
the country, town, polis
olive grove, wheat field,
each a satellite of Parnassus
where they and we
can finally breathe naturally and unconditioned

all romanticism aside
all science aside
all pride of discovery aside
the question of repatriation
is primarily a question of morals
and must remain so

once this fundamental question is resolved
then come the second, third
and other
how to actually reinstate
these artifacts and works of art
as they are called
by us who have lost
contact with the context
in which and for which
they have been initially created,
what to do with them and how
and when to change a misconception
once they have returned to the place of their nascence
the homestead, the agora,
the roads, the temples
many of which have vanished
partly or
totally

in what way to recreate
a true environment
congenial in spirit
with the one of origin—
that will have to be decided on
in each land and in each case
individually
and time and chance given
to readjust themselves to their new-old home
to live once more their destiny

they will be saved.
I know it
they will
Courage and glory to Athens!

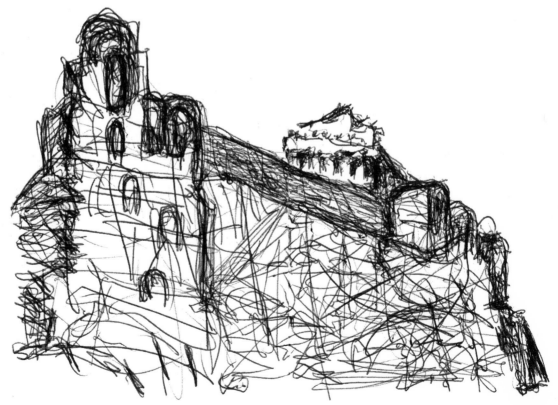

Individual paintings and sculptures—solitary mobile units—have existed independently of architecture since the fourteenth century and probably earlier, because man had discovered his extraordinary ability to reproduce natural sights in images made by his own hand, indeed a great distinction from his mammal ancestors. These portraits of people, objects of utility, forests and rivers, or the sky, these portraits were meant to fix the memory of them as permanently as possible, the glorification of an encounter. After centuries, such pictures lost their meaning as personal insignia. Desirable at the moment, their destiny became more and more ephemeral with the passage of time.

But art—as opposed to images of fleeting moments—was the magic circle of a man-made environment in which walls, ceilings, floors, and useful objects were transformed in a condensed, abstract manner. Even the bodies of people were painted or covered with garments of man's invention. Sights were not merely captured but became visions, with nature's reality transformed into a new image and typified rather than individualized. Thus man created a man-made universe in which he could feel protected from the unknown, the unknown which still persists in spite of science, technology and industry.

What is lacking today is an equivalent environment of our time, a co-ordination of our arts and architecture, all integrated into a new circle girding us with its magic of harmony in a world of ever-impending frustration. Of course, when everything in our physical environment becomes infused with fundamental content, then the objects of art are no longer objets d'art but part and parcel of everyday life. No imitations of cave paintings or of cathedrals, palaces or executive mansions, but every man's home to be an inspiration for his own more imaginative, exuberant life, without gadgeteering. Art and architecture unified—and the unification achieved for the purpose of man's own life and not for somebody else whom he fears, whether an imaginary god or an industrial or government despot.

Let the individual objet d'art continue, for the pleasure of memory, and let the artist, the collector and the museums have their play with aesthetics as a refuge from the harassment of unresolved social and economic conditions. Let them have a few concubines of art. Forbidden fruits even in ivory, stone or wood are a delight to the bite of the eye.

458

Summer
June 30, 1961

Afternoon, with Peggy Jackson, and she spoke, lying on her back on my lawn to dry her swimming suit wet with ocean:

"The sea is the perfect lover.

"He holds you with the lure of softness which seems an old dream coming true. Your fears of the ultimate are heightened by the waves' continual embrace, a squeeze of tender determination, an irresistible grip.

"The sea never lets go: float on top or face down, half or fully buried in the flesh of the water, you are happy and happier, your fears buried deeper and deeper.

"The hills of your torso match perfectly the valleys of your lover. He tosses your body as on a spit until the undertow will pull you, the woman, toward him and against your will. Now the lover does as he wills, and his rape, conquest, is the only one that quenches fully the thirst for love.

"Then comes the twist of a wave and it strives relentlessly to enter you—here, there everywhere, making your body the house of a thousand doors.

"The sea is the blind lover with the vision of instinct. The temperament of the sea is a mystery until you succumb; then the mystery vanishes. It's the turning point from casualness to intensity as inevitable as the tide after the ebb. The sea's temperature equals your temperament, the fit is perfect: timing, space, and heat that cools. The foam crackles. The most powerful woman has no control over the tide, she is overruled.

"Now the arms of the ocean envelop you in a total grip. The sea makes you feel afloat, weightless, except for the weight of your lover. Earth, water, sky: you are all of it. Your lover's body is now a lullaby of peace. At other times he is relentless, has a constant drive which wears you down and destroys you, as a rock is whittled away. You don't mind, you have aimed at it all your life. Now delivery is salvation. Ebb and flow is the rhythm of the man making love. If you want or not, you submit to rape, like death, that final embrace of our destiny; and drowning is new life."

459

As a vast space is broken by a single water jet shooting up through a dense cement floor, so did Peggy break my solid quietude by fixing her gaze suddenly on me, forcing my eyes and ears on her to accept the shower of a tale, urgently and apparently of necessity emerging.

"Twice a year, you know," she shot at me, "I pile all sorts of clothing into the car and take it to the cleaners. In May, it's the woolens—dresses, sweaters, blankets, and last time six pairs of my boys' trousers, too. In fall, it's the summer things—the depressed silk and organdy dresses are cleaned and made ready to parade into a pink spring.

"You know the American obsession, hygiene; it is something to hold on to like your flag. Your hands get dirty but you wash them, the cloth gets soiled, but see, you send it to the cleaners and everything is O.K. again.

"I don't know why, but moments come when I have to dedicate myself to someone else or take care of something, and the twice-a-year cleaning routine helps me to get active in a practical way. It's good therapy for your nerves, helps you veer away from your emotions. Particularly since these days I no longer take care of my two boys because they're at Harvard. I transfer my care to these objects, I mean the sweaters, the socks, et cetera. And I know I'll still be busy when they come back from the cleaners. I'll have to sew buttons on (they get broken in those cleaning turbines, or lost), stitch some lining back in, things like that, look each garment over carefully and darn holes before they are laid to rest in the pliofilm bags.

"The season for moths to lay their eggs is May, so May is the month to protect the winter garments. But in spite of that, I put off doing it, and then last month, almost too late, the day for action came. There were no telephone calls, no real-estate business pressuring me, so I felt, This is it. It really was.

"I took on the whole mess. I went forth and back, in and out of every room of my house, into every closet, into every drawer—I still hear their hollow sound when I slammed them closed. The little boys' things left behind since, oh, so many years ago, I took to poor children of the neighborhood, who need clothes badly. I was contented. I did as thorough a job as possible. I was in the

attic, in the cellar, went to both villages—Lambertville and New Hope—to the hardware store and the cleaner, the laundry, taking things into the car, out of the car.

"It was twilight when I finally got into the tub to bathe, and suddenly discovered that my mother's bracelet which I wear on my left wrist all the time wasn't there any more. It was gone. I had obviously lost it that day. This bracelet was given to me by my sweet mother the day she died. Since then—and it's been many years—I have never had it off my wrist. I was shocked and felt desperate. All my efforts and labors of this cleaning day seemed useless, with that loss as the pay-off. Obviously I couldn't go back to all the places I had been that day; it would be silly, in fact, impossible, to retrace all my hopping in and out, coming and going. The loss seemed final. It was simply too much and too late anyhow.

"The water in my tub was still transparent in spite of my soaping and washing off. My legs silhouetted against the white bottom of the tub. I looked along and between them, lifted my arms to look behind me. The contours of my submerged hips were bulky and utterly ugly—no bracelet. The water felt more humid from minute to minute, it was clammy to a degree that at any other time would have made me stand up at once and shower it all off—but not now. I decided to do only one thing before dark: to search for the bracelet in one place and in no others, and, if it wasn't there, just to give up. I chose to look for it in the driveway, the transfer place of all my hustle and bustle. Thus I reasoned, stepped out of the tub, draped a towel over my front and entered the driveway. Protected by my fence and the lilac bushes, I walked the short route on tiptoes, staring at the ground, my two eyes focusing through their lenses, my inner searchbeam of light. The sandy, slightly pebbled, driveway gave no gleam of gold; it was nothing but desert.

"I walked back into my house. In the living room, I turned on the television set and had a cup of cold coffee to console myself. I put the bracelet out of my mind. I really did. I let my thoughts loose and forgot it.

"I did not bring it back to mind again until the next morning. I was sitting in my bed, reading the Sunday *Times*, when I suddenly put down my cup of coffee, pushed the newspaper aside,

walked over to my closet where the new pliofilm bags were hanging, opened the door, put my hand inside one of the bags, down to the bottom of it, and picked the bracelet up. I remember I was not a bit surprised. I did not say, 'Oh! goody, how lucky I am.' No such thoughts.

"I snapped it on my wrist, got back into my bed, picked up the newspaper and finished my breakfast."

"Peggy, what made you get up and look for it in your closet and then dip your hand into one of the bags? Did you receive a secret message from some buzzing mosquito?"

"I don't know, I really don't know. But wait . . .

"A year ago I had lost the bracelet and given it up too. I found it twelve hours later in a bush outside the house. Pulled the branches apart and there it was on the ground. It was lost under similar circumstances. I was clearing up the garden yard. You see: cleaning again. Instead of clothes, my arms were full of dry leaves."

Peggy stopped talking. I was watching her ardently. Her enlivened face had frozen into a mask of memory. After a few seconds, not more than three or four, she came back to now. And she spoke again, but with a smile that wiped off all the marks of her harassing experience:

"Yesterday afternoon I told you about my feelings, 'sea is the perfect lover' and 'the most powerful woman has no control over the tide, she is overruled.' Well, at midnight I wanted to go into the ocean with John, your friend, and I realized that my bracelet might be swallowed up by the sea, so I took it off, went to the car and locked it up in the glove compartment. Then I went into the water. It felt fine to have sea waves caressing my wrist, freed from the clutches of my bracelet."

Suddenly I got the link. "With your bracelet, you locked your mother out of the way." I clinched it.

"Look"—and she stretched her naked summer arm out toward me—"it's not on." She swallowed a giggle. She was free.

I am here at a rented summer house, a hundred-fifty-year-old salt-box, now a modernized cottage still retaining its massive wooden honey-colored planks, covering the floor, and in the living room, once the family kitchen, the planks line up one next to the other as high as the low and beamed ceiling goes.

The white sky seen from the porch hovers above a ring of July-green trees, which circle at fifty feet distance.

This veranda, protruding from the house proper, faces the garden and is covered on its three sides with open mesh screens. It has a solid shingle roof protecting us against the direct blows of the sun, as the mesh shields us from the stings of mosquitoes. It is in fact a sheltered outdoor living room in which we three, that is, guests Peggy and Lillian, and I, linger on an old chaise longue covered with an ugly blue plastic, a wooden rocker and a modernistic aluminum folder. Physical comfort most conducive to listening silence.

Only a few minutes ago a motorcycle carrying the son of our neighbor, sculptor Nivola, descended upon us, bringing a peach tart from his German mother, a weekly gift now neatly placed in the middle of the round table.

Neither the rocket sputter of the motorcycle nor the sweet look and smell of the peach tart disrupted the peace of the hour, a tranquility padded by the dense white clouds to form an absolute quietude, this Sunday high noon.

The silence became penetrating, with a voice that could be persistently heard, not with our (commonplace) ears but with our pores, as compelling as the continuous whisper of a sea shell.

Gradually the peace gave way to a feeling of emptiness, and, as in the emergency of drowning one grasps anything tangible, so we felt forced to break that silence and talk about something. The thing I chose to hold on to was a sentence I remembered from the day before, growing out of one of the recent events that had stirred us all: the suicide of Ernest Hemingway.

"Do you remember," my wife, Steffi, had said to me in New York, "when we met Hemingway, for the first and last time, in 1925 with Jane Heap?"

463

And I started to recount to my friends on the veranda an incident of more than thirty years ago.

It was on the terrace of the Café Select in Paris. The café had opened only a few days earlier, we were told, and had already become known as the café of the Americans.

We had lived the year long in Paris. Jane Heap, we heard, was an editor of the avant-garde *Little Review* and first to print in the U.S.A. chapters from James Joyce's *Ulysses*. She came to see us to induce me, at the insistence of Tristan Tzara, to reassemble the large international exhibition of theater models and scenic designs then being shown in Paris so that it might be transported to New York.

We had an appointment with her at the Select to discuss the matter once more, and to make it stick.

As Steffi and I arrived, she was standing in the entrance to the terrace with Hemingway. I remember our first impression of him very well. He was without hat, wore sloppy clothing, an open shirt, the face unshaven and both shoes split at the toes. He looked so dilapidated even in comparison with artists of Paris, artists, literati or renegades, that the imprint of his looks still lives with me. We would easily say today that he was the very image of a beatnik; probably the first one outside the U.S.A. His Bowery-bum appearance, you felt, however, only covered up the generous heart of a young American, foreign to Paris, posing strength to disguise his displacement in a world already full to the rim with artists of great renown. In spite of his forlornness, he was feigning a smile, waiting to be introduced.

His hatlessness and his disheveled dark hair were in strong contrast to Jane Heap's head because she wore, as always, a man's black felt.

"Ernest," she said, "this is Mr. and Mrs. Kiesler. They might go to America. The Theater Guild is ready to invite them and we expect Lawrence Langner to arrive any day to put his seal on the invitation. Kiesler first assembled this show for the Vienna Theater Festival and you can now see it at the Grand Palais of the World's Fair."

She made a communicative turn with her head from him to us, with a cordial smile from us to him, inducing us to stretch our arms out for a handshake.

Hemingway froze in his *salope* position and said, "I do not shake hands with Germans or Austrians."

With that he turned around and away and disappeared inside the café.

The first World War was apparently not yet over for him.

Unfortunately, it was our only meeting with Hemingway. He stayed in France. We left for America in February 1926. It is now July 1961. We became Americans. He could have shaken hands with us now. But he is gone.

July 17, 1961

> *Men say they know many things*
> *But lo! they have taken wings,—*
> *The arts and sciences,*
> *And a thousand appliances:*
> *The wind that blows*
> *Is all that anybody knows.*
>
> (*Thoreau*)

That rocky island of Manhattan, stolid base for a megalopolis, our New York City, bought from tiptoeing Indians for twenty-four silver dollars, has, after three hundred and twenty-nine years, become a toe-dancing billion-dollar baby.

The populace stacks its floors like packs of bank notes one atop the other until the greenbacks scratch the sky and delight in the reflection of its abstract blue, as if blessed by heaven. In between the scrapers live the poor, the money-makers and the money-changers, and underneath it all, through endless tunnels which the people have dug, citizens rush forth and back, morning after morning and night after night, to homes or jobs, as if fearful of losing both.

Atop the piles of floors, the architects put up
tin crowns of Architecture,
imitations of Egyptian tombs,
Greek temples, Renaissance domes,
Turkish minarets,
or lately,
Treasure-Chests of air-conditioning—
and over it all, they pour
electronic gravy
of slimy
advertising.

Yes, at night the city's skyscrapers put on their evening jewelry made of artificial light. The earth opens the gates of her secret jewel zoos, lets out endless coils of luminescence, snakes crawling without stop among the flashing eyes of tigers, flying peacocks, cranes, and dragons, also manticores, beasts that have the face of a man with the hissing flame of red retinas. It's a display for everybody who has eyes to steal—ravishing in its waste of beauty.

But during the day, in that ruthless daylight of a stinging hot July noon, the naked buildings of the same, the exactly same city, are agonizingly barren and banal; in spite of the courageous forays of embattled architects, the city—filled to its dead ends with the hurry and scurry of a vigorous population—still seems empty of architecture's life, clusters of petrified shelters, "machines for living," vast containers with little content to transcend the natural limitations of shelter.

Why, after so many centuries of tryouts, are we still building these dried-out shells which clamp down our bodies and souls instead of helping us to embrace the world by day, by night, at dusk and dawn, that world we are born to live in rather than to be crushed by. Why do the buildings fail in their purpose of birth? And that in spite of such pioneer architects as Jefferson, Frank Lloyd Wright, Richardson and dozens of ideal-pushers against the stream of conformity.

And this is a city
in name—but in deed
it is a pack of people
that seek after meed
for officers and all
do seek their own gain
but for the wealth of the common
no one taketh pain.
And hell without order
I may it well call
where every man is for himself
and no man for all.

This is a quotation from Robert Crowley's writings in the sixteenth century, but I find, by a strange coincidence on this day in the 1960's, on the front page of *The New York Times*, the outcry of Robert C. Wood, associate professor of Political Science at the Massachusetts Institute of Technology, who predicts "regional chaos within twenty-five years." He envisions "an unplanned, shapeless, unrelated sprawl of houses, factories, offices, shops, stores and recreational areas covering the region's twenty-two counties in New York, New Jersey and Connecticut."

He foresees "more and more traffic jams, noises, air pollution . . . obsolescence, with inadequate housing, unsolved problems of railroad commuting, and poor access to both city centers and open spaces." And he declares: "On the Eastern Seaboard of the United States, where the State of New York wedges itself between New Jersey and Connecticut, explorers of political affairs can observe one of the great *unnatural wonders* of the world . . . the economic capital of the nation . . . determined more by chance than by design."

There it is, grandiose New York, twenty-two stories below my home dwelling, a city made visible at night by its myriad window lights, the one-thousand-and-one-nights Arabian dream, so inspiring, but only in the hours when all plasticity of architecture is wiped out, when the buildings have lost their pseudo substance, that is, at night, when nothing is left but the iridescence of electric stars.

And looking at the same city from my terrace, once more during my thirty-six years of living atop this tall building, and particularly today in the harsh and merciless light of this hot July day, I am moved to awe by the mighty will to power of the city skyscrapers, raised like arms taking the oath of success; I am bewitched, but at the same time I am anguished (as are so many dwellers) at the opportunities lost by architects, builders, financiers and speculators, to make the buildings architecturally inspiring, a satisfying experience functionally and aesthetically, enriching human potentialities. Instead, we find building after building, low or high rise, still potential slums (no matter how recently erected); a casualness of concept and execution, in spite of building codes (or because of them) and stiff competition, be they office structures, residences or churches. Most of them represent emergency solutions based on worn-out models, too many of them are hand-to-cash designs, in spite of the universities bent on teaching well, the libraries available to search in, wide traveling to gain experience of the best in old and new architecture. And let's not forget all the printed information in the daily press, the periodicals with their specialized essays and construction surveys, and the monster load of reference books in architects' offices.

The dehumanization of architecture seems to have taken place during the shift from hand to machine production. We live in an in-between period which has lost the inborn responsibility that goes with either direct handcraft or the indirect machine to produce housing adequate in structure and aesthetics. Responsibility for quality in design has been laid at the feet of the Unknown Machine, instead of with the individual and the group. But it is exactly the individual and the group on whom we must rely to reset the disjoint. Most of us are only too aware of this—but powerless to do anything.

The utter detachment of the modern architect from the materials he builds with, be they for houses or chairs, has demoralized the profession. No longer does the architect-builder collaborate hand in hand with the skilled and unskilled laborer as in the times of the guilds, not to speak of earlier periods when shelter-building was a natural procedure rooted in tribal tradition and fashion fiction was nonexistent.

Today the industrialized production of building parts has produced standard scales of design, thus giving architects the perfect

excuse to fall in line, to conform to fashion—all in the devil's name of saving time and money. Industrial organization methods have overflowed into the architects' offices, influencing decidedly their own work methods and office procedures. We are turning out frozen building types. We are killing architecture hit-and-run by planning. We are approaching, at rocket speed, the Death Dance of Design.

Therefore, for myself, I am trying to clarify the causes of this phenomenon of anti-architecture and I dedicate my thoughts to it:

Dedication to the Architect of the Indoor Desert

I am speaking of the indoor desert which is, clearly, the office world of the many professionals, those "pro"-men one judges fit as designers, constructors and decorators at the drafting board, but in whom, at the board meetings, in their own offices, or at their clients', when real decisions on design or construction have to be made, one witnesses again and again the breakdown of their design character. Those proud bearers of a noble profession crack.

It is truly heart- and spirit-breaking to see good and best men being forced to abandon their original pursuit of quality. This happens for several reasons, of which they themselves must be aware:

first:

their own lack of persistence to stand up long enough for their beliefs. They seem only to come up to the brink of truth, hardly ever to truth itself;

469

second:

their routine resignation to compromise, with the excuse of economic survival, a powerful weapon. The marriage of art and architecture, even isolated functional progress in architecture, presents for everyone a crucial test: how much to give in, and how much to remain steadfast. The painter has it easier: he is the master of his own production. The architect depends on other people to accept his ideas, such as the owner, the engineers, the contractors. The architect only remains the master of the whole complex of building if he is ready to sacrifice profits to quality. If he resists compromise too much and too often, there appear the nightmare images of his financial obligations to his family, his jeopardized security, the dispersion of his office staff, and last but not least, the humiliation of giving up his office. But that applies chiefly to small firms. It does not, definitely not, apply to large firms. These companies can afford to be firm, yet they give in. It is they, the big offices, with plenty of jobs at their command, whom we have to rely upon to clear the path for straight-foreward design-in-progress. The tragedy truly lies in the fact that knowing by experience, and therefore in advance, that they might not be able to maintain resistance strong and long enough, they give up—even before the first sketches—the pursuit of a design-in-progress. It is a psychological block which very few can overcome. *The accumulation of these various "give-ups" forms the pattern for a whole town, a city, and even a country.* And no one in particular can be pinpointed as the guilty party. There always remains, at the board meetings, the presiding ghost with his hypnotic command not to forget that the main goal is selling the design and with it, the office which produced that design;

third:

the pros easily become subservient to contractors and engineers, due to the ever-increasing specialization in the building field. They know that after first estimates, the contractor's prices on specific jobs will usually rise, and rise maliciously over fixed

budgets to the agony of the helpless client as well as the pro; yet the pro goes on instead of off;

fourth:

they are white liars; they denounce the masters of design they imitate and often banalize—those good men, those honest men, who give freely;

fifth:

they lack courage. They must hate themselves because they are unable to solve their design problems with guts rather than greed; because they lack the moral responsibility to share the overflow of business with younger men, to hire, or associate with, or give a job to those capable design-planners who are vainly hunting for chances and get none, who succeed only on those occasions when crumbs from the tables of the rich cartels fall overboard.

Our prosperous pros would, by sharing, satisfy not only their own consciences, but also prove to the community that our cities and towns could be much happier places to live in, that is, if adequately designed and carried out craftsman-like; yet, in spite of this depressing state of affairs, they hardly ever agree to farm out jobs; overstuffed, they are still greedy for more, they go on and on, expanding their services to industries, to governments, to private clients, particularly in times of prosperity, prosperity, that potential killer of quality in art and architecture, where time, meditation and humility are eternal facts of creation; the prosperous go on, adding table after table to their drafting rooms, hiring personnel, piling more and more bookkeeping into their ever-increasing filing cabinets; not to forget their office libraries, incubators for cross-breeding by skimming through the latest reviews, magazines and newsletters, just to be on the *qui vive* and ahead of the office next door.

Oh, so many architects of so many buildings claim to have designed the architecture while having only designated someone to conceive for them, and assume fatherhood through their signature, not out of planned deceit but simply because they have no time to solve the basic questions of a project. Even if they wanted to, they can't; those pros must become promoters of business, conferenciers, cocktail mixers, after-dinner hosts, contractees, and the newly born project is left to foster office-parents who try their best "under the circumstances." But it is more important for the architect to be true to himself than to circumstances. Therefore he cannot rely on foster parents to conceive and conclude the project. Only he can:

side-step routine complaints,
change or amend programs,
resist clock-control,
bypass economics,
reinforce basic solutions rather than
 applied ones,
thus bringing a project home to Architecture
rather than bestowing degeneration
 onto coming generations.

See and study the Seagram Tower by Miës van der Rohe where he has affirmed just
that. Yet its bronze façade is almost
disintegrating from the blabber-fallout
of imitators' gossip.

Those registered regulars, the twelve-o'clock-lunch boys, going in twos and threes from their offices to eat and sip around the corner, hatless summer and winter, slipping both hands into their trouser pockets, pushing them underneath the jacket so that the folds tumble forward over their arms, because you don't pull the coat back and stick your hands into the trousers just like that: that's the lazy grocer's attitude; you must saunter to appear smug. In reality, these are the Teddy Boys of Architecture, headline-seekers, unaware that they might become the inheritors of equally delinquent father-professionals.

August 14, 1961

One of those overstuffed days, with appointments and routine disappointments, but no harm done.

472

Late morning: Phoned the Ford Foundation to get permission to visit my own model of the Universal Theater, sleeping in dead storage, curled up in its cast-aluminum coat waiting to be awakened by my gaze.

Midday: At 1 P.M. joined art historian Argan of Rome and Mme. Bucarelli, director plenipotentiary of the Museum of Rome, both here for the Congress of Art Historians. We three converged at the Plaza Hotel to have luncheon in the bar. Famous wood-paneled, Central Park-outlooking barroom, but barred to us: "Sorry, only men up to three o'clock." Argan and Mme. Bucarelli stunned at such regulations in democratic U.S.A. We left.

Across plaza, sunbathed and windblown, the open space surrounded by old buildings of American vintage yet aged enough to remind us of Rome and Paris. We slipped quickly into a fancy luncheonette at the corner of 59th Street and Fifth Avenue where, at this time and hour, every nook and high stool is occupied, and people stand in line waiting to be fed in plush haste. My guests amazingly patient. Finally we sat down at a tiny wall table for two with one chair added by special permission of the manager. But the waitress made it clear in polite tones that she would not be able to serve more than two luncheons on that small surface —"It's against union regulations"—and that I could have only a cup of coffee or a glass of juice. I conformed.

Afternoon: By taxi, we three went to the Hahn Brothers' storage building on West 107th Street, temporary mausoleum of Ford Foundation models, to view my model theater. On the third floor we saw it, minus one of its shell lids which had to be put back on by an attendant before I invited my guests to see it. Unexpectedly the dean of a school of architecture (well known) appeared. I had forgotten that he had been hired by the Ford Foundation to arrange for the models to be shown in the coming year. He, who only last year prevented my being nominated architect for the Juilliard School of Music at the new Lincoln Center, embraced me now and said, "I've never seen such a wonderful piece of architecture as your theater! Thanks for giving me a chance to exhibit it." This is splitting the blue sky with a sword and out of the gash bubbles urine.

Forgot to have the taxi wait for us, and we had to stand on a god-forlorn uptown street of the West Side for an endless time. It

must have looked as gloomy to my Roman friends as an abandoned movie set.

After seeing my Italian friends off to Columbia University, I dashed downtown to my office to work on the Science Building. Later home to work on correspondence. Contacted town planner Paul Wiener and his wife Ingeborg to join me for dinner with Argan and Mme. Bucarelli.

Early Evening: I met again with Argan and Mme. Bucarelli at Loeb Student Center of New York University at Washington Square. Here they viewed my "Endless House" model on its last day of exhibition. The lounge of the Student Center, that is, its walls, were completely barren of the usual display of paintings and sculptures, apparently being readied for a new show to come in, but the floor, an immense one, was crowded, actually littered, with modern and pseudo-modern chairs, sofas and tables, huddled together into a big herd, like animals before the break of a storm. I had to bribe one of the guards to put the lights on for us so the model could be seen. If I remember correctly, my friends were stunned at the consistent curvatures of my house, rolled up on its pedestal like a sex-kitten.

Walking from Washington Square through MacDougal Street over to Fourth Street, my guests were amazed to see night clubs and cafés interspersed with strip-tease boîtes, promenading teenagers, females with boys' shirts hanging over their waist to their knees, mono-sexual boys with panty-pants as tight around their hips as brassieres, and Negro girls with their pro-African short sculpted hair-undos. This was not Via Veneto of Rome, but it was O.K. Greenwich Village, an off-beat Montmartre.

Dinner: The Wieners came, and earlier than we, that is at 7:45, to Monte's Italian restaurant on MacDougal Street where I had reserved a table for five. Strange to see two lonely people sitting around an empty white-linen lake of a round table while the rest of the restaurant is overcrowded with eating and waiting people. The owners were faithful to my twenty years' patronage and held the table for us.

"I recommend manicotti," I said. In unison my Roman friends asked, "What is manicotti?" I answered, "It's one of the most Italian dishes in New York."

"Never heard of it in Italy!" both answered.

"Then it's like chow mein," I said, resigned, "which doesn't exist in China."

After manicotti, the conversation started:

"It's the perfect fascist citadel, Brasilia," Argan said to town planner Wiener, referring to Brazil's newly constructed capital which he and I visited two years ago during the Congress of Art and Architecture. "It's waiting for a dictator, it's socially and economically deliberate, an imposition on the populace just like Mussolini's city outside Rome, E. 42. That's dead. And reviving the idea is like filling a cemetery with living people. A vanity in vain."

I found myself defending Niemeyer, the architect of Brasilia who, I said, played single-handedly an architectural chess game on an enormous land, empty, barren, desolate, and had to invent the individual chess pieces, too. A gigantic task. The capital of Brasilia created out of the void and in a void. It's the only abstract city on this globe, just as Frank Lloyd Wright's Guggenheim Museum is the only abstract building of our time. Both will have to wait for other generations to inject life into them.

Evening: Around the corner from the restaurant a group of young actors were playing Dylan Thomas' *Under Milk Wood* which I had seen before and found excellent. I invited my guests to hear it. Production and reading of this beautiful poem were splendid, but Argan and Madame didn't get the Welsh of it, and my whispered translations flustered my neighbors. After the intermission, we left. Argan suffered from a cold and had been fighting it with aspirin during the play. He was eager to go to bed.

We could not find a taxi on Bleecker Street. But while waiting for one, my Roman friends caught another image of New York. Across the street a flophouse stood, the front cheerfully illuminated by a bright red-and-blue neon sign, "Hotel," quite imposing. A ten-story New York business-structure.

"Behind those bourgeois stone walls, you can see bums, drunkards, social fallouts, people-all, sleep-sitting on benches, their arms and heads resting on railings of rope for twenty-five cents

475

a night. Dylan Thomas drank himself to death only a few blocks away from here at the White Horse Tavern on Hudson Street and in between is St. Vincent's Hospital, where he died."

"*À mercredi, semaine prochaine*," Argan and Mme. Bucarelli threw at me from the departing taxi, "when we return from Philadelphia. *Merci.*"

I decided to stroll home. No taxi for me tonight. Instead, landmarks and memories. From Fourth Street and Sullivan (Varèse dwells here) along Washington Square's Waverly Place (where sculptor Nivola hides at home); winding through the milling crowd of tourists and artists on Eighth Street, turning into Sixth Avenue (where I once dined so often with Charles at his French restaurant); through Greenwich Avenue (painter Irene Rice Peirera, ten years, fifteen years ago in that pseudo-brownstone house); bypassing Patchin Place (old-time friend E. E. Cummings lived here and Matta, too); finally turning into Seventh Avenue, passing Thirteenth Street (Howard and Barbara Wise have just moved in down the block) where, on the corner, a giant new apartment house rises forbiddingly and replaces, but not for me—spiritually—the old home of Stuart Davis once on that spot.

Finally, across from it, I reach my home gate, Number 56 Seventh Avenue, erected thirty-two years ago and ever since my dwelling place.

The walk through the August night was unwinding, at the same time rewinding my peace. I felt I had discharged all of my duties as well as I could. The evening was already of the past. The push-button elevator lifted me gently toward the sky. I looked forward to my sleep as on a bed of clouds of peaceful memories.

August 18, 1961

Today was another day of many dates.

Many-colored months of waiting, hoping and planning compressed into twelve hours of a pre-noon, noon, afternoon, and evening.

476

At eleven o'clock, builder Chanin; at one o'clock, Billy Rose; at three o'clock, Exhibit-Master Messer; at seven thirty, dinner with friend Peggy, and at nine o'clock, the last date, with the author couple of Broadway, the Kanins.

Action Living:

Living in New York, that is, toiling in New York, is often so multifaceted that one wonders how it is possible to compound so many activities into a single day. Yet we do it. The answer is: The more the better, otherwise we miss it. Be it the compulsion of survival or fascination with the abundance of possibilities for advancing your causes—everyone does it. Thinking about it sanely, the activities seem absurd, frivolous, if not obscene.

Let me start my account with Mr. Chanin, the chairman of the architectural committee for the medical research building of a college. The other encounters will follow as they fall into the order of the day.

The Classical Compromise

This meeting engendered the typical anguish of the architect, progressing from a first imperceptible pressure on him to change his design to a definite command, however softened by back-slapping. The trumpets of compromise sound with a fortissimo muffled like the drums of the firing squad. They paralyze nevertheless.

Compromise in design is, of course, an accepted ritual these days, but the question is how far do you compromise your design, and how far do you compromise yourself, how much do you compromise your own organization or the firm you're working with, and how much will you compromise your friends who see it and try to defend you, talking about the various circumstances which forced you to compromise. So, from composition to compromise is a matter of comparative values, and that comparison is made by

people of good will and by those of ill will. Although compromise is not an invention of our time, it has been made more pernicious by the implicit dictate to combine Art and Business for the sake of Sales. Of course, it's legitimate to attempt to submit to the personalities of your collaborators and to try to subdue the dominance of your own individuality, to try to put yourself on a level where others can reach you. But the persistence of compromise may, without your being aware of it, pull you down, down, down and finally into a hole from which you may never come up again, left to breathe that foul air of self-deceit which truly stinks to heaven.

So there you are on the lower level, pseudo-successful. Once you place yourself on the popular ground, everyone will understand you; but sooner or later you won't understand yourself. You have ditched your belief and given in to a low concept of your profession.

Had my discussion with Mr. Chanin in solitude, on top of the Chanin Building. The interior of this office is wood-paneled, the ceiling in silver, black and white cassettes is of 1925 Paris World's Fair modernism. The furniture is also of that period. Facing him is facing valid standards of the past. His speech, however, is lingo of today. Being a builder as well as philanthropist, all the more does he consider the price and the maintenance involved in any project. This means: providing just enough space, rooms, and equipment to shelter and sustain the work being done. Standardization of routine practice. Antagonism still persists everywhere against all attempts in architecture which might be genuinely new.

Thus, a minimum of equipment and space is considered sufficient for research. The artist-architect must adapt himself to the dictates of prevailing economics and prevailing aesthetics. I hope a future time will bring the boards of overseers of now and tomorrow to reverse themselves and adopt the vision of the artist-worker, a vision perhaps not always too clearly defined since it is a work in progress, but strongly felt and needed by the creative mind.

The doctors themselves had been very much interested in our first scheme. As a matter of fact, my partner and I had worked in close co-operation and consultation with them for almost three-quarters of a year. We had devised a plan where, in an eleven-story

building, each floor was drawing its main light from a skylight which jutted out diagonally from the bulk of the building. The walls curved out and each skylight above receded toward the next floor to meet the next wall, this pattern repeating for eleven stories. The exterior of the building would otherwise be without windows, to insure the necessary seclusion and soundproofing for the workers. One doctor insisted that he would like to be able to look out, purely from an emotional point of view, and so we inserted elliptical windows, horizontally, a little larger than you might have in your car, sufficient for a look at the outside world. But once the architects started to give in, their good will proved seductive to the client: the doctors subsequently requested a complete glass wall in the customary functional fashion and so we had to change the entire scheme. The Board of Directors sensed savings in the making, and finally the whole skylight idea and the oval windows were thrown out. Thus we arrived, step by step, at the ordinary Sears-Roebuck, Hearns, Bohack façade. We would now have to lay bricks like a mosaic, one on top of the other and next to the other, which means corners, sharp corners, the opposite of our flowing concrete forms. We must insert standard casement windows. In case you do not know about them, they are the windows you see in old-fashioned apartment houses today, either in iron, painted black or white or gray, or in aluminum. Now it's all a matter of cost and comparison studies: of the way you set them into the brick, of how the outside walls prevent them from falling out, or caving in, and the rain from seeping through them; of the manner of window cleaning, which under these circumstances has to be done from inside and outside almost simultaneously.

Remember the eyeglasses of your grandparents? They were fitted in steel. My father had lenses encased in slender gold. The oculists currently sell imitation tortoise frames, plastics, inlaid plastics (the Eskimos still wear wooden eye-plaques with a tiny slit), but what possible assistance are these various fittings to better sight or aesthetics, especially when contact lenses have made all framing obsolete? All they do is perpetuate a dead-end approach to aesthetics.

Depressing for any designer to give up ideas which have grown out of his persistent ideals.

I will, for the first time in my life, have to accept a compromise amounting to defeat or else close up shop. The steel web of cir-

cumstances has closed on me and my partner.

As I was leaving Mr. Chanin in his fifty-six-story-high building at 42nd Street and Lexington Avenue, I recalled having gone up one floor higher about twenty-five years ago when Erika Mann, Thomas Mann's daughter, came to this country with a cabaret troupe, *The Peppermill*, and played in the Chanin private theater on top of this same skyscraper, a performance we all enjoyed, particularly those of us ex-patriots from Europe with our sense of political satire. It was she, currently in Switzerland recovering from a serious automobile accident, whom I recalled now as I descended in the automatic elevator from the highest part of the Chanin Building to the low level of my compromise. I wonder how I'll recover.

Intermission:

My solar plexus signaled hunger. And starved I was. Found a luncheonette right down there. Committed to pick up Billy Rose in fifteen minutes, I stepped into the coffee shop, which had little time to serve breakfast at noon. Ordered my usual two fried eggs, with an apology to the waitress for troubling her with a cooked-to-order item at rush hour. She: "Oh no, sir, no bother! This is my job!" Her friendliness did me good, as did my customary breakfast bite, which I now had as lunch. I twirled out the revolving door to find Billy Rose.

The Show Goes On:

From the architecture of Billy Rose's side-street palace, you expect, on ringing the bell of the monumental door, that it will be opened by two guards in armor standing left and right, presenting arms designed by Lipchitz. Instead, a Latin American came to

480

answer, struggling into his jacket. In a very *kauderwelsch* English, "Appointment?"

Upstairs, I met Billy slipping on his jacket over a South Sea Island shirt. Open collar, khaki trousers. Bright squirrel eyes. Said he, "Let's get out and back fast. Must hear the news. That crisis, Berlin, has far-flung implications—even for me. But I love art anyway, so let's go. First let me show you quickly two large new sculptures I have acquired, a Renoir and a Rodin. Then we'll go to see your theater model·"

I had presumed haste and squeeze. Kept my taxi waiting. It took us from East 93rd Street to West 107th to see my Universal Theater—my second trip there this month. I had cleared our visit the day before. In spite of that, we were submitted to lengthy questioning. Many valuable minutes lost. Finally permitted to go up.

We viewed my model for a few moments; then down into the cab again to bring Billy back. He: "Tell me, can that large theater of yours be built in aluminum, like the model is?" Me: "I'm too long an American to say no. Sure it can. Just a question of money and time." Billy: "Leave the money problem to me· You worry about the fabrication. I don't give a damn if they don't play a thing in your theater. Since Reinhardt's death, there has been no one I know of who could bring yours or any theater to life. I'd like to help you and help your project become a reality. Industries want publicity. So does the World's Fair. Let's contact Alcoa, Reynolds or Portland Cement. They know they'll have to spend a hell of a lot of money to build something at the Fair to draw attention, beat competition. Your architecture is the thing, not the play. If that doesn't work, what about Zeckendorf, who's building that aluminum city near Hollywood? Any planning has to wait, though, until I return from Edinburgh—you know, the Music Festival . . . Cabby, let me off here."

Via Guggenheim:

Hopped into a cab to pick up Tom Messer at the Guggenheim Museum for a drive to my foundry. At the Museum, I had my first brief glimpse by daylight of Wright's inspiring spiraling void, brightly illuminated through the dome which cast a pleasant white sky light. It didn't do too much for the exhibited sculptures (the paintings I could not see at all due to the ramps) but it transformed the milling visitors into walking sculptures.

Upstairs, at the director's office, I encountered two more human statues, this time seated: secretaries, one exotic-looking, the other formal. I met Messer, and down we went by push-button. At the elevator entrance, we ran into the chief director of the museum, who greeted me warmly and regretted that he could not go with us to the foundry, but hoped to do it another time.

On our way, I talked with my guest about his native city, Baroque Prague, dotted with Gothic and Romanesque spots, which I knew and still remember well.

Purification in a Hell's Kitchen:

To my astonishment, at the foundry, the large sculpture which I had made more than a year ago, almost to the final detail, was not yet assembled as had been promised the previous day. Marking time, we strolled around, winding and squeezing our way through abstract twists being turned out by remnants of that great Italian period. Then, stepping over graveyards of molds and casts and plaster figures, we came to the spot where my large sculpture was being set up for the first time.

That work of mine was obviously a look into the future. It spanned from floor to ceiling and consisted of eleven pieces. It looked better to me than when I had begun it, more than a year ago. An aluminum-cast table locked into the ceiling had its four half-legs hanging down. On the floor stood a similar table, upside down, four full legs up into the air. On the tips of the legs rested a heavy translucent plate of lucite. From the middle of this pane

rose an array of bone sculptures piled one upon the other, up and up, some in bronze, some in aluminum, one leaf-gilded. The same type of units, except not so numerous, hung down from underneath the lucite, as if a mirror image of the one above. But on the inside of the table on the floor, the one with its legs up, was imbedded in what perhaps could be called the eye of a vast woman's belly, cast in white bronze, highly polished. The belly button was an actual opening through which, later on, a light would shoot up toward the bronze cluster of the sculpture floating above.

Judging by their expression, the workmen who had assembled the various parts of the sculpture seemed to agree with my guest that this intricate work must have been carried out with great perseverance. It contained so many diverse parts spread between the ceiling and floor, yet it had a surprising unity of content and form. It seemed to convey continuity transfixed at different levels. This was the piece, I think, which, without explanation by me, at once conveyed to my guest the galaxial concept of my sculpture.

Presently we stepped into the taxi again and drove off to my studio on Ninth Street, one of my last opportunities to visit it because I would soon have to move the entire contents of this work home to a new location. Also my last chance to acquaint my visitor with the entire sphere of my work, the continuum-planning of my painting, sculpture and architecture.

It is always embarrassing to show one's work and not show off with it, no matter how old its vintage.

if you convince
they often wince

my sculpture's turn
from north to south
and east to west

upsets my guest

but when the curio-seeker
gets heated up
in fake embrace
his pseudo flame
can burn my guts to blisters
or cast my intellect
in packs of ice

I had these thoughts in mind as we ascended to the fourth floor of the old building. My companion, although pressed for time, kindly let me stop and rest at each level, according to my doctor's advice.

There was enough clearing between the helter-skelter for him to view the large "Horse Galaxy" which I had exhibited nine years

484

ago at Sidney Janis', although it was unfinished (and still is), and one completed new galaxy displayed four months ago at Leo Castelli's. Since we were both rather hurried, I promised to let him review at a later date the many other works—paintings, sculptures, drawings—which illustrated my principle of constellation.

Next stop was my top-floor home on Fourteenth Street. There he saw the tall wooden and bronze sculpture I had made a year earlier, what could be called an "endless" sculpture. It consists of various pieces, partly on the floor, partly on the wall, partly on the ceiling. Every one of them keeps an individual aspect, a world of its own; still each has an inborn tendency to co-ordinate with its family members.

My patient guest understood the implications of the continuum-planning concept which had occupied my whole life. I was quite amazed to hear him grasp the problems so fast, so deeply, and humanely. He did not approach my work solely from the visual point of view, but considered living within it and with it. He now suggested that a show be planned which would include the models of the Universal Theater, which he had seen before, and the "Endless House" plus the free-standing and wall sculptures, drawings and paintings. Together they would indicate the floors, walls and ceilings of our future home environment.

I walked him to the elevator, the door swung open, and he disappeared into the car, back to his world of commitments. And I to mine. A day of many dates continued.

More Links in the Chain:

After supper with Peggy Jackson, I called on Mr. and Mrs. Kanin, Broadway's writing pair, to return their heavy bag of reference books about Schnitzler's *Anatol*, which they had left behind at my Amagansett salt-box this summer. I arrived at their temporary Beekman Place home at about ten o'clock. They were guests in an apartment whose owners, now away, were the builders of this skyscraper. Their hosts had done a lot of traveling in the East, judging by the assemblage of curios, tables, vases, shields, screens and other paraphernalia from Japan and Korea laid to rest in this

Manhattan penthouse. The living room, situated between two terraces overlooking the Hudson and the East Rivers respectively, was a mixture of Western comfort and Oriental discomfort. Rather hard to take, but the charming couple made up for it.

Mike and Fay Kanin, brother and sister-in-law of Garson and Ruth Kanin, a team driving the Broadway bandwagon successfully through Times Square in spite of the sharp critics' corner, screaming publicity traffic, defectors from Broadway to Hollywood and from TV to Broadway, are following the footprints of Bernard Shaw's *Pygmalion*, which ended up so profitably in the business boudoir as *My Fair Lady*.

Fay and Mike had occupied the guest room in my old American stone-and-plank house on the Long Island shore. Over the weekend, they had peppered me with questions about old Vienna and Austria. They were rehearsing a musical based on Schnitzler's *Anatol*, and the script was in the stage of being sliced to the bones, with the constant threat of total dislocation.

To my astonishment, they had never visited Vienna, yet were adapting the most Viennese play possible. They were naturally quite eager to extract from me, in cordial squeezes, information such as what would be a typical Viennese girl's first name and what delicacy (*Leckerbissen*) a teen-ager (*Backfisch*) would console herself with when recovering from a suicide attempted because she had failed to snag Anatol. There arose a big dilemma because a chocolate-covered "Neapolitan," which in my youth was the big treat, does not connote the same lusty satisfaction in America as strawberry shortcake, which, according to my author friends, would be the first thing a girl here would call for when coming out from under.

But first what name should be called out to awaken her before she asks for her treat? Mitzi, of course, is unquestionably the bull's-eye name for *das Wiener Mädel*. Strangely enough, it was missing from their register of babes' names. So was Lisl, but they had Poldi and Gusti, which were O.K.

Suddenly both shouted together, "Hey!" and raised their hands, holding off any further suggestions of mine. Mike's palm turned into a pointing finger at me: "You are Anatol, my man, sure enough! That takes care of his family name. Thank God!" I didn't

get it. They explained: "We can't have Anatol all by itself. America demands a family name for a decent fellow, aristocrat or no aristocrat. We went through one name after the other. They aren't any good, too German sounding. Since, in all justice, we think your life is very much like *Anatol*—will you permit us . . . can we use your name and call him Anatol von Kiesler?"

"Oh, no, thanks," I replied. "You flatter me. I don't measure up to this aristocrat in love. Anatol's love was sheer gallantry, based on the inability to say no as far as love was concerned, and the inability to say yes as far as marriage was concerned. Compared to him, I am only a humble bourgeois."

From Chanin to Kanin, the day of many dates was completed.

The Universal Theater: Poetry Versus Automation

August 21, 1961

A few minutes ago I delivered the total bulk of seventeen plans to the Ford Foundation, which, a year and a half ago, requested me to design a new prototype of an American theater for large cities. A giant piece of drafting and sculpting finished in nine months; a quarter-inch scale model in plaster and wood was made, too. I ordered the model cast in aluminum, without having the six thousand dollars to pay for it, and it will be ready for delivery tomorrow. Money has never interfered with my work. To have or not to have is not the question.

The postscript to all this was a description of my theater which I dictated in the morning in the last rush of sending off the plans. It is now 5 P.M. Here is the text, word for word:

For some time it has become very clear to me that a new prototype theater for our time could not be conceived as a mere theater, either artistically or economically, regardless of how good its ar-

chitectural design might be. Wherever it was placed in whichever of our cities, it would become another white elephant.

None of us, no matter how talented, living in this or any other country, and no matter how productive we might be in our sphere of activity, can exist today self-sufficiently, relying solely on our home ground. The shifting stresses of our highly competitive societies demand that we relate to an ever-widening circle of demand and supply. Madison Square Garden would be a failure if it was only the home of an exquisite circus. A theater cannot survive healthily in isolation, no matter how well designed.

I have therefore designed not only a theater by itself but a "Universal"—a center, a co-ordinate of such units of the performing arts as deemed necessary to balance art and economics.

I designed a main theater with a capacity of sixteen hundred people. Running behind its stage is a throughway for spectators arriving by car and, on a lower level, for delivery trucks. Off this throughway is a foyer leading to a smaller theater (capacity six hundred) and the elevator banks of a skyscraper rising thirty stories high. The skyscraper is a complex serving the performing arts and its correlatives. It contains a variety of small theaters with a capacity of one hundred twenty to three hundred persons. It also houses large and small television studios and radio stations, office and rental areas for a variety of professional people such as publishers, record makers, and motion picture producers, plus seven floors of industrial or art exhibition space. Together they have the advantage of common dining facilities, storage and workshops. This is a business as well as an entertainment and art center, where each part supports the other directly or indirectly.

The main theater of the Universal is a theater of many purposes. It does not try to project the playwright, the actor, the technicians into a distant future, into a dream house. It also does not depend on modernized equipment to make it contemporary. The Universal tries to bridge many centuries of the past leading to the future.

The main theater is a Greek-type arena with a present-day proscenium. In addition, it offers two continuous runways, which could be called peripheral stages. The ceiling of the theater flows into the sides, left and right from the proscenium, in the form of a shell. This strongly inclined hood reminds us of a sheltering sky

488

with all the natural possibilities of infinity, produced here by light and projection. As a matter of fact, the Universal. *is* an endless theater as far as vision, sound, and movement are concerned. To produce variety-in-unity, to co-ordinate light, projection and sound, there are three major communication towers inside the auditorium, one left, one right and one in the rear. These monumental structures also serve as vertical communication units with the various balcony levels. The three towers are connected below

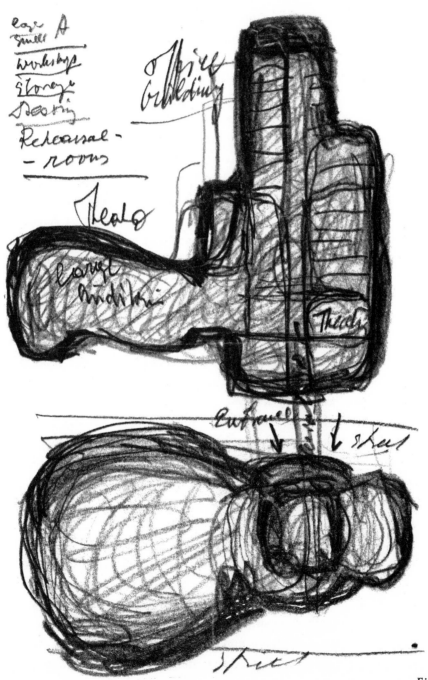

First conceptual sketch

489

the auditorium with a main control booth, situated almost in the center of it, low enough not to be obstructive to the audience yet located in such a way as to make it possible to direct all projections (film, television and satellite) onto the auditorium interior as well as the stage. In addition, there are two more projection booths in the audience area at a height which permits shooting films or slides directly into the depth of the stage and the cyclorama.

In fact the Universal Theater is designed to give the audience as well as the actor an instrument which can be manipulated by the stage director as a transformation center of magic illusion and touch-and-go reality.

Thus the theater affirms my basic belief: We live in a time when technology and science try to overtake human endeavor. We always strive to steal the secret fires from the gods, hoping to save man's labor energy and give him leisure time and health. Any true architect who designs a present-day structure must expose in his design the philosophy he lives by. He must select from the vast arsenal of past achievement and present-day automation those elements which will co-ordinate willingly in contributing to a creative way of living.

Having worked for forty years in the world of the theater, I was able to make some drastic cuts and some new concepts. I eliminated the gridiron where old painted scenery is normally flown up. I cut off this hunchback from on top of the stage, foreseeing that in coming decades we will have a more or less plastic scenery rather than painted scenery, since the painted one will be chiefly replaced by projection, which is much more economical and much more imaginative. However, in case painted drops are desired, provision is made to roll them on tracks on and off the stage horizontally.

An important factor in the Universal is the possibility of automatically transforming the lower part of the auditorium and turning it into an arena without disturbing the spectators in this section. At any time it can be returned in a few seconds to its original position while the action continues on the proscenium stage. With this and other design devices the Universal offers facilities for the individual demands of various branches of the performing arts, as follows:

490

A. A great variety of spectacles such as operas, reviews and large-scale dramas, using the peripheral stages in addition to the proscenium arena.

B. Smaller-scale drama, with focal concentration possible on the proscenium stage.

C. Symphonies and choral works in the vast arena and quartets and solo concerts within the intimacy of the arena center.

D. Conventions and other large public meetings. A person or group of people can appear and walk on the runways, on different levels of the auditorium, in full view of the audience and sometimes even through it.

E. Motion picture presentation, with perfect view from all seats and the possibility of expanding the screen if so desired.

F. Actual happenings such as sports and news events taking place outside the theater can be instantaneously communicated to a waiting audience, thus making everyone a participant.

It is natural that a building of new content should have a new form and also a new construction principle. It is questionable whether one can pour new wine into the old-modern flask of architecture.

The Universal Theater, as well as the skyscraper, in spite of being large structures, are constructed without the support of a single column or beam. They are enveloped in continuous shells of reinforced concrete.

This is a building method I had sponsored in 1923 in the so-called "Endless," in the "Space House" (1933), and last year in the "Endless House."

In the present-day theater, the most diverse types of productions have to be squeezed into the strait jacket of a fixed architectural scheme. My new shell structure, built on the principle of continuous tension, seems to be the right container for infinite variations of sound, light and stage action. Through its elastic spatial planning, it offers the possibility of creating the environment best suited for each species of the performing arts.

491

Will the Universal ever be built, or will it be another concept whose formula serves others for semi-solutions in committee enterprises?

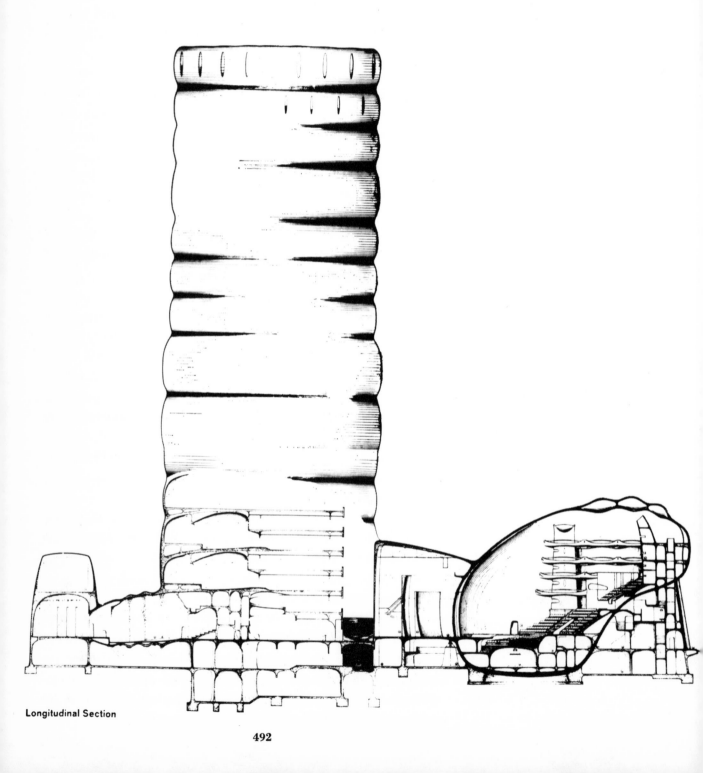

Longitudinal Section

Amagansett

My eyes broke open with a bang at eight o'clock sharp. I suddenly felt the upper lids lifting, and my eyeballs naked. The night-morning before, I had gotten to bed at four o'clock after an evening with Guggenheim's Messer and then to a film called *The Joker*. 'Twas a haphazard decision to enter the cinema, but ended in a lasting impression.

The Joker is a man who takes life seriously—at the roots. The roots meaning growth, and growth meaning striving toward the sun—indigenous to natural living as opposed to man's longing for the moon, the poet's playmate, melancholia.

The film, the man, the situations almost portrayed me and my interpolations, as I was told by my friend-neighbors. I, who could take life gaily and attach myself to the thousand loose ends of being, swinging on each of them as on a Maypole. But these last few years, instead of floating freely, I am leaning against the pole like a wilted daisy who needs constant watering to straighten her neck and face the sky.

Yes, that Joker was no joke for me. He is called "the Joker" because he does not conform to the standard pseudo seriousness of social aims, but acts from the inside out, his solar plexus powering the radiance of his being.

I could watch myself in that film as in a Coney Island mirror, viewing the interchange of two grimaces, one the face of joy as interpreted by the Joker, and one the face of dismay, portrayed by the lady of the play. She considers only casually the chances constantly offered to her by the Joker to live life exuberantly, and at each crucial moment welcomes misgivings and fears rather than the freedom and satisfaction of being herself.

These Coney Island mirrors can show you in their convex form the micromized past of your life, removed into the corners of a deep perspective, and in their concave curvature the enlarged moments of the Now. You have your choice: convexing, concaving or vegetating on an asphalt plane.

September 22, 1961

If not another one, it probably should have this one, I think it's correct, yes, to call the entries of September 22, September 26 and October 16 by the summary title of:

Mr. Auer and the Owl

I knew for weeks that I'd have to move out of my studio.

The anguish of quitting a place I had been accustomed to work in for nine long years, the fear of not having the right help and assistance in carrying through the task, was condensed into a special current that wandered from my throat to my brain, back and forth, during office hours, during home work, waking me up at night.

The decision was made three weeks ago, that is, to rent a certain studio, and now the last span of September was at hand, dictating the day for moving out of my studio on Ninth Street, up on the fourth floor, to around the corner at Twelfth Street and Broadway, on the second floor. I was taking it over almost sight-unseen from exiting painter, Marca-Relli—my chance for a vast studio, a hundred feet in length, forty feet in width, and fourteen feet in height, split in the middle by a cast iron colonnade of Renaissance beauty rising from a new, newly waxed, parquet floor. The second floor will be better for carrying up my heavy sculptures than was the fourth-floor location on Ninth Street, although here too there is no elevator, mainly because Bill de Kooning, who rents the third floor, which is the top with skylights, objected to the remodeling landlord's installing one. Bill thus succeeded in making it difficult for his visitors, who now have to climb three runs of steep steps to his domicile, and for my sculptures to carry their weight with grace.

Mr. Auer, over seventy, withered from work he loved, an old German hand at hoisting oversized refrigerators, overstuffed couches, overlarge anything, through windows, is moving me. This seventy-year-old trucker, with superb craftsmanship in scanning weights and measures in relation to door openings, elevator cages, window frames, and in rigging block and tackle for roof ledges, is my type of man. He has that true responsibility toward his craft, one of those rare workers, the last ones, dying out, be they carpenters, plasterers or truckers. I feel fortunate.

Unexpectedly this day, the Today, contained some of those specific coincidences which force us, whether we like it or not, to look within, that is into the mechanisms of the hidden social forces which play chess with us, making us perform the role of pawn, king, knight, or castle—thus giving us blind men a chance to see our destinies. Luckily I retained the vision and followed through.

What harassed me most those last days was having to shift all the materials from my old studio to my new one—that is, moving drawings and sculptures, models, plans, furnishings, mechanical saws, shelves and planks, finished and unfinished work in progress and a lot of work in retrogress, waiting to be moved on and ahead—all without supervision by a disciplined disciple. I had no one to assist me in the preliminaries of deciding what to weed out, what to co-ordinate, what was but did not need to be any more, to keep the mover coming and going at certain dates and hours; to supervise, finally, the landing; not one assistant available to me—having fired my right-hand man months ago. Indeed, a tricky situation which could not endure more delay, not a week more. I know and knew, it was now and no other week to come when I must move out and into a work home still unknown to me.

Now watch how circumstances helped me, entirely unexpected, and good. They made my D day into a V day.

At eleven o'clock, Mr. Auer phoned me at the office, having failed to reach me earlier at home since I had taken the receiver off the hook after working deep into the night. Finally he got me. "I am en route to your new studio at Twelfth Street to ascertain the width of doors and windows for pushing through your "Endless House" model (which was now in its last days as an exhibit at New York University). I can't wait any longer to move you, but I have no key!" I answered fast: "Haven't been to the new studio myself. I'll be glad to go with you, otherwise I'll postpone it endlessly. Please pick me up at my office on Fourth Avenue and Twenty-ninth Street, the fifteenth floor. Then we'll go to my house on Fourteenth Street and Seventh Avenue where I have the key to the studio. I'll pick it up and continue on with you to Twelfth Street." "O.K.," said Mr. Auer, "I'll be right over. *Auf bald!*"

My office secretary stepped in to tell me that a young man had tried to reach me several times since early morning, apparently a young architect. She finally had taken the liberty of asking him to

come up to see me, and he sat waiting now in the foyer, his crossed legs displaying Texan boots under jeans. He wore a windbreaker closed at the neck and above it his head fell back casually while his blond bushy hair leaped forward. He looked like a tall tree trunk, uncomfortably folded up into the molded modern chair.

"I've been driving for three days and two nights to see you, hoping to become an apprentice of yours. I've quit my senior year in order to be with you, if possible. I'm twenty-three years old and I come from Santa Fe, New Mexico. In my car I've brought tools, clothes, and my wife." He looked, in his blue jeans and beige leather jacket, the real Texan youth, naïve and statuesque.

There was an endless moment of silence, in which I tried to probe his sincerity and mine.

"Go downstairs, please, and ask your wife to come up. You sit in the car so you won't get a ticket. I don't want you to begin your stay in New York being hooked by a cop and losing money."

"By the way, Mr. Kiesler," he added, going out backwards through the door, "I just want to tell you something else . . ."

"And what is it?" I asked.

"I am a Mormon, sir. You know, we have our own religious beliefs, and we are very individualistic people. That's what gave me the courage to quit school and come here to be with you."

"That's fine," I answered. "Perhaps we can find a place for you here in the East. Are you interested in the fine arts?"

"Not much. I am, or was, but I think it's all too standardized. After a try at it, I felt it was foreign to me."

"Did you like to attend the theater or concerts in Santa Fe?"

"No. I've never seen a live stage show or a real concert in my entire life. But I've listened to plenty of records and seen lots of movies."

I was quite stunned. Here was a youth from the healthy army of young Americans whose education was chiefly based on canned

496

music, celulloid, and printed matter. In spite of this, he appeared to me different from an average country boy. He seemed to be clamped shut, unable to open, and I felt that inside him was live matter that longed to get out. In this moment of eye-to-eye encounter, when decisions often come without specific will, I felt an obligation to help. And he might be of help to me in the precarious situation I found myself facing.

His wife was pale of skin, pale blond, pale of figure and demure. Not the type of Western girl we hear about or see in the movies, an Amazon in the making. And she was not pregnant.

"Please join your husband downstairs," I suggested, "drive with him to Fifty-nine East Ninth Street, the address of my old studio. I might let you stay there until the end of this month when I have to be out of it. It is cluttered with the bric-a-brac of my work now, but there's a hefty couch, a kitchenette, a radio, and leftover liquors. You'll save rent. Wait opposite the house. I shall soon arrive there with Mr. Auer, my trucker."

As she went, Mr. Auer came in. We hurried to my house on Fourteenth Street. The taxi remained waiting. I soon came down with the key and we continued on to Ninth Street. A few minutes later we arrived at the entrance door. When our taxi rolled off and gave me a free view of the opposite side of the street, I saw a large American automobile, with the tall boy standing behind it. Gazing across from sidewalk to sidewalk, I saw his young wife in the front seat of the car. At the window of the back seat, I spied, to my amazement, a live owl with a head as big as mine. Its two eyes looked like rifle targets with golden rings and pitch-black bull's eyes in them. Mr. Auer remained at the stoop while I walked across the street and put my face against the glass of the car window, my flattened nose matching the depressed nose-hook of the owl's beak like a mirror image. Without the slightest hesitation the boy opened the car door, put his arm in as one lends it to a lady at a square dance, the owl stepped onto his wrist like a falcon and he carried it out into the open, lifting it up to the branch of a meager but charming sidewalk tree. The owl perched and spread its silvery wings as if breathing wide, while automobiles flashed by, unaware that a city street had just been turned into a forest. On the ankle of one leg the owl wore a bracelet of leather, attached to a leash which its master now wound around the branch and fastened fast. The owl remained on the branch while the New

Mexican sprinted across to join me and Mr. Auer. We three scurried up to the fourth floor of my old studio.

Upstairs.

"By the way, what does the owl eat?"

"Meat. I buy dead meat at the butcher, sort of hung-up, from the Argentine—but I'm looking for live meat. Live meat, that is, mice or pigeons."

"Pigeons . . . ?"

"Yes. Somebody told me that pigeons are under protection in this city. Kinda difficult to get . . ."

"Why just pigeons? Could it not be fresh-slaughtered chickens? Orthodox Jews, you know, they . . ."

"No," my young friend said. "Pigeon feathers are the best thing for his digestion."

"I see. And how does it devour the creatures? Does it . . ."

"He grips them with his claws, which are curved like a sickle, and then swallows the animal whole. If he has any trouble getting it down, he vomits it, cracks its neck with his beak, and gulps it chunk by chunk. But he really likes his animals whole. The bones and feathers, or fur, are regurgitated the following day in the form of a pellet. This pellet often contains perfect skeletal remains of the animal."

"Seems pretty natural to me after all," I answered, "at least compared with us. To eat, we humans need special instruments, plus the blessings of pepper, salt, garlic, 'natural' juice or concocted gravies, and we are very particular about having the flesh rare, medium rare, or well done—all standard illusions of being 'civilized.' We are shocked at the Shah of Persia who spits the pit of an olive *over* his shoulder, or at Dali who serves the lamb chop *on* the shoulder. At least the owl relies on himself, gets along without help from the cute products of our industrial kindergartens."

498

While indicating to my two men how the rummage of my atelier should be sorted for transfer to the new studio, I was thinking about Dave, my unexpected apprentice, and his wife who would live in the clearing of this floor after Mr. Auer had disposed of all the remnants except the bed. The owl, too, would live in these quarters, I suddenly realized.

"You must know, Dave," I said, "that New York is a conglomerate city of races, permanent residents, transients, gamblers, thieves, and crooks, and while the police are very lenient in the beginning, once they are suspicious they become chicanerous. In order to protect you and your pet, may I ask you how and when the owl flew into your life?"

"My interest in owls," he pontificated, "stems from a passion for the ancient art of falconry. All birds of prey intrigue me, not only because of their unjust persecution by the greatest predator of all animals—man—but also because of their beauty in flight and their noble character. These birds have no natural enemy on earth except man.

"Moses' (that's the name I gave him) Moses' first home was located about fifty miles from Santa Fe in what is called the Estancia Valley. This valley used to be lush grasslands, but since the plow was applied to the fertile land—and there was a drought lasting some ten years—the land has become a dust bowl with weeds and abandoned farmhouses scattered about. The only signs of life in the valley now are the desert creatures—coyotes, badgers, snakes, rabbits, vultures, a few songbirds and various birds of prey.

"Of these birds of prey, the great horned owl is quite plentiful. The owl builds—or more often steals—his nest in a hollow tree where there are great cottonwood trees in the riverbeds.

"Most of the nests are in the low rolling hills that straddle the valley. They are made of dried twigs and measure from about two to four feet across and nine to twenty-four inches deep, are usually perched at the very top of the trees—as was Moses' home. It was three and a half feet in diameter and eighteen inches deep. This nest was fifteen feet from the ground. I stole up to it and waited for my chance to snatch one of the baby owls—there were two in the nest. I had to duck behind branches and plan my theft be-

cause the parents were screaming and diving at me constantly. This owl is the most ferocious of all birds of prey. It shows no fear of man, its greatest enemy. I admire that ultimate courage."

"Nevertheless you went ahead and stole a child, didn't you? You actually perpetrated what you denounce in man?"

"I did, because I love these birds," he retorted without hesitation and quickly continued, "The small owl was with its sister in the nest. The sister seemed slightly larger and more aggressive. Both were about three weeks old and covered with down. He was only the size of a big fist—with gigantic wings that he could not control. He tried to bite and scratch. While keeping one eye on the marauding parents, I reached down and let the young male clamp onto my bare finger with his talons . . . he had quite a grip for his size. When I raised my hand, he remained attached to my finger all the while alternately applying and releasing pressure as if he were exercising his muscles.

"I then wrapped him carefully in a blanket—so as not to damage his wings or talons—and climbed down the tree with my prize."

The Southwesterner will work for me as an apprentice, I had decided. He'll be paid enough to eat, sleep, and travel. His wife is to get a job. She will, I know. The owl will supervise. Thus it would be, after Mr. Auer moved me from one workshop to another, but during the shift the boy will help me. His sudden apparition came just in time, as the week was running out on me. Now my other friends will fall in line and also time—a chain of help, unformed before the boy from New Mexico arrived. The outlook had been vague and blurred. He cleared the mist.

The 22nd of September, my birthday, was a howl of a bird day.

As I anticipated, the young wife got herself a job. She'll be working steadily now. Both are getting settled.

A new secretary started yesterday at my home studio. A Chinese-born American girl, neat, of good figure, intelligent, efficient. But today, only the second day, she gave me a shock from which I have not yet recuperated. Once in a while every one of us is caught with his mitts down.

Being low on funds in my checking account, I decided to transfer to my checking account five hundred dollars from my last savings in the bank around the corner. For this purpose, I signed the necessary credential letter for her, gave her my bankbook and suggested that she withdraw the amount in five one-hundred-dollar notes. She put on her smart basket-type hat, and walked out with the customary smile and the promise to return quickly for further work. She never came back.

After an hour's wait I left for my office. From there I phoned my home and there was no answer. An ominous silence. It was a quarter to five, the closing hour, when I called my bank to inquire if the five hundred dollars had been deposited. As expected, it seemed to be too late for any tracing to be done, but my insistence on speaking about it to the director of the bank brought the news that nothing had been deposited. This is not the shock I'm speaking of. The shock came when, after returning home from my office, and finding the apartment still empty of her, there was nothing else to do but to phone her home. To my astonishment, she seemed to have been deeply asleep, confused in her account, but as her mind got clearer this is the story she told me:

"My father had difficulty whenever he touched cash. I seem to have inherited that, although I'm fighting it. But when I was faced with your order to transfer the cash to the bank, I apparently had to escape the obligation and, in the elevator going down from your studio, I felt rather ill. When I reached the street, I took the next taxi home, swallowed a sleeping pill and went to bed. I'm terribly sorry for having disappointed you, but I'm afraid I'm not well enough yet to come back to work for you, although I enjoyed everything I had to do."

"Where did you leave the bankbook?"

"I didn't take it. It's on the desk in the folder."

She was correct. I found the bankbook in an envelope with my letter of introduction. She never took them along. I thought of giving her another try. She was honest; she couldn't help herself; she was blocked in a certain direction. I called her a few days later.

"Glad to find you home, I've been thinking the incident over, and decided to give you another chance if you'd like me to."

501

She answered, "I'm very happy to hear that you haven't lost all confidence in me, but what I told you the other day wasn't true. The truth is that when I arrived at ten o'clock in your apartment, there were still on the side table remnants of the party you had the night before for Madame Bucarelli. I had an hour to clear everything away before you would start to work. I very rarely drink and I don't smoke—but handling all those marvelous bottles I decided to take a drink from here and there and by one o'clock I felt ill, had a dizzy spell, and was glad when you asked me to go down to the bank. I went home to sleep it off."

This incident set me to thinking once more about the mercurial quality of many of our youths. They seem to throw out anchors, pull them in, throw them out again, try to swim, scuttle their boats, scream for help. They shift their interests from singing lessons (as she did in the morning) to dance or painting lessons (as she did on weekends); change domiciles from city to city or from parents' homes to their own or a friend's—alone, back home, off with a man or woman, around and around in circles. They strive for individuality, oppose regimentation, yet fall into conformity.

The bugaboo of financial insecurity conflicts with the desire for absolute independence, an independence which is nothing but a mirage that has blurred and caricatured the American vision of liberty once so brilliantly projected to the world.

Is she, or anyone young, to blame for the distortions of a derailed society? Our cities seem to be giant switching yards which carry the freight of fright even into the one-track towns, mountains, deserts. Do we take jobs because we have to have some cash to pay essential bills, or do we gradually shift from the idea of making some money for basic needs to the goal of having surplus cash with which to buy surplus goods—three-trouser suits and four-basket bras? Do we aim, in a job, at finding ourselves and maintaining enough stamina to wait until the roots solidify their hold—or do we use our city or town as a social playground, carrying the ball from kick to kick until it deflates from so many punches?

There seems to be a new, accepted kind of *personal nationalism* whereby each of us is a land, a race, a creed, or what have you—to sell without having paid for it (in terms of training and dedication), yet believing we were born under the profit star.

The boy from New Mexico is now working for me half a day. In the mornings he works at a museum, where I helped him to get a job. His wife works too, earning seventy-five dollars a week. Together they should get along fine, financially, I thought—but: I see signs of an approaching breakdown, a split in the body illusion.

The first crack appeared when my new apprentice told me that for years in New Mexico he had owned a rickety secondhand car to get around in, like everybody else, but on deciding to go East and start a new life, he got himself a new car to transport his wife, his tools and the owl. Understandable. Gives you a lift for that new drive. But the shocking part is that he bought himself a deluxe model for five thousand dollars without having the money. In order to make the down payment he borrowed fifteen hundred dollars from the local bank. He now has to pay the part payments for the car, the part payments for the loan and the interest on it, he has also gotten himself a rather expensive one-room apartment for which he had to give one month's security and one month's rent in advance. All this besides the expenses of daily living.

Then today he came to work at 2 P.M. from the museum. Normally he appears at my studio in jeans, open-collar shirt, Texan boots and a leather belt studded with Navaho silver set with turquoise stones. But this time he came in a dark-gray silk hipster-fashioned suit. Out of his breast pocket—very parallel to the edge—the rim of a handkerchief looked out just far enough to let you read his full name embroidered all along it. Needless to say, I immediately turned it upside down, sticking it back into his pocket, and calmed him by saying, "Designers don't wear their names as badges."

That same day his drafting tools arrived from provincial New Mexico, in an old corrugated cardboard box of supermarket vintage. Out of this the handsome young man from the prairies produced the most modern mechanized drafting tools I have ever seen. I watched him spread the contents across the drawing board: the latest tubular light for drafting; a T square sprawled in the shape of an iron crocodile with movable legs and fangs which almost cover the board completely with the spirit of Machinal, making it impossible to behold a plan as a whole, thus preventing awareness of an over-all scheme. In addition he gripped in his hand the pear-shaped bulk of an electric razor which, as he ex-

plained to me, was not a razor but an eraser, motorized. On the edge of the board was a small steel rock with a hole in it, into which he inserts his pencil which is sharpened by the release of a built-in motor.

I knew I could not suddenly ask him to remove all these machine-monsters from his working table. I felt I had to make him realize the necessity gradually. I did not want to blunt his pride in being equipped with the latest, nor to give him the feeling that I am opposed to mechanization or industrialization in principle. But I did want him to know that I am certainly opposed to indiscriminate mechanization, even of tools; that there must be a limit, that the Golem march of mechanization must be stopped, particularly when it transgresses the field of individual creativity. The proof, for instance, is that we have in our architectural office a small three-partite machine for blueprinting drawings, a mechanical tool that saves the cost of having it done at an outside printing establishment, producing blueprints almost immediately if needed for repetitious studies. Indeed, a welcome help in furthering and speeding up the accumulation of data for concluding designs. But there are instances where mechanization is not only undesirable but almost deadly to the flow of ideas in birth. To detect these differences we must put man ahead of the motor and design ahead of tools.

All this I explained to my young Mormon, step by step, cautious infiltration, watching his reaction with keen attention. "But they save time!" He stared at me. It was a crucial moment in our relationship.

the hand that grows
from the heart,
the crayon,
adopted child
of the body,
sends the message
to the world,
spreading the word,
delicious wine
of the vintage of
your own garden
with bubbles of the

"But you see, the minute minutes saved by these mechanized tools are a loss of those intervals in design activity which provide in a very natural way the slowdown so necessary for the evolving of a creative thought. When I sharpen my pencil with a penknife instead of a machine," I continued, "and shave the wood casing of the pencil into carefully sculpted flakes, I watch the lead emerge gradually to the point I feel desirable and thus I continue the trance of a design."

spirit

making the instant

a fountain of inspiration
504

I remember American youths when I was teaching at Columbia and at Juilliard some twenty years ago. How different they were at that time, male and female—that is as far as money and possessions were concerned. It seems that victory in World War II swelled the ambition of even our most gifted youths—endowed already with natural riches far beyond their innate needs.

I remember a conversation I had in Florence with Elizabeth Mann only half a year ago when we discussed the choice for an artist between prosperity and poverty. I chose poverty. She disagreed vehemently. I remained steadfast. To me it was quite astounding to hear that she, herself an artist and writer of renown, had chosen prosperity. Perhaps it was the memory of the riches of the Renaissance which still permeates the air of the land where she resides. My argument was that all wise men of all lands and races throughout the centuries have never deviated from the one and only rule for life, namely: Live simply, don't accumulate property, don't base your life on ownership, don't live against people but with people. But through the centuries no society has taken heed of these simple maxims, either in the land of Lao-tse, or Buddha, or Christ, or Gandhi—just to mention a few guides. Their teachings are still read, but sidetracked in life.

Perhaps my attitude is the result of a false persistence of old-fashioned ideas, dead, outmoded. But it does seem to me that today youngsters too often garland themselves with leaves and blooms of wax and papier mâché. One can hardly see the skin through them, a skin, I am sure, still healthy and breathing normally in spite of being choked by layers and layers of false ideas of wealth.

"Tear these masks down, Dave! For your own sake and for the sake of your talent—which you have."

3 P.M., Wednesday, November 22, 1961

The New Mexican appeared unexpectedly in the doorway of my apartment and, leaning casually against the doorframe like a slightly deflated rubber hose, he drawled, "For days, the Santa Fe Bank and the car dealer have been pestering me by telephone about my one defaulted payment. I told them I have the money and will send it at once, but they wouldn't listen, no, wouldn't listen. Once you default, you must pay the total debt immediately or

505

your car is forfeited. Sorry, they said. Standard regulation. Sure is a blow to me. 'Then keep the car,' I said to them.

"Gee, if I'm already on the carpet for one unpaid premium, I won't have anything to do with those people. I don't care about the car. No, I'm through—they can have it.

"You know," he postscripted a few minutes later, "with that burden gone, I only feel now the weight of what I carried before. Thanks, Mr. K., for having given me the strength to get rid of the car. I'll get along without it.

"Will you come to the studio with me, sir, and check the green color with which I filled the white lines of the sepia print?"

"I'll gladly come with you in a few minutes," I answered, "and we'll work together for an hour or two."

October 27, 1961

Pierre Soulages, a brilliant young French painter with an equally brilliant intellect—both imaginative and rational—came to my house after we had dinner at the Fonda del Sol together with Mrs. Fitzsimmons from Zurich, wife of the director of *Art International.*

My living room had been converted into a drafting room with four drawing boards blocking every turn. My so-called Endless Sculpture, with its core of flame, was squeezed in between the drawing boards like a guardian of the sketches pinned down on them.

Soulages, being a scholarly type, tried to convince me that there had been no sculpture with a built-in flame in the entire history of art. But he also seemed to catch the spirit of all the displayed plans, and proposed to talk to Cassou of the Museum of Modern Art in Paris and to the director of the Musée des Arts Décoratifs about having my sculptures and architectural work exhibited there. He felt that the principle of continuity should be unfolded before the artists in Paris.

Yes, one of these months to come, I hope I shall return to Paris on wings of the spirit of 1925, when, for the first time, I exhibited at

the Grand Palais my projected "City in Space." I described it then as a "constellation without boundaries." Floating dwellings, the habitat for the man of the future, where he can feel at home in anyone's place, and is welcome. After all, it's a matter of eating, sleeping, dressing, resting. Why must there be such diverse designs for housing when the functions are so simple and so similar? The variations in room sizes and materials for which we now clamor are really meaningless. The forced dissimilarity in housing today is outrageously naïve. So much ado about nothing. It would be a lovely world, to feel at home everywhere. Of course, the sense of property would have to be abandoned because every house would belong to everybody. But the only real problem would be the standard of living: it should be on a high cultural level, not measured by the yardstick of plumbing. I imagine that Gandhi and Einstein could have exchanged homes very easily.

Once caught in the laws of continuity, we cannot escape the rhythm of leaving, returning, leaving again, which is inherent in the cycles of eternal transformation. These laws seem to be the only solidity we can build on.

October 30, 1961

These days, day after day, the days have been the same as I feel today; valleys and hills of emotions. A sensation like dropping down from a high level, not necessarily into a cave or a hole in the ground, but, as the saying goes, you feel damn low.

God only knows how some inner pull lifts you up and again makes you go higher onto a hill and higher and even to a mountain crest, so unexpected a miracle realized. And such a landscape does remind me of the swelling greens of Vermont, a rolling panorama of the earth, and also of my field of professional operations, rich in projects rising and disappearing like hills and valleys.

But whatever the psychologist tells you in explaining your emotions, trying to clarify your anguish by relating it to your suckling days or to your being a sucker-of-environment, the truth is that, whatever your past or neighbor-society has done to you, "it" dwells in your very own being. No one knows where it sits, lingers, or dashes about, but it is there with rubber shoes on its feet and suede gloves on its hands, blindfolded, dancing its ballet through

507

your body and mind while you're eating, planning, chatting, even making love, or are extinguished in sleep. Whatever one might call the unknown master of ourselves (or as religion calls it: the master of the unknown) the psyche is the commander in chief of my life and yours, too.

I have no other explanation for feeling so unexpectedly down-hearted one moment and at another, on the same subject matter, so elated. Circumstances, that is, actual happenings in my daily cur-riculum, have of course great influence on the change in the status quo of my psyche, but I can with honesty say that these disturb-ances or furtherings are no more than the stop-and-go lights in the traffic jam of my overcrowded routine. There is something in-dependent of myself and of me, or better, there is something that nourishes itself on the shocks or releases of the stops-and-gos, as if satisfying its inherent hunger for independence and dictator-ship. "It" feeds itself ruthlessly on my daily doings and undoings. Much steadier is my resistance to that monster of good, evil, or indifferent neutrality when I am working at my drawing board or painting, sculpting, or writing. I seem so much less vulnerable to uncertainty and anguish, to pangs of memory and to the un-known ahead, to the past and to the future—those two jaws ever-ready to crack your freedom.

But in human relationships, in man and woman alike, there is great interference from haphazard encounters sprung upon us by that damn pseudo-eternal inner force which dwells in us. It sucks my experience for its own nourishment, makes up its own mind about me and myself, and doesn't give a hoot how I react to it.

I don't understand why I cannot release myself from a relation-ship to a certain woman, although, again and again happenings unmistakenly have conveyed to me the necessity of a break. I am unable to act in spite of my intellect, which seems to be talking to me very clearly—as if I were blind of ears and deaf of nerves. The psychologist explains that intellect and emotion do not mix, except when stirred by real love. But if the love is egocentric and subversive, intellect and emotion will automatically split apart.

The explanation, or, so to say, clarification, of the magnetic field of lovers' relationships is completely unsatisfactory, intellectually and emotionally. If I try to maintain an artificial balance between intellect and emotion, I will invariably fall and land in the un-

yielding arms of that independent psyche which remains my, and everybody's, master; sacrosanct, beyond recourse.

Or: take the architectural project on which I have been working for a long and artificially elongated time. I first invented with enthusiasm a specific functional design, serving the very purpose of the building freely and unbiased by semi-solutions of the past for similar buildings. In dealing with authorities and co-designers, I was forced to reduce this original version to three different new schemes. The fourth one, and there is the crux of the psycho-emotional conflict; I had to go back to give this last banalized version an added expression in design to link it "somewhat at least" with the first concept in spite of knowing that it is quite hopeless to attempt to turn time back. That tenacious attachment to my original vision of the project cannot be credited either to the will of my intellect or to an emotional jolt (to reduce the complexity of the psyche to these two basic components); it can, to simplify matters, be packaged into the term "talent," apparently an envoy of that dictator commanding our individual being from genes to genius.

October 31, 1961

Painter Scarpita doctrinated last night: "I have color under my nails. See. Not dirt, sir, color. After many a year of approximation, like most of our colleagues. Color!

"How dramatically different color can be.

"There is the bark of the tree that changes from winter color to spring color to autumn color; four-season color in one tonality; all browns: brown-green, gray-purple-brown—such apparent variety, yet still monochromatic.

"But color painting means all seasons at the same time in one painting. Leaves and barks and blooms and apples—everything in the one field of the one canvas.

"No abstractions. No condensations. All spots and dots and strokes soaring with the seasons."

"Matisse," I answered soon, "is the bloom of all seasons in one painting. Correct?

509

"But the early Braques are sinfoniettas in sepia, yet no less colorful.

"And the cubist silver-browns of Picasso, although color-abstracted, evoke not the bark-browns but the riches of the tree's crown. And Rembrandt's burnt and charred ochres are a triumph of the sunny side of shadows."

November 2, 1961

Into the blue of my fluorescent drawing-board light flapped this letter from a dear old-young friend, Jacqueline Breton-Lamba. It was more than ten years ago when we had met in New York, where she and André Breton were refugees, and she and I always had see-saw battles regarding surrealism or architecture. The letter of today was scribbled on the back of a poster advertising:

La Maison Forte de Reignac
(Ensemble de Grottes, Abris Préhistoriques
et Habitations Troglodytiques)
TURSAC—Route Nationale No. 706—DORDOGNE

And underlined by her in convoluting curlicues were the following lines:

Toutes les Venus du Paleolithique réunies
Collection de Vièrge Romanes (authentiques)
Vièrges Noires Auvergnates—etc . . .
Collection de Vièrges du XIII au XVI siècle
Meubles—Armes (authentiques)—etc . . . etc. . . .

Les Eyzies
10/26/61

Dear Kiesler

At each step in these marvelous grottoes, my mind has rejoined your vision of a space for living. For the first time, I really understood how the "Endless House" would be—only you, and the sea, have known how to make one—Lascaux, colored like ripe Tokays and Muscatels—pearly, with crystal under the animals' color, like a layer of light—is the most joyous space-in-movement I have ever seen.

Tendresses du tout coeur

Jacqueline

How often have I tried (in 1942, '43, '44, '45, '46) to make clear to her with words, by molding spaces with my sculpting hands in free air, at her home, at my house, stopping in our promenades on Sixth Avenue, trying to form the spirit of the "Endless" for her, demonstrating, talking, silently inducing the feeling about it into her—no results! None. But now that she had a living experience by walking into the world of the Lascaux caves, her atheistic attitude toward my architecture vanished and she came back to my concept, although really never having been in it (only at its outskirts, like a vagabond of art history), now she got it. Yes, architecture cannot be experienced by plans, space planimetrically flattened out. Space, it seems, one gets only by walking, tramping through it.

She did it now. Now, Fifteen years later.

Thank God! At least one who got it once.

November 6, 1961

**heterosexual triangle
in architecture
(floor, wall, ceiling)**

511

Athens

November 7, 1961

Parthenon
of male colonnades
and of double-breasted pediments
thy spirit
is of eternal flesh, milk, blood and marble

so here we are put
where we weren't before,
and no biologist
with his best abacus of
logistics could tell us
when and why the splitting
into function and aesthetics in architecture
occurred; neither can we precisely
say why architecture
is striving, instead of for simple
shelter, to be more than that,
but it is striving persistently
to be even more emotional, more
than "aesthetic,"
thus urge is an unexplained
dictate of faith in the unknown.
Yet when buildings are
less than all that,
less we are too.

Isn't sex enough (the snake)?
Who invented love (the apple)?

Certainly
architecture seems to be one of the
links between the known and the unknown,
a bridge we like to span
to promenade
hither and yon,
be safe between
the now and the beyond
and blow smoke rings
into the air of nowhere.

November 14, 1961

Simone Signoret. Sitting opposite her, not too far however, at a dinner table in the Puerto Rican section of Central Park West, home of Dick Seaver, editor at Grove Press (whom I still, and very belatedly owe a book on my "Endless House"). His boss and mine, publisher Barney Rosset, was facing me with his white grin of dynamic cordiality. Janette, Seaver's wife, is the twenty-six-year-old daughter of my beloved Austrian friend, Medina, of the Paris '20's, who died ten years ago. I had never met her before. Like an apparition she emerged from a dancing group at a midnight party two months previous, at the summer home of Bill de Kooning in East Hampton. Our meeting was a shock of pleasure.

Janette served vol-au-vent, gigot *with chestnut* purée *and hot-frozen Alaska, her Medina-Medusa head a gypsy vision of medallion beauty as she proffered plate after plate with Viennese légèreté, intersecting her movements with meandering Parisian syllables, forming sentences like the flow of sparkling Burgundy. Yet for all her Vienna-Paris charm, every one of us was fascinated by the flicking fire-tongue of Simone, and even more by her eyes, encased in the storm clouds of their lids, yet open enough to let us see the two moon lakes of her irises, blinding ice-blue, the pupil a black meteorite dropped by the sun in eclipse into the dead center of her eyeballs.*

Czech-born, Simone served, in a lull of the conversation, the hot vol-au-vent *pieces with her naked fingers, and set them deftly down on each of our plates, thus giving us the appetite of peasants. Simone, a woman made of earth, milk and fire and a will power of iron ore.*

November 15, 1961

I had put myself on the spot back in 1923 by initiating the "Endless Theater" and then, in 1928, the Universal; both lawfully terminologized as multiple-purpose theaters. Decades went by in which those idea-plans were printed, squinted at, plagiarized; I had almost forgotten my youthful design-crimes against our society's showhouses. I was, therefore, believe me, stunned by yesterday evening's meeting of ANTA at the Actors' Studio (brought to note by students Marilyn Monroe and Marlon Brando) concerning possible new-type architecture for theaters. The topic of the evening was phrased as *The Multi-Purpose Theater,* my own old

513

slogan. There were to be three speakers: playwright Arthur Laurents, Tyrone Guthrie, and George Izenour, super-engineer of back-stage mechanics for under and above-stage level.

Those boys were black-print invited, but not I; I was only a guest.

In the sparse audience sat scenic designer Boris Aronson, his face always dead-pan when confronting Broadway's brooding minds; Eddy Cook of Century Lighting, of this century; Abramowitz, mastermind of the Lincoln Center's Philharmonic, and many forgotten and not so forgotten stars and bystanders. To my surprise, there wasn't a single architect on the official list of speakers—after all, ain't architecture the theme they called for? Strange. However, Louis Kahn, architect from Philadelphia, was suddenly extracted from the audience to harangue us. He made a charming confession and then threw a bomb.

"I suppose I've been invited because I know nothing about theater architecture. Forgive me. But whatever job I have ever undertaken, I have tried to remain a hearty amateur. I suppose, therefore, I could have a fresh approach to your problems too. So let me try."

He spoke from the inside out of the total world of the theater in which audience, actors, playwrights, and stagehands live together. Said he, a new concept should be approached without further functional considerations; the important thing is a simple total constellation. Then, pointing to me (who had come belatedly and sat on a couch hastily rolled over almost behind the speaker's platform), he said, "And there is the man who accomplished it already, more than thirty years ago. Why did you ask me to talk when he is here? He's done it already. I can't remember anyone else having planned it before, so completely encompassing the world of the theater in a single concept."

I was on the spot, stunned. Yet I chuckled at this unexpected acclaim.

Scenic designer Jo Mielziner, chairman of the evening ("Dear Fred . . . et cetera, et cetera inviting you to be part of the audience as guest et cetera, et cetera [thus securely locking the louvers against my official participation] et cetera, et cetera, signed cordially, Jo") did not ask me even now to step forward, no sir. He ignored the incident and gave the floor to Izenour, the new

514

Harvard theater-equipper. Izenour (pronounced Eisenhower) introduced his automatic speech revealing to us his fabrication of super-automation for theater designs which, he disclosed, are contemplated for twenty-seven theaters now under construction from Australia to Austria. "But I must confess"—I was startled again as he threw in the towel, too—"almost all the architecture of these theaters is based on some ideas of Kiesler, whose work I have known for more than twenty-five years."

Chairman Mielziner passed up another opportunity to ask me for a statement. Rules of procedure: no personal feud, just general insurance for future job chances. How stingy we become with professional impartiality.

Having twice been pointed out unexpectedly but given no chance to speak, I welcomed the darkness which fell for Izenour's slide projections and tiptoed out.

Yes, K.
don't be fooled
it is
it is hurt pride
in spite of brain-brakes,
a tough push
from down under, stiffly,
a stiff upward drive,
a gush, filling throat and
mouth and nose
oozing through
nostrils over
chin and
lip bristles,
acid etchings,
no shave can rasp it off,
scrape past

No,
no bastard-praisers,
inner sanctum thieves
can cure that anguished anger,
patting my shoulder
gilding their guilt
with plaudits, no.

Fallout-Gabriel
come! have mercy
awake me

No multi-purpose theater yet
just one damn function
all the time
My spearhead crashes.
Atom-arrows rain
smash me,
burn brass
and fast.

Time calling me
Chance long past,
can't I hear?
 it's calling
 come down,
 pole-sitter

Views of Rio

BRAZIL

Last Day Here

New York, Monday
September 14, 1959

Although my plane departure for Rio is set for tomorrow at one o'clock, I already feel the take-off this minute, which is four o'clock, sunset this afternoon, today. My thoughts, the emanations of my emotions, have condensed my time sense. It is only three days ago that I received an invitation from the Brazilian consul to attend an international Congress on Art and Architecture as guest of *Architectural Forum*. A welcome occasion to see Brasilia, the new capital, already legendary although not yet completed.

I am elated at the thought of once again being lifted out of my American nest and propelled into a new orbit, the descending curve touching Rio de Janeiro. I have to obey the call to shake off the dust of my brows.

decaying hopes
stirred to new rising
from far away
force me gently
to come nearer myself
and healthy selfishness is
induced by strangers
yet intimates of my work

I must follow the call
of the Macumba
the thumb-wink
of the Sugar Loaf.
the anacondas of the Amazon
are courting my
arrival

plucked by battles and
sneaking age
the feathers of my wings
are not too many any more
but
flowing still is the mane
and I will
soar
once more

Quickly bought new hats, two (I usually wear one for five years or more); Jackie, my private secretary, rushed to the drugstore to get bottles of Astringosol, boxes of aspirin, Kent brushes, two, and thirty Seconals for sleep insurance; Mrs. Regler, just back from Italy, brought me extract of rosebuds with that high-powered Vitamin C to cure my cold; Ralph, my assistant, went to the Health Department to have my vaccination paper stamped. Thank God, my passport is still valid. I am mobilizing.

My friend Hally Erskine, a photographer, offered to drive me to the airport tomorrow to take portraits of me requested by the airline for display in Brasilia. Events and dates move fast, accumulate. Today at six o'clock Thomas Creighton, editor of *Progressive Architecture,* comes to talk over his article on "New Sensualism in Architecture" (received a set of galleys yesterday). He wants my comments on it before it is put to press. Found it high-handed. He, an old friend, can take my rejection of it without resentment, I'm sure; we are both from the Old School of manners (which I intend to take with me to Brazil).

Before his arrival, I am to receive Gerri Trotta, special-feature conjurer of *Harper's Bazaar,* for lunch, rarely served at my house. It will be only scrambled eggs, ham, coffee (prepared by my secretary) and talk. Miss Trotta is bringing proofs of photographs of the "Endless," as well as of my honorable self, which the magazine is supposed to spread over a double page. My objection to a single-page treatment was only to prevent the one-hundred-foot-long model of the "Endless" from being reduced to the size of a toy, which would contradict the idea of a house-in-expansion. I wonder what I shall see.

It seems editors have carte blanche to play with other people's work, and so do their art directors. They shuffle pictures, photos, illustrations and text in order to display with *our* work their own ambitions as page decorators. Art directors are usually fallen Art Angels; we would like them to be the Archangels of Art. But the struggle is bittersweet for them, too, in a three-cornered squeeze between editor, printer, artist—a harassing outpost, indeed. Yet in spite of my sympathy for them I must insist:

The reductions of large pieces of art and architecture to a half, a third, a tenth of their real size upsets me. It is dishonest to the spirit of the work and obscene in its invitation to imitation. I

519

am glad that even at the last minute I can give attention to this ethical question.

After sundown, assistant Arthur brought photostats of my "Endless" and of the Jerusalem sanctuary. Folded them square and they fitted into the top layer of my suitcase.

Last dinner before my departure, at Monte's, with friends Alice and Lillian. On our way home, Steffi, my wife, shouted to us from across the pavement; we stopped the car, she got in, and we drove on to Broadway in search of a night barber (my hair needed a trim badly), but believe it or not, two barber shops were overcrowded at 10 P.M., and we drove home with my hair still shaggy. I shall try the Puerto Rican barber opposite my house before leaving for the airport tomorrow, en route to the Latin jungles.

Trip to Rio

In the airplane en route to South America September 15, 1959

The very hour Nikita Khrushchev landed at Washington, that very hour, 12:45 P.M., I took off from Idlewild for Rio de Janeiro. With me were: Photographer Halley Erskine, my secretary, Jackie Kiang, and painter Scarpita. None of the ladies of my heart and soul, none of them, came to see me off.

The interior atmosphere of the airplane, serviced by Latin-American pilots and stewardesses, vibrates now between day and night (it is about 6 P.M.), and I have never felt this "between light and darkness" stronger. The light inside the plane and the light outside do not match. Neither by contrast (as by night) nor by overlap (as by day); it is half and half, and one is really not clear which half is which, part of day or part of night. There is real antagonism between them, of which poets and industries have made the most.

520

The center ceiling lamps have been switched on, but their candle-power is depleted because the sky is still blushing rose-purple around the horizon, the dome above green-brown; the after-flow of day and the fore-glow of night. The mountain ranges of the clouds below are an icy blue.

Hypnotic twilight has forced a pre-sleep on most passengers. The seats in pairs, left and right of the aisle, wear white hoods, like nuns. Protection from the oily scalps of travelers. These hoods shimmer a brilliant white in the darkness. In order to shorten the tedium until the great event of dinner at eight o'clock, a few passengers are chatting with due curiosity about what type of food this "underdeveloped area" of Brazil will have to offer. Our group, those who are invited to attend the congress in Rio and view the new capital, Brasilia, is quite distinguished. In front of me, half-awake, are Saarinen and his wife; Mrs. Alexander Eliot and Meyer Schapiro; Mr. and Mrs. Douglas Haskell (Editor of the *Forum*); a Japanese architect, and Mr. Neutra, the architect, of California, and his wife.

My neighbor, a Spaniard, his semi-sleep ended, stretches his hand upward and switches the night spot on, and I can now see the sharp shadow of my hand moving across the pad I am writing on. Dusk is wiped out. Other little neon suns are popping on along the ceiling racks. It won't be long now and there will be general awakening from the drowsing. Conformity inside the plane will reign again. A procession of slender cocktail and hors d'oeuvres wagons is rolling up and down the aisle. The reclining backs of the chairs are straightening. The Brazilian stewardesses are performing with disciplined tropical fervor. I feel foreign, a floating ruin of Old Europe.

Night-hours later, looking through the plane's porthole, the two motor exhaust tubes seem hollow, like severed arteries bled empty. I remember now, at daybreak, the two onrushing geysers of heat coming out of these exhausts, inexhaustibly, all during the night, blue-purple and green-white flares, the lion's mane of the motor-skull, licking the darkness with the will and vigor of Zeus. These bushels of flame tongues were pushed backwards, driven again and again into their fume-blackened throat by the constant pressure of the slip stream, but stubbornly forced out again, industry taming nature—luckily for us, floating passengers of forbidden space.

521

Rio de Janeiro

When we rode into Rio from the airport, bird-delegates from many lands, we soon discovered a cortege of vultures flying high, flying low, beside, before, and behind us. The sweep of their flight, their dives in guerrilla formations, were so spontaneous, a space language of their own I understood so well, that I wanted to put my hand out the window and let one of the vultures descend onto it to be transformed into a falcon.

Luckily for me, with any impulse to offer a perch to one of the vultures, the o-so-modern window's mechanism was hopelessly locked . . .

Apparently, they smelled living carcasses. Had we been riding in open buses, they would have swooped down and clawed and picked at us (a performance we ourselves were to give later on as we pursued artists and other delegates through the exhibition).

The vultures' wingspread is wide and royal and slow, moving up and down like Chinese fans with feathers radiating like stiff palm leaves, darkly silhouetted against the sky, always pointing outward, open fingers of prey, ever-ready. The patience of self-assurance.

Our varied herd of critics, buffaloes, elephants, poodles, giraffes, dachshunds, have transformed themselves into courteous politicians, aware of their status as guests of the Brazilian government, having been visibly ordained with the diplomatic miter. The government and the Congress chairman and his aide-de-camp left no doubt that we have freedom to see and feel and express what we like. But most critics and writers live quite a meager financial life if they are strongly dedicated to the job of honest judgment. It is only natural that, since all the costs of transportation and living have been generously donated by the Brazilian government, the gear shift of criticism is not immediately put into high. So it is in the hotel lobbies, before and after sessions, and in the buses taking us to and from them, and at luncheons or dinners, on private sneak-out excursions, that the buried hatchet will be disinterred, and, while decapitation is omitted, slashing and slicing do occur—with swiftness.

September 17, 1959

The very best architecture of Rio de Janeiro is its supra-functional mountain array, a vision of a future Brazilian Venice.

They emerge from the engulfing sea with their heads out of water, some with their shoulders showing above waterline, some with their noses pointing upward, some bald-headed, but most of them

covered with jungle hair, dense and black-green in color. They lie on their backs or on their sides; their bellies swell and roll to elevated hips or kicked-up knees, a multitude of shapes and forms, all prominently rising from the sea, like·the humps of dromedaries, elephants, or prehistoric dinosaurs; a herd of giant animals resting comfortably at the bottom of the sea in groups, in pairs, or singly, but giving us only glimpses of their backs and necks and skulls. Among these natural monsters, in

contrast to the encircling industrial monsters of skyscrapers, reigns the super-monster, Sugar Loaf, which has rightly become Brazil's image of independence and liberty. How arty the looks of New York's Statue of Liberty, manufactured in France, transported to America, compared to the indigenous thrust of the form of Sugar Loaf, unmistakably a challenge to action.

All these mountains circling the vast bay of Rio de Janeiro form a ballet, a choreographed architecture of the first magnitude. The ranges and their bulkheads rise, fall and flatten out into lagoons; the differences in the intervals between the mountain humps are pure space-timing without beginning or end, a lesson in spontaneous planning.

What can man do to compete with nature?

Only once did he rival her successfully, and that was when he learned from the atmosphere of light and time what space is; it was in Athens, when man condensed outer sight and inner vision into the one and only Parthenon.

Here in Rio, clever man has unfortunately abandoned competition with nature outright. He has put belts of skyscrapers around the mountain bodies, girdling the bay. No longer can anyone look out from the city proper onto the sea: the view is blocked by steel rings.

Wandering on the beach along the fashionable sidewalk laid out in waves of blue mosaic, I suddenly encountered a small pyramid of wood, ignited. In front of it sat the swathed figure of an old woman whose face reflected the fire's glow. Everything around her disappeared in a halo of darkness. There was the sound of the breakers, but she never broke her silence. I felt immediately drawn to her but my companion pulled me away decisively and made me understand that I should not speak too loudly. "You never can tell what might happen to your life if you disturb a Macumba meditating," he whispered. I obeyed reluctantly and walked on.

The sand shore was empty. An endless stretch that curved and bent and led you on. After twenty minutes I still didn't dare say anything; I felt the wind might carry our words back to the voodoo woman.

My feet, walking the sand in shoes, got very tired. I stopped to let them breathe. To the left, across the sidewalk, I saw a small restaurant, still illuminated; we decided to have a cool drink. We mounted four steps, opened the shiny stainless steel door and a fish smell from the interior of the restaurant hit me—but what hit me more, and pleasantly, was:

"Kiesler! What are you doing here?"

It was mobile Alexander Calder, in the jolliest of moods, with friends. We drowned in his energy, his continuous dancing and swirling and twirling.

September 18, 1959 **To Brasilia,** *the not-seen but much heard-of, projected in the air with fingers as long as searchlight beams, images of the future thrown onto clouds, blueprints hanging in the blue on hooks of stars, endless garlands of city plans, unwanted but being done, done, done. Not because of, but in spite of. Neither by dictatorship nor democracy but by inspiration.*

525

*Not since my baby crib have I been taken out of my sleep at 5 A.M.
But now I made it by myself at that hour to board the plane
for Brasilia from Rio. And when we Congress delegates finally
went down on the knees of our planes, we landed at a shrubby
plantation station, a one-story shack of pre-railroad time: the
temporary airport of Brasilia.*

*We were full of expectations about what we would see in this
dream capital on a plateau-desert in the middle of Brazil. A huge
area empty, barren, with clayey earth of pulverized terra-cotta
red. Columns of red dust arising before the rainy season, we
were told, join to form mountain ranges of impenetrable dust
clouds, where men and trucks and buildings appear and disap-
pear like ghosts, covered with the breath of the red earth. And
then, when the cloudbursts reach this semitropical climate, the
dust mixes with the mud of the earth, making knee-deep porridge,
and all work has to be stopped. Construction has to continue at
night, and the skeletons of the future government buildings, now
almost up to the fiftieth floor, glisten with hundreds and thou-
sands of naked bulbs like decorated Christmas trees, social toys,
perhaps, of a future dictator, but at the moment the superdream
of a Republic.*

The first human being I spotted was a naked two-year-old In-
dian kid, clad in the rags of a man's coat, without trousers or
shoes, with a belly as big as his nearby grandmother's. She, with
breasts slumping as if two heavy loads carried on her back had
tumbled over to the front, wore an accordion-folded shirt cascad-
ing to the earth. Its character suggested younger days when she
may have whirled as a dancer and exposed chocolate legs rising
up from rosy toes and disappearing into the jungle of her multi-
colored petticoats. Behind her, the boy's mother, a beautiful image
in cocoa-brown, azure-black, ivory, magenta and shimmer-gold
garments bleached by time; and next to her, her husband, a pos-
sible hero of bandit days, robbing covered wagons, swinging toma-
hawks with one hand and shooting pistols with the other. The
horses are gone. The covered wagons are in museums, but he is
standing here, a beggar whose pride has been broken and who has
lost even the courage to step forward and raise his palm for alms.
A mute monument to poverty.

Five billion dollars to be spent on government buildings for the
new capital of Brasilia. Wide space, five hundred miles in diame-

ter, as far as the human eye can scan, is provided for it. The wasteland is ready; the footprints of the wandering Indians are small and the prairie wind wipes them out with dust of red clay.

Inside the rickety airport shack, the busy businessman, of Portuguese ancestry, handles a glorified espresso machine, ball-point pens, postal cards mounted on rollers for each viewing, three checkerboard tables with iron chairs, and a corner with magazines of pin-up girls, hooked to one another by washline clamps, hanging from the ceiling like large confetti streamers. All of it an attempt at conformity with big-brother city airports.

We, seventy-four delegates and some of the wives, stepped into three elephants of autobuses and lumbered over no man's land toward the promised land of Brasilia. We crossed and bypassed blue bands of endless highways laid in the lowland of the monstrous Anacondas winding their way through the unknown. One had the impression that each of them led toward the end of the continent, and that you would tumble off its edge, the feeling our ancestors had about the disk of the earth.

After a twenty-minute ride in the bellies of those aged elephants, which rocked us from left to right like a cradle, we soon became aware of a row of sticks along the roadside, set back about twenty-five feet, carrying cardboard signs, of equal size and placed about one thousand feet from one another; perhaps forty or fifty altogether. We could read what was handwritten on these small tablets:

"Embassy of Venezuela" . . . "Embassy of Italy" . . . "Embassy of the United Kingdom" . . . "Embassy of Uruguay" . . . "Embassy of Portugal" . . . and as one of the last, of course, closer to the center of the city, which we saw twenty minutes later, a placard reading "Los Estados Unidos." The embassy of the U.S.S.R. was several placards before this—I forget exactly what was interjected between these two cold-warriors, but I think it was Yugoslavia. We were all amused and touched by this glorious naïveté in city planning and in diplomacy, and I am sure that somebody must have been promoted at the Ministry of Foreign Affairs for this gesture toward good international relations.

The president's palace is a long, two-and-a-half story, elongated

factory building of glass with a terrace all along in front and in back. Columns flattened out into the shapes of halberds rise from the terrace and touch the cantilevered roof with their points, their hips resting on the floor. Built of concrete, they are covered with white marble plates, these halberds, guardians of the emperor-president; they have become the symbol of Brasilia. You find them on letterheads, on postage stamps—and I saw one guarding the entrance to a shack bank in the cowboy town of Cidade Livre an hour away by bus from Brazil's future capital, housing forty thousand workers and their families.

We get out of the buses in front of the only hotel, and, walking just a short distance to the entrance, we notice that our shoes are covered with that clay-red powder from Brasilia's earth. The manipulations of the hotel's staff, carried on in several languages with the delegates, show perfect international hotel training. But the sea of baggage in the lobby; what an old-fashioned way of travel! One carries one's past habits with one. Everybody travels with talismans; certain specific suits, dresses, medicines—all charms of security, yet the spirit remains free and independent.

Of course, baggage has in the last fifty years become smaller and smaller, lighter and less voluminous; still we carry along many of our fetishes. When will the time come when airlines submit catalogues of clothing in standard sizes for one's choice along with the flight ticket—all in one operation, an extension of the gift overnight bag?

The elephant buses are changed for more modern ones and we sit in them, waiting to be taken into the heart of Brasilia. Through the windows, which do not operate in spite of their elaborateness, one sees the wide, wide undulating earth like a circular sea with rolling waves coming from the horizon all around you and playing soft ridges on the surface of the new, man-made desert. Ochre-yellow, green-ochre, warmed up to a high-pitched Indian red. In between the ripples of the land, stretches of green, young, tender grass. In the distance, the light and warm greens become bluish and finally pure blue, toned white by the touch of the descending sky bell.

Another half-hour and the buses bring us to the unfinished Supreme Court building, to await the descent of President Kubitschek in his giant helicopter. He arrives properly a few majestic

528

minutes late, shakes hands with all of us as though we had known each other since Bolívar: a gentle, handsome man with distinctly Brazilian features and a distinctly Czech name. Strange how similar his features are to those of his friend Niemeyer's, who looks so very much the Brazilian, although his grandparents come from Czech Austria.

The Supreme Court, where the Congress will be in session, is a square building with an outreaching flat top and a square terrace underneath, a few feet off the ground. In each of the four corners of the promenade is a column between the roof and the terrace floor, in the shape of the tail rudder of an airplane, spreading its curvature, widening on the floor diagonally toward the edge of the center block. The building's entrance halls are of Bauhaus design; the one large Supreme Court room is square and wood-paneled. In this courtroom I found the same Europamerican metal folding chairs with plastic seat covers, the same loudspeaker units (cheap walnut cases with a cut-out lyre covered by golden mesh), the same Roman travertine, the same window frames, the same light-holes in the ceiling. The only difference is the color of the endless massive plateau seen from the windows, that sienna red which mixes beautifully with dwarf trees and bushes, in great color contrast to the cobalt blue of the asphalt roads which wind their way like monstrous cobras through the unknown land.

The Supreme Court room, although unfinished, gave one the impression that the design did not emerge from primary considerations of good sight and good hearing. (We had temporary loudspeaker hookups.) The district attorney or the opposing lawyers would be pushed to the limits of their vocal capacities in making their cases and I wonder if sometimes the timidity of the accused, of whispering his or her answers, might not bring injustice in this room. Acoustics, not the accused, could prove to be the real guilty party.

I was asked to help improve the acoustics for the Congress and suggested that the long speakers' table be placed diagonally across a corner to make the two walls behind it a megaphone for sound. It worked.

Mrs. Aline Saarinen, who was one of the delegates, collected opinions from the guests at one of the final sessions of the Congress as to the validity of the plan, architecture, and social concept of

529

Brasilia. The first reactions were evasive, but you felt that future reports would be derogatory. Bruno Zevi of Italy spoke his thoughts with great temperament, shuffling pros and cons like cards; then I was asked by Mario Pedrosa, chairman of the Congress, to sum up my observations of Brasilia.

I said that although I had seen the grandeur of the government buildings only in construction, and from a distance, I could feel the *élan vital* of Brasilia. But I hoped that besides the will to power and to enrichment of the population with agricultural and industrial products, the sense of humility would not be lost, particularly in Brasilia's satellite cities where people will be living, rooted there not by duty-bondage but by their free choice to be part of a new concept of living.

"You have it easy," I said. "You can telescope two centuries of technological evolution, and therefore should have perspective on what we in the Western world have done and what contradictions that evolution has produced.

"The great asset of your Brasilia is that it can select the best from what the peoples of other lands have struggled with and achieved. Your thoughts and actions must be the sieve through which all past glory and failure pass. The remaining values can then be reassembled and newly co-ordinated with your indigenous past. The results of such transformation will be healthy, your own, and enduring.

"Now that you have started to keep pace with us, don't accept everything blindfolded and take it over by decalcomania, simply because it has been branded with success. Success is a double-edged sword: it cuts the future open and destroys tradition at the same time. When wealth grows, corruption grows. The values of original intent are too often led astray and may even end up in the opposite camp. Progress is often the devil in disguise. And he feeds on progress. You must recognize his face at an early age.

"It is one thing to create and it is another to exploit. Progress is like fire; it must be tamed. Otherwise it devours the individual as well as the social structure of a country.

"The denominator of social judgment is humility, and, in my experience, only humility. The intelligence of humility is the safe-
530

guard of peace. Ruthless progress harbors war. It arouses ire, envy, and mistrust among your neighbors and in your own land.

"We humans really do not need much to live happily: a decent, clean shelter, some seasonal clothing, simple food, with holidays of heightened taste, and above all, security of income and unconditional help for the sick and the aged. We in the West have made a mess of our natural chances. And now we are committed to the credo of going, going, going ahead. The earth will soon be too small and we will have to look for the moon.

"Be on your guard. Stand your ground. Don't be distracted and frightened by the deluge of information which is so often pseudo-educational and so insistent in its attempts to sell the benefits of new products.

"Miës van der Rohe's Barcelona Chair, the X frame of the seat and back, has been taken over in the palace of your President. Miës' design has been changed slightly; its original structural strength has been diminished, apparently for reasons of economics, local pride and decorative effect. The steel framework was originally stainless; it is now gilded.

"As an architect and as a member of the delegation, I feel obliged to point this out to you, although it may seem an insignificant detail at first glance. I hope it is not a typical sample of your planning. If you are in love with some other country's architectural work, that should lead to inspiration rather than imitation. You should either take over in toto or transform, according to the demands of your own history and present cultural ambitions. A cast from the original of Michelangelo's "Moses" must be kept intact, as it was conceived and executed by him. No one has the right to trim his beard or enlarge his horns.

"Brasilia has many roots in its own past; it does not need grafting from international fashions.

"Perhaps this is the moment to touch upon the future also—not merely the present. A future which might come about as a result of a destructive war followed by economic collapse. Then there might be no more construction, no town planning. Farewell sweet Architecture! People might carry their houses on their backs like snails their incrustations, except that the houses would be Sca-

531

phanders—individual diving suits—in plastic, with air-condition-ing inside, regulated by dials on a wrist watch or an amulet worn over the heart, radar stations showing the condition of the inhabi-tant and that of the cosmos. These translucent shells could also, by a turn of the dial, be made opaque in any section, or could change color and texture like chameleons, to let one become in-visible to trees and animals, plants and people, leaving one en-tirely in privacy. The glass, steel or stone enclosures we call houses would become a great-grandmother's tale. It could be a happy life, of civilized primitiveness, in the open yet protected, wandering or settling wherever we like, living in simplicity and not competition. And, naturally, there would be Scaphanders for two, as well as many other variations. Our architect colleagues will then of course be no more than human beings.

"But before we reach the age of no-architecture, your best bet is to stick to indigenuity. Its sap is richer than bottled import, no matter what the label."

I sat down. The applause was warm, and chairman Pedrosa smiled benevolently at me. But I felt strangely encumbered. Some-how my nerves went blind. I needed to be alone. Before the session ended, I stole my way out and let the breeze of a late spring en-gulf me. No one was outside. Only giant skeletons of isolated sky-scrapers one thousand, two thousand feet away.

Facing me, stood the steel cage of a future art museum, with workmen tiny as monkeys running back and forth, putting con-crete flesh on the steel. In the distance rose the cluster of six super-blocks, one day to house the sixty thousand government employees. To the left, I saw the rim of an enormous concrete bowl: a stadium-to-be. Another bowl, in reverse, of a theater, its shadows displaying the indigo-blue of the oncoming night, rapidly discolor-ing to purple-gray. The sun had withdrawn.

Two empty buses appeared unexpectedly from the direction of our hotel. In a few minutes my seclusion would be ended. The buses must stop right here, and out of the Supreme Court building will swarm the delegates homeward bound.

It would be good to be with my crowd again.

BRASILIA

September 19, 1961

hypnotized upon the red clay wasteland
of the Brazilian desert
the presidential palace-to-be cantilevers
its roofing and flooring into
a boundless terrace, propped up
by a colonnade of giant spearheads,
compressed shapes of concrete covered with white marble,
plastic symbols of sentinels,
pinpointed uprighteousness.

tropical rain waters flooding the area
produce ominous shadow-reflections
extending lance shafts downward through
ages when guards were arm-bracketing
protection of emperors.

President Kubitschek is a democratic man.
his movements are as charming as his
rising and descending helicopter, translucent.

September 20, 1959

La Cidade Livre
The stalagmites of new Brasilia are solidifying from the muddy concrete. Many buildings are still full of holes; steel lace in continuous construction. They rise mute into the night sky, burying the secrets of their future in the hollows of their spaces. The earth of Brasilia is dead silent. Not a soul anywhere. Up in the air, workers balance their way among electric bulbs on the beams of these building cages.

"But where are the rest of the forty thousand construction workers who are building this giant new capital?"

"Oh," I was answered, "the workers live in their own town, three quarters of an hour away. They built it by hand. They refused to live in the prefabricated molehills provided by industry.

533

They prefer shacks with the draft and rain coming through the improvised joints. They baptized it Cidade Livre—Free City."

"Now there's a workers' town I would really like to see. As a matter of fact I would like to see it more than Brasilia. I don't wish to offend the architect and the town planner of Brasilia—they have a difficult job ahead. But I have had enough of planning, replanning and unplanning. I like to see a populace working for itself, by itself. Who will join me in hiring a car to visit Cidade Livre?"

After our "Commonwealth Dinner" at Brasilia's hotel we did hire a car, and four of the delegates, including myself, drove toward Cidade Livre.

After three quarters of an hour, at fifty miles per hour, we saw the first meager lights of this frontier town. A little farther on we stopped and jumped out of the car at the beginning of an endless main street that looked like the main artery of an American shanty-town.

To the left and to the right were illuminated shacks leaning against one another, the walls built with planks, metal sheeting, cement blocks; the roofs of corrugated iron covered with old cloth weighted down by concrete rubble. These were shops of one type or another. Along the seemingly endless sidewalk one expected to see hitching posts for horses; instead, there were helter-skelter rows of American jeeps, second and third hand, painted in various colors, converted into travel-toys. To our amazement, one one side of the street we encountered at such a late hour a dense corso of young and old people moving forth and back, singles and whole families, in jolly mood, singing and shouting, not celebrating but just enjoying the evening air, the liquor, the climate of girls exhibiting themselves, mixing their mixed races, Negroid and Indian of Carib and Quechuan descent, Portuguese mulatto, women and teen-agers, almost every one of bewitching beauty with warm skin, black hair, glowing eyes; rapidly or slowly moving their compact bodies while most of the single men leaned against the walls of the shacks, forming outposts of subversive sex.

All architectural pretentiousness was missing. Just protecting walls and a roof over your head, stamped earth, and you could

walk barefoot. The older men wore laced leather shoes, the younger ones short boots or cotton sandals or nothing. Mothers and daughters wore velours or silk slippers of hyacinth-blue, of blood-red, of ochre. God bless the color sense of these Latin people. We northerners look like puny thieves in a paint box—to them color is all natural and casual, and whatever they wear never impairs their self-assurance. They please themselves without egocentricity. What a spirit of earthiness so near the industrial monster of Brasilia. Such a contrast: there, empty plazas and a color scheme of cold concrete while here the bright bunting of humanity. Now I know what it was that struck me: family life in the raw.

To hell, I felt, with construction concoctions, semi-industrialized materials, and equipment beyond our needs. Let's stop being victims of high pressure salesmanship or cynical advocates of blind progress for profiteering's sake. This town of Cidade Livre put the accent on life, not on architecture. Thank God! Finally.

I couldn't wait to go into one of the shacks, I longed to meet some of the people. From one shack came the smell of coffee brew, fish-fry, wine and blood, evoking the palette of Brazil's semi-tropical colors. It was a blend of irresistible seductiveness. I entered. The shop displayed a veritable library of liquor bottles on the shelves and three baby tables and chairs where I could sit down to have a customer's drink. My colleagues strolled on to sightsee. So long brothers!

A man wearing a wiry dark mustache over thin lips and shirt sleeves buttoned at the wrist, dusted the table with a clean napkin and pointed to the surrounding liquor library, asking from which of the bottles I wanted to be served from. I, however, became fascinated by the deep interior of the shack. Through an open door leading to the rear I recognized a wide kitchen where a hefty woman was surrounded by cats and dogs. Two girls and two boys leaned lazily against the walls, the cuisine evidently being the center of the house. Mama was the pivot of activities, performing them with a gusto and verve that showed no hint of burdensome duty. Her personality was magnetic, and so I, a Northerner, became encouraged to break through the barrier of the bar and enter the kitchen.

The woman's many-layered skirt swung back and forth like a fan. The more it hid her body, the more it revealed it to the imagina-

tion. Her hair was prune-black, her face glistening from the heat of the stove like polished bronze. In spite of her bulk she moved with swiftness and grace, carrying slit-open fishes of two- or three-foot length to one of the tables where they joined water creatures of other sizes drenched in blood and prepared for frying. On another table lay a lamb, split and quartered by perfect dissection. Its diluted blood had colored the table pink and splashed over the many utensils. The stove had four coal burners all flaming lustily under the cover of the iron rings, glowing red, waiting to eat into the fish and meat.

Mother turned toward me. I was still standing in the doorway, transfigured by the memory of my own kitchen at home where the stove also had four coal burners, where my Ukrainian nanny was as hefty as this woman and like her spoke a language which I couldn't understand; but in the glow of her eyes I felt the same warmth for me. I was at home. "Come and sit down," she indicated with a gesture of her hand, an invitation by a generous sweep. A youngster about four brought me a wooden beer-bottle box. I offered it to the daughter who stood silently, leaning against the wall, not more than twenty-one years of youth; on her highly pregnant belly was sitting a baby boy of about a year, an olive-colored Christ Child with curly black hair and blue eyes, his lips open like the leaves of a budding rose. She didn't react to my suggestion; then, after a pause, she turned her head toward me. Now I could see fully the most beautiful mestizo-Portuguese complexion, wavy and highlighted black hair that fell and rested on her shoulders, framing the golden icon of her face. After a pause the gleam of her teeth began to show, although only slightly. Then she addressed me in broken English, without changing the position of her body, her hands holding her boy against the cleft of her bosom, which I could see in the neckline of her flowered cotton dress, an open inlet to her body. "Can't you find me a rich American husband?" "You wouldn't like American city life. He wouldn't like the primitive life here. I'm afraid the warmth of your family would be lost, and the coldness of our business world would make your blood freeze."

Her young sister, of equal beauty, an immobile Lolita, was leaning lazily against the post of the second doorframe of the kitchen. That door led to a small corridor, the end of which opened on the prairie, and I could see the misty night sky tenderly illuminated by a rising moon. A moment later I ventured out into the back

yard. I saw to the left an electric generator which apparently every shack had. Beyond it extended the pampas-waste; the grass unmowed for a long, long time, since the birth of this planet it seemed. In the darkness, garbage and refuse, boxes of indistinguishable deposits, formed the only dismaying element, the only thing I felt could one day impair the health of these brave people. But that anguish belongs to modern civilization; primitive people maintain better resistance than we drug-protected hygienists, being hardened by their constant battle for physical survival.

After many minutes of silence, in which I seemed to merge irrevocably with the atmosphere of heat, blood and sex, the mother, who had followed me outside, swerved toward me, took me softly by the arm and, stepping into the passageway, offered me one of the four bedrooms should I care to accept her invitation to stay with them away from the ugly big new city. "Remain with us— just a holiday!" I was touched by the magic spell of her spontaneity, which blotted my brain out. Silently, but deeply, I was toying with the idea of getting away from it all—modern architecture, history, speeches—and reeling back into one of those unmade beds, ivory with the sweat and oil of many days, never mind, rest and peace. But at this moment, most inappropriately my colleagues from the Congress reappeared and crammed into the doorway of the shop. They beckoned to me. Fearing that I might really get lost in my nostalgia for the peasant life of Carpathian youth, Meyer Shapiro said, "No, you can't stay here any longer. Don't be sentimental, come back with us. The car is waiting at the front door."

I turned quickly and put the evocation of my childhood back into some godforsaken pocket of memory. I left. But before stepping into the black limousine, I embraced the mother, her daughters, and, in the whirlwind of thoughtless leaving, the father too. I turned my pockets inside out and all the paper money and coins I found I tossed onto the counter of the bar.

Adeus Cidade Livre! Adeus.

Brasilia to São Paulo to Rio

6:30 A.M.
September 21, 1959

Forced up at late dawn by the trumpets of the military guard at the distant palace shrouded in the fog of the desert plain.

The tone of the trumpet was clear and beautifully modulated, long and not persistent in its rhythm. Calm, gentle, as if careful not to waken the President too abruptly.

Now, at seven, down to breakfast, and then at eight thirty, off by plane to São Paulo, a three-hour flight, and then on to Rio.

We delegates are indeed good soldiers of architecture.

The In-Between

Rio de Janeiro
September 22, 1959

Rio is an in-between world, architecturally speaking: it is neither folkloric Brazil with its warmth and timelessness nor is it cold-blooded Chicago with machine-made hopes. But it has no social in-between. The middle class is missing. There is a promoting group spiked with its individuals, and far away from them are the people who carry out their business dreams. There has not yet been enough time in this fast-growing land to work, make a living and at the same time to teach everybody to read and write (much less to read or write between the lines).

But that will come. Sometimes, however, I fear that here, future generations will learn by such methods as tape, records, TV, outer-space machines; and the struggle of spelling and the painful twist of fingers holding a pen, learning to guide it in order to produce hand-script, may never be known. That ink-blackened middle finger which ours and older generations so proudly displayed in spite of soap-and-water-minded mothers and fathers and teachers—that mark of the struggling calligrapher will not be worn any more. Nor will this loss merely be true of Rio's mountain slum called Favela—all future generations will be facing it.

538

Rio, Sept. 24 1959 Favela, Rio

Parquet Floor

Hotel Excelsior São Paulo
Lunchtime
September 23, 1959

The parquet floor the same as in Vienna, Rome, New York;
the chairs, exactly the same;
the lamp shades, bedspreads,
salt shakers, Fiats,
songstresses and teleshows—
all known to us delegates
from our homelands
and crowding us here too—
but no common language among us
nor between us and the designer-architects
of Brazil

539

the modernism of walls and ceilings is old-hat,
the orange marmalade is the same, the ham,
the glasses, knives, napkins, bookshelves and hairdos
all of the same Western descent
(and make no mistake about it)
we all wear the same trousers, jackets, neckties;
use the same fountain pens—

 but the language:

not the same

the ladies, girls and teen-agers
the same combinations of skirts, hairdos, jewelry,
the curtains in rooms and restaurants—
the lighting fixtures,
all over again:
Venetian, New Yorkese or Parisian
all of similar origin, industry transplanted—
but we cannot communicate with each other—
the people who are here and we who come
bow and stutter and grope in vain—
we do not sing the melody of common language
spoken words are like sand between our toes.

Industry! Produce language pills!
pink for French, purple for Italian, brown for German . . .
take the right one
and be able to tongue-twist any language at will.

São Paulo's Skyscrapers

São Paulo
September 23, 1959

São Paulo's skyscrapers stand shoulder to shoulder with their friends, petit bourgeois family houses lining the main street densely, as if waiting for the arrival and procession of their Business King.

540

A sunken plaza in three levels easily beats Rockefeller Center: massive fountain, proudly outspread stone basins and flying buttresses of bronze sculptures. Twelve royal palms rise from below almost to street level, stretching their tall torsos stiffly, displaying plumed heads like eternal fountains.

A trolley with clusters of people hanging on to her sides, an overflow of men riders, dangerously brushing elbows with buses rushing by, cars and trucks. The unconcerned optimism of city tropics.

Up on the heights of the outskirts, a view of the town below; a scramble of overturned children's building blocks, the city. Along the high roads, villa after villa separated by subtropical and pseudo-tropical growth, deliberately modern houses, crossbreeds of functionalism and Portuguese patio colonnades, glass and perforated bric-a-brac walls, terra-cotta roof tiles and hanging gardens supported by walls with masterfully inlaid river stones.

Out, way out, to a World's Fair remnant which houses the Fifth Bienal of São Paulo. Just before entering the display grounds, an alley of high palm trees; between the trunks samples of woven hammocks in beautiful colors for sale at a shack in the forest beyond. Unable to stop and buy, which I wanted so much to do, particularly for Mrs. Regler who had told me back in New York, "That is what you learn in Mexico, to sleep in a hammock. And in your 'Endless House' you must not have beds, but hammocks."

Parking difficulties, even here. Maneuvering the car in and out, finally giving up and walking a long distance through an outdoor arcade toward the entrance of the Bienal. A three-story factory-like glass building almost one kilometer long. The Exhibition had been laid to rest in the open well of this long, translucent box. A huge tree of concrete with wide-swinging ramp-branches links the center of the building with its three floors, an overwhelming structure to the eye, very tiresome to walk in. A superimposition by the architect for architecture's sake, taking away, *a priori*, much of the glory of the exhibiting artists. We deplored it unanimously.

Since one cannot hang pictures on glass walls, flying partitions were set up on both sides of the corridor, the most diffused possible way of displaying art.

The day before, I had made a reservation for my return flight on the following afternoon, four days before the Congress' final session. I congratulated myself on that sudden decision, made easy for me because the Varig office was across from my Excelsior Hotel in São Paulo. Thus at ten o'clock that evening, after the official opening of the Bienal by São Paulo's society and the Congress art world and President Kubitschek, I trotted down the center ramps like a prisoner of Art, consoled by the thought of being released the next day.

Exiting into the open, I encountered a guard who asked me if I had seen the Bahia exhibit. My puzzled face made him point to a building across the way. I walked in, and here was the surprise of the Bienal. Bahia, probably the oldest town of Brazil, founded in the early sixteenth century, four air-borne hours away from Rio, has retained marks of its Negro and Portuguese and partly Indian origin. Entering the rather small exhibit, one stepped on a floor densely covered with eucalyptus leaves. I have already de-

scribed it elsewhere in this journal, but my impression at the Bahia exhibit echoes through my heart and soul, and brain and veins—I can't get it out of my system.

What an atmosphere, in which folklore, craft, religious and secular beliefs, were combined and unified! At the rear of the exhibit, I saw three Negro women of advanced age, not too heavy but plump enough to be impressive with their monumental thighs, sitting on Coca-Cola boxes, each clad in a continuous flow of white lace, apparently a Sunday garb to praise the Lord and now life. The three were sitting around a small iron stove on the floor, making dumplings in a hot-water pot and offering them to visitors in a most generous and inviting manner. Close by, in a sort of open garage, was the most exciting event of the Bienal de Arte. The event: an old man in everyday worker's garb and a young man in shirt sleeves performed a dance of a feigned fight between father and son, the eternal inner problem of that relationship made visible. Four Brazilian Negroes beating metal pots and tambourines in a most syncopated rhythm stood grouped around the dancers, participating through sound and sometimes by movements so precisely improvised that they looked choreographed. The experience was unforgettable for me in its creativeness, simplicity and directness. Oh, Art and Architecture—you must learn from the simple people.

Early next morning, I canceled my reservation to New York, having decided to stick out the whole Congress so that I might have a chance to follow the spirit of Bahia.

Bienal

São Paulo
September 25, 1959

The criticism of the Bienal comes too bluntly and too fast.

One sample, so far, from A.S., who air-shot a criticism directly to a New York daily (it had already appeared when I landed back home): "Ninety per cent of the paintings and sculpture of the four thousand works exhibited in São Paulo could have been

thrown out or used for industrial design purposes." There's the swoop and scratch.

So monstrous an exhibition as this international Bienal cannot be hung and displayed in continuous open corridors of almost a kilometer's length, all in a single building, without dispersing the hope for a warm relationship between the visitor and the work of art. It is unjust, particularly to the paintings, to plaster them on the endless partitions of these endless lofts. I bet that almost all of these pictures would look well if displayed in the solitary confinement of some home, in a warm atmosphere of peace and relaxation. The Biennale in Venice has it easier in that respect, because each nation has a pavilion of its own, apart from the others, in a vast park on the border of the canal. No matter how irritated you might become by one exhibit, you can always wander out into the gardens, sit down, forget, contemplate, and thus gather courage for a visit to another pavilion. That makes for good will.

But here in São Paulo, the paintings are gathered into a single procession and, being so very much of the last decade of modern style, with only slight variations, they automatically look alike. The conformity hurts. Each of these artists has given his best, but his best is not enough in such a mass demonstration, and the one who looks entirely different can easily be suspected of being a phony, and will be discarded as an outcast almost at the outset. This is the tragedy of vast internationales, biennales and triennales.

It seems, altogether, that if a style in painting, such as abstract expressionist or surrealist or non-objective, is adopted by artists throughout the world and practiced by them day in, day out, year after year, the paintings and sculptures will lose their individuality, their precious uniqueness. Is that the definition of a style? The very muscles of their art seem to be beaten into numbness by the violent brush strokes characteristic of our present period. Thus, art comes to the end of a cycle—it has detached itself from life.

Critic Carl Bühler, Swiss, fifty years old, with light-gray hair and bangs covering his forehead, cut loose at a party in a small villa on a mountaintop. Buses had pulled us up a giant mountain through tropical jungle, on a road slashed out of forest and rocks, an amazing feat, yet also a seeming extravagance because the road led neither to a towering outlook nor a plateau but to a private hideaway. Time and again we delegates had to disembark

because the motor was not strong enough to pull us up along the steep curves, serpentines walled in by intertwined trees, and parasitic vines holding hands like police cordons, keeping us intruders firmly in line.

At the villa, four youngsters brought in to entertain us picked up dishes and cake boxes and pounded out a samba with such sensuality that they literally pulled our Swiss critic from his seat. He danced with two lighted cigarette butts, pushing them in and pulling them out of his mouth to the rhythm of the samba, in a free-from-all critical duties. We shall see what steps he will tap later in his criticism, back home among the green valleys of Switzerland.

vultures at play
do not mind decay

nothing matters
the beak chatters

clawing talons
clowning buffoons

murderers at rest
are not at their best

All Visitors

Rio de Janeiro Airport
September 28, 1959

My fellow travelers, male and female, waiting to be flown back to their various homelands, all have Rolliflexes or Kodaks hanging from their shoulders or pressed against the walls of their breasts. I am pretty sure that if the photography mania continues, human beings will soon be born with a third breast, including a telephoto lens for moon-shooting.

545

Opposite, on a wall, are clocks around the world:

New Orleans	New York	Buenos Aires
4 o'clock	5 o'clock	7 o'clock

Rio	Londres	Rome	Cairo
7	10	11	12 o'clock

We are waiting for the litany of the loudspeakers, when the Word will be given! New York—and we shall exit, homebound.

Trujillo,
September 28, 1959

I am in Trujillo, Dominican Republic, dropped fast out of menacing clouds and "a dependent free nation—with a balanced budget of 27 years of progress" as the prospectus of the El Embajador Hotel reads, where all Congress members went down in an emergency landing on our air-way to New York from Rio de Janeiro.

View from my air-conditioned deluxe quarters outward to the heat-breathing vast expanse of a plain, so very green, ever-green with dense bushels of grass, all cropped curly blades, and to the east I indulge in the expanse of a blue belt of sea water. In the distance a rocky bracelet around the horizon, far out, constantly rising and falling. The landscape, semicircular, with its hills of many breasts, sharp noses and undulating humps of a multitude of the earth's body, all peacefully resting since, oh so many ages when first seen by the Spanish eyes of Christopher C.

While waiting to depart, we were taken by an airline hostess on a tour through the old city, we combatants for a utopian architecture were, however, enchanted with the sudden encounter with a monastery of the seventeenth century surrounded by a stone wall of magnificent build and of a large cathedral harboring inside a baby replica of this cathedral as a shrine for some of the old bones of discoverer Christopher Columbus. They were vaulted in a box like a blackened iron trunk, aged and petrified by now. What a miniature casket for a giant! who died in Valladolid in neglect and penury, May 20, 1506 in hunger, poverty, need, want, privation, indigence and destitution after opening up the portals to a new world.

546

The two swimming pools outside the dining room, whose ceiling is spanned tautly with tiny bronze wires, a metal spider-net electrically charged to kill mosquitoes who might annoy vacationing tourists. Luncheon is served on floating tables with magnetized tops and bottoms of cups, dishes and cocktail mixers, protected by balanced beach umbrellas.

This is Trujillo's contribution to modern architecture, to the future of the flying jet sets and to the gambling jetton clan from the U.S.A. and South America. Farewell tropic of chance!

547

1962

The last three days in New York for me: Death of Franz Kline. Marina. Dr. Sandberg. Passport. Vaccination. Seconal. Dick Grossman. Sweeney. Dane and new studio.

Compact actions. Fencing, that is, parrying and thrusting, all around me—up to boarding the plane. Never welcomed "Fasten your seat belts" with greater obedience. Relaxed.

"Did you hear the bad news?"

"No."

"Kline died at six o'clock today."

That was Miss Morrison speaking on the telephone, a few minutes before I left my home for Idlewild. Her teen-age daughter, Marina, had been operated on for a brain tumor just two days ago, a thunderbolt experience for all concerned. Therefore, "Did you hear the bad news?" was a breath-slamming shock to me, since we were ready to learn the worst from the hospital. Thus, when the question referred to Kline, although a close friend of mine, it was strangely a relief, by comparison, since he had suffered three heart attacks, had been in an oxygen tent for a week, and despite the news that he was out of danger, we were still fearful, praying for his coming-through, but the chance for his survival had remained tragically slim. Always full of vitality, Franz enjoyed competitive toasting to the bottom of the beer mug, endless double-talk-kidding and horseplay, yet in spite of this wearing night life, he remained a powerful painter during the day, the most powerful of them all. Since the end of World War II Kline had been a towering artist to the glory of American art. His loss is monumental because his paintings were unique in spite of no-color in his big-boy canvases. He proved that black and white are colors if brushed on blind-folded, that is, with pure instinct. To me he was an architectural painter, scaffolding with his brush. He was set into the brick and cement block as one of the few colorful stones (Marcel Duchamp, Kline, Egas, Stuart Davis). This, our block, is bordered north and south by Fourteenth and Thirteenth Streets and east and west by Seventh and Eighth Avenues. Although living around the block from each other, we never met street-walking. His life and work hours were different from mine. He occupied a business flat on the second floor of an old brownstone house on Fourteenth Street. A large display window facing the street gave him ample light,

550

but he preferred to paint by artificial illumination. His window had full curtains of unbleached muslin, split in the middle. They were usually wide open and, when closed, were never completely drawn. They remained always a casual one or two feet apart, proving that he really did not care if anyone wanted to go up the stoop of a few steps, bend to one side and look into his workshop. I went by yesterday. For the first time, the curtains were completely drawn.

"Hello, Fernandez, nice of you to call at so late an hour. You know I am a night watcher. You can always . . ."

"My God, Frederick, I am going insane. Imagine, my daughter Marina has a brain tumor. They diagnosed it today. I can't believe it! She's been moved to Presbyterian Hospital on One Hundred Sixty-eighth Street. She's in the ward because we're poor artists, but luckily Presbyterian has the best neurosurgeons. We couldn't pay for it, nor could you. Tomorrow her skull will be opened. My God! she's only seventeen . . ."

"I'll be right over. Calm yourself. It won't take me more than ten minutes."

Fernandez and I were on the telephone the whole night.

I tried and finally did reach Dr. Wilder, heart-surgeon specialist at the Hospital for Joint Diseases, and a warm friend, to ask for his help in a matter we knew nothing about. "We are at a loss. Could you extract the facts?" "Please stand by." I phoned Rome, awakening Piero Dorazio at five in the morning, begged him to contact Marina's mother, whose whereabouts could not be determined here. Glory to the Telephone!—she returned the call in less than an hour. We wired the American consul in Rome for financial assistance and an emergency visa for the mother. Bill de Kooning, *copain* of Fernandez, was notified of the crisis by my studio assistant, who at midnight slipped a note from me under Bill's door. He arrived at five in the morning, stayed with Fernandez the rest of the night and through a whole day of talk, silence, food, drinks, rushing to dial numbers that never answered again and again, waiting, pacing, sitting down, getting up, going from despair to hope, from hope to despair, the day seemed an endless night. In the evening they both taxied to Bill's studio. Not too long a time before, Bill had generously promised to provide his friend with

551

a drawing for sale in case of financial emergency; but when confronted with this ultimate of emergencies, he at once offered his checkbook. He now insisted upon buying jet tickets for the mother and the five-year-old brother of Marina, who could not be left behind. Closed in the taxi on the way to the studio, the space seemed too choking and smothering for the escape of their emotions. Spasms of anguish finally burst into crying spells. The atmosphere of distress finally engulfed the driver, who suddenly veered the car and stopped. In tears, shaking his head, moving from side to side the overgrown white hair which fell in sweaty curls on the nape of his neck, he told, in broken English with a Russian accent, a despairing story of two teen-aged daughters who were causing him endless troubles. Bill and Fernandez had to console him and ultimately induced him to start the drive again.

Marina's mother arrived from Rome the next day, that is yesterday, at 6 P.M. We had gathered in a family session when Dr. Wilder broke in with a call giving the news that the operation had revealed no malignancy, not even a tumor—only a cyst. The Italian temperaments went wild with joy, and I finally could retire to my home on Fourteenth Street.

Not much rest after that. Rushed next day to U. S. Passport Agency in Rockefeller Center to get my new passport and swear allegiance to our flag. Discovered myself in the same skyscraper as my publisher. Shot up from the mezzanine, the passport floor, to the twenty-eighth, to visit my editor. He shocked me with the news that he is resigning, in all friendship, from the old house, to form his own company; and as early as June. Last night's mood of disaster seemed to continue. This was the man who had encouraged me, novice as I am as a writer. I felt deserted, and it must have shown. He said, "Don't worry. I'll stand by. And we've selected an editor for you who will be sympathetic to your hesitancies and impulses." I still felt dazed.

Strange how conservative I have remained in human relations despite my ahead-ideas in work. Living in a land of continuously progressing industry, the environment which pounds at me incessantly, and in which I am naturally interested as a designer, I still retain my reluctance to change. The change of a designer in my office, the shift in personages of my friends' circle upsets me. And now the vanishing of the editor, at the moment when I had just finished a full year of editing work on my manuscript, left me

blank and shaken. I was even more shaky because it was exactly at this visit that I had intended to ask for more advance money when I delivered the final manuscript in two weeks. I had realized that the text needed illustrations, which meant more work and of a different nature, covering a great variety of themes. I felt I was justified in asking for more, but I couldn't.

I rushed away from Rockefeller Center, into the shadowy lobby and out into the sunflower radiance of a Fifth Avenue afternoon. What a contrast of in- and outdoors! A Yellow Cab took me uptown to 77th Street and Fifth, where my doctor squeezed me in between appointments for a smallpox vaccination shot. Me: "I'll need some, a few, sleeping pills for my ten-day trip to Jerusalem. My experience is that only deep sleep in the morning hours keeps me fully awake during the day. Otherwise I am drowsy, unfit. Will you give me a prescription?" "No," he answered, "I've told you before." I: "How uninspired doctors can be—just like artists! Good technicians, but unimaginative. Do you treat every patient with the same illness the same way, exactly the same way? You claim that I got too much accustomed to sleeping pills and was on the verge of becoming an addict, and by cutting off the supply completely I'll learn to forget them. You are wrong. You heard about my accident, when I stumbled going from my bed to the bathroom. You heard how I knocked down the side table, fell over it, split my lips and knocked myself out. They told you about the blood-drenched carpet and you saw the bruises on my face. So I understand your diagnosis, that I had stumbled from drowsiness because of taking too many pills. But actually I tripped over the cord of my heating pad. This is a fact. You might not heed my assertion, but the fact is that I am perfectly capable of restraining myself from practically everything that I feel is physically harmful to me. I have proved this by stopping the advance of my arthritis through the good and evil effects of food, climate and habits. You cannot, my dear Doctor, ignore the specificity of an individual and its influence on the course of an illness." "I cannot prescribe a single sleeping pill for your trip. If you insist—this is the parting of our ways," he said. "If I would follow you blindly, I would undercut my workability," I answered. "I'll need all my wits in Jerusalem, Rome, Paris and Amsterdam. This is the wrong time for a new experiment with my old habits. I accept your severance."

I bid him farewell with a click of my heels and left to visit next

553

door with Leo Castelli. In this short walk I brooded the distance of a block, realizing that with only half a day left I had to get another prescription and supply myself with at least a few pills. I caught Castelli just before closing time. It was a relief to shake the hand of an old friend. We discussed my imminent visit to Dr. Sandberg of the Amsterdam museum, to schedule my exhibition next autumn, which, to our bewilderment, he had dropped through some misunderstanding. In Amsterdam I hope I'll meet my old *de Stijl* friends: J. J. P. Oud, Rietveld and Van Eesteren—and Rembrandt van Rijn at home. I never have.

Cut from 77th Street at Fifth Avenue right through Manhattan's sea of city blocks to Thirteenth Street and Broadway, my studio. Squeezed in a visit to meet my new assistant to whom I handed over my loft to live in in exchange for a few hours a day work for me. Surprised by his full forest-beard. He explained that he had to grow it as an extra in Hollywood, but the acting part never came through. Handsome, companionable, Los Angeles-born, twice divorced. "Too many painters," he volunteered, "no need for me to add paintings to the mass graves of contemporary art."

There was no time for chitchat. The one-hundred-foot loft had to be broken up: its height, its width, its length. Paintings or sculptures, no matter how big, would get lost; they need precision of environment.

"Let's hang flat eight-by-four panels below the ceiling. Let's hang the same size panels vertically, to form niches. Inside we'll place free-standing sculptures, their environment thus defined by these panels on top, left, right and back. Sort of flexible stalls.

"Can you suspend them while I am away? I'll leave some money. Also a tall ladder must be bought and nylon cords, wooden strips for backing of the panel boards." With a last glance before saying goodbye, I could see those floating niches in the semi-darkness as clearly as if they were already built and the sculptures inside starkly lit.

I realize only now that it was an unexpected call from Houston, Texas, which had inaugurated the rush of those days before my departure. Almost never in the last ten years had I seen James Johnson Sweeney. Last time it was at the Museum of Modern Art, when we planned a *de Stijl* show together. He resigned soon afterward

554

and nothing came of it! A pity. Unexpectedly last week Sweeney invited me to lecture on my model of the Universal Theater exhibited at the Museum in Houston of which he is now director. He introduced me cordially, recalling 1924 when he met me in Paris with Fernand Léger. I hope we'll meet in Europe—Paris or Venice—as he had said when we goodbyed.

Breakfast at noon
Paris
May 16, 1962

"Viens déjeuner!" shouted Henri. And I feel: Glory to friendship in France! There, the roots never grow foul. I mean: cordiality, directness, embrace, even by telephone if it's a friend-wanderer. You are kissed on both cheeks with both cheeks.

It was Henri Laugier, with whom I became close ten years ago when he was cultural attaché of France at the U.N. in New York. Our bonds stretched, but never tore. I had arrived last night and first thing today I phoned Marie Cuttoli and Henri answered. "Hello, *cher ami*," I said when I recognized his voice once more after two years. "Come, come!" were his first words! Not even an official hello first. At once: "Come, come to lunch!"

"I am having lunch with Soulages . . . we have . . ."

"Then come to dinner! Yes?"

Marie came to the phone, too. I knew she had been ill, but she spoke into the telephone: "How lovely you are here. I hear you'll dine with us. I'll ask Mary Callery to join us."

I attached the receiver back onto the wall telephone. I sat down on the bed. The cover, heavy woven in red and green stripes, felt sympathetic. I stroked it like the neck of a horse that has behaved well. There was not much time to meditate. In a few minutes Soulages would be here—in my mansard overlooking the proverbial roofs of Paris. Same room—I insisted on having it this time, too—as in 1947 when I came, during hot July weeks, to construct the surrealist show at the Galerie Maeght. I am happy looking backward and happy looking forward. I know nothing has changed in my chances as long as I take them. The future is full of presence and the immediacy of life is neo-time. A clinching of the past.

555

At four o'clock, theater experimenter Polieri. At five, El Al office, verifying reservations for tomorrow's flight to Tel Aviv. At six o'clock, Marie Cuttoli and late at night, Anita Veillard and Chastel at the Café des Deux Magots.

When I had entered my mansard room on the top floor of the Hotel Lutétia, I felt at home because the doorplate I have known for thirty years had remained unchanged. I mean the plate around the doorknob, that vertical brass shield which protects the usually white-painted door from being soiled. There is no economy involved. The plate, although industrially manufactured, presents a highly decorative element on the door. It is a good one foot long and three inches wide. The metal sheet is rather thin and lies very flat on the doorframe. It is deliberately overdesigned so as to make its practical raison d'être not too obvious. The top and bottom of the shield end in a *corniche* while the middle part is perforated in the classical rococo tradition, that is, a basket-weave pattern. The oval door handle proper sits on a square brass box which contains the key mechanism and also the one for the doorknob's twist. Plastically speaking, it forms a blunt contrast, a compact square against the basket-weave perforation. Opening and closing a French door is pleasant visually and mechanically. There is no slamming necessary to make it stick. While depositing my raincoat in the foyer on a wall bracket, I again felt like an old-timer because the hook was not an upturned rod with a point, but an upturned rod carrying a metal shell laid horizontally upon it, to prevent piercing a hole into, or beneath, the collar of my coat. Seems so natural, yet everywhere coats and hats are almost lanced. These French coat hangers are also more securely fastened to the wall, because, instead of having only one screw, they have three, one in each of a three-pronged leaf design. They can carry more weight and the leverage is much more secure. I can't see any necessity of "progress-design" regarding this hook-hanger—unless we all go hatless, which we should do, and it becomes an antique.

Before opening the window, I visited the bathroom, with its sarcophagus-bathtub, which made me feel Roman-like three decades ago, when I always made an imperial entrance into the tub after taking the hurdle of the rim and descending into the depth of the Tyrrhenian Sea. I was happy to see the pull chain of the water closet with its handle hanging down on the straight rod like the weight of my father's kitchen cuckoo clock. A simple pull, the

metal joints at the handle and on top of the lever quivered, releasing the mechanism in the water box, and the gush of water was storming forth with pride and loud fanfares still resounding after I had stepped back into my room. The French seem to get along very well with this old-fashioned mechanism, while we in the States invent all kinds of push buttons, levers, turnbuckles to precipitate the water. A novelty which we might soon expect in our bathrooms I saw on an airplane where the water, when released, proved to be sky-blue. Watch out for new developments in toilet gushes, particularly deodorizing by Dior, Raphael, Chardin, Poussin.

The third item which struck home was when I opened for the first time the French door-window. There still ran all the length of the window from ceiling to floor the steel rod locking the double door, top, center and bottom with one single turn of the handle. Quite an ingenious trick, hard to outdo unless automation with its touch-and-go replaces handicraft completely and makes a real saving of energy. The roofs of Paris seen through the open door-window are quite unchanged except for the new height of new apartment houses, not too many, however, to make much of a difference. A prison building right opposite the Hotel Lutétia, fronting on the Boulevard Raspail, had been demolished. This gap in the street façade immediately brought back a gruesome memory. I was told in 1947 that it was in this prison that French political prisoners of the Nazis were held and their shouts of revolt were heard across at the hotel.

When coming down the landing stair from the Air France plane yesterday, a delegation of men was waiting. During the flight I had unexpectedly been the traveling companion of a young mother, wife of the brother of writer Nabokov. I had met the young lady several times at minor and greater distances during cocktail hours in New York. I found her unusually attractive in a rare way. Her slender figure was dominated by a face with such an expression of inwardness that the red fullness of her lower lip seemed like a protective lock. Chatting freely with her restless baby on the plane, the bolt was released. I also tried in my best, although academic, manner to satisfy the child's hunger for attention. When we finally arrived at Orly, we had run out of clowneries. To my surprise she was greeted at the otherwise empty airfield by a group of five gentlemen, and an elderly lady, who had come to fetch her. With a gracious attitude, she introduced me to her father. He was Louis

557

Joxe, Minister of Algerian Affairs. She insisted that her two younger brothers in the group take me in their car to the hotel, while she, her father, mother and the other gentlemen would continue in theirs. En route to the hotel we got involved in politics, quite natural in Paris, and I was told that the prison opposite my hotel is only one in a series to be demolished, since prisons will not be necessary any more in an age of freedom. French youth thus spoke. Three days later the Salan trial ended, and the voice of the verdict coming from the prison tribunal shook France.

At the airport, Zurich,
I am waiting for the transfer
to El Al for Tel Aviv,
this May 18, 1962.

Having gone through the maze of that super-organized airport of Orly and before that Saarinen's TWA airport, I am still amazed at the conceit of our design age. Truly deceptions of progress, comfort and profit! So-called functional architecture has grown drunk on professional amateurism and now landed its fashions in airports.

Fifty years ago, functionalism was a revolutionary attack on the fashions of the Victorian age. By now it has become a fashion in itself. The wide spread of its news value is due to our speeded up communication system. There is no time to assimilate new principles, no time to root them, no time to develop them—only to imitate and apply as quickly as possible.

The mere walking distance from where one enters a modern airport to the actual door of the plane is so elongated and often on so many levels that I always have to stop and rest several times, since I usually carry a small but weighty handbag. No moving sidewalks (too much risk?), no rolling cars, no porters. Of course if it were horse-carriage age we would expect the discomfort of long-winded preparations and rare enough indeed would be the occasion to travel long distances by road or sea, a few in a lifetime. Now lifted into the air, off the ground, our hopes of miracle comforts rise high and higher as the miracle of transportation has risen from propeller planes to turbo-jets and finally to jets. But what price speed? The red and white or black glistening formica tops of the split-up ticket counters at Paris-Orly have nothing to do with the comfort of the passengers; they are for the comfort of the management, part of a mechanized process of receiving and

558

delivering people and packages, a dead-end development not a new concept of flying machines and their servicing. What a difference it will make when aircraft no longer look like imitation birds with their wings spread and cast in petrified metal! When that conversion takes place let's hope that a simplification of operation will go hand in hand with it, and the complicated methods of imitating natural processes will be reduced to fundamental laws of human behavior. The labyrinth of compulsory stops and gos at an airport is clearly part of a police policy of an industrialized, world-wide prison where every move is predesigned, premeditated, the individual is a pushover. I am waiting, waiting for my transfer plane. No sign of it. And now I am called by name over the loudspeaker to appear at the transit counter. El Al reports engine trouble. Three more hours' delay! It will be six hours of waiting and a middle-of-the-night arrival at Tel Aviv.

Lost in the transit room among a few lingering "waiters," not allowed to leave the airport, it suddenly flashed through my mind that I could call two friends in Zurich, Dr. Curjel and Max Bill. I found Dr. Curjel's number in my blue leather book, dropped some coins into the telephone box, and Dr. Curjel answered. An hour later I shook hands with him. An art historian, a very vivacious elderly gentleman, alive with curiosity about the happenings in the world of art, architecture and the theater. We had engaged, two years ago, in violent discussions at the Museum in Winterthur after the opening of a futurist show. I had promised to send him photos and writings about my work. I never did. I promised again. Hearing of my impending shows in Europe, he now insisted that I must exhibit at the Museum of Industrial Art in Zurich, and that he would immediately contact Dr. Sandberg in Amsterdam about it. I felt happy that this chance meeting had led to something concrete. Out of the boredom of that transit prison was born a new extension of my exhibition program in Europe.

Two hours later I finally boarded an El Al plane for Tel Aviv. I found myself on this economy flight as though on the sidewalks of a market street, high up in the air. To my surprise, most of the men, apparently small merchant-pilgrims from New York, got up from their packed three-and-three seats and, stepping over bundles and neighbors, wandered back and forth in the aisle, chatting incessantly in the most nonchalant manner, cluttering the passageway in the best of humor, creating a pandemonium with their movements and their confessions of family gossip, business sins

and hopes, all to be topped off later by making merry with blintzes and ice cream. A grown-up children's carnival. But there was a moment of serenity first. Just before dinner was served, many of them put their black caps on, retired toward the tail of the plane and, crowding the kitchen and lavatory area, held an evening's prayer session. I must say that, while bewildered as a traveler, I found myself admiring these men who pursued their age-old rituals thirty thousand feet up in the air, just as they persisted in their religious adventure on the ground and underground.

Stepping into Jerusalem, I went immediately below the earth's crust, that is, into our caves of the Shrine of the Book, now in construction.

May 29, 1962

In the next six days we selected all the stones for floors, walls and ceilings below and above the ground, quenched an assistant's attempt to insert his own idea into the plan for an important stone setting, and built a sample wall ourselves. On the seventh day, I received a telegram from painter Soulages giving the date and hour of a meeting with Mathey, director of the Museum of Decorative Arts of the Louvre. I left for Paris hurriedly.

My meeting with Mathey ended highly satisfactorily, he having invited me to exhibit next May a comprehensive show of my ar-

chitecture, sculptures and galaxial paintings. I could not have asked for a more cordial reception in Paris, professionally and privately. It had taken thirty years. I dined every day at Madame Cuttoli's house, feeling almost at home. The last evening, sitting around the desk of Henri Laugier, she suddenly asked permission to search for two large sculptures of mine which I had abandoned eight years ago in Vallauris and completely forgotten. I gave her permission in writing, and said that if they were found she should accept them as a gift from me. There was one more stop to be made before my return to New York. Amsterdam.

Amsterdam

May 28, 1962

Arrived there at three in the afternoon. After saying hello to Dr. Sandberg, I rushed to the Rijksmuseum for my first visit to see the two paintings by Rembrandt which I have admired since my student days. The group portrait of the cloth makers' guild, with that daring corner of the table sticking out of the foreground practically into the open, and, of course, "The Night Watch." It's in a room by itself, covering a large wall, and opposite it, at a much too respectable distance of fifty feet, is an array (in a half-circle) of several bourgeois couches, now filled with silent, elderly ladies and gentlemen who look as though they were holding a church service for art. I stepped up to the canvas to see at close range Rembrandt's method of painting the white-yellow embroidery of a gauntlet, and was stopped by a mummy of a guard who suddenly appeared from nowhere. He pointed to the floor in front of the painting, covered with a six-foot roll-strip of carpet, and made me understand that no one was permitted to step over this no man's land. I retreated. Casually visiting another room in the vicinity, I discovered three paintings by Vermeer among an array of third-rate Dutch artistry. I was surprised at his pointillist method of modeling the highlights while the rest of the picture was painted with that satin smoothness which Dali so much admires.

Rembrandt's "Night Watch," which I knew only from contemporary reproductions with their keyed-up color cosmetics, has black-

561

ened considerably since the seventeenth century. It looked as though it were incessantly mourning the loss of its creator, getting darker and darker. "The Night Watch" suddenly appeared to me to be the first documentary news photograph in paint. A perfect still-picture of a street scene in motion—caught and transfixed by a flash of light. In his other compositions Rembrandt himself, like his Italian master-colleagues, composed paintings of posed figures, backgrounds and foregrounds—they were really composites of parts intelligently studied and ingeniously put together, successful elaborations of traditional imagery. Rembrandt caught in "The Night Watch" an instant view of a most conglomerate action, in a coincidence of sight and vision, and bound the parts together by throwing semi-darkness over some parts, night over others and highlighting only three figures with brilliance. The intellect browbeaten by emotion.

Exited, I waited for a taxi in heavy rain. Leaning against the wall of the Rijksmuseum, under a protective marquee too short and narrow for dozens of visitors, I watched the endless chains of bicycles driven on and on in steady streams by riders of all ages. This was Holland as Van Doesburg always had described it to me.

At the Amsterdam Hotel

The room at night felt fluffy like camel hair. An interior's warm embrace. Left orders to be awakened at ten o'clock, but definitely not before. Sharp at the iron-gray morning hour of eight, the telephone gripped me rudely and woke me up in spite of my hypnotic indulgence: don't answer. There was no letup. I turned and fingered for the receiver. I finally pulled it toward my ear. "A telegram for you, just arrived, from Paris, and Mr. Sandberg said you ought to get it before you leave. I am his secretary Hendrickje. It is signed Mathey." I was too drowsy to care much about the message and turned back to sleep, knowing there was only one hour to catch more rest before my seven-hour flight to New York. Still holding the receiver in my hand, high and away from me, I listened again.

562

micralyst
Stydelyk Museum
May 29/1962

I listened again. I recognized now the voice of Dr. Sandberg: "It's not a telegram but a color transparency of your 'Endless House,' which you forgot at the museum in Paris. Mr. Mathey sent it to us for you. I would love to keep it. May I?" "Of course." Relieved that it was not a cancellation of our Paris exhibition plans for next May, I crawled happily back to bed and rolled myself into the Dutch covers. But my sleep was gone. It was brutally ten o'clock, and the telephone rang as scheduled.

Dr. Sandberg

May 29, 1962
At the airport in Amsterdam

I was an hour early for my departure to the U.S.A., and having been equipped at the sign-in counter with two slips, one for lunch and one for coffee, I find on entering the dining hall the fifty-year-old dream of functional architecture once more realized. Just another fashion routine. The vast space presents itself like a jewel box of velvety wood, anodized aluminum, lemon-ochre-colored plastic upholstery, sparkling white tablecloths, pastel-colored tiled floor, rows of hidden ceiling lights and naturally one wall entirely in glass. Through it I see the expanse of the airfield and, no doubt, that is my Royal Dutch plane which will carry me to New York.

There is still half an hour until boarding time. The vast restaurant is unusually empty and so is my mind. I cannot select and focus between my immediate sights and the memories of the last ten days, either those of Jerusalem, Paris or Amsterdam. Although I have the desire to do so, because I have been quite successful in these three places, I cannot conjure any events, happenings, hopes or conclusions, although I try again and again. The mind refuses to acknowledge any particular facts and I remain blank, indifferent. I turn my head backward, lower my lids, waiting for the announcement to board the plane. There'll be the loudspeaker's voice, the shuffling of chairs, the cries of children fearing to get lost, the rush of whole families toward Gate Number 3, then the lone walk across the concrete field toward the hind end of the air-

563

plane, the rectum entrance for second-class voyagers. While already climbing in my vision the stairs of the plane and just about to enter it, a family of three sits down at the table next to me. Their sudden presence brings me back to here and now. Arab-Italian faces, Americanized clothing, adopted hygiene.

I see to my left a young (probably twenty-one-year-old) lady, most likely the elder of two daughters, and she is deliberately turning her face away from my look, offering me only her profile. There is really nothing extraordinary about her. She has the ivory-colored skin, raven-black hair, rich and parted in the center, of the Middle East, her blouse displays an open collar and English sleeves, long and tight at the wrists. It's shop-bought. I cannot see her skirt. It is covered by the white tablecloth which she lifted and spread willfully wide over her knees. No question about it, my glance has offended her. Below the edge of the tablecloth, however, I can see her foot, wearing an open-lace leather sandal with a fashionable high metal heel, a miniature minaret. Defying its camouflage, her foot appears naked. The color is unmistakably flesh in spite of stockings, the existence of which I recognize only by the dark square of the heel. Although hidden in the shadow of the tablecloth, the sight below the cloth took on for me a life of its own, isolated from the rest of the dining room, the life of a singularly delicate form, a damn successful product of the inspiring exoticism of the Orient and Western mercantile cleverness. One does not need to be a foot fetishist to be attracted by the sight of a casual masterpiece of nature's mass manufacturing or by a graceful fitting of a heeled sandal, to pursue the image further, and with compelling curiosity. If aesthetics have been invented by man or nature as a camouflage for sex, I leave it to art historians and psychologicians to uncover the rules of the game, but to me it seems quite natural to take an imaginary voyage upstream from her foot. Following her stocking beyond what I actually can see, I remember at once such glimpses, sights, which assailed me like any other boy, because obviously the slight discoloring of the foot skin by her stocking will not continue indefinitely. It must stop somewhere, that is higher up, with a dark edge either folded flat or rolled by hand, and then the naked skin of her thigh would breathe freely. That stop might be under her kneecap, if she is old-fashioned, or in the approximate middle of her thigh if the stockings are held up by garters. This flash vision X-raying the tablecloth, her skirt and possibly a petticoat, as if they did not exist, was automatically inspired by the mere sight of her foot,

which, dressed in thin slices of black patent leather, heightened the ivory of her satin skin to a faint rose. The hard glitter of light reflected from the black-lace jungle of her shoe straps had exactly the effect that she, the manufacturers, her mother and doorway gossip hoped for. I was not an exception. I fell for it.

Above it all, that is, on the table top, she was busily maneuvering dinnerware instruments, gradually moving from well-organized plastic airplane plates and platelets, food, cold and lukewarm, into her mouth. She apparently (or am I naïve?) remained unaware of my eating up her hidden toes, the arch of her mini-foot. Resting in this vicinity with patience and perseverance, I finally arrive at her exposed heel, darkened by that square and sharp-contoured patch of the double-layer nylon which obscures the swell of her heel. Remaining there for seconds and trying to penetrate the mystery of body and mask, I suddenly reel back into my past when dust and quasi dirt would nestle in the grooves on either side of the tendon of the heel, curving slightly and elastically toward the bone of the ankle. "Wash your dirty feet," I was often told. But of course the heel being out of my sight, even bending or twisting my head, I quite often did not know how blackened the skin there appeared, or really was. I now remember clearly that I did not mind if a girl's foot disclosed these darkened caves of her heel or not; as a matter of truth it seemed to enhance the expectation of contrast with her luminous skin, the higher up the more luminous, until the night patch of her pubic triangle would stop my imaginary voyage and bring me down to earth. It does now, too, with the town crier's loudspeaker voice: "All aboard! The Orville Wright DC-Eight departing for New York at once!"

New York, Christmas Eve December 24th, 1962

Today I finally wrote the following description of my "Endless House" for the new Japanese magazine, *Bokubi Forum*.

The meaning of Bokubi delights me—"The pleasures of ink; the beauty of black and white."

The "Endless House": A Man-Built Cosmos

The "Endless House" is called the "Endless" because all ends meet, and meet continuously.

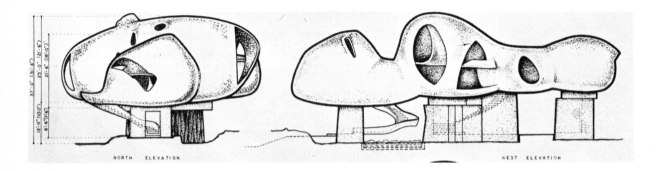

It is endless like the human body—there is no beginning and no end to it. The "Endless" is rather sensuous, more like the female body in contrast to sharp-angled male architecture.

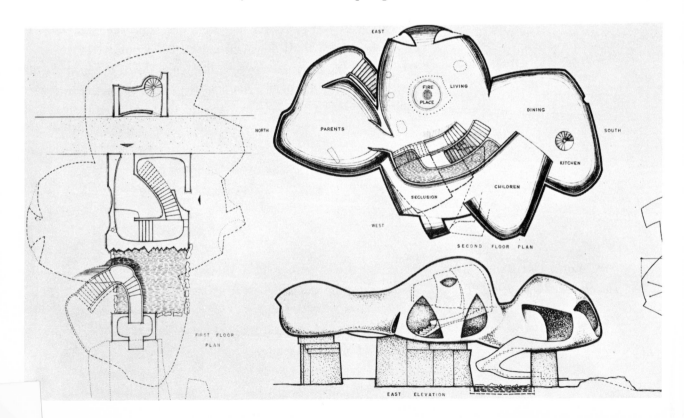

All ends meet in the "Endless" as they meet in life. Life's rhythms are cyclical. All ends of living meet during twenty-four hours, during a week, a lifetime. They touch one another with the kiss of Time. They shake hands, stay, say goodbye, return through the same or other doors, come and go through multi-links, secretive or obvious, or through the whims of memory.

The events of life are your house guests. You must play the best possible of hosts; otherwise the hosts of events will become ghosts. They will. Yes, they can, but not in the "Endless House." There, events are reality, because you receive them with open arms, and they become you. You are fused with them and thus reinforced in your power of self-reliance. You are indeed a rich man, wealthy with happenings of no end.

SOUTH ELEVATION

Machine-age houses are split-ups of cubicles,
one box next to another,
one box below another,
one box above another,
until they grow into tumors of skyscrapers.

Space in the "Endless House" is continuous. All living areas can be unified into a single continuum.

But do not fear that one cannot find seclusion in the "Endless."

Each and every one of the space-nuclei can be separated from the totality of the dwelling, secluded. At will, you can reunify to meet various needs: the congregation of the family, of visitors from the outer world, neighbors, friends, strollers. Or again, you'll womb yourself into happy solitude. The "Endless" cannot be only a home for the family, but must definitely make room and comfort for those "visitors" from your own inner world. Communion with yourself. The ritual of meditation inspired. Truthfully, the inhabitants of your inner space are steady companions, although invisible to the naked eye, but very much felt by the psyche. Those invisible guests are the secret-service men and honor guard of your being. We cannot treat them as burglars. We must make them feel comfortable. They represent diligently the echoes of your past life and the projection of a promised or hoped-for realm of time-to-come.

FREDERICK J. KIESLER © ARCHITECT

DIMENSION PLAN
SCALE: 7/32"-1'-0" (IN PARENTHESES)

It is self-evident that congregations of real people as well as those of the imagination will live together peacefully in an endless

567

house. Neither must be restricted by prejudice of any kind. Welcome travelers. Common rest.

The "Endless House" is not amorphous, not a free-for-all form. On the contrary, its construction has strict boundaries according to the scale of your living. Its shape and form are determined by inherent life processes, not by building-code standards or the vagaries of décor fads.

Nature creates bodies, but art creates life. Thus living in the "Endless House" means to live an exuberant life, not only the life of a digesting body, of routine social duties, or the wind-up of functions of the four seasons, the automatism of day and night, of high noon and the midnight moon. The "Endless House" is much more than that and much less than the average dwelling of the rich or pseudo rich. It is less because it reverts to fundamental needs of the human in his relationship to man, to industry, to nature (that is, to eating, sleeping and sex). The "Endless House" is not subservient to the mechanics of life activities or to techniques of manufacture; it employs them wherever profitable but it is not a slave to industrial dictatorship.

In the "Endless House" nothing can be taken for granted, either of the house itself, the floor, walls, ceiling, the coming of people or of light, the air with its warmth or coolness. Every mechanical device must remain an event and constitute the inspiration for a specific ritual. Not even the faucet that brings water into your glass, into the teakettle, through your shower and into the bath— that turn of a handle and then the water flowing forth as from the rock touched by Moses in the desert, that sparkling event, released through the magic invention of man's mind, must always remain the surprise, the unprecedented, an event of pride and comfort. There are many flowers in the garden of industry that have the enchantment of happy happenings, but not all of them have an inspiring color or scent. They must be weeded out, to prevent their overgrowth absorbing the sap of life. Ours is the decision to select, to dismiss, to elect, to reinforce.

Obviously the flow of life activities cannot be squeezed into an array of room-boxes, no matter what sizes, be they of wood, paper, steel or glass. The house, that is, the walls, floors and ceilings, must not meet one another at sharp angles and be fused together artificially, but should flow into one another uninterrupted by

columns or beams. The "Endless House" solves this problem of construction through a continuity of lighter and heavier shells. The column is dead. Having created reinforced concrete, we are now in a position to achieve buildings in unending spatial formations, lateral, vertical, in any direction of an expanse we wish to achieve. But concrete must not be considered the only material in which a continuous plasticity can be achieved. With a bit of imagination and knowledge of one's craft, the spatial planning that gives you a feeling of freedom can be expressed in practically any material, from wood to canvas, from stone to paper. The concept is the thing, not the execution. Automotive tools can be very welcome, but the architect as a craftsman can build with any material and express the ritual of life within a dwelling even with such primitive means as earth solidified in the manner of the American Indians in their adobe houses. The architect-technician will not think in terms of material as such. He will evoke from any one of them strength, closeness and depth, an abundant scale of textures.

While it is being built, the "Endless House" will grow its colors, in vast areas or condensed into compositions (fresco-like or paintings), into high or low reliefs, into the plasticity of full sculptures. Like vegetation, it grows its form and color at the same time. And so let us avoid the museum term "art" in connection with architecture, because, as we understand it today, architecture has been degraded to old-fashioned or modern-fashioned make-up and décor. Art as a ritual cannot be an afterthought. It must again become the usual link between the known and the unknown.

The "Endless House" is indeed a very practical house if one defines practicality in not too narrow a sense, and if one considers the poetry of life an integral part of everyday happenings.

The coming of the "Endless House" is inevitable in a world coming to an end. It is the last refuge for man as man.

1964

A Reminder to Myself: A New Era of the Plastic Arts Has Begun.

It Is Now 1964

*Written in my sickbed
for my exhibition
at the Guggenheim Museum.
April, 1964*

Our Western world has been overrun by masses of art objects. What we really need are not more and more objects, but an objective.

L'art pour l'art of seventy-five years ago and the period of art for the artist's sake of the last twenty-five years are over. Before we can go into new productions, a new objective must first be crystallized out of a world consciousness which is the concern of all of us, not of any particular stratum of society. The world events since the last war have grown in turbulence and have thrown us together. Aestheticism as a sole criterion for the validity of a work of art is evaporating. The artist will not work any more for his glory in museums or galleries but for solidifying the meaning of his creations on a larger scale without falling into the pitfalls of social realism or anecdotal accounts of events. He will take active part through his work in forming a new world image.

The era of experimentations in materials and forms over half a century has run its gamut; a new era has begun, that is an era of correlating the plastic arts within their own realms but with the objective of integrating them with a life freed from self-imposed limitations.

The poet, the artist, the architect and the scientist are the four cornerstones of this new-rising edifice.

Just as we have been restricting our lives to this earth since homo sapiens became man, so have the plastic artists acted within the confines of the spirit of this planet. What we artists were doing was simply trading traditions with little forays into the unknown to flatter our fickle ego. To look up at the sky, at the stars, at the moon, at the sun was a romantic or fearful dream. Now the outer space (as the super-galaxies are called) is coming closer and

closer to us and is changing from an abstraction into the realism of our world.

The plastic arts must now expand their horizons, too, and widen the arena of their activities to unforeseen capacities. It is evident that the constantly expanding universe of our environment forces us more and more to give attention to time-space continuity.

The traditional art object, be it a painting, a sculpture, a piece of architecture, is no longer seen as an isolated entity but must be considered within the context of this expanding environment. The environment becomes equally as important as the object, if not more so, because the object breathes into the surrounding and also inhales the realities of the environment no matter in what space, close or wide apart, open air or indoor.

No object, of nature or of art, exists without environment. As a matter of fact, the object itself can expand to a degree where it becomes its own environment (see my wooden galaxy exhibited at the Museum of Modern Art in 1951).

Thus we have to shift our focus from the object to the environment and the only way we can bind them together is through an objective, a clarification of life's purpose—otherwise the whole composite picture in time and space will fall apart.

In my show at the Guggenheim Museum, I tried on a small scale to indicate the new relationship between object and environment, of course with moderate means but taking in the whole scale of architecture, painting, and sculpture, real and abstract—but non-objective.

There are several galaxial co-ordinates in that large room, yet, without losing their individual identity, they are related to one another in a totality forming its own continuum. I hope that this first exhibition of environmental sculptures is successful, inspiring other artists, poets and scientists alike, to work together and bring the expanding universe of the plastic arts into an ever-growing reality.

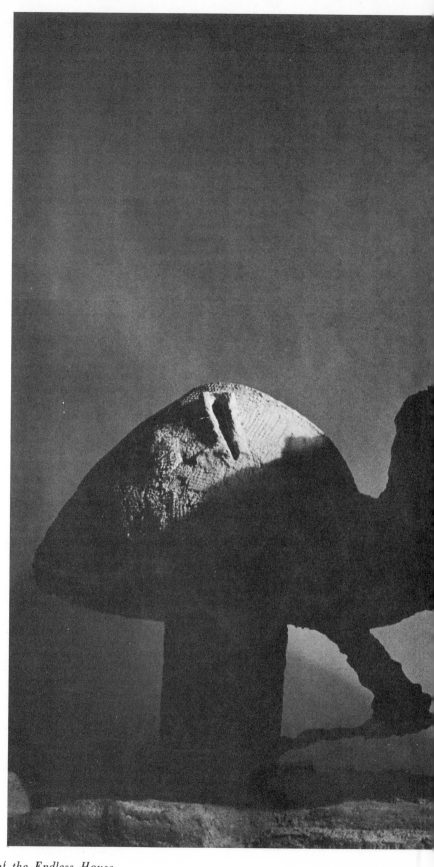

Frederick Kiesler and his sculpture-model of the Endless House

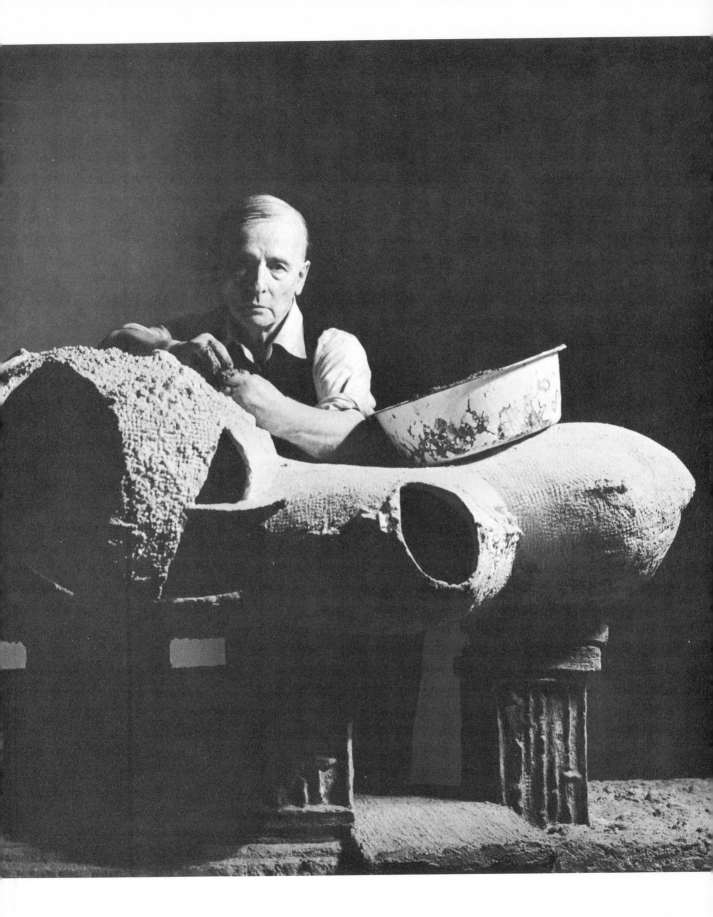

Profound homage to Len Pitkowsky, for many years my husband's assistant, for resisting the crushing blow of his unexpected death by immediately working under "all, all circumstances," selflessly, impeccably, to complete this book. His "courage de nuit" has guided me.

Lillian Kiesler

Photograph by Irving Penn